To my husband Frank,
whose constant encouragement,
support and patience
helped it all happen.

GRACE RUSSO BULLARO

THER

Beyond *Life is Beautiful*: Comedy and Tragedy in the Cinema of Roberto Benigni

t

© Grace Russo Bullaro 2005
Beyond *Life is Beautiful*: Comedy and Tragedy in the Cinema of Roberto Benigni

Troubador Publishing Ltd
9 De Montfort Mews
Leicester LE1 7FW, UK
Email: books@troubador.co.uk

Bullaro, Russo, Grace
Beyond *Life is Beautiful*: Comedy and Tragedy in the Cinema of Roberto Benigni
Series: *Transference*
Troubador Publishing Ltd, Leicester (UK), 2005

1-904744-83-4

www.troubador.co.uk/transference

Acknowledgements

I wish to most particularly thank my editor, Erminia Passannanti, whose support, advice, and firm but gentle touch contributed immeasurably to this project. In addition, I am grateful to Carlo Celli for his generous offer to write the preface, and to my students and colleagues whose stimulating conversations helped build the foundations of this book.

GRACE RUSSO BULLARO

Beyond *Life is Beautiful*:
Comedy and Tragedy
in the Cinema of Roberto Benigni

t

Contents

Preface

Grace Russo Bullaro's timely and vibrant edition of essays about Roberto Benigni covers the bases of Benigni's foundations as a comedian, from his directing debut *You Upset Me,* his brilliant comedy *Johnny Stecchino,* the apex of his work as a comic actor in *The Monster,* even musings about the ethnocentricity of the reception of *Pinocchio.* Russo Bullaro's collection wisely focuses on Benigni's Oscar winning *La vita è bella/Life is Beautiful,* a film which has set off continuous and often bitter debate about Holocaust representation and historical consciousness. The topics covered in Russo Bullaro's collection offer rich insights from critics around the world in a compelling forum for the consideration of the wider issues that Benigni's films provoke.

The essence of Benigni's appeal has been his ability to use his comedic talents in tragic settings. He has been compared to a *fescennino,* the ancient rodeo clowns of Etruscan origin, who distracted crowds at the Colosseum while seconds removed fallen gladiators. Like a *fesceninno,* Benigni's works are dependent on public approval. In fact Benigni films have consistently reflected larger trends and events in Italy – the decline of peasant culture in *Berlinguer ti voglio bene* (1977), references to debates about the American military in *Non ci resta che piangere* (1984), the decline of traditional Catholic culture with *Il piccolo diavolo* (1988), the anti-mafia struggles of the early 1990s in *Johnny Stecchino* (1991), serial killing and Berlusconi-spoofing in *Il mostro* (1994). If Benigni's ability to be on the cutting edge of Italian popular culture was an asset of his earlier films, this has not been the case with *La vita è bella* (1997), a film clouded by the subsequent political climate in a Europe where a candidate from the National Front came in second in French presidential elections of 2002 and a 2003 European Union report about anti-Semitism revealed the persistence of unsettling attitudes.

Benigni's last offerings to the Italian public were the nationally televised *L'ultimo del Paradiso* (2002), a brilliant

recitation of Dante's declaration of faith in the *Divine Comedy;* and *Pinocchio* (2002), a traditional adaptation of Collodi's fable which was received relatively well by Italian audiences who understood to bring their children to the theatre. On the set of *Pinocchio* Benigni admitted difficulty infusing Collodi's story with the clownish brio the public expects in a Benigni film. The themes that the author Carlo Collodi, a committed follower of Italian republican revolutionary Giuseppe Mazzini, put into the puppet character of Pinocchio are tragically relevant for the cultural and personal defects of the Italian people. The limited praise *Pinocchio* received in Italy included a political undertone whereby critics fashionably sought to distance themselves from the Mazzinian republican precepts of Collodi's cautionary tale.

With works with such set moral foundations like *Pinocchio* and canto XXXIII of Dante's *Paradiso,* Benigni seems to have moved away from his comedic roots. Before making *Pinocchio* and his televised recitation and commentary of canto XXXIII of the *Paradiso,* Benigni had even seriously considered making a film about another great moral figure, Saint Francis, but he admitted feeling uncomfortable in the part. The mischievous puppet Pinocchio may have the soul of a *fesceninno,* but St. Francis did not, and the film never went beyond early discussion. Benigni's upcoming film *La tigre e la neve* (*The Tiger and the Snow*), seems to be a return to the larger issues of *La vita è bella.* According to the press release from Benigni's production company, the plot features a poet struggling with the unrequited love from the female lead played by Nicoletta Braschi. Benigni's character, Attilio De Giovanni, ends up in Iraq at the beginning of the present conflict, "armed only by poetry in the land of *A Thousand and One Nights.*" Will the playful jabs at America from *Non ci resta che piangere*, in which Benigni and Massimo Troisi travel back to 1492 to stop Columbus from discovering America, open Benigni's next film to the sort of criticism that has been leveled against *La vita è bella*? Or will *The Tiger and the Snow* sufficiently evoke themes of love and humanity to reach beyond the tragedy of current political events? Russo Bullaro's expertly edited and introduced collection provides a perfect forum to prepare for these and

other questions. But the ultimate message of the essays in this collection and indeed any examination of Benigni, is that he is one of few cultural figures currently on the scene able to consistently treat weighty themes in a manner that attracts public interest and critical attention. If Renzo Arbore had teased Benigni during his days as a confused cinema critic in an oversized armchair on the *L'altra domenica* (1976) television variety show, that one day he would be the subject of academic studies, Benigni would have surely played along with the joke. But after *Life is Beautiful* and his performances of Dante's poetry, Benigni has gained a lonely status. He is not only the heir to comedians like Totò or Alberto Sordi and directors like Federico Fellini, but also a *de facto* ambassador of Italian culture, and by extension of European culture. Very few Italians, and few European directors for that matter, are now able to command the sort of international attention and distribution for their films as in previous generations.

Carlo Celli

Notes on Contributors

Gefen Bar-on is a doctoral candidate in the Department of English at McGill University. Her dissertation examines the influence of science on the editing of Shakespeare in eighteenth century England. She has an honors B.A. in History and English from the University of Victoria and an M.A. in English from the University of Toronto.

Grace Russo Bullaro is Assistant Professor at the City University of New York, Lehman College, where she teaches interdisciplinary courses in the areas of literature, philosophy, film, and popular culture studies. She has been invited to lecture in venues including the Yale Club and Columbia University. She has published chapters in books and essays on Jean Genet, all the major films of Lina Wertmuller, Gabriele D'Annunzio, *Blade Runner,* Masculinity and Cooking, and Postmodernism, in journals such as *Forum Italicum, Italian Culture, Gradiva, Riverside Quarterly, Columbia Journal of American Studies* and most recently, in *Post Script.* Her book reviews appear regularly in some of these journals as well as in *Film Quarterly and Annali D'italianistica.* She is currently working on a full-length study of the cinema of Lina Wertmuller.

Carlo Celli is Associate Professor at Bowling Green State University in Ohio. He is the author of *The Divine Comic: The Cinema of Roberto Benigni* (2001), an upcoming book on Gillo Pontecorvo and articles on Italian cinema in journals including *Cinema Journal, Critical Inquiry, Film Quarterly, Forum Italicum, Italica, Journal of Popular Film and Television* and *Quarterly Review of Film and Video.*

Mirna Cicioni is Senior Lecturer in Italian Studies at Monash University, Melbourne. She completed her Ph.D. in Linguistics at La Trobe University. Her publications include the monograph, *Primo Levi—Bridges of Knowledge* (1995) and articles on

Italian women, post-World War II Italian Jewish writers and Cultural Studies. She is currently working on a study of autobiography and humor in the works of Primo Levi, Natalia Ginzburg, Aldo Zargani and Clara Sereni.

David Scott Diffrient, a Ph.D. candidate in the Department of Film, Television, and Digital Media at UCLA, is currently completing his dissertation work, a study of internationally released anthology, omnibus and sketch films.He has contributed essays to *Paradox, Film Quarterly, CineAction, Asian Cinema, The Encyclopedia of Men and Masculinities,* and forthcoming volumes entitled *Gender, Genre, and National Cinema: South Korean Melodrama* (Wayne University Press), and *Moving Pictures/Stopping Places* (Minnesota University Press).

Janice W. Fernheimer is completing a Ph.D. in English with a specialization in rhetoric at the University of Texas at Austin. Her dissertation focuses on Kenneth Burke's theory of consubstantiality and the rhetoric of Black Jewish identity construction in the United States and Israel. The project builds upon research conducted in Dimona, Israel and makes use of archival materials from the Schomburg Center for Research in Black Culture in New York.

Victoria Kirkham is Professor in the Department of Romance Languages at the University of Pennsylvania, where she teaches Italian Literature and Italian Cinema. She is the author of three books on Boccaccio. The most recent, *Fabulous Vernacular: Boccaccio's Filocolo and the Art of Medieval Fiction* (Michigan, 2001) won the MLA Scaglione Prize for the best Italian manuscript. She has published widely on literature and the visual arts, including studies on the iconography of the poets Dante, Boccaccio, and Laura Battiferra degli Ammanati. Her article, "The Off-Screen Landscape: Dante's Ravenna and Antonioni's *Red Desert,"* appears in the volume, *Dante, Cinema, Television* (Toronto, 2004).

Laura Leonardo is Lecturer in Italian at Manchester Metropolitan University and she researches and publishes in the area of contemporary cinema and narrative. Her research interests also include Eugenio Montale and she is completing her Ph.D. on his role as the translator of T. S. Eliot, Dylan Thomas and Gerard Manley Hopkins.

Vittorio Montemaggi is a member of Robinson College, Cambridge, where he studied theology and European literature, and where he is currently completing his doctoral research on the theology of Dante's *Commedia*. His primary research interest is in the intersection between literary, ethical and theological reflection, and his publications include forthcoming essays on how this intersection may be seen at play in the *Commedia*. The other main focuses of his research are the works of Roberto Benigni and the ethical and theological dynamics of comedy and laughter.

Erminia Passannanti (Ph.D. University College, London) is tutor of Comparative Literature at St. Catherine's College (University of Oxford). She is the author of *Il corpo e il potere: Salo o le 120 giornate di Sodoma di Pier Paolo Pasolini* (Troubador Publishing Ltd., 2004), and *Poem of the Roses: Linguistic Expressionism in the Poetry of Franco Fortini* (Troubador, 2004). Her publications include the anthologies *Emily, Anne and Charlotte Bronte: Poesie (*1989), *Gli uomini sono una beffe degli angeli* (1993) and *R S Thomas: Liriche alla svolta del millennio* (2000), *Mistici* (2003), *Exstasis (*2003), *La realtà* (2004). Her doctoral thesis, *Essay Writing, Lyric Diction and Poetic Translation in the Work of Franco Fortini,* was included in the *Archivio Fortini* in 2003.

Umberto Taccheri is Assistant Professor of Italian at Saint Mary's College in Indiana. He received his degree in *Lettere* from the *Universita di Roma, La Sapienza,* and his Ph.D. in Romance Languages from the University of Pennsylvania. He has written articles on Dante, Ariosto, Luchino Visconti. His

essay, "Cinematization and its Discontents: Benigni's *Il Mostro*" is forthcoming.

William Van Watson is currently a Visiting Professor of Italian at the University of Arizona. He has taught at universities in Italy, and Portugal, and has guest lectured at universities in Ireland and France. He is the author of *Pier Paolo Pasolini and the Theatre of the Word*, and has contributed chapters to anthologies on Shakespeare, Visconti, Fellini, fascist cinema, and most recently, to the book *Queer Italia*. His articles on MTV, literature, theatre and film have appeared in such journals as *Theater InSight, Il veltro, Theater Journal, Romance Languages Annual, Semicerchio, Literature Film Quarterly, and Annali D'Italianistica.*

Rebecca West is the William R. Kenan Professor in the Department of Romance Languages and Literatures, and the College at the University of Chicago, where she has taught since 1973. She is also a Professor on the faculty of the Committee on Cinema and Media Studies, and Director of the Center for Gender Studies. West has been a Fellow at the American Academy in Rome and a Guggenheim Fellow. She has taught as a visiting professor at Northwestern University, the University of Pennsylvania, and Stanford University. Her areas of specialization include modern and contemporary Italian literature and culture, Italian and Italian-American film, and gender studies, and she has published extensively on texts and issues pertaining to these fields of interest.
Her 1981 book, *Eugenio Montale: Poet on the Edge,* won the Howard Marraro's Prize, and her 2000 book, *Gianni Celati: The Craft of Everyday Storytelling,* won the MLA's Scaglione Publication Prize. West has edited or co-edited several volumes including the *Cambridge Companion to Modern Italian Culture* (with Zygmunt Baranski), *Italian Feminist Theory and Practice* (with Graziella Parati), and *Pagina pellicula pratica: Studi sul cinema italiano.* Her interest in cinema and popular culture has led her to an exploration of Pinocchio's continuing presence in

literature, film, and popular culture, and she is writing a book on this topic, the working title of which is: *The Persistent Puppet: Pinocchio's Heirs in Contemporary Literature, Cinema and Mass Culture.*

Introduction

The Trajectory to *Life is Beautiful* and beyond it

Grace Russo Bullaro

A study of Roberto Benigni's cinema inevitably suggests that *Life is Beautiful* is the apotheosis of his life's work thus far. Indeed, especially in the Anglophone world, Benigni is synonymous with *Life is Beautiful,* and *Life is Beautiful* with Benigni. This is not true in Italy, where he has been, and continues to be, a household fixture on television, stage and in films, since the 1970s. There, although he certainly has his detractors, he is generally loved, despite the persistence with which he plays the role of gadfly to the political establishment. After winning Oscars for Best Foreign Film, Best Actor and Best Original Score in 1999, he was also proudly seen by many Italians as a sort of national treasure, another feather in the cap of Italians everywhere. Indeed, even those who did not particularly like his films declared themselves proud of his exploit.

In the United States, judging from the repeated references to the incident, it appears that the image etched on the minds of the public is of a clownish Roberto Benigni vaulting over the seats in the Dorothy Chandler Pavilion, oblivious to the inconvenience he was causing, on his way to the stage to collect his Oscars for *Life is Beautiful.* [1]Once there, rambling on in virtually incomprehensible English (that some have claimed he

[1] The reaction of many Italians and Italian-Americans to Benigni's performance has been markedly different from what many Americans found so cute. We read in *Jam!Movies* that, "Italian commentators have been complaining bitterly about the *Life is Beautiful* star and director. The leftists accuse him of 'groveling' to the powerful and the conservatives of playing the undignified 'court jester.' The newspaper *Il Foglio* asked him in print, 'Do you finally understand that life is not always beautiful?'" (1).

mangled deliberately), he finally ended his speech by thanking his parents for giving him "the gift of poverty."

With the power of the Miramax juggernaut behind him, and the Oscars awarded to his film, Benigni became an international star with what at the time appeared to be unlimited expectations of future success in Hollywood, and naturally, in his own country. As it turned out, this was not to be. The project that followed *Life is Beautiful, Asterix et Obélix contre César* (1999), did not cause so much as a ripple in France, Italy, or the USA. *Pinocchio* (2002), released internationally, including in the USA, far from adding lustre to his reputation, damaged it severely. In the context of the present situation, therefore, it would appear that the widely-held belief that *Life is Beautiful* is the culmination of his career may be justified, at least from the perspective of box office and critical response; and especially in the Anglophone world to the present time.

One of the results of Benigni's sudden international celebrity was the appearance, in Italy, of a spate of books that clearly aimed to feed the hunger of a public that could not get enough of the man who had beaten Americans out of three Oscars, and on their home turf of Hollywood, to boot. Among these we find: *Benignaccio, con te la vita è bella; Benigni secondo Benigni; Roberto Benigni, superstar,* and *Datemi un Nobel!* In almost all cases these books offered little more than a personal and professional biography of the phenomenally popular television, stage and film star and a facile summary of his filmography, with only occasionally a veneer of critical study thrown in. A few, such as Cosentino's *La scena dell'osceno,* go a bit further in attempting to get at the roots of Benigni's creativity and the nature of his artistic style, but focuses only on the early work. In English, however, this explosion did not occur. Carlo Celli's *The Divine Comic* stands out for its obvious effort at filling the voids of the Anglophone public's knowledge of the Benigni oeuvre, and Masi's book was eventually translated into English. We hope that the collection of essays found in this book, some written by established scholars with an international reputation and some by newer, vibrant voices, will go a long way towards problematizing, enriching

and rounding out the image of Benigni as actor and director, and helping the public to understand his central place in the culture of his homeland, as beloved actor, reviled radical and proud international symbol of Italian ingenuity, charm and dynamism.

On 20 August 2004, on the RAI International program, *La giostra dei borghi,* aired in the New York Metropolitan area, the theme was, *La memoria, un peso o un aiuto? (Memory, a burden or an aid?)*[2] The special guest, a frail yet articulate and impassioned elderly Holocaust survivor, told her story, bringing tears to the eyes of the audience, and pleaded that we must love and forgive, but never forget. Confiding that she is terminally ill with cancer, she stated that with her last breath she will do everything possible to see that such horrors will never be repeated. As part of this effort, she has not only published a book, but she is also about to open a museum in Milan. "Bisogna ricordare!" (We must remember!) she exhorted weeping.

It was not too long ago that, according to Francesco Caviglia, the role that Italy played in the Holocaust was by and large "un buco nella nostra storia" (a black hole in our history), with most Italians still confidently placing the blame for the deportation of Italian Jews squarely on the shoulders of the Germans and maintaining the widely held fiction of "Italiani brava gente."

Indisputably *Life is Beautiful* has caused a great deal of controversy, a number of essays in this collection will discuss the acrimonious debate that Benigni's thematic and cinematic treatment of the Holocaust as comedy has engendered. What's more, his highly contested decision to prettify and sanitize the death camp has only added fuel to this roaring fire. Much of the rancour in the USA, France and the UK has revolved around the possible dangers of misrepresenting or downplaying the evil and horror of the Holocaust at a time when, as many believe, the

[2] All translations of Italian passages in this Introduction are by Grace Russo Bullaro.

contingent of denialists and minimizers is growing steadily; not to mention that anti-Semitism is on the rise as well. Yet, paradoxically, in Italy *Life is Beautiful* was praised for having opened the eyes of the public to the ugly reality of the Holocaust (Caviglia 1).

It is true that the film, by generating the discussions, has led to some necessary soul-searching on the part of Italians. Until very recently history books still glossed over the Holocaust. Now the subject is being aired, and it is not always a pretty sight, with recriminations among numerous groups playing the blame game. It is ironic to think that had the Benigni detractors not insistently pointed to the historical inaccuracies of *Life is Beautiful,* and attempted to correct the record, Italians might still not have had their consciousness raised as a result of this film. By misrepresenting the true nature of the Holocaust, Benigni has caused historians to "spell it out" for those who were still ignorant. As such, in a circuitous manner, Benigni's dubious representational strategy has served history well indeed.

The high visibility that he has attained through this one film has caused some misunderstanding about the totality of his work, especially in the Anglophone world. Those who were relatively unfamiliar with his work before this film are under the impression that there is not much more besides it, and those who were familiar with the actor believe that his art and creativity are encapsulated by *Life is Beautiful.*[3] Indeed, many of the latter group are now reading the film as the sum of all his previous work. Like Existentialist biographers, they see his future inscribed in his past. As we will see, this is not necessarily an erroneous impression, if we are careful not to take it too far, for

[3] An informal review carried out by some British, Australian and Canadian contributors to this collection of essays has confirmed that, as Laura Leonardo stated it, "I wouldn't go so far as saying that he is a familiar face to the average British cinema goer." Leonardo added that the films available at Blockbusters Video Rental and shops such as HMV and Virgin are *Life is Beautiful,* and frequently *Down By Law,* not very much when we consider the totality of Benigni's output over the years.

we must also remember that innovation and creative development are not predictable, nor do they follow a linear progression. Nevertheless, it is valid to examine his previous work with the object of identifying the threads in the warp and weft of *Life is Beautiful*. After all, as we know so well, no art object is born in a vacuum, and this is especially true of Benigni, whose artistic development has been so markedly influenced by a number of forces that will be explored in these essays. Accepting this idea, Benigni's body of work acquires a greater unity, coherence and texture that only an extensive, in-depth, yet diachronic study can uncover. We need therefore to look more closely not only at *Life is Beautiful*, but also at the fundamental theoretical, thematic, conceptual and structural elements that have characterized the Benigni signature style since the beginning.

Thus, this book is divided into two main sections. In the first we analyze these forces and the resulting themes, as they have featured in films other than *Life is Beautiful*. The films that will be foregrounded are those that are familiar not only to Italian audiences, but also likely to be known to the Anglophone public as well: *Johnny Stecchino, The Monster, You Upset Me* and the latest, *Pinocchio*. All of these titles have had theatrical releases. The one performance treated in this section that constitutes an exception to this rule is Benigni's hugely popular television reading of Dante's *The Divine Comedy*.

Section Two will turn its attention exclusively to *Life is Beautiful*, scrutinizing it from multiple angles and through different methodologies, weaving the threads paid out in Section One in order to trace Benigni's creative development and to examine how these influences have resulted in recurring themes that will be taken up by each contributor to this collection.

Thus, delving into his earlier films we will notice that he has always had an overarching interest in the protection of children, in fairy tales, in history, in the iconic Hollywood comedians such as Buster Keaton and Charlie Chaplin, and in Dante. And above all, we remark that in almost all his films, life is presented as an inextricable mix of tragedy and comedy. These prominent features of his Oscar winning film, commented on with such

passion by critics and public alike, did not emerge full-blown in *Life is Beautiful.*

A cursory glance at these threads, before we turn to their full study, will show us, for example, that in Marco Ferreri's 1979 release, *Chiedo asilo,* Benigni played a vaguely Montessorian nursery school teacher who, while treating the children as his equals, nevertheless does not attempt to draw them prematurely into the adult world. Instead, in order to safeguard and prolong their child-like innocence as long as possible, it is he who transforms himself into a child, much as Tom Hanks did in *Big,* but without the benefit of magic (Masi 36). As the loving and protective teacher, he invents a game that allows him to share the children's lives and their daily activities, down to taking naps with them, playfully jumping out of closets and even using their own little potties for his biological needs. However, in the end, foreshadowing events in *Life is Beautiful,* the game turns tragic, as Roberto the teacher rejects the responsibilities of the adult world and walks into the sea to drown. As Masi states, "rientrando nel ventre materno del mare..." ("re-entering the maternal womb of the sea") (36); a metaphor that richly suggests what may accurately be considered the ultimate prolongation of childhood.

Benigni's passion for fairy tales in general and Pinocchio in particular, dates even farther back, reportedly to his childhood. Like many Italian children of his generation, he seems to have had an abiding interest in the wooden puppet. But for Benigni it went well beyond the simple temporary infatuation of a child. As he himself has made clear on many occasions, and as we read in Rebecca West's essay, Benigni has identified with the rebellious puppet whose picaresque adventures will feature explicitly in the film that he will finally release in 2002, and implicitly in most of his other works on stage, television and films. Cristina Borsatti suggests in *Roberto Benigni,* that the importance of Pinocchio in the professional (and possibly personal) life of Benigni cannot be overestimated. Not only has he been told "un milione di volte" ("a million times") (Borsatti 111) that he is just like Pinocchio, but he is also therefore imbricated in the subtle relationship existing between Pinocchio,

Italians, and their national identity. This crucial topic is fully investigated by Rebecca West in her essay, where she also examines the film's obvious fidelity to Collodi's 19th century classic tale, and the effects of such fidelity on the transference from witten word to visual language. West also explores the problematic nature of Benigni's choice to play the puppet himself as well as to direct the film; and then offers some possible explanations for the film's spectacular failure, especially in the USA.

On the professional level, Benigni's determination to play Pinocchio dates almost to the beginning of his acting career. One of his early "implicit" representations, which in this case proved to be abortive, came in 1978 when Benigni and Giuseppe Bertolucci conceived of a sequel to *Berlinguer ti voglio bene,* in which he would play, "un Pinocchio diventato adulto, un uomo di venticinque anni, un pò cattivo, ma soltanto per sopravvivere..." ("an adult Pinocchio, twenty five years old, a little naughty, but only in order to survive" (Masi 32). In Fellini's *La voce della luna* (1989), once again Benigni conceives of his character, Ivo Salvini, as "un pò Pinocchio, un pò poeta triste" ("a little bit Pinocchio, a little bit sad poet") (Masi 38).

Nor is *Pinocchio* the only fairy tale that Benigni has represented on stage or in film. Some of his earliest appearances on stage were in fairy tales. In 1972 he had a role in Paolo Magelli's play, *Una favola vera,* presented at the Teatro Metastasio in his hometown of Prato. In the same year he also appeared in Lucia Poli's production of *Le fiabe di Basile* in Rome and the following year in *La contessa e il cavolfiore*, once more directed by Poli and this time also Mario Moretti. In 1990 he returned to the fairy tale as the narrator in *Pierino e il lupo* in a prestigious production of the classic children's tale set to the music of Prokofief, played by the Chamber Orchestra of Europe under the direction of Claudio Abbade. In this collection of essays, the formative role of fairy tales in Benigni's creative matrix, and his subsequent deployment of them in his own works, is foregrounded in the essays of Leonardo, Russo Bullaro and West.

History is another central element to consider in a study of Benigni's artistic development. Although it becomes the focal point in *Life is Beautiful,* and of the post-release controversies we alluded to before, and as such we will go back to this shortly, for now let us mention that it is already present in Sergio Citti's *Il Minestrone (1981),* a surrealist parable (Moscati 53) of three picaresque characters in search of a square meal or preferably, of many square meals.[4] With the aid of magic realism, space, time, and History itself are negated (Parigi quoted in Moscati 53). In Y*ou Upset Me,* Benigni's directorial debut, History features implicitly and explicitly in all four episodes. However, in the first, "Durante Cristo," there is a deliberate parody of History and religion. Roberto Benigni plays the shepherd Benigno, father to Lazarus and uncle to Judas, who babysits for the infant Jesus while his parents Mary and Joseph, go out on the town. In what amounts to an irreverent monologue, Benigni does not hesitate to rewrite the New Testament accounts of Jesus'childhood or of his public ministry (Moscati 55). David Scott Diffrient's essay not only explores Benigni's use of history to satirize the prevailing attitudes of the bourgeosie, religious orthodoxy, state power, and inter-office bureaucracy, it also provides a brief tour of Italy's sketch film tradition and recalibrates it to trace its historical movement from parody to social satire, from a devalued hybridized cinematic genre to a sophisticated and frequently mordant artistic weapon.

The next film, *Non ci resta che piangere (Nothing Left To Do But Cry),* is the most explicitly historical as Benigni and his co-director, Massimo Troisi, play two characters who through some unexplained mechanism are catapulted back into the Renaissance, specifically to the year 1492. Meeting historical personages such as Girolamo Savonarola, Leonardo Da Vinci and Christopher Columbus, they attempt to change the course of

[4] *Il Minestrone* is interesting for an additional reason, as it is considered by some critics to be a parody of *The Divine Comedy.* This film therefore unites two of Benigni's long-standing and enduring passions. Additionally, it marks the encounter with Vincenzo Cerami, co-author of *Life is Beautiful* and collaborator on other projects.

history by trying to convince Leonardo to market his inventions and Columbus not to sail to America. In short, much as he will do in *Life is Beautiful* in a somewhat different manner, Benigni demystifies "serious" history by deflating its certainties and pretensions.

Benigni's generation, like so many before in Italy, and unlike the present one, grew up venerating Dante and his poetic tradition. For Benigni the great poet and his *Divine Comedy* became a virtual obsession; what Massimo Moscati has colloquially called, "un chiodo fisso"(8). And of course, it should not escape our notice that Dante's "comedy" deals with that most serious of subjects, the salvation of the soul. As such, it is valid to ask ourselves to what degree did Dante's concept of comedy[5] influence Benigni's? *Life is Beautiful*, like *The Divine Comedy*, is conceived in such a manner that the ending does indeed conform to the classic definition of the genre. Although both endure hardships and suffering, Dante is saved as Giosuè is saved.

As early as in 1990 Benigni gave his first *Lectura Dantis* on television. The invitation, coming as it did from the *Magnifico Rettore* of the University of Siena on the seven hundred and fiftieth anniversary of its foundation, no doubt gave much satisfaction to the culture-hungry but self-taught actor. Dante is to the atheist Benigni what the Bible is to a religious believer, a daily source of solace and inspiration. As he has stated, "Dante uno lo ama sempre. Insomma, si sa: uno va a casa, piglia il caffè e ogni tanto d`a una guardatina alla *Divina commedia*" ("Dante is someone that a person loves forever. You know how it is, you go home, have a cup of coffee and every once in a while you take another look at the *Divine Comedy*") (Masi 52).

The presence of Dante in Benigni's life was as natural as that of his mother's. Indeed, the two were also inextricable, his mother apparently not only introducing her son to the poet's work but also continuously referring to him and his poem. It is therefore not surprising that Roberto, already an accomplished

[5] According to *Webster's Dictionary*, "originally, any play or other literary composition with a non-tragic ending" (361).

practitioner of the improvisational poetry of the Tuscan oral tradition, the *poeti a braccio*,[6] later found the learning and declamation of *The Divine Comedy* as easy as breathing. "Dante è uno che s'impara facilmente, lo leggi una volta e ti rimane in testa, anzi ci sono proprio delle terzine che le leggi e non ti vanno più via dal cervello, come un motivetto" ("Dante is easy to learn, you read it once and you won't forget it. In fact, there are some tercets that, like a little tune, you just can't get out of your head" (quoted in Masi 52).

In 2002 Benigni offered another reading of *The Divine Comedy* on Italian television. This one was such a success that it turned Dante's eight hundred year old classic into the best-selling book of that Christmas season. Vittorio Montemaggi's essay explores this performance in all its resonance. Montemaggi examines Benigni's coupling of joy and suffering as a filmic strategy in *Life is Beautiful* and *Pinocchio*, tracing it back to Dantean ethics and theology. Drawing many parallels between Dante and Benigni and their respective works, he illuminates their understanding of human personhood and relationships, all along suggesting that Benigni's comic art, especially as seen through his own comments on his work, aims to draw us into a particular kind of ethical reflection. Montemaggi further argues that this reflection, on one hand sheds light on the influence of Dante on Benigni's thought, and on the other helps us recover aspects of the *Commedia* often not taken into account by Dante scholarship.

Finally, no study of Roberto Benigni's cinema would be complete without considering the role that iconic Hollywood figures such as Buster Keaton and Charlie Chaplin have played in his development and in his films. The Hollywood success signified by the three Oscars awarded to Benigni's film is appropriate enough when we realize the enormous influence that Hollywood iconic comedians have exercised in shaping

[6] For a fuller description of this poetic tradition and its role in Tuscan culture, see Andrea Cosentino, whose book, *La scena dell'osceno*, is an in-depth study of this tradition and Benigni's early influences. In addition, see Celli and Borsatti.

Benigni's style of comedy. This is a fact that has been commented on by countless critics and by Benigni himself, who has many times declared himself indebted to Lloyd, Keaton and Chaplin. Indeed, at one point in his career, before *You Upset Me,* Roberto Benigni tried to realize a series of one-reelers in which he would, very much like Keaton at his most classic, interpret different characters in vignettes such as *Benigni-fireman, Benigni-on-the-escalator,* and *Benigni–and-the-devil.* When this project, originally planned for Renzo Rossellini's Gaumont Studios, did not materialize as a result of financial difficulties, Benigni turned instead to Bertolucci and *You Upset Me.* According to Masi, in the mid 1970s, when Benigni was attempting to soften the edges of the Rabelaisian Cioni Mario persona whose humor relied heavily on scatology and obscenity, Benigni immersed himself in the classic Hollywood slapstick comedies, haunting every cinema club in Rome that was playing these films. He himself had occasion to remark later on, referring to Buster Keaton, "Credo che sia il maestro da cui ho preso di più" ("I think he's the master from whom I've gotten the most") (Masi 32). [7]

Yet his debt to Chaplin is no smaller. We could provide a catalogue of critics who have, in one way or another, hailed Benigni as the new Chaplin. But more importantly, we have Benigni's own words to acknowledge his artistic kinship to the great Charlot, as he is known in Italy. At various times he has stated, "Nei miei film c'è sempre un omaggio alla silhouette di Charlot" ("In my films there is always a tribute to the figure of the Tramp") (Masi 11). To Benigni, Chaplin is "una leggenda, un tesoro del mondo" ("a legend, a world treasure") (Masi 11). Indeed Benigni has gone as far as revealing that the original idea of *Life is Beautiful,* if not actually in imitation of Chaplin's

[7] Notice the use of the word "ho preso" ("I've gotten" which can be understood as having learned from but also as having taken from).

masterful tragi-comic *The Great Dictator*, was at least inspired by it (Masi 54). The Chaplinesque mixture of pathos and gags, become even more pronounced under the influence of his co-writer Vincenzo Cerami, has been at the center of the maelstrom created by the *Life is Beautiful* debate. But let's also not forget that the *Commedia dell'Arte* was the quintessential comedy of despair; what Diffrient calls "gallows humour" in his essay. As such, although it is widely acknowledged to be Chaplin's signature style, it was not of his invention.

Attempting to vindicate his much-debated strategy of representing the tragedy of the Holocaust as comedy, Benigni recalls that in one story Chaplin is about to kill a child who is in a garbage heap but then grows to love him, in another he deceives a blind girl into believing that he is a wealthy man and helps her regain her sight only to have her fall in love with another, handsomer man. Then there is Monsieur Verdoux, Benigni says, who murders all his wives and in the end is hanged (Simonelli and Tramontana 141-142). Although William Van Watson will explore the provenance of these gags fully in his essay, for the time being allow me to underline that critics point to scenes in *Life is Beautiful* that are clearly inspired by Chaplin. For example, the runaway car and bicycle in the opening scenes, the lovers' encounters between Dora and Guido under the banquet tables, the Barcarolle played from the victrola that Guido has pointed outwards from the windows of the Officers Club. Most importantly, Guido's need to protect Giosuè from the reality of the Camp is highly reminiscent of Chaplin's relationship with *The Kid* (Simonelli and Tramontana 142). Thus we see that the most distinctive features of *Life is Beautiful* bear the imprint of one of Benigni's most important artistic models.

In his essay William Van Watson investigates Benigni's indebtedness to the iconic Hollywood comedians, especially to Buster Keaton. Watson argues that both Benigni and Keaton appear as modern-day manifestations of the *Commedia dell'Arte* character, Truffaldino, a highly physical trickster who remained simultaneously both inferior and superior to the world around him. While with Keaton this inferior-superior position allowed

him to critique the place of humanity in an early twentieth century society of machines, with Benigni it enables him to critique the continually more invasive and dehumanizing late twentieth century machines of society. As *The Monster* fuses the police surveillance state with the contemporary culture of compulsory consumerism, it appears as Benigni's most Keatonesque film, the one in which the mechanical predictability of society proves most susceptible to the Truffaldino-like trickery of the protagonist.

Although *Life is Beautiful* caused a scandal because of its comic treatment of what is indubitably one of the most serious topics of the twentieth century, those familiar with Benigni's work know that this strategy is not new to the actor and director. His comedy has always been deadly serious, taking on the sacred cows (including the Pope), exposing corruption, commenting on the bankrupt social and political institutions. In short, as Diffrient illustrates in his essay, at the heart of his comedy is his intention to *upset* not only figuratively, but literally, not only the individual, but the establishment. As Masi has commented, "il suo è un riso anarchico che sconquassa l'ordine costituito...che porta in sè il germe della rivoluzione" ("his laughter is anarchic, it shatters the established order...it carries within it the germ of revolution" (Masi 40). And yet, not for the first time, we realize that understanding Benigni is never easy, for he himself has unequivocally stated, "guai al comico che lancia messaggi" ("woe to the comic who flings messages into his work"). This idea is reiterated by his co-writer Vincenzo Cerami who has also stated that comedy by its very nature relinquishes claims to profundity. Umberto Taccheri, in his essay on *Johnny Stecchino,* tackles this seeming inconsistency in the narratological esthetics of Benigni, as he teases out the many ways in which this film is an acerbic critique of Italian society on all levels, the social, economic and above all, political. Taccheri also, like West, draws a suggestive parallel between Benigni's representational strategies and Italy. As West identifies Pinocchio as an iconic representation of Italy, so does Taccheri suggest that the Mafia serves the same function, especially in *Johnny Stecchino.*

Yet despite Benigni's self-contradictory pronouncements on the inadvisability of using comedy as a vehicle for messages, we clearly detect the tendency to inject protest and criticism into his comedies (either singlehandedly as director, or in collaboration with the director(s) when appearing as actor) from as far back as *Berlinguer ti voglio bene (Berlinguer I Love You)*. As Simonelli and Tramontana have explained in *Datemi un Nobel!*, 1977, the year that the film was released, marked the beginning of the darkest period of contemporary Italian history, ushering in the disillusionment that followed the so-called economic miracle of the 1960s. By the mid 1970s it became apparent that the utopic idealism of the previous decade had dissipated and been replaced by cruel disappointment, social and economic upheaval, and eventually the terrorism of the Red Brigades (83-86).

The Cioni persona that we see in *Berlinguer ti voglio bene*, unlike the Cioni seen on stage two years previously, bitterly pines for the muscular communism that characterized the pre-1968 era and that proved to be only a pipe dream. With the rise of the hated materialistic, hedonistic middle class, Cioni-Benigni gives way to the vituperation of their hypocritical and self-serving ways, though still adhering to the generic conventions imposed by comedy.

Chiedo asilo (Seeking Asylum), already discussed above, can also be read as an indictment of a fossilized educational system that has lost all sense of how to nurture childhood; as we know, a theme that is close to Benigni's heart. *Il mostro (The Monster)*, although hilarious comedy, was released in the midst of the trial of the notorious serial killer known as *il mostro di Firenze*, and Benigni was castigated by many critics for having exploited a tragic situation. Equally, *Il mostro*, can be seen as a denunciation of the methods of criminology and forensic psychology, not to mention of the public's morbid voyeuristic fascination with sex and crime. *Johnny Stecchino*, while undeniably a very funny film, condemned not only the Mafia, this would have been nothing new, but the political corruption and government incompetence that allows it to flourish. In short, the narratological strategy adopted in *Life is Beautiful* not only

has been present since the start, but represents the very essence of the Benigni signature style.

Furthermore, in looking towards the future we can confidently predict that the pattern established in *Life is Beautiful* of uniting comedy and tragedy in a combustible mix, is likely to continue at least for the foreseeable future. Consider the advance promotion of *The Tiger and the Snow* that is scheduled for release in 2005. *Variety* describes it as "a comedy about a love-struck Italo poet in Iraq at the outset of last year's American-led invasion" (MovieWeb 1). In another snippet we learn that, "*The Tiger* is Benigni's return to a *Life is Beautiful*-like tale—comprising comedy and historical tragedy..." (MovieWeb 1).

Other essays in Section II of this book afford us a prismatic glimpse into this multi-faceted film. For example, both Leonardo and Russo Bullaro tackle the crucial question of Benigni's use of the fairy tale in *Life is Beautiful*, but from different angles. Since so much has been made of this issue, by detractors, defenders and Benigni himself, clearly it needs to be addressed fully. Taking a structuralist approach, Leonardo argues that *Life is Beautiful* is a transposition of fascist myths. Thus, historical inaccuracy and lack of factual truth are necessarily indispensable to Benigni's *real* aim, to parody the fairy tales that Mussolini and his propaganda machine offered up to the Italian people in order to maintain power and the population's acquiescence to his imperialistic aspirations. Leonardo focuses on the themes of the Ethiopian cake and the Jewish horse as metaphors for this embedded discourse.

Russo Bullaro, on the other hand, accepts Benigni's given as a starting point. She argues that since he has stated that he should not be held accountable for historical accuracy because his goal was to create a *fable* (Benigni's chosen word), then we should examine the film in that context. Drawing on theories of Bruno Bettelheim, David Luke and J. R. R. Tolkien, she analyzes the function of fable and fairy tale in the child's psycho-emotional development in order to assess whether Guido's/Benigni's strategy to fictionalize the violent reality of the concentration camp in order to protect Giosuè's innocence is

a valid one, even within the parameters of the director's chosen genre, fairy tale. Russo Bullaro goes on to illustrate how Benigni's narrational strategy ends up by creating a multi-layered network of deceit, both diegetic and extra-diegetic.

Gefen Bar-on, takes still a different perspective on Benigni's narrational strategy, defending the director against the charges of distortion that have been levelled at him. Drawing on work that she has done in Israel, and the theories of Abraham B. Yehoshua, a major Israeli writer and theorist, Bar-on argues that, when judged in the light of Yehoshua's theories on the obstacles of Holocaust art, *Life is Beautiful* emerges as an aesthetic and moral triumph. Indeed, a close reading of the film filtered through Yehoshua's five obstacles to the representation of the Holocaust, leads Bar-on to conclude that *Life is Beautiful* "is the most morally accurate film about the Holocaust ever made."

Fernheimer's essay explores territory largely ignored up to now by film and literary scholarship—viewers' responses to *Life is Beautiful.* As Britton and Barker remind us in *Reading Between Designs,* scholarly treatment of audience response is viewed as a controversial subject of cultural studies and is frequently the object of critical scorn (132). However, I am confident that in the present case, given the central role that audience responses have played in the controversy surrounding Benigni's film, and the dissonance existing between the critics and the public, it is an indispensable and valid tool if we are to gain a greater understanding of the passionate condemnation and defense that the film has incited.

Boldly building her essay on audience responses to *Life is Beautiful* and *Schindler's List* posted publicly on the Internet Movie Data-base (IMDb), Fernheimer attempts to reconcile the conflicting genre expectations for film, Holocaust representation, historical realism, and fable. By investigating the different ways in which both films break the "Commandments of Holocaust representation," Janice Fernheimer concludes that it is precisely these films' mechanisms of departure that enables them to fulfill expectations for other genres, and thus communicate "truths."

Mirna Cicioni too employs this methodology in her analysis of *Life is Beautiful*. But while Fernheimer focuses on responses posted on the Internet by non-specialized viewers (or at least not identified predominantly as such as a group), Cicioni limits her inquiry into the reception given the film by "public intellectuals" in Italy, the film's country of origin, and in Australia, a country significant in Cicioni's analysis for its multi-cultural composition. In the latter Cicioni was most keen to concentrate on responses from non-Italians. The specific questions that Mirna Cicioni aims to answer are: whether the film's representation of history is revisionist; whether it appropriates Jewish discourses, and whether its humor is comforting to an excessive degree. In the process, she maps out convergences and divergences in historical, political and ethical discourses about the film, while bringing still another perspective to the collection, the Australian.

Both Passannanti and Kirkham situate *Life is Beautiful* in the discourse of Postmodernism. Borrowing from the theories of Eagleton, Jameson and Benjamin, Passannanti juxtaposes Benigni's film to other filmic Holocaust representations in order to compare strategies and to tease out some of the implications of the director's decision to distance the audience from historical accuracy. By contrasting Pier Paolo Pasolini's *Salò o le 120 giornate di Sodoma,* Passannanti concludes that the valorization of imagination over reality, translated into the comforting lies that Guido tells Giosuè and that Benigni tells the audience, ultimately reveals a fundamental paucity of inventiveness on the director's part. Citing Cioran's theory that eclecticism and comedy are born when creative energy has died, the author concludes that Benigni has thus resorted to the only other possibility at his command, *kitsch.*

Victoria Kirkham gives us a vivid picture of the depth and breadth of Benigni's cultural eclecticism; what she calls his "postmodern storehouse of culture." The essay provides the entire tapestry out of which the other contributors foreground discrete elements. With the aid of Kirkham's catalogue of references, we place history, fairy tales, Dante, iconic Hollywood comedians, and much more, into the total Benigni

context. Thus, metaphors used by other writers in this collection, such as the Ethiopian cake and the Jewish horse, take on more resonance as well. Kirkham also touches upon the many other influences and forces that have shaped Benigni's art, but which, limited by realistic considerations of space and scope, we have not been able to develop fully in this volume. These include: his childhood poverty, the Tuscan oral tradition, Rabelais, Dostoevsky, Fellini, and more. In the present book we have focused on those that are most prominent in Benigni's cinema. Coincidentally, they are also the ones that will help us to understand the full, yet sometimes disputed or misunderstood artistry of Benigni; the one that goes beyond *Life is Beautiful.*

Works Cited

"Benigni to Direct *The Tiger and the Snow.*" *Google,* 8 September 2004. <http://movieweb.com/news/news.php?id=5049>

Borsatti, Cristina. *Roberto Benigni.* Milano: Il Castoro Cinema, 2001.

Britton, Piers and Simon J. Barker. *Reading Between Designs: Visual Imagery and the Generation of Meaning in The Avengers, The Prisoner and Doctor Who.* Austin: University of Texas Press: 2003.

Caviglia, Francesco. "Tra Chaplin e Fellini: *La vita e' bella* come *summa* di fine secolo." *Google,* 15 September, 2004.
<http://www.hum.au.dk/romansk/romfrc/papers/benigni.htm>

Celli, Carlo. *The Divine Comic: The Cinema of Roberto Benigni.* Lanham, Maryland and London: The Scarecrow Press, 2001.

Cosentino, Andrea. *La scena dell'osceno: alle radici della drammaturgia di Roberto Benigni.*Roma: Odradek Edizioni, 1998.

"La memoria, un peso o un aiuto?"*La giostra dei borghi. RAI International Television.*New York Metropolitan Area. 20 August, 2004.

Masi, Stefano. *Roberto Benigni, Superstar.*Roma: Gremese Editore, 1999.

Moscati, Massimo. *Benignaccio, con te la vita e bella.* Milano: Superbur Saggi, 1999.

"The New Benigni, A Poet in Love." Google. *Corriere.it* 8 September, 2004.
<http://www.corriere.it/English/articoli/2004/08_Agosto/31/Benigni.shtml>

"Roberto Benigni to Direct *The Tiger and the Snow.*" Google. MovieWeb, 8 September, 2004. <http://movieweb.com/news/news.php?id=5049>

Schindler's List. Director, Steven Spielberg. Dreamscape Productions, 1993.

Simonelli, Giorgio and Gaetano Tramontana. *Datemi un Nobel!: L'opera comica di Roberto Benigni.* Alessandria: Edizioni Falsopiano, 1998.

Webster's New Universal Unabridged Dictionary. New York: Dorset and Baber, 1983.

Section One

Beyond *Life is Beautiful*: The Foundation

Italian Sketch Films and the Narrative Genealogy of Roberto Benigni's *You Upset Me*

David Scott Diffrient

Fifteen years before scrambling over the heads and seats of Hollywood's elite and taking center stage at the Dorothy Chandler Pavilion to claim three Academy Awards for his international breakthrough *Life is Beautiful* (*La vita è bella*; 1997), Roberto Benigni made his directorial debut with the episodic sketch film *You Upset Me* (*Tu mi turbi*; 1983). Hitching together four tangentially related, roughly twenty-minute vignettes, Benigni and co-screenwriter Giuseppe Bertolucci transposed the comedy routines they had honed during their stints in Rome's underground communist theater and subsequent television work onto the structural foundation of the feature-length film. At first glance, Benigni's modestly budgeted sketch film seems to be a buoyant if insubstantial novelty compared to his weightier yet audience-friendly Holocaust fable. However, *You Upset Me* not only sets in motion many of the thematic motifs central to the filmmaker's oeuvre; it is also a benchmark in the history of Italian cinema, made at a time when a staple of the nation's motion picture industry—the multi-story episode film—began segueing from frequently misogynistic excuses for cinematic striptease to a socially conscious form of storytelling.

By examining the ways Benigni's unique brand of absurdist pragmatics partakes in a variety of comic techniques, and by placing *You Upset Me* within specific historical and industrial contexts, I hope to illustrate how this unassuming yet incisive sketch comedy opens a window onto a landscape of cerebral buffoonery and political allegory. Theatrically released in the wake of enormous social upheavals in Italy, *You Upset Me* is a product of its time, a cultural artifact whose abrupt shifts in narrative provide a diegetic correlative for a country whose citizens had grown accustomed to quick, sometimes violent

change.[1] Taking satiric jabs at religious orthodoxy, state power, inter-office bureaucracy and the prevailing attitudes of the bourgeoisie, the film consolidated the many social grievances and political persuasions of the period as few other motion pictures did.

Besides articulating the public's growing concern with contemporaneous social ills and administrative corruption, the film conjures Italy's cinematic, literary and theatrical pasts. *You Upset Me* recalls the *commedia all'italiana* cycle of films that came into vogue during Italy's economic and industrial boom of the 1950s and 1960s. It also hearkens back to the pantomimic traditions and improvisational techniques forged four hundred years earlier, when the sixteenth-century mode of performance known as *Commedia dell'Arte* gave poor traveling players and palace-bound professional troupes the opportunity to tip over the sacred cows of Church and State through satirical stories and songs. By emphasizing the historical precedents of *You Upset Me*'s satire and narrative symbolism, I hope to substantiate the general claim that episode films—as texts that are simultaneously unified and fragmented—function as metaphors of the nation-state in times of crisis. I also hope to illustrate that the sociopolitical turmoil of the 1960s and 1970s laid the groundwork for Benigni's iconoclastic take on authority figures and hegemonic institutions during the 1980s.

Although episode films (randomly referred to by critics as "anthology," "composite," "omnibus," "portmanteau," or "sketch" films) pepper the histories of most national cinemas, a comprehensive filmography would attest to their pervasiveness in the land of Fellini, Antonioni, Visconti and Pasolini. These

[1] Indeed, by the time Premier Amintore Fanfani took office in 1982 (initiating Italy's 43rd government since 1945), Italians had become increasingly alienated from the political process yet paradoxically aware of its transformative dimensions in the post-Democrazia Cristiana era. For an elaboration on this combustible period in Italian politics, which saw the forced resignation of the scandal-ridden DC government in 1981 and a rising tide of violence among the working classes, see Ginsborg, 418-419.

filmmakers, along with their lesser-known compatriots, collectively churned out no fewer than 150 such works between 1946 (the year Rossellini's six-episode *Paisà* went into production) and 1998 (when the Taviani Brothers' two-episode *You Laugh* (*Tu ridi*) was released). Indeed, *il film a episodi* is to Italian cinema what *olio d'oliva* is to Italian cuisine: an essential if oft-ignored ingredient in the material constitution and authentication of a national culture—an element without which any attempt to write a comprehensive history of Italian film would be malnourished. Despite their significance to this and other national cinemas, however, episode films—particularly sketch comedies—have been critically belittled and grossly understudied. This is both understandable and lamentable; for, while they offer "bite-size," quickly consumed stories in a single sitting (and are therefore perfect for an audience increasingly characterized by short attention-spans), the anecdotal nature of sketch films—their apparent slightness in terms of thematic content, plot development, character growth and diegetic duration—suggests a narrative form of little consequence and limited returns. However, a look at episode films produced in Italy reveals a narrative complexity as well as a literary awareness that belies their outward irrelevance.

As a work consisting of two or more discrete, causally unrelated yet thematically related stories strung together like beads, the episode film simultaneously adheres to and departs from conventional narrative paradigms. Traditionally, a mainstream single-narrative film is characterized by rising action and a set of conflicts faced by a lone protagonist or group of characters that must be resolved within a three-act structure. To a certain degree, each short narrative comprising an anthology, portmanteau or omnibus film is expected to comply to this rule, even if the brevity of the form makes this easier said than done. Additionally, for all their heterogeneity, episode films are supposed to "hang together," harmoniously, around a central theme or narrative conceit—their individual parts less important than the syncretic whole. This is complicated by the fact that an episode film might be the product of numerous directors, each working in "collaborative isolation" and

contributing a short work to a producer who then links several together.[2]

Regardless of the number of cooks in the kitchen, the episodic sketch film is an inherently disparate text, capable of allegorizing any of the many contradictions plaguing Italian life through a narrative form that is both singular and multiple, unified and fragmented. Consider the six-episode omnibus feature *Love in the City* (*Amore in città*; 1953), for instance. Originally conceived by Cesare Zavattini (in collaboration with "publishers" Riccardo Ghione and Marco Ferreri) as the inaugural issue of *Lo Spettatore*, a "screen magazine" that was ultimately abandoned after the first volume, *Love in the City* mined many of the social rifts opened up in the postwar years. Although it gave seven luminaries of post-Neorealist cinema (Carlo Lizzani, Michelangelo Antonioni, Dino Risi, Federico Fellini, Francesco Maselli, Alberto Lattuada and Zavattini) the opportunity to pool their considerable talents and editorialize on such issues as prostitution, attempted suicide and unwed mothers, this occasionally playful, frequently morose marriage of celluloid and journalism shifts tones and milieus so radically that new ruptures become apparent.

These narrative fissures diminish the emotional rawness of the film's most compelling episodes: Antonioni's "Tentato suicidio" and Zavattini and Maselli's "Storia di Caterina." The two most amusing sequences, Risi's "Paradiso per tre ore" and Lattuada's "Gli italiani si voltano," concern the mating rituals of young and old alike—the former by casting in relief the chasm between northern and southern Italy in Rome's Paradise Dancehall, and the latter through a series of "candid camera" close-ups of men gawking at hip-swinging women. Both sketches stand alone yet sit tenuously next to the other, more

[2] For example, *Of Life and Love* (*Questa è la vita*), a 1954 adaptation of Pirandello stories that was compiled from two preexisting episode films, muddies the already murky waters of cinematic authorship by uniting the work of four directors (Giorgio Pàstina, Mario Soldati, Luigi Zampa and Aldo Fabrizi).

downbeat episodes. The resulting tension between comedy and calamity, between individual story and what might be called the "narrative community" of the entire package, foretold the psycho-schizophrenic split that would characterize Italian life during the mid-1950s and early 1960s—a period of economic prosperity marked by cultural homogenization and what Mirco Melanco calls "social atomization" (388).

Throughout these years of industrial development, both Lattuada and Risi led the charge of the *commedia all'italiana*. This cycle of commercial, ostensibly escapist fare turned away from the shantytowns of Neorealism to the high-rise offices and vacation resorts being peopled by the emergent middle class—a group whose demand for salary increases, mass migration to northern cities and consumption of such ubiquitous goods as home appliances and sports cars sparked this socioeconomic progress. In place of impoverished shoeshine boys and their vehicularly challenged fathers, shallow intellectuals, feminized cuckolds, petty politicians and bulbous-eyed businessmen took center stage in comedies that cynically revealed the dark underbelly of Italy's so-called *miracolo economico*. This new class of "suburban subaltern"—a bumbling alternative to *peplum*'s hyper-masculine Hercules and Samson—was a figure of little virtue and much vice for whom personal incentives took precedence over collective needs. As sketch films of the 1960s attest, greed, crime and corporate scandal came with the economic upturn, as did a kind of cultural displacement that can be partly attributed to the influx of American pop music, movies and goods.

After the economic boom, *commedia all'italiana* continued to gain momentum, only now as a cathartic, if still satiric, means of resolving conflicts among the classes and sexes, none of whom were exempt from the dull blade of caricature. Grotesque figures, from the gap-toothed yokel to the *maggiorata fisica*, magnified economic disparities of the era while harkening back to the tradition of *Commedia dell'Arte*, a popular public entertainment consisting of comic sketches, witty banter, music and dance. Performed throughout Europe, whether on the Pont-Neuf by companies like the *comédie-italienne* or in Roman

piazzas full of snake-charmers and charlatans, these medieval and early Renaissance plays may seem remote from 1960s Italian cinema, but they not only established the exaggerated postures and ridiculous situations that would characterize raucous episode films like *These Crazy, Crazy Women* (*Queste pazze, pazze, pazze donne*; 1964) and *Let's Talk About Women* (*Se permette parliamo di donne*; 1964), but also made political subversion and religious satire safe for even the most disenfranchised spectators. Mario Monicelli, one of the key writer-directors responsible for the international dissemination of both *commedia all'italiana* and episodic cinema, makes a case for historical continuity, contending that the impetus behind the former's malicious humor of misery stems from the satiric disposition of *Commedia dell'Arte*. Monicelli states:

> *Commedia dell'Arte* heroes are always desperate poor devils who are battling against life, against the world, against hunger, misery, illness, violence. Nevertheless, all of this is transformed into laughter, transmuted into cruel joking, in mockery rather than wholehearted laughter. This approach belongs to a very Italian tradition that I have always defended: Italian comedy comes from this and it isn't true that it's vulgar, that it was always a matter of chamber pots, excrement, clysters, farts. Let's face it, there is a crude side, but this isn't important since the true underlying factor is the element of despair (Gili, 75).

The "element of despair" upon which Monicelli muses was certainly an engrained quality of the sketch comedies released during the post-boom era, a period which saw renewed interest in the gallows humor of *Commedia dell'Arte*. Although Monicelli attempts to diminish the importance of scatology to the legitimization of comedic forms in Italy's cinematic, literary and theatrical heritage, I argue that the "vulgar" slapstick and "obscene" gestures found in *Commedia dell'Arte* (buffoons strapping sausages to their groins, breaking wind and baring the ubiquitous ass) have been a vital if recklessly deployed means of recuperating the margins of society while attacking bourgeois conformism.

It could be argued, however, that the sketch comedies of the 1960s, while critical of the increased privatization and social indifference resulting from Italy's economic upturn, never adequately revealed the systemic causes of this national malaise, opting instead to focus on the surface excesses and "monstrosities" of the era. It was as if the physical tics and stereotypes performed by ubiquitous actors Nino Manfredi, Vittorio Gassman, Ugo Tognazzi and Alberto Sordi were sufficient material for social critique. Sordi, an iconic fixture of *commedia all'italiana* who went on to flex his directorial muscles in such episode films as *A Common Sense of Modesty* (*Il commune senso del pudore*; 1976) and *Where are You Going on Holiday?* (*Dovè vai in vacanza?*; 1978), had apparently so "benumbed the minds of the Italians" with his vulgar yet palatable shtick that he alone bore the brunt of blame in Nanni Moretti's *Ecce Bombo* (1978), a film in which a character launches the invective, "It serves you right, Alberto Sordi!" (Melanco 387). Although his characters (salesmen, craftsmen, clerks) were often, like most audience members, "deprived of social authority," Sordi represented the self-absorption and conformity of the middle-class to a younger generation of leftist filmmakers who saw in the sketch film the potential for disseminating dissent through pluralistic discourse and group solidarity.

So, on the one hand, the sketch film, as Enrico Giacovelli points out, gave *commedia all'italiana* directors and screenwriters the opportunity to tackle topics and themes *en masse* that had otherwise been deemed taboo in the context of conventional narratives; on the other, it propogated images that fed middle-class consumption. Be it the pitfalls of drug-abuse (*White, Red, Yellow, Pink* [*Bianco, rosso, giallo, rosa*; 1964]), the felicities of cross-dressing (*How Funny Can Sex Be?* [*Sessomatto*; 1973], the backlash against homosexuality (*High Infidelity* [*Alta infedeltà*; 1965]), or the social stigmas faced by people with physical defects (*The Complexes* [*I complessi*; 1965]), the episodic sketch film foregrounded alternative lifestyles and widespread prejudices without fully explicating the institutional roots of exclusion (Giacovelli, 64-66).

In the wake of the "economic miracle," the film that had the most profound effect on the future of episodic sketch comedies in Italy was director Dino Risi's *The Monsters* (*I mostri*; 1963). Sardine-packed into one film are twenty brief segments that provide both literal and figurative evidence of the monstrosities plaguing Italian life during the 1960s. Cross-eyed policemen ("Il mostro"), bruised ex-boxers ("La nobile arte") and towering transvestites ("La Musa") vie for time against excessively manicured clergymen ("Il testamento di Francesco") and big-wigged barristers ("Testimone volontario"). The *real* monstrosities, however, reside less in any physical deformation than in the moral vacuum of a world where cheating spouses ("L'oppio dei popoli"), fathers who teach their sons con-games ("L'educazione sentimentale"), penniless husbands who spend more time at soccer matches than at home ("Che vitaccia") and middle-class couples unfazed by the horrors of World War II ("Scenda l'oblio") are the norm.

As is often the case in sketch films, a small group of actors dons multiple roles in *The Monsters*. Like Benigni in *You Upset Me*, Vittorio Gassman and Ugo Tognazzi are chameleons at play, transforming their speech and physical comportment to suit a diverse cross-section of male characters episode-to-episode. In interviews, Risi was unreserved in his admiration of what he calls a "masculine cinema, a cinema of actors." Although equally adept at creating plum roles for actresses with whom he had "developed a good rapport," Risi himself admits that the female roles in his films "have always been a little 'on the side'" (Gili, 87-89). This point is illustrated in the seventh episode of *The Monsters*. Titled "Amanti latini," this beach scene consists of nothing more than scantily clad women sunning to the pleasure of ogling men, who represent the target audience of most Italian episode films of the 1960s such as *Countersex* (*Controsesso*; 1964) and *Three Nights of Love* (*Tre notti d'amore*; 1964). The re-masculinization of Italian cinema throughout the decade was therefore contingent upon the widely accepted view that women, if central to the preservation of national/familial ideals, were little more than "side dishes" on the banquet table that is episodic cinema. Even the titles of

sketch films from this period attest to the cinematic chauvinism aimed at female characters, who were called, among other things, "witches" (*Le streghe*; 1966) and "dolls" (*Le bambole!*; 1965) (Giacovelli, 64-67).

Although *commedia all'italiana* came to an end with the release of Ettore Scola's 1973 non-episodic *We All Loved Each Other So Much* (*C'eravamo tanto amati*), the ten years leading up to *You Upset Me* saw an unprecedented spate of multi-story films, mostly in the chauvinistic vein. Kicking off this trend was Dino Risi's aforementioned *How Funny Can Sex Be?*, which was followed by a number of single- and multi-director episode films. While these films are now nearly forgotten, there were a few works that earned high praise at the time of their release. Pasquale Festa Campanile's *Let's Shake on It* (*Qua la mano*; 1980), which flirts with Benigni-like religious parody in episodes titled "I'm with the Pope" and "The Dancing Priest," was one of the most popular films in Italy at the time of its release (second only to the American import *Kramer vs. Kramer* in box office receipts). While a few of these films tackled subjects like terrorism, children's sweatshops, the corruptibility of the judicial system and the political status quo, even the most biting satires, such as *Goodnight, Ladies and Gentlemen* (*Signore e signori, buonanotte*; 1976), could not resist the temptation to "assault the solar plex [with] close-ups of breasts, buttocks, and thighs" (Vogel, 18-19). In the years leading up to *You Upset Me*'s theatrical release, this once vital cinematic subgenre had sunk into abysmal decline. No longer a vehicle for addressing matters of great national import, nor a form whose intrinsic heterogeneity could cogently represent the country's linguistic, racial, ethnic and regional differences, the episode film—indeed, Italian film in general—had become mired in the tired iconography of "tits and asses."

Another reason for this decline in quality rests in the Italian film industry's predilection for directors who continued to work well past their prime. Luigi Zampa, one of the important progenitors of episodic cinema during the *neorealismo rosa* period, was—by the end of the 1970s—a septuagenarian seeking refuge in the comparatively safe haven of television. Zampa's

Letti selvaggi (1979), a Spanish-Italian co-production loosely translated as *Tigers in Lipstick* for its American release, gave Roberto Benigni his first bit part in a sketch film, yet his contribution to this eight-episode bedroom fling bears little resemblance to the saturnalia on display in *You Upset Me*. In contrast, the years immediately following the release of Benigni's *You Upset Me* witnessed a return to political engagement and social critique in omnibus films (for example, *L'addio a Enrico Berlinguer*; 1984)[3] and *Before the Future* (*Prima del futuro*; 1985), as well as multi-storied literary adaptations (such as the Taviani Brothers' *Kaos*; 1984).

While his contemporaries in the United States and Great Britain continued to mine the farcical depths of sexuality, excrement and abjection with such sketch comedies as *National Lampoon's Goes to the Movies* (1981), *Monty Python's Meaning of Life* (1983), and *Amazon Women on the Moon* (1987), Benigni momentarily turned away from juvenilia, scatology and corporeal limits towards a more loquacious inquiry into matters of the soul. This movement from parody to social satire, from so-called "sick" forms of comic relief to philosophical humor, entailed a radical alteration of preexisting textual paradigms—a transformation that, however short-lived, lent the bastardized sketch form a semblance of sophistication and legitimacy. Although Benigni's Cioni skits and subsequent films tapped into the "vulgar idiom" of Boccaccio's "Florentine ruffians," balancing a "taste for exorbitant digressions and irrelevances" with an exploration of bodily functions and sensations, he nevertheless maintained what Carlo Celli calls a "physical philosophy" in which his improprieties syntactically shattered cultural conventions while lending corporeal expression to abstract or spiritual concepts. (26-27, 65, 71).

When Benigni returned to the episodic form as an actor in Jim Jarmusch's (literally) dark comedy *Night on Earth* (1991),

[3] *L'addio a Enrico Berlinguer*, a documentary overseen by Francesco Maselli, features the work of thirty-five Italian filmmakers (including Roberto Benigni), who took to the streets of Genoa to capture images of the many demonstrations sweeping through the city.

he brought with him his trademark loquaciousness—only this time laced with a perverse fixation on pumpkins and sheep—not to mention the longstanding fascination in Italian cinema with nocturnal settings and lunar imagery. Broken into five vignettes of equal length, *Night on Earth* glimpses the lives of taxicab drivers and passengers around the world, from Brooklyn to Helsinki. In the "Rome" sequence, set at 4:07 a.m., Benigni plays a libidinous trickster, a Ray Ban-wearing rogue named Gino who has the city nearly to himself. "Roma deserta," he muses in singsong fashion, sending the Crazy 8-Ball stick-shift into high gear as his taxi zips past the Colosseum, magazine vendors, transvestite prostitutes and an amorous couple making love on a Vespa under the moon. That this episode seems less like an American's romantic view of the city than an extension of the Italian sketch film tradition is a testament both to Jarmusch's coffee-stained cosmopolitanism and Benigni's unique brand of lunar lunacy, his ability to transform night—the stuff of astronomers, burglars, and jazz musicians—into a chronosphere of conscious and unconscious yearnings, the time-space where man and monster merge.

Indeed, the moon as celestial guide and signifier of a destined yet unobtainable dream has dominated the semantic and scenographic terrain of Italy's image-based culture, dating back to the "Lazzi of Nightfall" and "Lazzi of Day and Night" routines performed by *Commedia dell'Arte* players of the sixteenth-century.[4] The twentieth-century alone witnessed innumerable examples of this, from the moons of silent cinema (including *L'amante della luna*, Achille Consalvi's 1919 serial consisting of linked yet separate episodes) to those of high literature (Cesare Pavese's mid-century novel, *The Moon and*

[4] *Lazzi* refer to the rehearsed musical numbers and impromptu bursts of slapstick (leaps, tumbles, pratfalls) peppering *Commedia dell'Arte* performances that—like episodes in a sketch film—were independent yet connected. For more information about these miscellaneous bits of physical comedy, which frequently hinged on abrupt shifts between extremes (for instance, Pulcinella's behavior at night and his behavior in the day), see: Gordon, 47-49.

the Bonfire [*La luna e I falo*], leaps to mind). This lunar motif, which punctuates *You Upset Me* at key intervals, has been a part of Benigni's visual lexicon since 1979—the year he appeared in Bernardo Bertolucci's *The Moon* (*La luna*)—and would resurface in Federico Fellini's swansong *Voices of the Moon* (*La voce della luna*; 1989), an adaptation of Ermanno Cavazzoni's *Poems of a Lunatic* in which Benigni plays the idiot savant Ivo Salvini, an ex-mental patient given to chimerical "meanderings in the moonlight." Just as Qfwfq, the forlorn figure in Italo Calvino's *Cosmicomics* (1965), looks for his lost love in the "flat, remote circle" that is the moon, and like the sad *Commedia dell'Arte* clown Pedrolino, whose powder-caked face suggested the moon which so fascinated him, so too does Benigni's Salvini gaze at that celestial beacon, which reminds him of the angelic Aldina Feruzzi, a woman whom he has been spying and whose luminous face appears superimposed on the moon's milk-white surface in a moment of magical realism.

Interestingly, the full moon that appears in the second shot of Fellini's dreamlike picaresque—when Ivo, before being swept up in "demonic frenzy, moping melancholy, and moon-struck madness," first ventures out into the world—recalls a similarly framed lunar backdrop concluding *You Upset Me*'s credit sequence. Set to a melancholic version of Paolo Conte's "Via con me" (sung by Benigni himself), this suite of shots takes us from buttery dusk to the ascendancy of the full moon against a sequined sky. Next to this image of the moon is the director's name, as if Benigni were punctuating his presence *behind* the lens; no longer just an actor but a *director* in a film industry that had heretofore used the moon as a visual symbol of things perpetually out of reach, beyond the grasp of the common man and woman. The similarity between the two shots is irrefutable, and suggests that *You Upset Me* may have been a source of inspiration for Fellini in the twilight of his career.

The sudden appearance of a half-moon in the first episode of *You Upset Me*, besides casting light on Benigni's own indebtedness to previous films, puts a poetic spin on what Maurizio Viano posits as the characteristic feature of actor-director-writer's comedic style: a "sudden eruption of

freewheeling slapstick." Like Fellini's, Benigni's films hinge on unexpected eruptions of chaos and accidental encounters—none more so than *Life is Beautiful*, the opening sequence of which consists of his erratic driving of an automobile and the pandemonium that ensues. As Viano states, the unforeseen brake failure and downhill slalom of the out-of-control vehicle provide "at once the material support of a slapstick routine (it has, in other words, a diegetic role) and an apt allegorization of the text as an intoxicated/intoxicating fairy tale that will stray not only from the rules of realism but also from those of fairy tales themselves" (26). Whether or not *You Upset Me* diverges as dramatically from the narratological conventions of episodic cinema is a question I pursue in the following paragraphs, which are devoted to a textual analysis of the film.

As a four-episode sketch film, *You Upset Me* is clearly prone to digression. Its ruptured diegesis—the intervallic fragmentation of its narrative—makes Benigni's subsequent, single-plot films seem classically composed, almost Aristotelian in comparison. This proclivity toward digression is even visualized in the opening scene of the first episode, "During Christ..." ("Durante Cristo..."), a title whose ellipses suggest both continuation and drift. Benigni plays a hapless herdsman (self-reflexively named "Benigno, devil in the flesh") struggling to lead an impetuous sheep back to his flock. Smarrita, the naughty animal in question, refuses to be led down the straight-and-narrow, and her refusal is an outward expression of the deviations and detours forming the syntactical base of this and other multi-story episode films. "Smarrita," a feminine version of the Italian word for "lost," coincidentally figures in the title of the sketch that begins Nanni Loy's contemporaneous *Heads or Tails* (*Testa o croce*; 1982)—"La pecorella smarrita"—and is furthermore reminiscent of Giuseppe Bertolucci's *Lost and Found* (*Oggetti smarriti*; 1979), a film about a disconsolate woman's encounter with a childhood friend.[5] The image of the

[5] Giuseppe Bertolucci, Benigni's collaborator on *You Upset Me*, was himself no stranger to episodic cinema, and later directed two sketches of the omnibus film *Especially on Sunday* (*La domenica specialmente*;

sheep leading her shepherd is also an ironic commentary on the inverse logic of political and religious authority, a connection that gains significance given the fact that "During Christ....," besides being the only period piece, is the film's *first* episode, behind which the remaining three follow. "Advance! Go forward!" Benigni pleads to Smarrita (a command that invokes the onward march of history); but to no avail, as the grass-nibbler seems more interested in her own prerogatives than in the pursuits of the collective. Straying from the path, the obstinate sheep is a visible sign of what transpires when spiritual guidance and moral imperatives are shirked in the name of free will and individualism. The entire film is in fact a veiled treatise against religious dogma and a parable about the struggles to balance personal independence with group responsibilities.

Throughout a career that spans some of modern Italy's most turbulent decades, Benigni has not shied away from taboo subjects, and continues to draw upon his impoverished childhood experience at the Jesuit's Seminary in Florence, where he once toyed with the idea of becoming a priest, so as to gently mock the traditions of Christianity. This is particularly true of *You Upset Me*, the first episode of which is set five years after the birth of Jesus. Although the title, "During Christ...," offers an amusing alternative to the binaristic teleology of the Christian Calendar—divided between BC ("Before Christ") and AD ("Anno Domini," meaning: "In the Year of Our Lord")—it would not be a stretch to imagine the secular, as opposed to religious, connotations of the abbreviation "DC," which might suggest to some viewers "disorderly conduct" as well as the District of Columbia. Besides this possible allusion to the U.S.'s geopolitical seat of power, a more convincing case of collusion can be made for the Democrazia Cristiana regime, an American-backed, right-wing clerical government whose decades-long hold on power had significantly weakened by the time of this

1991), a multi-national co-production overseen by Bertolucci's more famous brother, Bernardo.

film's release. Because the DC government was itself beholden to the Catholic Church for its moral legitimacy and electoral victories (one need only watch the amusing church scene at the beginning of *Divorce, Italian Style* [*Divorzio all'Italiana*; 1961] to get a sense of this), the many symbolic meanings of the episode's title can be brought into alignment.

Benigni, taking a lead from Smarrita, leaves his flock temporarily to baby-sit a five-year-old boy. The tike in question is none other than the Son of God, whose mother—a one-time object of Benigno's boyhood affections—continues to unwittingly cast a spell on the romantically inclined shepherd. While Mary and Joseph dine out at Bethlehem's finest restaurant, Benigno keeps a watchful eye on their son, playing "horsey" and hide-and-seek and counseling the young savior on politics and organized religion—two pursuits in adult life to be avoided at all costs. "Life is short," says the shepherd, who advises Jesus to wait until the age of thirty-three before getting hitched to a beautiful girl from a good family. As in many of his subsequent films, *You Upset Me* finds Benigni ensconced in the world of children, who are more than kindred spirits to his emotionally stunted adults. Jesus, even at the tender age of five, exudes an unusually stoic wisdom, and this discrepancy between the child's silent complexity and Benigno's effusive straightforwardness once again capsizes the logic of authority. Before nodding off for the night, the mop-topped child performs minor miracles (standing on "hard" bath water, leaving the image of his face on a "towel of Turin" and producing a small bounty of fish), all the while remaining silent.

In this and the other three episodes, Benigni plays a searching soul whose verbal virtuosity and rapid-fire, idiomatic riffing ricochet off straight-faced, tightlipped partners who act as foils for his comedic barbs against bureaucracy, technocracy and snobocracy. His penchant for endless monologue resurfaces in the "Rome" sequence of *Night on Earth*, in which Benigni's Gino confesses his sexual fetishisms to a grimacing priest (whom Gino keeps calling a bishop) in the grips of a fatal heart attack. In a sense, the natural pluralinguism, polycentrism and democratic élan unique to ensemble and multi-episode films

have been overwritten by Benigni's nonstop chatter, which offers few chances for others to join in. A less smarmy version of Groucho Marx (whose profuse, polysyllabic patter casts in relief Harpo's speechlessness), Benigni unleashes a torrent of words that highlight his indebtedness to the oral tradition of *Commedia dell'Arte* and the improvisational barroom poetry of Tuscany, yet curtail the possibility of meaningful debate. Indeed, the verbal dexterity of these monologues and soliloquies comes at a price, for it enthrones the individual artist and stifles the voice of opposition.

Unlike the film's narrative markers (intertitles which delineate the beginnings and endings of episodes), there are no visible boundaries or partitions inside the farmhouse. Joseph's woodworking studio blends into Mary's kitchen—the two spaces separated only by a conspicuously situated bathtub occupying the center of what might be the dining room. The lack of dividing walls lends the small, meagerly furnished farmhouse an appearance of expansiveness that ironically inspires Benigni—a shepherd accustomed to boundless stretches under the moon—to enviously intone, "Beautiful interior...a little large, though." This lack of division, in addition to the actual or suggested presence of what critic Carlo Celli calls the pre-boom "peasant reality of barns, livestock, poverty, vulgarity, excrement, and heavy dialect," suggests an eradication of "barriers between high and low culture, between sanctified literature and Rabelaisian effusion" (35, 10). Moreover, this collapsing of gendered domestic spaces within a single environment suggests the slippage between male and female identities throughout the film—a slippage most pronounced in the second episode, which features a female guardian angel protecting her nerve-jangled husband.

In "During Christ," Benigni forgoes his work in the fields so as to act as babysitter, eventually rocking the boy to sleep in a manner that recalls "Madonna and Child" paintings of the Renaissance. This image of Benigni the babysitter emphasizes the shepherd's connection to both religious and maternal conventions, and aligns *You Upset Me* with other early films in which he undertook the roles of instructors and educators

watching over children: Marco Ferreri's *Seeking Asylum* (*Chiedo asilo*; 1979), Zampa's *Tigers in Lipstick* and Sergio Citti's *Il Minestrone* (1981). *You Upset Me* also points ahead to later films such as *Life is Beautiful*, where the supervision of a child is lent moral gravity. Given this custodial tendency, Benigni seems to be situating himself—both onscreen *and* offscreen—as an instructor, someone who will use comedy to educate his audience.

At the end of this sketch, the shepherd says goodnight to Mary, then leaves. Climbing a hill so as to gaze at the half-moon, he is joined by Smarrita, the sheep in sheep's clothing who takes her place among the woolly congregation. Although it might seem of little consequence to the overriding dynamis of the plot, this shot of the sheep is but one among many in which seemingly trivial details are lent significance due to the narrative condensation unique to sketch films. Just as the lone sheep joins her baah-baah brethren, shown in wide-shot ascending a hill, the four episodes in this film—though dissimilar in many ways—demand to be seen as a unit.

After *You Upset Me*'s first episode introduces the theme of childhood and the anachronistic prefixing of Christianity in a milieu that is both artisan and partisan, theatrical and provincial, the second episode, titled "Angel" ("Angelo"), elaborates a subsequent stage in human development and interpersonal relations by way of a guardian angel who turns her winged back on Benigni for the comforts of God—an act which fuels her forsaken boyfriend's jealousy. This sketch, set in modern-day Rome, begins with Benigni dashing across dark, DeChirico-like piazzas of peopled emptiness, searching in vain amongst the late-night cops, street-cleaners, bus passengers, and prostitutes for his supernatural sidekick.[6] The handheld camera—bobbing along with the protagonist as he moves from nocturnal cityscape to neon-lit interiors—marks a considerable break from the

[6] This sketch consolidates many of the visual and thematic motifs of an earlier episode film, Nando Cicero's *Love Non-Stop* (*La liceale, il diavolo e l'acqua santa*; 1980), which includes images of an angel sent to earth and a policeman who roams the streets of Rome by night.

cinematographically fixed, sometimes anemic *mise-en-scène* that generally characterizes the filmmaker's visual style, and conveys the protagonist's emotional quandary and mental discombobulation. Although, as Maurizio Viano argues, "Benigni is not the type of director to astonish with sweeping camera movements, against-the-beat editing, [and] non-narrative detours" (26), the occasionally bold stylistic exuberance of *You Upset Me* problematizes this generalization.

After being informed by a prostitute of his guardian angel's whereabouts, the lovelorn man tentatively enters Hotel Paradise. Lurid, candy-colored lighting emphasizes the sleaziness of this sexually charged setting, which might seem more at home in the films of Rainer Werner Fassbinder. He finally finds the disillusioned woman sitting alone in a hotel room. When asked to identify her new lover, she responds in a reverent yet yearning tone, "Him." Oblivious to the angel's own desires, the cuckold sobs, "You had no right to do that," in essence failing to grasp God's superiority over man. The angel's litany of reasons for her change of mind and heart is cut short when Benigni (as if imitating a "a fallen angel") plunges from the window only to suddenly wake screaming from his nightmare. Attentive fans of Jim Jarmusch's *Down by Law* (which stars Benigni as a prisoner named Bob who, at one point, draws for cell-mates Zack and Jack "la bella finestra" on a prison wall) might associate this fall from the hotel window with words scribbled on the heavily graffitied wall of Zack's shack: "It's not the fall that kills you, *it's the sudden stop.*"

Episode films like *You Upset Me* are indeed filled with "sudden stops" that test a viewer's willingness to move from one story or sketch to the next, each "ending" infringing upon the lived continuity of the film-viewing act. Upon discovering that he had been napping for five minutes during a raucous costume party (a number that recalls the age of Jesus in the preceding episode), Benigni breathes a sigh of relief when his wife, Angela, emerges from a crowd of religious and historical figures gathered at his bedroom door. In a plot-twist worthy of *The Twilight Zone*, we learn that Angela, dressed as an angel for the party, has a real pair of attached wings. A costume party, it

seems, is the only place where this physically deformed woman can be seen in public. Once again invoking the pastoral iconography of the first episode as well as the sketch film's inherent predilection for numbered order and seriality, "Angel" ends with the woman falling asleep to the childlike sound of her husband counting sheep in bed.

The next episode concerns another obstacle on the path to maturity, and positions its protagonist on the righteous (if not right) side of the law, like a loquacious David trying to slay a corporate Goliath. Titled "In the Bank" ("In banca"), this sketch recalls the fourth episode in Sergio Martino's 1976 *Sex with a Smile*: "I soldi in banca"—a narrative whose ostensible interest in Italy's troubled financial institutions foretold their near-collapse amidst skyrocketing inflation and the suspected corruption of Bank of Italy officials throughout the late-1970s and early-1980s. As its title suggests, the third episode of *You Upset Me* is principally set within the fiscal and physical confines of a bank, where Benigni tries to take out a loan of five million lire for an apartment. As in *Life is Beautiful*, which shows Benigni's fledgling bookseller struggling to fill out the paperwork needed to open a shop, bureaucratic hurdles prove insurmountable. After being sent from one teller window to the next, the would-be homeowner is finally given audience with the loan director, Signor Diotiaiuti ("Mr. May-God-help-you"), a modern-day Pantalone (opposite Benigni's mischievous Arlecchino) ensconced in his patent leather throne several stories up. Wearing a friendly façade, the director patiently informs Benigni that some kind of collateral should be put up if he is to receive the astronomical amount. What's more, he hasn't even opened an account yet. Either blithely ignorant of the institutional restrictions of the banking world or naïve in his belief that a person's word of honor is sufficient security for so large a loan, the frazzle-haired applicant persists, insisting that he be given the money immediately. Adopting a condescending tone, the banker confirms a suspicion held by many cynics, one lent comic inflection by one of Benigni's heroes, Bob Hope, who once famously referred to banks as places "that will lend you money if you can prove that you don't need it."

Benigni's scene with Signor Diotiaiuti—besides giving the fidgety actor opportunities to turn everyday items, such as a mushroom-shaped desk lamp and a blue phone, into imaginative props that recall his filmic forbearers Buster Keaton and Charlie Chaplin—once again highlights his predilection for puns, expanding their situational context to connote the "syntactical doubling-up" characteristic of *Commedia dell'Arte*. In a sense, Benigni is both punster and pundit, his intricate wordplay lazzi casting in comparative relief the sterility and rigidity of bureaucratic language. Moreover, the scene with Signor Diotiaiuti gradually reveals a sadistic side of Benigni's persona. As an actor, Benigni is not afraid of appearing scabrous, bombastic or overly hostile in situations that demand composure and level-headedness; nor does he seem to be concerned that, in shedding his dignity in the name of moral integrity, his overzealousness might dissipate the audience's sympathies.

Waving his arms wildly, Benigni—as if to invoke Dario Fo's "Madman," the powerless figure of civil disobedience in the hugely successful *Mistero Buffo*—throws more than caution to the wind in his conference with the loan director, an authority figure who functions as an easy target of Benigni's caustic wit. Desperate, Benigni picks up a framed photo of the banker's three children and demands a ransom of five million lire for their safe return. Ultimately, his anarchistic craving to attack bureaucratic conventions leads to prison. Dumped into a tiny cell, whose measurements are not unlike those of the apartment he had been so eager to rent, Benigni seems ironically pleased with the results, or—like many Italians throughout this era of trade unionism—at least content to have a place to settle down.

Although an anomaly in terms of setting (this is the only narrative taking place during daylight hours), "In the Bank" builds upon the earlier episodes' thematic terrain while gesturing toward other films made by Benigni. Many of the motifs and images introduced in the first two episodes bob to the surface in this vignette. For example, its first shot, which shows a long procession of men and women trailing Benigni down a winding staircase outside the apartment complex, echoes the flock of sheep depicted earlier. It also prefigures the more disquieting

image of Jews in *Life is Beautiful*—men and women marching to their death, one after the other, in a line. Moreover, this vision of a depersonalized modern cityscape filled with glass partitions, with men and women trapped in a rat race, sets the stage for the highrise topography on view in Benigni's 1988 film *The Little Devil* (*Il piccolo diavolo*). With each apartment the real-estate agent enters, he barks out the measurements; this repeated foregrounding of the spatial dimensions of the rooms, along with the emphasis on ownership and property, recalls Benigni's earlier remark about the large size of Joseph and Mary's house, which he thinks is much too spacious for a carpenter's family. In contrast, the prison cell provides ample space for a man faced with solitary confinement—a strangely draconian form of punishment thrust on someone whose only crime was failing to understand the policies of the banking system.

His search for an apartment is furthermore related to his earlier pursuits of the sheep (in episode one) and the angel (in episode two), suggesting an overriding quest on Benigni's part for both material and spiritual comforts. The thematic consensus of the episodes is even insinuated by the loan director who, though sitting alone, tells Benigni, "*W e* are at your disposal...Tell *us*." Confused by this slippage of the singular and the plural, Benigni protests, saying that he wanted to see the director and no one else. Interestingly, the loan director is played by Giacomo Piperno, the same actor who appears as the real estate agent, the gray-haired bank teller, and the prison ward. Besides emphasizing the notion that the banking industry, the real estate industry, and the State are in cahoots, the plurality of this single actor's performance gestures toward the narrative abundance of the sketch film, a genre whose distinctiveness is often diagnosed as multiple personality disorder.

The many acts of civil disobedience in this episode lay the groundwork for the fourth and final sketch, "The Two Soldiers" ("I due militi"). This episode finds Benigni once again erupting into a nonstop patter. This time he is one of two Roman guards keeping "silent" watch over the Tomb of the Unknown Soldier at Piazza Venezia in Rome. As in previous sequences, the subject of God's existence is broached as Benigni's insouciant

sentinel bombards his less-talkative partner, who stands dutifully before the *Altare della Patria* and its Eternal Flame commemorating Italy's military past. Watching cars zoom across the vast piazza surrounding the *Monumento a Vittorio Emanuele II*, Benigni says, "God, if you exist, make it snow!"—a request that is fulfilled at the end. Before this miraculous event, the more sensible of the two men insists that they are neither to talk nor to move, words of reason that apparently fuel Benigni's desire to break the rules of professional etiquette. In a comic monologue that touches on everything from the zodiac and wizardry to the ontological certitude of death, the irrepressible comedian manages to superimpose the earlier theme of property onto the backdrop of state control and government surveillance. Bending to light his cigarette on the eternal flame, he not only breaks the bilateral symmetry of the two guards but also trivializes the colossal folly that is the monument, which is often ridiculed by locals as an architectural anomaly, a marble monster whose wedding-cake whiteness contrasts the honey-gold hues of Rome's ancient artifacts.

Erected in the late 1800s to honor unified Italy's first king, the *Monumento a Vittorio Emanuele II* brings historical significance to the film while reinstating some of the symmetrical patterns seen in earlier episodes. In the bank sequence, for instance, while waiting to speak to the loan director, Benigni becomes so mesmerized by the rug design outside his office that he does an impromptu mix of Twister and tightrope-walking, stepping carefully so as not to fall outside the lines. The four-point star pattern on the rug, besides suggesting the number of episodes in the film, highlights what Luigi Barzini describes as "the Italians' peculiar passion for geometrical patterns, neat architectural designs, and symmetry in general." According to Barzini, fear and insecurity can be detected behind this form of *sistemazione*, "which is part of their love for show—mainly the fear of the uncontrollable and unpredictable hazards of life and nature" (111-113). Fear of the random, of the unknowable, is quelled by *repetition* and *order*, byproducts of this and other sketch films built on structural

synchronicities and symmetrical patterns. "The Two Soldiers" is, not coincidentally, the one episode in which the words "You upset me" are spoken—first by Benigni's harassed cohort and then by Benigni himself in a fit of parrot-like ripostes. This nervous repetition of the film's title is perhaps a justifiable response to the political situation in Italy at the time of the film's release.

Despite its discursiveness, *You Upset Me* is one of Roberto Benigni's most sustained and coherent works, with thematic reverberations and structural symmetries belying its outward appearance of capriciousness or random play. As in the anarchic yet highly disciplined tradition of *Commedia dell'Arte*, which allowed comic improvisations to be built around pre–established scenarios, there is a rigor to Benigni's rigamarole. His inventiveness and the sense of freedom it engenders are achieved through delimiting means (minimal staging; budgetary constraints; the threat of censorship or political suppression). This seeming contradiction is connoted by the *Monumento* itself: Rather than being lit up, the flamboyant landmark is subtly silhouetted against the night sky. Its excess has, in effect, been toned-down. This might seem unusual, given the fact that excess and hyperbole—key traits of Benigni's outsized persona—typically filter into the illogical worlds he inhabits. But it underscores the contradictions of someone who paradoxically attacks grandiloquence through bombast and affectation, someone who—through the compressed economy of the sketch form—gives the spectator both more *and* less than what he or she expects. The entire film, bound by an internal rule of "ordered disorder," in fact revolves around such dichotomies and apparent contradictions. Lowly characters spar with their elevated counterparts. Provincial landscapes give way to urban environs. Suspicions about the legitimacy of social institutions sit side-by-side with sacred and mundane musings about the sterility of officially mandated discourse.

Lending cohesion to the fragmented film is the ordering of its episodes, which follow one after the other in a cradle-to-grave trajectory. This correspondence between life and narrative suggests that something of ontological, perhaps biographical,

value might be salvaged from its stop-and-start time signatures. The film begins with a post-nativity focus on childhood and youthful displays of curiosity and longing. Next we are introduced to the themes of devotion and jealousy—each linked to an image of marriage formed by two young adults. The third episode revolves around property and money, counterpoising the needs of an individual against the greed of a corporate giant. The film culminates with an emphatic nod toward death and propriety, to the public decorum and protocol brought to bear on a national treasure or sacred emblem. Bringing the film to a literal and figurative end with an image of death (the Tomb of the Unknown Soldier), the last episode and its oft-repeated catchphrase "You upset me" convey the apprehensions and complaints accompanying old age.

In the appropriately titled *You Upset Me*, as in Benigni's subsequent films, there is a tension between cathexis and catharsis, comedy and tragedy—collapsible binaries found in many of Benigni's subsequent films. It is primarily this imbrication of comedic and tragic forms that upsets even the least supercilious of critics. Taking the film's self-consciously declarative title into consideration, one can see how the double meaning of the word "upset" is inscribed at textual, critical and industrial levels. To upset is to perturb as well as to overturn, to invert. Just as the discombobulating nature of episodic cinema deconstructs the foundational tenets of traditional narrativity, so too are social institutions unseated by the anarcho-utopian alternatives to the established order posed by Benigni and other politically engaged popular filmmakers. As evidenced by the intense, sometimes vitriolic debates sparked by *Life is Beautiful* (a film whose cross-wiring of tragedy and comedy *literally upset* cultural critics not won over by its historical whitewash), this capsizing of the narrative status quo also resonates with the critical apparatus in which Benigni's work has been, and continues to be, entrenched. Only by freeing *You Upset Me* from that critical entrenchment, and only by connecting this formative sketch comedy with Benigni's better-known works, will a more judicious assessment of the director's oeuvre come into focus.

Works cited

Anon., "Le Sexe faible," *Figaro Magazine* (June 21, 1980).

Barzini, Luigi. *The Italians*. New York: Atheneum, 1964.

Celli, Carlo. *The Divine Comic: The Cinema of Roberto Benigni*. Lanham, MD: Scarecrow Press, Inc., 2001.

Giacovelli, Enrico. *La Commedia all'Italiana: La storia, i luoghi, gli autori, gli attori, i film*. Rome: Gremese Editore, 1995.

Gili, Jean A. *Italian Filmmakers—Self Portraits: A Selection of Interviews*. Trans. Sandra E. Tokunaga. Rome: Gremese, 1998.

Ginsborg, Paul. *A History of Contemporary Italy: Society and Politics 1943-1988*. London: Penguin Books, Ltd., 1990.

Gordon, Mel. *Lazzi: The Comic Routines of the Commedia dell'Arte*. New York: Performing Arts Journal Publications, 1983.

Melanco, Mirco. "Italian cinema, since 1945: The social costs of industrialization." *Historical Journal of Film, Radio, and Television*, Vol. 15, Issue 3 (August 1995).

Viano, Maurizio. "*Life Is Beautiful*." *Film Quarterly* Vol. 53 (Fall 1999).

Vogel, Amos. "Limits of Neo-Realism." *Film Culture* #12 (1957).

The Italian Buster Keaton?
Benigni's *The Monster* and the Comic Machine

William Van Watson

In *The Village Voice*, film critic Richard Gehr has called Italian comedian Roberto Benigni "the Italian Buster Keaton."[1] Carlo Celli repeatedly invokes Keaton as a predecessor to Benigni in his book, *The Divine Comic: The Films of Roberto Benigni*, although he does not investigate the relationship between the work of the two comedians in any detail.[2] For his part, Benigni has conceded, "Buster Keaton is a zen persona, and possibly the greatest of silent comedians."[3] Keaton's and Benigni's working methods, as well as the roots of their comic screen personae, reveal striking similarities. Keaton repeatedly collaborated on his scripts with Eddie Cline in order to achieve an amount of narrative and dramatic coherence not found in Keaton's earlier Mack Sennett comedies, while at the same time permitting Keaton to showcase his particular talents. Cline provided the overall structure, while Keaton furnished the improvisational comic details. In like manner and for similar reasons, Benigni has co-authored his last several scripts with Vincenzo Cerami. Cerami's screenplay for *The Monster* (1994) appears as a geometric series of gags, of set-ups and pay-offs that aspire to the comic purity of Keatonesque zen.

Benigni diverges from Keaton primarily in terms of the artistic intent of his Chaplinesque sociopolitical ambitions,

[1] R. Gehr, "The Monster." *The Village Voice*, vol. 41, no. 17: 69. 23 April 1996.

[2] C. Celli, *The Divine Comic: The Cinema of Roberto Benigni*, London, Scarecrow Press, 2001

[3] "Buster Keaton è come un personaggio zen, è forse il più grande." Translations are by the author of this text unless otherwise indicated. E. Biagi, "Indovina chi è Pinocchio," *L'Espresso*, Anno XLVIII, no 42, 17 October 2002: 32-42, p. 34.

although artistic intent and artistic effect do not always coincide. When asked which film comedian he considered to be most influential on his work, Benigni responded, "I have categorically repeated that all my love is for Chaplin."[4] Like Chaplin, Benigni wants "his ideas of comedy and laughter to be taken seriously. [These ideas] aim to bestow legitimacy on comedy by re-framing topical issues through the subversive lens of laughter."[5] The topical issues Benigni has turned into comedy have included the mafia of *Johnny Stecchino* (1991), the compulsive consumerism and invasive media society of *The Monster*, and the fascism and Nazism of *Life is Beautiful* (1997). Some critics have simply taken Benigni at his Chaplinesque word. In reference to *Life Is Beautiful*, Cristina Borsatti declares "how much of Chaplin there is in the runaway rides on the bicycle and in the automobile," forgetting that such mechanical mastery and misfire was more fully the province of Keaton rather than Chaplin.[6] Similarly, Massimo Moscati praises *The Monster* for its "comic finale in the manner of the slapstick of . . . Chaplin."[7] Moscati's erroneous assumption neglects the indebtedness of *The Monster*'s climactic chase to specific comic routines and bits of business from the finales to Keaton's *Cops* (1922) and *Seven Chances* (1925). In contrast to the filmography of Chaplin, Daniel Moews claims that "Keaton films do not belong among the works of art possessing significant social themes."[8] Moews thus presumes Keaton's work exists outside of ideology,

[4] "L'ho manifestatamente ripetuto: tutto il mio amore è per Chaplin." *Ivi*, cit., p. 42.

[5] M. Viano, "Life is Beautiful: Reception, Allegory, and Holocaust Laughter," *Annali d'Italianistica*, vol. 17, (1999): 155-172. UNC Press, UNC, p. 160

[6] "E quanto Charlot c'è nelle corse in bicicletta e in automobile" C. Borsatti, *Roberto Benigni*. Milan: Il Castoro, 2001, p. 107.

[7] Moscati writes of the "'comica finale', dello slapstick di Mack Sennet e del primo Chaplin." M. Moscati, *Benignaccio: Con te la vita è bella*, Milan, Superbur Saggi, 1999, p. 76.

[8] D. Moews. *Keaton: The Silent Feature Close Up*, Berkeley, University of California Press, 1977, p. 44.

which is, of course, impossible. In actuality, Keaton's films persistently and insistently examine the human condition in the machine age. As a secondary consequence of his primary interest in staging and executing elaborate trajectory gags, Keaton consistently if incidentally engages ideological issues such as labor, leisure, and man's place in an increasingly mechanized society. Keaton's filmography serves as a less deliberate, but perhaps more organic, counterpoint to Charlie Chaplin's *Modern Times* (1936), but then for Keaton machinery ultimately constitutes a source of fun far removed from the drudgery of Chaplin's assembly line.

In the 1960s Italian critic Josè Pantieri first cited Henri Bergson's comic theory as the driving force behind Keaton's comedy, while Borsatti similarly invoked Bergson as the key to Benigni's comic cinema in the 2000s.[9] Comedy tends to reduce human behavior to its more animal, infantile, or mechanical aspects, allowing the spectator to feel superior to the comic hero, and to learn from his or her foibles. Written in 1900, Bergson's writings on comedy coincide with the rise of the machine age, and so emphasize the mechanical as a comic source. Bergson comments that:

> the vice capable of making us comic is, on the contrary, that which is brought from without, like a ready-made frame into which we are to step. It lends us its own rigidity instead of borrowing from us our flexibility. We do not render it more complicated; on the contrary, it simplifies us.[10]

The term "vice" here can be read in two senses, as both an internal moral flaw and as a machine tool "from without" which tightens, and in its tightening grip, externalizes the moral flaws of the character. For Bergson, the ultimate vice, and the only one that truly renders a character comic is "rigidity" because rigidity

[9] J. Pantieri, *L'originalissimo Buster Keaton*. Milan, Centro studi cinematografici, 1963, p. 15. C. Borsatti, *Roberto Benigni,* cit., p. 92.

[10] H. Bergson, "The Comic Element," in *European Theories of the Drama*, ed. Barrett H. Clark, New York, Crown Publishers, 1978: 386-392, p. 387.

renders human behavior mechanical. Bergson argues, *"The attitudes, gestures and movements of the human body are laughable in exact proportion as that body reminds us of a mere machine."*[11] Keaton's comedy plays upon Bergsonian comic theory, as his agile body and comic persona adapt to the world of machines, the various "vices" that entrap him "from without." Moews' summarizes the trajectory of character development in the Keaton persona: "Most of Keaton's heroes . . . quickly move from an incredibly exaggerated state of incompetence and inactivity, relieved only by clumsy, feeble, or childish gestures, to one of incredibly competent activity, in which all moves are intense, athletic, and supremely sure."[12] At first, Keaton's relationship with machines is adversarial, but through a trial-and-error learning process, he becomes expert at negotiating his mechanical world. Keaton forges symbiotic relationships with his machines, some of which have names and function as virtual characters in his narratives. Keaton merges with his machines, and in the process he becomes more like them, while they become more like him. Keaton thus turns Bergsonian comic theory in on itself, while Benigni turns it inside out, as in his films society at large, rather than the single individual, becomes more mechanical. In opposition to such social mechanization, Benigni's early peasant persona, Mario Cioni, emphasized the animal and infantile in his behavior. This lower body humor of the animal and the infantile remained an important weapon in the Benigni comic arsenal even after he discarded his early Cioni persona.

While Keaton primarily studies the society of machines, Benigni examines the machines of society. As exhibited in the gagging trajectory from the early twentieth-century filmography of Keaton to the late twentieth-century filmography of Benigni, the vice of the machines of society becomes intolerably tight. The intimidation tactics of the mafia, the conformity of Nazism and fascism, parasitic governmental practices, numbing

[11] The italics are Bergson's. *Ivi*, p. 387.
[12] D. Moews, *Keaton: The Silent Feature Close Up*, cit., p. 33.

educational systems, the invasive surveillance of the media police state, the burden of compulsory consumerism, and the facile pathologizations of the scientific, psychiatric and medical establishments all form a tightening social vice from which Benigni attempts to extricate an essential humanity. Certainly, physical and social machines are not mutually exclusive categories. Keaton, like Benigni, must repeatedly adapt to the machines of a societies foreign to him. In *Go West* (1925), a Midwesterner must learn the life of a cowboy. *Battling Butler* (1926) relocates Keaton from an urban society to a rural environment where, despite the abundance of wild game, the protagonist cannot find anything to hunt. Raised as a Yankee in *Our Hospitality* (1923), he must negotiate the social mores of the South. His presence as a guest in the Canfield household points out the feudal absurdity of feuds, and the lack of ethics in etiquette. According to the tenets of Southern hospitality, the Canfields must wait for him to exit their home so they can kill him. This archaic code of honor, expressed through decorum, vendetta, and violence, serves as a cultural analogue to the *mafioso* mentality that Benigni's Dante must confront in Sicily in *Johnny Stecchino*. Conversely, Benigni, like Keaton, must repeatedly fumble in his attempts to assert mastery over literal machines, such as the electric chainsaw in *The Monster* or the runaway bicycle in *Life is Beautiful*. However, from the early twentieth century of Keaton to the late twentieth century of Benigni, the focus of their respective filmographies shifts gears from the society of the machine to the machine of society. Keaton celebrates the society of the machine with a classic American optimism, while Benigni attacks the increasingly intrusive and oppressive machines of society with typical Italian skepticism. Paradoxically, Keaton's society of machines often retroactively appears more human and humane than Benigni's machines of society. Compared with Keaton's, Benigni's filmography explores the dehumanizing effects of both the formal and informal institutional structures of contemporary society, as he, like his predecessor, attempts to find a place in the world around him.

This search leads Benigni to a sentimentalized vision admittedly more akin to Chaplin than to Keaton. Italian critic Piero Conti Gadda faulted Keaton specifically from the all-important Italian perspective of *simpatia*. Gadda notes, "Keaton's reliance on the stone face takes the flavor out of the protagonist's part in his adventures and leaves it in the adventures themselves. Since the character doesn't react, the spectator's participation . . . is cut in half."[13] Perhaps more than anything else, the plasticity of Benigni's face sets him apart from Keaton. Benigni notes, "I realized that the face of a comedian is so strong that it has to be dealt out carefully."[14] Whereas Benigni became reticent in his use of close-ups, Keaton became reticent in his use of expression in close-up. As a result, in contrast to the facially hyperactive Benigni, Keaton was known alternatively as The Great Stone Face and Mr. Deadpan. His rare lack-of-reaction shots revealed his imperturbable zen-like oneness with the machine world he inhabited. Keaton repeatedly engaged potentially topical and (melo)dramatic subject matter, but he did so in order to lampoon it, not to explore it as did Chaplin, nor to exploit it as did D. W. Griffith, the latter of whose works Keaton detested. George Wead notes that in such films "the humor is . . . heightened by Keaton's refusal to take the melodramatic threat too seriously."[15]

In *Life is Beautiful*, Benigni's Guido takes the Nazi threat extremely seriously, but he encourages his son Giosuè not to do so. In attempting to have it both ways, Benigni aspires to a quintessentially Chaplinesque poignance. The problem lies not in Benigni-the-actor's presentation of survival in a Nazi prison camp as a game to his son, but in Benigni-the-director's presentation of survival in a Nazi prison camp as a game to his

[13] P. C. Gadda, "Ti voglio così! con Buster Keaton," *La Fiera Letteraria*, January 15 1928, n. p.

[14] C. Celli, The Divine Comic: The Cinema of Roberto Benigni, cit., p. 139.

[15] G. Wead, *Buster Keaton and the Dynamics of Visual Art*. New York, Arno Press, 1976, p. 265.

audience. Using Giosuè as a conduit for most of Guido's (re)actions during the second half of the film, Benigni reduces his audience to a child-like state. This Spielberg-ification of Italian art film reaches its nadir in the visually "safe" representation of an ostensibly obscene pile of dead bodies by a cartoon drawing, accommodating the viewer to, rather than discomfiting the viewer with the Holocaust. Benigni has cited Chaplin's *The Great Dictator* (1940) in order to validate his efforts, but Chaplin's film never addressed the Holocaust, and both this specific Chaplin film and his later filmography as a whole have the opposite effect of Benigni's, pushing the audience out of its comfort zone. Benigni's Chaplinesque emotional aspirations confound his Chaplinesque ideological aspirations. Benigni ends up making the sort of feel-good film that typifies the mentality of the very same Hollywood that ousted his beloved Chaplin.

As for Benigni's exposure to the Keaton legacy, Keaton enjoyed a more enduring popularity in Italy than he did in the United States. This began with the Italian release of a series of his films with Fatty Arbuckle in 1917, bearing such international retitles as *Fatty macellaio, Fatty cuciniere* and, in the best Mozartian tradition, *Le nozze di Fatty.* After this introduction, virtually all of Keaton's major films of the 1920s received Italian releases in a period when Italian film production was at its ebb. Italian critical attention to Keaton's film comedy reached past the level of journalistic reviews to a more scholarly apex in the 1930s. Despite his popularity, critical reception was not always positive. The leftist Guido Aristarco, an integral figure in the critical assessment of Italian neorealism in the postwar era, predictably claimed that Keaton's "primitive art could never become profound, like Chaplin's."[16] Keaton's films continued to find an Italian audience until 1935, when Mussolini, inspired in part by his son's interest in cinema, passed protectionist laws in an effort to resuscitate the Italian film industry. Keaton returned to Italian screens in liberated

[16] G. Aristarco, "L'età d'oro di Keaton e del cinema sovietico," *Cinema Nuovo*, no. 165 (Sept-Oct), 1963: 353-358, p. 356.

parts of the country in 1943 in *Per sempre e un giorno* (*Forever and a Day*), a tribute to England's war effort. Another four films in which he played minor roles received Italian releases in the late 1940s, and in 1952 he made *L'incantevole nemica* (*The Enchanting Enemy*), with Claudio Gora directing. Keaton performed onstage in Italy in the 1950s and was favorably compared to the great Neapolitan comic of stage and film, Totò.

The first serious analysis of Keaton's films of the 1920s was undertaken by an Italian critic, Ernest G. Laura, in an article in *Bianco e nero* in 1963.[17] Keaton's connection with his Italian audience remained until his death, as he made his last film *Due Marines e un Generale* (*War, Italian Style*) directed by Luigi Scattini in 1966. Keaton played a German general in the film, which was released posthumously in 1967. The actor died of lung cancer shortly thereafter, missing the Venice Film Festival where he was lauded and "rediscovered" by the Italian audience. The Keaton Italian legacy persists even beyond his death with the 2004 recent release of David Ferarrio's *Dopo Mezzanotte* (*After Midnight*), in large measure a metacinematic tribute to Keaton, as the film features a number of excerpts from Keaton's *One Week* (1920) and Ferrario's protagonist bases his personality on the Keaton persona.

Keaton and Benigni share a number of physical characteristics—long faces, pallid complexions, dark unkempt hair, rectangular eyes, long noses, high foreheads, and sunken cheeks. Facially, only Benigni's fuller lips and pronounced mouth distinguish him from his American predecessor. Physically, both have the quick, wiry body of an ectomorph. In his masterpiece *The General* (1927), Keaton's Johnny Grey presumes his insufficient height disqualifies him from enlisting at the recruiting office. Throughout his filmography, the somewhat diminutive Keaton emphasized his shorter stature by casting noticeably larger actors opposite him. Keaton even called his screen persona his "little man." The relatively taller

[17] J. Rapf, *Buster Keaton: A Bio-Bibliography*, Westport, CT: Greenwood Press, 1995, p. 119.

and lankier Benigni employs the same tactic in *Life is Beautiful*, as fascists and Nazis alike appear both taller and bulkier than Benigni's Guido Orefice. This creates the effect that he does not measure up or out to the physical standards of Italian Aryan racist ideology. Benigni explicitly parodies these standards when he impersonates the fascist official at the local school, derailing the fascist propaganda machine with a giddy display of his gawky body culminating in the infantile revelation of his belly button. In like manner in *The General*, Keaton's persona also confronts the insufficiency of his physique to measure up to state ideological standards. He rebels against his own smaller stature as the imagined cause of his being rejected by the Confederate army, and repeatedly attempts to circumvent the enlistment officer.

Keaton's and Benigni's dress also approximates one another. Aside from his recurrent porkpie hat, Keaton generally wore a slightly oversized generic suit that marked him as a modern-day Everyman of the machine age. Similarly, the Benigni persona has evolved away from his earlier Tuscan-specific roots into a more contemporary universalized Everyman. In *The Monster*, Benigni reveals his indebtedness to Keatonesque generic dress with "Loris's closet . . . full of identical dark gray suits, Benigni's comedian's uniform."[18] Such deliberate non-specificity contrasts sharply with Chaplin's sartorial iconography. Chaplin's Tramp wore a semiotically complex outfit—tight-fitting morning suit, baggy pants, oversized clown shoes, undersized bowler and cane—that confounded class and professional signifiers.

Beyond such relatively superficial considerations of the similarities between the Keaton and Benigni screen personae, the two share much more profound comic origins. Keaton connected with Italian audiences in part because he was an indirect product of Italian culture, and of its comic tradition in particular, namely the *Commedia dell'Arte*. Alberto Checchi noted Keaton's indebtedness to *Commedia dell'Arte* as early as

[18] C. Celli, *The Divine Comic: The Cinema of Roberto Benigni*, cit., p. 89.

1929.[19] Canonized film scholar André Bazin ineptly asserted that between Keaton and *Commedia dell'Arte* there can be "no question of imitation, or of influence or of a remembered routine, just the spontaneous linking up of a genre with its tradition."[20] This "linking up of a genre with a tradition" was not "spontaneous" however, and "imitation" of more than one "remembered routine" did occur. Wead observed that the American vaudeville stage that nurtured and refined Keaton's craft from childhood "was one of the last forms of what was known in its most developed and influential embodiment as the *Commedia dell'Arte*."[21] More specifically, Wead recounts how Keaton was thrown about the stage and swung like a monkey on a chain by his father, a *lazzo* developed by the Grimaldi family, a *Commedia dell'Arte* troupe that performed in England in the eighteenth century. *Lazzi* are bits of stage business developed by *Commedia dell'Arte* troupes over several centuries of performance. *Lazzi* include the flat-footed slides around corners, the pratfalls, the leg-groping, the checking for falling objects which Newton declares must come down, and the slowness of perception to an instant response. All these *lazzi* mark the cinema of both Keaton and Benigni. Keaton was particularly adept at the standard *commedia* pratfall, termed a "buster" in vaudeville, which, as legend has it, led Harry Houdini to give him his stage name. Keaton's predilection for script outlines also places him firmly within the comic tradition of Italian *Commedia dell'Arte* insofar as *Commedia dell'Arte* troupes generally performed from plot synopses, or *scenarii*, which allowed them opportunities for improvisation and the inclusion and development of *lazzi*.

[19] See A. Checchi, "Nota su Buster Keaton," *La Fiera Letteraria*, 29 December 1929.

[20] A. Bazin, *What is Cinema?*, trans. Hugh Gray, Berkeley, University of California Press, 1971, p. 81.

[21] G. Wead, *Buster Keaton and the Dynamics of Visual Art*, cit., p. 231.

Commedia dell'Arte troupes were composed of different stock figures or character types, and different *lazzi* were deemed suitable for different characters. One such stock figure was Truffaldino. Truffaldino exhibited a natural physical exuberance sometimes beyond his ability to control, often requiring a performer with the talents of an acrobat in the role. While Benigni's first theatrical outings consisted primarily of monologues structured to allow for improvisation, he also claims to have worked with a circus in his adolescence in order to master certain physical tricks, gymnastics and pantomime. According to Celli, the resulting clown persona "is arguably the heir to the great comedians of the silent era, when performance relied more on pantomime than on verbalism."[22] Borsatti concurs, perceiving Benigni's "total embrace of silent cinema, resulting in the research into the language of the body adapted to the physique of the performer."[23] With its elaborate farcical attempts at seduction and chase scenes, *The Monster* articulates Benigni's "language of the body" at its most fluent.

As for Benigni learning techniques from silent cinema, Harold Lloyd and Charlie Chaplin may have developed their own specific and considerable physical talents, but the "language of the body" reached its unrivalled apogee in the career of Buster Keaton. Wead's description of Keaton's "naïve resourcefulness" and of his "body as an incredibly agile instrument, flawlessly timed" could just as easily denote either Truffaldino or Benigni.[24] Keaton's seemingly mechanized body approaches zen, while Benigni's spastic movement careens toward the frenetic, but the physical hysteria of both performers, whether in seemingly catatonic or agitated mode, requires acrobatic talents reminiscent of Truffaldino.

[22] C. Celli, *The Divine Comic: The Cinema of Roberto Benigni*, cit., p. xi.

[23] Borsatti describes "il totale accostamento alle tecniche del muto con la conseguente ricerca di un linguaggio del corpo che assimila la presenza fisica dell'attore." C. Borsatti, *Roberto Benigni*, cit., p. 58.

[24] G. Wead, *Buster Keaton and the Dynamics of Visual Art*, cit., p. 271, p. 195.

If Benigni seems an Italian Keaton, it is largely because Keaton was an American Truffaldino. Truffaldino was a servant character whose name derives from *truffare*, meaning "to trick" in Italian. Truffaldino was one of the *zanni*, or broadly comic servant figures in Commedia *dell'Arte*. Moscati references the *zanni* as a predecessor for Benigni's screen persona, and Borsatti even specifies Truffaldino as a prototype for his persona.[25] The Tuscan Benigni himself traces his performance roots to the Etruscan *fescennini*, jesters or fools that have been viewed as precursors of the *Commedia dell'Arte* stock characters Arlecchino and Truffaldino. As a modern-day Truffaldino, Benigni plays tricks on Nazis and fascists in *Life is Beautiful*, on *mafiosi* in *Johnny Stecchino*, and on landlords, shopkeepers and police in *The Monster*. Similarly, Keaton played tricks on Yankee soldiers in *The General*, on the feuding Canfields in *Our Hospitality*, and on the police in *Seven Chances*. All these other characters hold positions of power and authority superior to Keaton's and Benigni's more quick-thinking and slow-witted Truffaldino film personae.

Usually a supporting character, Carlo Goldoni promoted Truffaldino to the role of protagonist and central character in his 1743 play, *The Servant of Two Masters*. In the play, in order to earn two incomes, Truffaldino tricks Beatrice and Florindo into thinking he is her and his servant exclusively. In order to maintain the ruse, Truffaldino exercises the sort of mental and physical dexterity characteristic of the filmography of Keaton and Benigni. Like Truffaldino, Keaton and Benigni often respond to stimuli with the mindless rote efficiency of machines.

Theatre historian Oscar Brockett describes the Truffaldino figure as "a mixture of cunning and stupidity."[26] Like other characters in *The Servant of Two Masters*, Brighella queries that

[25] M. Moscati, *Benignaccio: Con te la vita è bella*, cit., p. 23. C. Borsatti, *Roberto Benigni*, cit., p. 76

[26] O. Brockett, *History of the Theatre*, Boston, Allyn and Bacon, 1987, p. 185.

"sometimes [Truffaldino] is a knave and sometimes a fool."[27] When Pantalone states, "I think the man is a fool.," Doctor Lombardi retorts, "I think the man is playing a fool."[28] Echoing such assessments, Borsatti describes the Benigni persona as both "clever and innocent like a baby."[29] The careers of both Keaton and Benigni have played upon this discrepancy between the feigned ignorance of the character and the actual expertise of the performer, as they have faced down their respective society of machines and machines of society. In *The Navigator* Keaton both knowingly and ignorantly takes control of an entire ocean liner. In Jim Jarmusch's *Night on Earth* (1992), Benigni both knowingly and ignorantly provokes a priest's heart attack with his scandalous confessions. As in other comic texts, the Truffaldino in *The Servant of Two Masters* appears simultaneously inferior, in terms of social station, and superior, in terms of plot knowledge, to those he serves. Truffaldino often has superior plot knowledge because he is a liar. Prior to his (mis)direction of *Pinocchio* (2002) Benigni had declared, "The liar is a marvelous being."[30] Truffaldino's claim that "I am learning my part as I go along" presages Guido's continuous chain of innovative lies in *Life is Beautiful*.[31]

Truffaldino falls firmly within the ancient Roman Plautine tradition of servants that either trick or trick for their masters, almost always with empathetic motives. Inhabiting a place simultaneously socially inferior and morally superior, despite his usually well-intentioned and inventive lying, to the characters around him, Truffaldino appears as a precursor to both Keaton's Johnny in *The General* and Benigni's Loris in *The Monster*, both of whom are far more sinned against than sinning. In *Life is*

[27] C. Goldoni, *The Servant of Two Masters*, in E. Bentley, *The Servant of Two Masters and Other Italian Classics*, New York, Applause Theatre Books, 1992, 126.

[28] *Ivi*, p. 84.

[29] Borsatti claims the Benigni persona is "furbo e innocente come un bambino." C. Borsatti, *Roberto Benigni*, cit., p. 62.

[30] Benigni said, "Il bugiardo è un essere meraviglioso." E. Biagi, "Indovina chi è Pinocchio," cit., p. 35.

[31] C. Goldoni, *The Servant of Two Masters*, cit., p. 103.

Beautiful, Benigni's Guido works as a waiter, a social position analogous to that of Truffaldino. When Guido bows to an overly obeisant ninety degrees, his Uncle Eliseo translates the simultaneous inferiority and superiority of the Truffaldino figure vis-à-vis those he serves into cosmological terms. Eliseo compares Guido as waiter to God, who serves mankind, but is not their servant.

Checchi notes, "Unlike Charlot, the Harlequin unhappy in love, Keaton is a Pierrot, melancholy and lucky in love."[32] While Chaplin became known as a latter-day Harlequin- or Arlecchino-Charlot, Benigni's own persona, like Keaton's, functions mostly as a Truffaldino-Pierrot. In their respective filmographies, Keaton and Benigni must master the machine, literal or social as the case may be, in order to win the female, even when this female is a cow, such as Brown Eyes in Keaton's *Go West*, or a lamb, such as Lola in Benigni's *Night on Earth*. Benigni's persona appears relatively lucky in love, in part due to the recurring collaborative iconic presence of his real-life wife Nicoletta Braschi. Like Truffaldino and Keaton before him, Benigni's success at love comes with obstacles, not the least of which are the high expectations projected upon the Latin lover. Carlos Sluzki notes:

A person raised in any Latin country has incorporated, in one way or another, the local version of the *machismo* cult, which dictates, among other things, that a man must signal that he is always ready for sex. Seductive behavior is expected from him and, even more, is mandatory in most circumstances when engaging in interaction with a woman who is not his wife or mother, aunt, sister, or equivalent.[33]

The machismo cult dictates that the Italian male be a love machine. In *Johnny Stecchino*, Benigni's Dante lives in a world

[32] Checchi deploys the French names of the *Commedia dell'Arte* characters here. A. Checchi, "Nota su Buster Keaton.," cit., n. p.

[33] C. Sluzki,. "The Italian Lover Revisited," *Ethnicity and Family Therapy*, Eds. Maria McGoldrick, et. al., New York, Guilford Press, 1982: 492-498, p. 496.

where all the other men have women except him, all other men are sexualized but him. Throughout the film Dante repeatedly steals and eats bananas, the limpest of phallic symbols, and wields them like soft guns. More impotent than Dante and his phallic banana is Johnny Stecchino himself and his phallic toothpick. As Stecchino, Benigni cast himself into the sort of sap role that Keaton had performed in *The Saphead* (1920) and *Battling Butler*. Johnny carries his toothpick in his mouth so obsessively that it has given him his nickname *stecchino*, "toothpick" in Italian, a diminutive term for a penis in any language. Fearing intimacy, Johnny refuses to displace his toothpick and kiss his wife, Maria. He is so macho that he is gynephobic. Maria eventually delivers her husband over to rival *mafiosi*, returns Dante to Rome and his Truffaldino role, and retains her own status as mafia princess, beyond Dante's reach.

In *Life is Beautiful*, Benigni manages to graduate from the Truffaldino role to that of the prince, the romantic male lead or *innamorato* of the *Commedia dell'Arte*. Early in the film he declares himself a *Principe*, but only really attains this stature when he marries Braschi's Dora, to whom he refers throughout the film as the *Principessa*, or princess, the romantic female lead or *innamorata* of the *Commedia dell'Arte*. Dora's gowns and class status confirm her function as embodying this role. Like Keaton's Johnny in *The General*, Benigni's Guido finds himself crawling beneath a table encircled by his enemies in his effort to obtain his lady love.

Traditionally in *Commedia dell'Arte* the stock character romantically opposite Truffaldino was not the princess figure or *innamorata* that Dante and Guido pursue in *Johnny Stecchino* and *Life is Beautiful*, respectively. Instead, Truffaldino's complement was the coquettish servant girl, Smeraldina. In *The Monster*, Braschi's Jessica Rossetti behaves very much as a modern-day Smeraldina, more aware of the operations of society than her male counterpart, and much more forward with her sexuality, while still retaining a certain degree of innocence. In *The Monster*, Jessica asserts her sexuality to provoke Loris' ostensibly hyperbolic male Latin lover impulses in order to prove his guilt as a sexual psychopathic serial killer. In a virtual

catalogue of Smeraldina-inspired *lazzi*, she walks about in her hose, panties and slip, straddles him, backs her buttocks into his face, and spills coffee on him as an excuse to wipe his crotch. In *Commedia dell'Arte*, Truffaldino usually had a worldlier, more knowing friend, the stock character Brighella, to provide him with advice. In *The Monster*, Pascucci plays this Brighella role. When Loris confronts him with the dilemma of his perpetually titillated but continually unfulfilled sexual desire, Pascucci suggests that Loris think of taxes and world economics in order to distract himself. On one level, Pascucci's suggestion seems a reasonable sexual deterrent, but the results of this strategy reveal precisely those processes of deferred and detoured desire upon which the consumerist social machine operates. During their nocturnal interlude in the park, Jessica reports that Loris spoke about nothing but the Italian GNP, the Bundesbank, the stock exchange, and the World Bank. Such a deflection of desire into capital constitutes the fundamental function of the consumerist machine. Paradoxically, Pascucci's ostensible "cure" for Loris' illness is instead the illness of the society itself.

As opposed to an Italian heritage that has produced such meticulously aesthetic cinematic *auteurs* as Federico Fellini, Michelangelo Antonioni and Bernardo Bertolucci, Benigni's directing style has primarily been functional and pragmatic, like Keaton's before him. Dismissing an over(t)ly aesthetic concern with the medium, Keaton shows that even a monkey is capable of cranking the camera in *The Cameraman* (1928). In metaphorical directorial self-parody, Keaton simply has the monkey reapply the mechanical skill he had learned from his former organ grinder owner. Like Keaton and Chaplin, Benigni's work behind the camera remains subordinate to his work before the camera. From American silent cinema, Benigni learned that the medium long shot best replicated the dimensions of stage performance, retaining it as his standard shot.

Despite their work as performers, however, both Keaton and Benigni as directors did come to a metacinematic awareness of the potentialities of the cinematic apparatus. Lellis observes, "Keaton is clearly aware of his medium's contradictory nature as both a mirror to reality and an artificial construction about

reality."[34] Keaton's *Sherlock Jr.* (1924) presents a projectionist protagonist trapped inside the film projects. This inventive sequence has been viewed as a precursor to films as diverse as Maya Deren's experimental *Meshes of the Afternoon* (1943), Woody Allen's *The Purple Rose of Cairo* (1985), and Maurizio Nichetti's *Volere Volare* (1993). In this last film, the protagonist works dubbing cartoons and eventually becomes a cartoon himself. As the title of *Sherlock Jr.* indicates, Keaton's projectionist protagonist fashions himself a latter-day version of the famous detective, a private eye, for whom issues of surveillance are of the utmost importance. While the precariousness of the editing process turns Keaton into a detective, in *The Monster* it turns Benigni's Loris into an object of detection. The surveillance film of Loris projected before an audience of policewomen demonstrates the political unconscious of the police state constitutes in its *tour de force* of selective editing. For Keaton, the cinematic gaze becomes a source of play, but for Benigni's the cinematic gaze forms part of the tightening vice of a society fully in the grip in the media age. The agenda for control implicit within surveillance cannot tolerate, or even recognize, a free radical such as Loris, and must therefore (mis)interpret him as a psychopath.

In terms of cinematic self-awareness, with a century of cinematic history behind him, Benigni's filmography can be metacinematic in a way in which Keaton's could not. *The Monster* opens with a woman's scream, followed by an elevator gone haywire, opening and closing. The sequence refers to Brian De Palma's *Dressed to Kill*, (1980), which itself refers to Alfred Hitchcock's *Psycho* (1960). Benigni parodies the entire slasher film genre in general, and *The Texas Chainsaw Massacre* (1974) in particular, by having Loris lose control of his chainsaw. Intended for his pruning work as a gardener, he holds it at crotch level. This phallic misfire, this inability to negotiate a machine, first prompts his being mistaken for the serial killer. Slasher film

[34] G. Wead and G. Lellis, *The Film Career of Buster Keaton*. Boston, G. K. Hall & Co., 1977, p. 13.

slang metaphorically designates the viscera of victims as "spaghetti"; Loris literally hides spaghetti in his desk, prompting policewoman Jessica to mistake it momentarily for human viscera.

After its opening cartoon title sequence, *The Monster* begins and ends with surveillance helicopters circling above the anonymous sprawl of the Roman suburbs. Benigni has noted, "The outskirts of cities are becoming identical all over the world."[35] As opposed to Loris himself, who is wrongly presumed to be psychopathological, the opening overhead shots reveal that it is Italian society itself which has lost its identity. Wead has argued that "Keaton [was] always careful to bring his human figures into relation with the epic environment."[36] However, Keaton's epic relationship with the world of the machine becomes dwarfed in Benigni's vision of the machine of the world. Wead claims Keaton "literally had to make space work *with* him," but Benigni's Loris inhabits a space which is virtually unworkable on any personal level.[37]

As Celli points out, the Italian Prime Minister Silvio Berlusconi made his millions in part through the construction of such alienating environments.[38] Moscati describes "the visceral aversion Roberto has nourished for . . . Silvio Berlusconi."[39] As a result, when Loris spells out "The Administration is a Thief," the diegetic reference to the condominium administration within the film's narrative extends extra-diegetically as a political

[35] C. Celli, *The Divine Comic: The Cinema of Roberto Benigni*, cit., p. 148.

[36] G. Wead, *Buster Keaton and the Dynamics of Visual Art*, cit., p. 269.

[37] The italics are Wead's. G. Wead, *Buster Keaton and the Dynamics of Visual Art*, cit., p. 236.

[38] Celli reports, "The condominium's president in *The Monster*, who tries to evict Loris, has been widely identified with Berlusconi." C. Celli, *The Divine Comic: The Cinema of Roberto Benigni*, cit., p.87-88.

[39] Moscati writes, "L'avversione viscerale nutrita da Roberto per . . . Silvio Berlusconi." M. Moscati, *Benignaccio: Con te la vita è bella*, cit., p. 27.

commentary on Berlusconi's governmental administration as well. Loris uses letters cut from magazines in the stereotypical manner of a sociopath who wishes to remain anonymous to create the message. Since the audience knows Loris to be innocent of the crimes of which he is suspected, the moment raises the question as to where sociopathology more truly lies. Celli describes this Berlusconian urban periphery as "the postindustrial Italian metropolis in the midst of brutally impersonal and dysfunctional, Gropius-style apartment buildings."[40] While Keaton employed "long shots [to] emphasize the body in space," in Benigni's *The Monster* the sense of space becomes vertiginous and the body is visually reduced to an inhuman hieroglyph.[41] This very sense of space sabotages the panoptic presumptions of the omnipotent gaze of the contemporary surveillance society. Even when police detective Jessica Rossetti conducts her surveillance of Loris on a more personal level, her vision remains partial and her predisposition myopic. She misinterprets Loris' frustration over his inability to extricate himself from a manikin caught in his jacket as his attempt to have sex with the manikin. This misread incident merely confirms her mistaken mindset that he suffers from a psychopathological repulsion and attraction to women, reducing them and dismembering them into inanimate objects.

In *The Monster* Benigni uses the Bakhtinian grotesquerie of lower body humor to undermine the pretensions of an increasingly mechanized consumerist society that attempts to predict, codify, and standardize the object desires of the human appetite. Both Benigni's film as a whole and its protagonist Loris in particular combat the codification and mechanization of consumerist society consumption with its own predictability. Bergson argues, "whether a character is good or bad is of little

[40] C. Celli, *The Divine Comic: The Cinema of Roberto Benigni*, cit., p. 87.

[41] R. Knopf, *The Theatre and Cinema of Buster Keaton,* Princeton: Princeton University Press, 1999, p. 38.

moment; granted he is unsociable, he is capable of becoming comic."[42]

Underemployed and in danger of eviction, Loris maintains the simultaneously inferior and superior status of a modern-day Truffaldino in his relationship to the machines of society that surround and threaten to subsume him. Loris takes pride in his Bergsonian unsociability, breaking one of the cardinal rules of capitalist consumerist society by refusing to pay for anything. In the ideological as opposed to the psychological sense, Loris becomes the ultimate sociopath, more than either the psychiatrist Taccone or the police investigator Rocarotta could possibly imagine. Loris refuses to pay rent, making himself literally as well as metaphorically a squatter, as he crouches past the doorman to avoid receiving his eviction notice. He steals newspapers, pilfers coffee and brioche in a café, and evades paying for a grandfather clock by sending the proprietors of the antique store a false notice of his own death. Benigni's subversion of the consumerist machine fittingly culminates in a supermarket, wherein commerce fuses with the police state in its anti-theft detection devices. Benigni's Loris slips unpaid items into the pockets of unwitting customers so that the alarms go off for everyone, including for the store workers themselves. Swollen with huge amounts of goods hidden beneath his trench coat, Loris proudly presents the cashier with a single stick of gum as his ostensible purchase. As with the condominium administration, Berlusconi again stands as Benigni's extratextual target in this sequence, as the supermarket in the film approximates Berlusconi's own Standa supermarket chain. Such chains have driven many family-owned stores out of business, as mass marketing has continued to erase individual enterprise and contributed to the sociopathology of consumerist alienation. Through such ventures, sacrificing quality for quantity, in direct opposition to Italian artisan tradition, Berlusconi reaped profits.

[42] H. Bergson, "The Comic Element," cit., p. 391.

Benigni's declaration that "Berlusconi seems like a parody of a gangster: Al Cafone" resonates fully.[43]

As the machines of consumerist society exploit, manipulate and warp natural appetites, this society itself appears pathological. First and foremost among these appetites are the sexual, which the consumerist machine defers and detours into product consumption. The modern sexual sociopath merely resists such a detour with a vengeance. Both the forensic psychiatrist Tacconi and the police detective Rocarotta overly invest in Loris as the serial killer. Envoys of the consumerist social machine, they project onto him and into him their own frustrated, deferred and detoured desires. Loris as serial killer appears quite literally only as a projection, when Tacconi and Rocarotta screen their film of his decontextualized behavior in search of a policewoman for the undercover assignment of capturing him. The editing machine has made him the image of the sort of sex machine that the self-alienated Tacconi and Rocarotta on some repressed level probably wish they were. With his psychobabble and simple-minded Freudianism, forcing Jessica to dress up as the fairy tale vaginal archetype of Little Red Riding Hood, Tacconi appears as an updated version of the *Commedia dell'Arte* Dottore. His self-importance and pedantry renders him a buffoon. Tacconi and Rocarotta dispatch Jessica as an agent of consumerist society, living vicariously through her experiences with the imagined unbridled appetites of a psychopath. Tacconi revealingly states that he wants to be there "in the moment [Loris] explodes." Tacconi's ruse as a tailor allows him to manhandle Loris' body in a suspiciously invasive manner, even including a prostrate exam. The sequence satirizes the naivete of nineteenth century medical practices wherein physical measurements were taken to be indicative of psychosis.

[43] In the original Italian, Benigni's wordplay on the name of Al Capone into "Cafone" functions as a double insult to Berlusconi, since *cafone* means hillbilly or hick as well. "Berlusconi sembra la parodia di un gangster: Al Cafone" E. Biagi, "Indovina chi è Pinocchio," cit., p. 34.

Throughout the absurd sequence Loris mundanely concerns himself with the most natural of responses to the appetite, the simple preparation of a meal.

Celli has rightfully discerned Keaton's influence in the final chase sequences of *The Monster*.[44] With its multiplicity of automaton-like participants, the climactic chase of Loris, at first hiding in plain sight surrounded by his neighbors, owes much to Keaton's *Cops* and *Seven Chances*. In *Go West*, this herd mentality of a chasing mob literally is a herd, over which cowboy Keaton exerts his newfound mastery. Knopf characterizes such scenes wherein crowds "move as one gigantic machine, chasing [Keaton] en masse."[45] This description applies equally to the conclusion of *The Monster*, wherein Benigni, like Keaton before him, can redirect and misdirect the entirety of the mob that chases him by merely changing body position or pointing in a different direction. Compulsory consumption results in their machine-like conformity. Benigni has asserted that "in reality there are many men who behave like puppets."[46] In the chase sequence, the individualist Loris pulls their collective strings. The chase reaches its peak both literally and metaphorically on the scaffolding attached to Loris' apartment building. Shot at first straight on, the scaffolding appears as a grid. The grid serves as a wonderful visual metaphor for the web of the social network that attempts to entrap him. Having established the size of the mechanism in a Keatonesque manner, Benigni's camera ascends the scaffolding in a close, perpendicular shot that emphasizes the vertigo of the situation. Loris then simply slides down the chute as an individual to his freedom, leaving the mass of puppets to confront the rigidity of their herd mentality in a moment of stunned, comic silence as

[44] C. Celli, *The Divine Comic: The Cinema of Roberto Benigni*, cit., p. 92-93.

[45] R. Knopf, *The Theatre and Cinema of Buster Keaton,* Princeton, Princeton University Press, 1999, p. 65.

[46] In Italian, Benigni argued that "nella realtà ci sono tanti uomini che si comportano da burattini." E. Biagi, "Indovina chi è Pinocchio," cit., p. 37.

they realize that they cannot descend the scaffolding in a mass to pursue him.

Lellis offers an unorthodox view of Keaton: "Buster may be seen as a tragic figure in the sense that his practical pragmatism is also a form of submission. He operates in a world that cannot really be changed, a world of dictated fate."[47] Keaton must merge with and, at best, master the machines of his world, but he cannot avoid them. In contrast, Benigni successfully, if precariously, subverts the social machines of his world, and sometimes manages to escape them, at least in *The Monster*. The film concludes with Loris and Jessica, insistently bent-kneed in their non-conformity, hobbling off into the sunset. In contrast to *Johnny Stecchino*, which merely returns Dante to his previous existence, and *Life is Beautiful*, which exacts the death of the father in order to justify its concluding archetypal Madonna-and-child image, the relatively uncompromised happily-ever-after ending of *The Monster* appears unique in Benigni's cinema. Borsatti's assessment of this Cerami and Benigni collaboration applies equally well to the work of Cline and Keaton. She writes, "Meetings, run-ins, and situations may be systematically structured in the script, but they leave the spectator with the impression that he or she is watching a film spontaneously invented before his or her eyes, scene and scene, improvised in an instant."[48] In terms of the comic machine, the ideological ramifications of the train in *The General* and the surveillance camera in *The Monster* are not as important as the extended and elaborate trajectory gags they inspire. Keaton and Benigni reach both zen and zenith by mastering neither ship nor electric saw, neither can opener nor bicycle, but in setting up the payoff machine of comedy itself.

[47] G. Wead and G. Lellis, *The Film Career of Buster Keaton*, cit., p 15.

[48] "Incontri, percorsi e situazioni sistematicamente strutturati nello script, ma che non tolgono allo spettatore la sensazione di veder scorrere davanti ai propri occhi un film inventato spontaneamente, scena dopo scena, improvvisato all'istante." C. Borsatti, *Roberto Benigni*, cit., p. 64.

Works Cited

Aristarco, Guido. "L'età d'oro di Keaton e del cinema sovietico." *Cinema Nuovo*, no. 165 (Sept- Oct), 1963: 353-358.

Bazin, Andre. *What is Cinema?* Trans. Hugh Gray. Berkeley: University of California Press, 1971.

Bentley, Eric, ed. *The Servant of Two Masters and Other Italian Classics*. New York: Applause Theatre Books, 1992.

Bergson, Henri. "The Comic Element," in *European Theories of the Drama*, ed. Barrett H. Clark. New York: Crown Publishers, 1978: 386-392.

Biagi, Enzo. "Indovina chi è Pinocchio." *L'Espresso*. Anno XLVIII, No 42, 17 October 2002: 32-42.

Borsatti, Cristina. *Roberto Benigni*. Milan: Il Castoro, 2001.

Brockett, Oscar. *History of the Theatre*. Fifth ed. Boston, Allyn and Bacon, 1987.

Celli, Carlo. *The Divine Comic: The Cinema of Roberto Benigni*. Lanham, MD: Scarecrow Press, 2001.

Checchi, Alberto. "Nota su Buster Keaton." *La Fiera Letteraria*. 29 December 1929.

Gadda, Piero Conti. "Ti voglio così! con Buster Keaton." *La Fiera Letteraria*. January 15 1928.

Gehr, Richard. "*The Monster*." *The Village Voice*. Vol. 41 no. 17: 69. 23 April 1996.

Knopf, Robert. *The Theatre and Cinema of Buster Keaton*. Princeton: Princeton University Press, 1999.

Laura, Ernesto. "Buster Keaton nel periodo muto." *Bianco e nero*, vol. 24, nos. 9-10 (Sept-Oct), 82-107.

Moews, Daniel. *Keaton: The Silent Feature Close Up*. Berkeley: University of California Press, 1977.

Moscati, Massimo. *Benignaccio: Con te la vita è bella*. Milan: Superbur Saggi, 1999.

Pantieri, Josè. *L'originalissimo Buster Keaton*. Milan: Centro studi cinematografici, 1963.

Rapf, Joanna E. and Gary L. Green. *Buster Keaton: A Bio-Bibliography*. Westport, CT.: Greenwood Press, 1995.

Sluzki, Carlos. "The Italian Lover Revisited." *Ethnicity and Family Therapy*. Ed. Monica McGoldrick, et. al. New York: Guilford Press, 1982: 492-498.

Viano, Maurizio. "*Life is Beautiful*: Reception, Allegory, and Holocaust Laughter" in *Annali d'Italianistica*, vol, 17, (1999): 155-172. Chapel Hill: University of North Carolina Press.

Wead, George. *Buster Keaton and the Dynamics of Visual Art*. New York: Arno Press, 1976.

 and George Lellis. *The Film Career of Buster Keaton*. Boston: G. K. Hall & Co., 1977.

Johnny Stecchino: l'Italia nel caleidoscopio

Umberto Taccheri

> Hanno organizzato una partita "ministri contro Mafiosi":
> praticamente un'amichevole. L'hanno organizzata ma dopo non si
> riconoscevano tra di loro, tutti passavano la palla a tutti (Benigni,
> *E l'alluce fu* 12).

Parlando di *La vita è bella*, il regista di *Dead Poet Society*, Peter
Weir, ha espresso un parere generale sul cinema di Benigni: "È
sbagliato considerare Benigni un attore-regista comico: ha il
senso del tragico, sempre. Ho molto apprezzato che ci fossero
due parti nella storia e così diverse l'una dall'altra, ma ben
mescolate" (Moscati 100). Questa commistione di elementi
comici e tragici è però contraria alle dichiarazioni di entrambi
gli sceneggiatori del film che esaminiamo in questa ricerca,
Johnny Stecchino. Alla domanda "hai anche un messaggio?"
rivoltagli da un giornalista, Benigni risponde infatti:

> Il messaggio è: guai al comico che lancia messaggi. Come
> dice Duchamp, quel grande musicista, "l'allegria perde il suo
> stesso senso di vita se viene presa sul serio". È una banalità
> tremenda. Da Eschilo a Fogazzaro l'artista ripete sempre la
> stessa cosa: esprime il turbinio di fulmini e di tempeste che
> gli si agita nelle viscere perché ne sente la necessità (Benigni
> *E l'alluce fu* 48).

Vincenzo Cerami, il famoso autore di *Un borghese piccolo
piccolo,* e coautore con Benigni, insieme a questa, di numerose
sceneggiature di suoi film, descrive a sua volta la comicità nel
cinema con queste parole:

> Il linguaggio della comicità è più vicino al fumetto che alla
> commedia: la dimensione a cui rinuncia premeditatamente è
> la profondità. I personaggi di un'opera comica sono
> totalmente privi di psicologia e agiscono fuori da ogni
> impianto sociologico, ideologico e naturalistico. È
> impossibile risalire da un film comico alla cultura dell'epoca
> in cui è stato girato se non a livello semplicemente lessicale
> e ambientale. La logica che ispira la comicità è pura

geometria, gioco sospeso nel nulla, che non vuol dir nulla
[...] L'unico obiettivo che la comicità persegue è *far ridere*.
Ma perché tutto questo avvenga è necessaria la presenza di
una *maschera*, cioè di un comico di grande talento (Moscati
62).

Ovviamente queste dichiarazioni contengono del vero: il
successo del cinema di Benigni indiscutibilmente dipende dalla
sua *maschera*, ossia dal suo magnetismo naturale, dalla sua
espressività, dal suo repertorio claunesco e funambolesco.
D'altro canto però, nel magma della giocosità e dell'energia
comica di Benigni è difficile non vedere, con Peter Weir, anche
quanto resista alla definizione di Cerami, senza dover arrivare ad
un film incentrato su temi di per sé drammatici, come *La vita è
bella*.

Tanto per cominciare, è difficile far rientrare in questi
parametri il Benigni prima maniera, a partire da *Berlinguer ti
voglio bene*, *Televacca/ Onda libera* o *Vita da Cioni*, dove
l'attore è spesso aggressivo e irriverente, ed assume il ruolo del
Pulcinella castigatore della morale consumistica e benpensante.
In questa categoria del "puramente comico" di Cerami, di un
mondo artificialmente separato dal divenire storico, fatto di
geometrie astratte e auto-referenti è anche difficile far rientrare
il Benigni televisivo che spesso si abbandona alla scurrilità,
"aggredisce" pubblicamente icone mediatiche (bacia sulla bocca
Walter Veltroni e Pippo Baudo, insegue Raffaella Carrà sulla
scena per poi simulare un amplesso) e soprattutto, satirizza
impietosamente vari politici del momento, in cima a tutti
Berlusconi, ma senza risparmiare sferzate impietose a Giuliano
Ferrara, Craxi, Andreotti, solo per citare i più famosi.

Questi atti di esuberanza, di ribellione o di denuncia,
rappresentano sempre la rivolta dell'uomo di strada che, salito
sul palcoscenico, si prende una rivincita sulla politica
dell'informazione di massa, offre un uditorio ai valori ed al
linguaggio del popolo, demistificando personaggi che il mondo
dei media ha circondato di un'aura di sacralità. Questo è vero
soprattutto per il Benigni televisivo, visto che nella sua
produzione cinematografica l'attore filtra gli aspetti più aspri di

questa figura, secondo un programma cosciente che lui stesso spiega nel seguente passaggio:

> La fortuna del toscano? È un vernacolo più nuovo, meno sentito, prima lo si usava poco forse perché era la lingua dei padroni e si ride solo con i servi [...] Io, nei film non ho mai sottolineato il toscano. Soprattutto non l'ho mai usato in modo volgare anche se nessuno se n'è accorto. Nei miei film non ci sono parolacce. In televisione sì, perché lì sei posseduto da un altro demone, è una cosa piratesca, bisogna rubare [...] io non riuscirei mai a dire "mi fa una sega", "trombare", o "'un mi rompere i coglioni" solo per far ridere. È meglio segnare su azione che su rigore, è meglio che la risata arrivi da lontano. In TV è diverso, non posso raccontare una storia, allora devo "esserci" in cinque minuti" (Moscati 46).

Benigni riserva quindi diverse strategie a cinema e televisione: il punto di vista "dei servi", necessario per ridere, rimane un elemento comune ad entrambi i media, ma viene espresso in modi diversi. Se in televisione l'uso delle scurrilità permette di "segnare su rigore", ossia di scatenare la risata del pubblico per effetto immediato, nel cinema si ha la possibilità di raccontare una storia, di "costruire l'azione" strategicamente, per giungere poi allo stesso risultato, che è quello di offrire la prospettiva "dei servi", i soli con i quali si rida perché, aggiungiamo noi, con loro si costruisce una prospettiva sul mondo alternativa ed opposta a quella dei "padroni", si può sovvertire la versione ufficiale della realtà e metterla in ridicolo.

Dopo questa premessa quindi, se noi volessimo rispondere alla domanda che, un po' provocativamente e un po' giocosamente Benigni pone nella sua introduzione alla sceneggiatura di *Johnny Stecchino*: "Dov'è finito Cioni Mario?" (7), la risposta sarebbe che non è finito da nessuna parte, e sebbene abbia cambiato vestito e modo di esprimersi, è rimasto padrone incontrastato del suo territorio. Il mezzo tramite cui Benigni esprime la prospettiva popolare e sanguigna tipica di Cioni nel periodo in cui nasce *Johnny Stecchino*, è il personaggio di Benigni-clown, che si affaccia a partire dall'episodio "in banca" di *Tu mi turbi*, per culminare nel Loris

de *Il mostro*. Questo è sempre un personaggio liminale, ignaro della realtà che lo circonda e non integrato in essa, un personaggio che in questi film viene sempre più definendosi, passando dal diavolo Giuditta de *Il piccolo diavolo*, estraneo alle consuetudini sociali della realtà terrena, al Dante di *Johnny Stecchino,* per finire con il Loris de *Il mostro*, nel quale la liminalità socio-economica di questi protagonisti diventa surreale paradigma di vita dell'individuo nella società di massa, smarrito nella giungla di messaggi proposti dai mass media, e permeato dalle valenze da essi create.[1]

Situato fra gli estremi di Giuditta personaggio *ex machina*, piovuto in terra dall'inferno, e di Loris *in machina*, ossia passato dall'altra parte dello schermo ed assoggettato alle sue leggi, è il protagonista di *Johnny Stecchino*, il film che nel 1991 ha fruttato a Benigni il suo primo record di incassi (Celli 86). La trama del film è piuttosto lineare. Troviamo qui Roberto Benigni nei panni di Dante, il conducente di scuolabus di un istituto che ospita ragazzi affetti dalla sindrome Down. Mentre la vita di Dante scorre serenamente, a Palermo esiste un suo sosia, Johnny Stecchino, boss pentito della mafia che, avendo rivelato i nomi dei suoi compari alla polizia, è ora braccato dai mafiosi locali e vive nascosto in casa. Un bel giorno la moglie del boss, Maria (Nicoletta Braschi), incontra casualmente Dante e, vista la somiglianza fra lui e suo marito, pensa bene di mandare l'ignaro Dante allo scoperto per le strade di Palermo a farsi ammazzare dai mafiosi, così che Johnny, creduto morto dai suoi nemici, possa godersi la sua fortuna da qualche altra parte del mondo. All'ultimo minuto, comunque, Maria realizza quanto la sua vita con Johnny sia vuota, decide di scambiare nuovamente persona, e fa assassinare Johnny, mentre Dante torna alla vita di prima.

I pochi studi destinati a *Johnny Stecchino* oscillano fra letture del film in chiave di commedia al cento per cento, e interpretazioni che lo considerano o come il prodotto di un periodo di transizione o come un film ibrido, in cui coesistono

[1] Mi riferisco qui alla nozione del clown nel cinema di Benigni illustrata da Simonelli e Tramontana, pp. 85-135.

generi diversi.[2] In questa ricerca noi ci proponiamo di fare il punto su questa situazione, e mostrare quanto *Johnny Stecchino* sia il prodotto di un "turbinio di fulmini e di tempeste" per esprimersi con le parole dell'autore, che è per sua natura socialmente e politicamente impegnato. Questo impegno traspare negli elementi che stridono con un'interpretazione in chiave puramente comica del film, ed il cui referente viene in luce mediante una serie di autocitazioni, tramite il ricorso a cavalli di battaglia personali frequentemente rivisitati, che

[2] Nella prima chiave lo leggono Simonelli e Tramontana: "Il cuore del film è rappresentato dalla serie infinita di equivoci, incidenti, assurdità che si vengono a creare nei momenti in cui Dante porta in giro, ignaro e tranquillo, per le strade di Palermo la sua figura in tutto simile a quella di un gangster mafioso pentito ..." (150) e Massimo Moscati: "Il film permette a Cerami di utilizzare Benigni in un doppio registro di comicità pura: quella caratteristica della sua maschera farsesca e bonaria contrapposta ad una cattiveria di fondo spesso abilmente celata dall'attore" (70), sebbene poi questo crei tempi morti fra una gag e l'altra (150). Altri contributi sembrano più rivelatori. Carlo Celli mette in evidenza la permanenza di nuclei tematici nati con la figura di Cioni: la reticenza a parlare con le donne in modo naturale, la marginalità sociale, la traiettoria del complesso di Edipo del protagonista, passata ora alla madre di Johnny. Secondo Celli, la maggiore differenza fra questo film ed *Il mostro* consiste nel fatto che in *Johnny Stecchino* la *performance* del comico domina ancora la scena, mentre nel film successivo "Benigni would present his running themes of ex-peasant alienation in a manner where the camera becomes an interpreter of a social reality that complements his comedic body rather than merely records it" (86). Cristina Borsatti infine indica come carattere distintivo di *Johnny Stecchino* la sua ibridità: "In questo risiede la sua postmodernità, il suo continuo riferirsi ad altro da sé: il film strizza l'occhio a nobili precedenti (Wilder è in prima fila) e ricorre continuamente all'ibridazione dei generi (melodramma sentimentale, film di denuncia, giallo, commedia degli equivoci" (74). Anche per la Borsatti, come per noi, l'interpretazione scaturisce dall'osservazione della duplicità introdotta dal personaggio di Benigni, clown *mezzo comico e mezzo tragico*, che può "parlare di cose serie e cucire loro addosso una macchina di risate" (81).

Benigni imbastisce con apparente casualità all'interno del suo film.

In particolare, in questa ricerca mostreremo come *Johnny Stecchino* ponga a frutto con consumata arte il meccanismo comico del doppio, uno schema che il regista moltiplica sulla scena per inserire, nella serie infinita di riflessi da caleidoscopio che ne risulta, elementi di critica sociale che qui sono presentati in modo indiretto, e ne *Il mostro* forniranno l'impeto dell'azione. La struttura portante della trama è lo scambio di identità fra due gemelli, che risale a *I Menecmi* di Plauto. In questa commedia Sosicle e Menecmo, separati in giovane età, si vengono a trovare entrambi ad Epidamno, generando una serie di situazioni in cui ognuno dei due, alternandosi sulla scena, si trova ad agire in circostanze stabilite precedentemente dall'altro, con tutti gli equivoci che ne derivano.[3] A questa struttura si sovrappongono qui molte altre varianti, alcune delle quali forse desunte dal film che molti indicano come il modello per *Johnny Stecchino*, *Il grande dittatore* di Chaplin..

Il complicato gioco di specularità di questo film si estende al di là del rapporto di similarità e differenze fra Dante e Johnny. Su questa contrapposizione il regista impianta infatti anche la rappresentazione di due diverse Italie, anch'esse opposte fra di loro. Da una parte c'è l'Italia del potere, formata dalle cosche mafiose e dai personaggi che partecipano da protagonisti ai

[3] Lo schema del doppio è stato studiato da una moltitudine di angolazioni. È soprattutto fertile la sua lettura in chiave psicologica, come rappresentazione della doppia personalità, o del conscio e dell'inconscio. Clifford Hallam, nel suo articolo "The Double as Incomplete Self" (*Fearful Symmetry: Doubles and Doubling in Literature and Film*. Tallahassee: University Presses of Florida, 1981, pp. 1-31) traccia una storia sommaria di questi studi, cominciati con "Der Doppelgänger" di Otto Rank (1914), ripresi cinque anni dopo da Sigmund Freud con "Das Unheimliche", e continuati negli studi di Carl Jung. Per un'analisi psicanalitica di questo tema in letteratura i due testi base sono: Rogers, Robert. *A Psychoanalitic Study of the Double in Literature*. Detroit: Wayne State University Press, 1970, e Keppler, Carl Francis. *The Literature of the Second Self*. Tucson, Arizona: University of Arizona Press, 1972.

giochi di potere occulto del governo, una piovra i cui tentacoli si estendono virtualmente ovunque. Dall'altra abbiamo l'isolamento impotente del nostro Dante-*everyman*, che socializza solo con i suoi pupilli Down e qualche conoscenza occasionale che lo utilizza per le necessità del momento, e la cui esistenza scorre ai margini della vita sociale, determinata da circostanze che Dante non capisce e tantomeno controlla.

Questa realtà dicotomica è da una parte un apparato puramente comico, che mette in burla l'armamentario di luoghi comuni sulla mafia creato dai film di genere, e crea episodi modellati sulla situazione che Cerami descrive come " la vacca e la moglie" (Celli 85), così assicurandosi il successo di pubblico ricevuto dal film. Dall'altra, questa realtà multidimensionale permette al regista anche di offrire una rappresentazione della società italiana che è in sintonia con le sue convinzioni politiche, e che espone, sotto la patina comica, i vari peccati della politica italiana del momento: la connivenza tra mondo politico e criminalità organizzata che pochi mesi dopo l'uscita del film, con l'avvio dell'indagine di *mani pulite*, comincerà ad occupare le prime pagine dei quotidiani italiani; il fenomeno dei "pentiti" della mafia, e gli abusi di una struttura sociale in cui il potere effettivo passa di mano in mano, ma rimane sempre nello stesso gruppo di persone. Anche un film come *Johnny Stecchino*, che apparentemente si esaurisce tutto nella comicità, finisce quindi per rivelarsi il prodotto di problematiche sociali e di un periodo storico ben precisi, e porta avanti la protesta politica e sociale del Benigni prima maniera che, lungi dal poter essere esorcizzato come fenomeno di estremismo giovanile, rimane ingrediente principale e motiva le scelte espressive del regista maturo.

Tornando ora al nostro film, vediamo da una parte il mondo di Johnny Stecchino. Questi è un membro preminente della mafia siculo-americana, in guerra con la setta rivale di Cozzamara (Ignazio Pappalardo), un altro capomafia che, sebbene sia stato denunciato alla polizia da Johnny, è ancora inspiegabilmente a piede libero. Vissuto per lunghi anni a New York ed avendo fatto lì la sua fortuna, Johnny ha fatto frequenti visite "di lavoro" a Palermo, e quindi è a casa in entrambi i

continenti e vive, anche ora che è costretto alla clandestinità, nel lusso che i suoi affari loschi gli permettono di mantenere fra abiti pregiati, ville, vini, manicaretti e macchine sportive. Il mondo presentato in queste scene non ha niente di realistico, ma è la caricatura di tutti i luoghi comuni sulla mafia diffusi dai vari film del genere, dal *Padrino* a *Scarface* a *Goodfellas.* Johnny, per esempio, è descritto come un individuo pieno di assurde nevrosi: come il solo pensare a Cozzamara fa ribollire il suo sangue caldo al punto da costringerlo a camminare forsennatamente in circolo, lui, che non ha un attimo di esitazione a spargere sangue, soffre di una paradossale repulsione per la polvere che lo costringe a pulirsi ossessivamente ogni qualvolta lui tocchi un oggetto sporco.

Oltre a questo, l'attaccamento tipico del mafioso alla "famiglia" si manifesta in lui in una dipendenza psicologica dalla famiglia in senso letterale, ossia in una paradossale sindrome tutta italiana del mammone: sua madre è l'unico elemento sacro ed intangibile del suo universo, e la sua menzione basta a provocare un raptus che costringe Johnny ad astrarsi in assorta contemplazione. Dall'altra – e forse come conseguenza di questo presupposto – Johnny disdegna quant'altro di femminile esista nell'universo, sia considerando tutte le altre donne come inessenziali, sia imponendo a Maria un comportamento virile, in particolare rimproverandola per le macchie di rossetto che lei gli lascia quando cerca di strappargli un bacio. Questi temi sono tutti introdotti nel dialogo in cui Johnny racconta a Maria il motivo della sua inimicizia per Cozzamara, che si è inspiegabilmente impermalosito per l'assassinio di sua moglie:

- L'unica soddisfazione è che gli ho ammazzato la moglie...
- Che cosa hai fatto?
- Quella volta che ho fatto fuori a Giacomo Melino[...] ti ricordi? Lo andai a far fuori e ci avevo la mitraglietta, la F 44. La F 44 ci ha la raffica un po' larga, non si controlla bene, lo sai. Ho sparato a Giacomo Melino e ho preso pure la moglie di Cozzamara, per errore. Poi gli ho telefonato subito.

Infatti, gli telefonai subito, dico, senti, Cozzamara, scusa, dieci minuti fa, circa, ho ammazzato la moglie, abbi pazienza, eh, scusa, scusa. Gli ho detto scusa, e s'è incazzato. Ha fatto tutta una storia! È troppo permaloso, eh, così non si può lavorare, no? E che sarà mai? E che è? Gli ho ammazzato la moglie, nemmeno fosse sua madre ... mia madre...

- Johnny!
- Eh, si... hai capito? Gliel'ho chiesto scusa, no? Perché io sono educato, a me l'educazione me l'ha insegnata mia madre ... sì, lo so... mi sono ripreso.[4]

Ovviamente, ogni particolare di questa descrizione, e di quanto segue, è parodino: la religione della madre, il rapporto con le donne in cui, come si vede immediatamente dopo questo passaggio, il desiderio fisico è da una parte irresistibile, dall'altra socialmente inaccettabile, e quindi negato, la particolare etica mafiosa del lavoro, per cui l'assassinio di una donna è un particolare trascurabile che non può intralciare il normale svolgimento del lavoro ("così non si può lavorare"). In questa parodia rientrano mille altre scene, in particolare l'allusione alla realtà siciliana che l'avvocato D'Agata (Paolo Bonacelli) offre a Dante nel breve tragitto dalla stazione ferroviaria all'abitazione di Johnny, con il pretesto di descrivere Palermo:

Jera una bella città, ma ora, ... purtroppo siamo famosi nel mondo anche per qualche cosa di negativo, eh, per esempio, quello che voi chiamate ... piaghe ... Una, terribile, e lei sa a che cosa mi riferisco, eh ... l'Etna, il vulcano, che quando si mette a fare capricci distrugge paesi e villaggi. Ma je una bellezza naturale [...] E nella terza e più grave di queste piaghe che veramente diffama la Sicilia e in particolare Palemmmmo agli occhi del mondo, ehhhh, lei ha già capito, è inutile che io gliela dica, mi vergogno a dillo, ... è il traffico! Troppe macchine, è un traffico tentacolare,

[4] Questa è una scena che stranamente non compare nella sceneggiatura di Benigni-Cerami, sebbene sia invece nell'edizione del film diffusa negli Stati Uniti, alla quale mancano altre parti, come ad esempio il finale della descrizione di Palermo dell'avvocato D'Agata, ed una scena all'inizio del film.

vorticoso, che ci impedisce di vivere e ci fa nemici tra famiglia e famiglia! Troppe macchine. E lo Stato in tutto questo, che fa? È assente, sta a guardare, impotente, anzi, complice: quanti ministri ho visto venire qui con la macchina a creare ingorghi ... che vengono a Palermo non per aiutare a risolvere questa piaga, ma per aumentare il traffico!

Ovviamente, come indica la Borsatti (78), tutta questa descrizione allude al vero problema siciliano, la mafia, senza mai menzionarlo direttamente: la distruzione di paesi e villaggi a cui assistiamo non sarà causata dall'Etna, ma dalle sparatorie dei mafiosi, e l'unico traffico che vediamo è quello della cocaina, ed in esso è coinvolto, per l'appunto, anche un ministro. Questo primo contatto di Dante con la Sicilia è quindi, una rappresentazione dell'omertà della mafia, e della connivenza fra criminalità organizzata e governo italiano.

Questa e altre scene simili del film – come la conversazione con il giudice di cassazione Cataratta, o la scena al teatro dell'opera, in cui Dante viene a contatto con la crema della mafia palermitana – fanno parte, come dicevamo, dell'apparato caricaturale del film, né più né meno di quanto i costumi egiziani o la pompetta di plastica per simulare muscoli da culturista fungano da richiamo parodico del filone dei film neomitologici degli anni sessanta, in *Totò contro Maciste*. A questo universo di macchiette e personaggi da fumetto per bambini si contrappone però una realtà meno disimpegnata, nella quale si muove il nostro protagonista. Sebbene descritti con colori umoristici, tutti gli elementi che costituiscono la vita quotidiana di Dante rispecchiano troppo da vicino problemi attuali e pressanti per poter essere considerati puri giochi di simmetrie astratte; questi sono gli elementi che, sotto l'abito da clown del Benigni maggiore, rivelano i lembi della giacca a quadri di Mario Cioni.

Il doppio registro che caratterizza quest'altra realtà trova il suo simbolo nel calendario troviamo a casa di Dante. Non appena Maria entra in casa sua, la telecamera mette a fuoco su un calendario in cui, in bella mostra e voltata di schiena, posa una donna nuda. Nel mezzo della sua conversazione con la sua

ospite, Dante si accorge della sconvenienza di quest'immagine e si precipita sul calendario che, rivolto contro il muro mostra non il fondo, ma la foto della stessa modella, nella stessa posa, ma vestita. Come il calendario di Dante, Benigni sembra suggerire con questa scena, la realtà illustrata in questo film è duplice, e sotto il livello giocoso e quasi infantile della narrazione ne esiste uno serio, che confina con il tragico.

Questa dimensione di vita specularmente opposta a quella di Johnny Stecchino comincia ad emergere nell'opposto rapporto che i due sosia hanno con il simbolo principe dell'opulenza consumistica: l'America. Questo tema non è nuovo per Benigni, si riallaccia alla lunga critica all'egemonia culturale ed economica degli Stati Uniti sull'Italia che comincia con *Non ci resta che piangere*, ed è specialmente sviluppata in *Daunbailò* (Simonelli e Tramontana 99). Mentre il nome di Johnny illustra chiaramente la sua origine americana, Dante ha un nome che richiama alla mente le glorie della tradizione letteraria italiana, un'eredità che presto si dimostra solo nominale. Con Dante Alighieri il nostro eroe spartisce infatti solo la condizione di esilio, non dalla città natale, ma da qualsiasi forma di aggregazione sociale. Il nostro Dante vive da solo e modestamente in un condominio impersonale, si muove sullo scuolabus di proprietà dell'istituto per cui lavora, e vive di espedienti, percependo indebitamente un assegno di invalidità dalla sua assicurazione, e rubacchiando qualche banana qua e là ai commercianti del quartiere. Lungi dall'estendere il suo controllo su due continenti come il suo sosia, come altri hanno notato, Dante è il rappresentante di tutte le debolezze della classe media italiana, per prima l'ignoranza delle lingue straniere, ed in particolare dell'inglese. Questo è quanto vediamo quando lui si reca all'hotel Excelsior per trovare Maria, e il portiere dell'albergo, che lo vede sbirciare dalla finestra, lo prende per la collottola per portarlo dal direttore. In quest'occasione, Dante non trova di meglio da fare che fingersi un turista americano, improvvisando un inglese creato per l'occasione: "Lasc me, please, lasc me, very dangerous for your licenziament, I am American, dangerous for Italy...". America ed Italia, il centro e la periferia dell'economia mondiale,

diventano in questo contesto simboli dell'appartenenza ad una classe socio-economica alla quale il criminale mafioso e la sua donna hanno libero accesso, ma che il nostro protagonista deve o guardare dalla finestra, o penetrare sotto mentite spoglie, come ospite indesiderato.

La sua condizione di marginalità costringe Dante anche ad altre simulazioni. Prima di incontrare Maria, ed accettare la metamorfosi in Johnny che lei porta a compimento, Dante vive simulando un'infermità derivatagli da un incidente automobilistico, un irrefrenabile movimento spasmodico del braccio destro per cui l'assicurazione gli versa un assegno mensile di invalidità. Anche questo particolare non è nuovo nei film di Benigni. A partire da *Il minestrone*, in cui Benigni insegna a Franco Citti e Ninetto Davoli come mangiare in un ristorante e poi darsela a gambe, a *Il mostro*, in cui Loris svaligia il supermercato locale ed evita di pagare il condominio, questi comportamenti antisociali esprimono la rivolta contro un ordine sociale che i personaggi di Benigni subiscono e nel quale non si riconoscono. In questo caso però Dante è fronteggiato da un vero e proprio cacciatore di taglie in versione burocratica, il dottor Randazzo (Ivano Marescotti) che, quasi emissario di un apparato statale che rappresenta gli interessi dei potenti a discapito dei poveri disgraziati, richiede esami medici su esami medici per poter smascherare la finzione di Dante e poter così aggiungere un altro trofeo alla galleria di piccoli lestofanti che lui ha rovinato. Alla fine il trucco di Dante è scoperto quando lui incontra casualmente Randazzo alla festa a villa Caputo (quasi centro nevralgico del potere che si oppone all'universo marginale del nostro eroe) e Dante apprende che ora dovrà fare i conti direttamente con il ministero, e sarà processato per direttissima per truffa ai danni dello stato.

Questa è una delle molte istanze in cui possiamo notare l'attrito fra i diversi livelli del film. Se il mondo di Dante è apparentemente giocoso, ed illuminato dall'allegria e dall'ottimismo del protagonista, esso presenta anche problemi pressanti e concreti che stridono con la sua spensieratezza. In questa sequenza in particolare, è difficile non notare il contrasto che emerge fra il mondo della macrocriminalità – che include

tutti i notabili come il ministro, il questore, il vescovo, e Johnny Stecchino – e la microcriminalità da monello dei poveri diavoli come Dante. Quello che risulta da questa contrapposizione è un atto di denuncia espresso implicitamente contro uno stato che offre l'impunità assoluta ai peggiori criminali, ed anzi garantisce loro la vita d'alto bordo, mentre si incattivisce contro i cittadini indifesi e creduloni come Dante, che, vittimizzati da strutture sociali che non proteggono i loro interessi, sono costretti a vivere di sotterfugi per sbarcare il lunario, finiscono per essere gli unici a rimanere incagliati nelle reti del sistema, e quindi a fare le spese per tutti.

Questa differenza di stato sociale viene rappresentata in molti diversi ambiti, ma trova la sua migliore espressione nel rapporto di Dante con il gentil sesso. Questo tema è preannunciato nella scena iniziale, nella quale lo stesso pubblico – per una volta invischiato nello scarto continuo fra apparenza e realtà interno al film – è indotto a scambiare Dante per un dongiovanni di successo. La scena ha luogo in una camera da letto. Il nostro protagonista, comodamente seduto in poltrona, assiste ad uno sfogo di sentimenti di Gianna (Loredana Romito) che, ai suoi piedi, piange e si dispera. Mentre il nostro eroe non pronuncia parola, Gianna supplica con toni sempre più patetici, con il volto cosparso di lacrime e la voce rotta dai singhiozzi, nell'apparente speranza di essere riaccettata dal suo amante:

> Ti prego, ti prego, qualsiasi cosa, ma non mi lasciare. Chiedimi qualsiasi cosa e la farò … io ti adoro, ti amo, ma non mi lasciare. Farò tutto quello che vuoi tu: sarò la tua serva, sarò la tua schiava, ma non mi lasciare. Non posso vivere senza di te. Tu mi hai insegnato tutto: che cos'è l'amore, che cos'è il sesso. Rispondimi, perché non dici niente? Non andartene. Vuoi fare all'amore con me? Adesso? Subito? … Rispondimi![5]

[5] Questa è peraltro una scena alla quale il film allude in seguito, quando Johnny descrive il proprio rapporto con Maria: "ho fatto tutto per te (mentre le infila la mano sotto la gonna) ti ho tirato su con le mie mani… non posso permettere che uno che si chiama Cozzamara…"

Dante entra quindi in scena nel ruolo dello "sciupafemmine", impassibilmente in controllo di sé stesso anche di fronte alle profferte più disperate della sua bella amante. Ma il ruolo di rubacuori inveterato, indurito dall'esperienza a non ascoltare le preghiere delle donne, dura poco: presto impariamo che abbiamo assistito ad una replica, originariamente indirizzata a Rocco, ex fidanzato di Gianna, che, nonostante la disponibilità e gli inviti della ragazza, l'ha comunque lasciata. Dalle stelle alle stalle, il nostro Dante passa in un istante dal ruolo di dongiovanni a quello di compagnia indesiderata, visto che quando Gianna lascia la festa, lei declina l'offerta di Dante ad accompagnarla, e torna a casa da sola. La marginalità sessuale del protagonista, insieme con gli espedienti che lui inventa per uscirne, è forse l'elemento più battuto da Benigni in tutta la sua produzione. Come Simonelli e Tramontana illustrano bene, il rapporto irrisolto con le donne fa parte delle caratteristiche fisse del clown impersonato da Benigni, ed esprime in chiave comica la marginalità sociale del personaggio.[6]

Se il rapporto con l'universo femminile ha queste valenze generali nel cinema di Benigni, in questo film esso assume valenze che lo rendono anche il sinonimo del mondo promiscuo della politica italiana e delle leggi inspiegabili che la governano. Questo tema è presentato nella scena della festa che segue immediatamente la partenza di Gianna, in cui Dante assiste a un gioco di società che cattura la sua curiosità: un giovane distribuisce carte ai vari partecipanti, attribuisce agli uomini del gruppo i ruoli di vari personaggi pubblici, ed alle donne quello delle loro mogli. Il gioco consiste nell'individuare la moglie del ministro che, per punizione, deve sollevare la gonna e mostrarsi

[6] Leggiamo a questo proposito in Simonelli e Tramontana un brano che riassume bene questa problematica: "la donna-angelo nella filmografia di Benigni è direttamente collegata all'ignoranza del mondo da parte dei personaggi da lui interpretati; ne diventa addirittura il simbolo: non conoscere la donna e i suoi segreti significa non conoscere il mondo, non conoscere la realtà delle cose; e l'impatto tra lo stato d'ignoranza e questa realtà sconosciuta si traduce nello *stupore* caratteristico del non integrato di fronte alle meraviglie del mondo adulto..." (105)

in mutandine a tutti gli invitati, così rivelando il suo "ministero", fra le risate generali. Questo è un precedente che offrirà occasione per una scena comica verso la fine del film quando, alla festa a villa Caputo, Dante incontrerà la moglie di un ministro non fittizio, ma reale, e memore di questo gioco, penserà bene di sollevare le gonne alla povera donna provocando lo scompiglio generale. Ma anche in quest'occasione il gioco apparentemente insignificante, il ricorso ad una visione infantile del mondo e della sessualità è solo il livello letterale di un discorso plurivalente che contiene un messaggio politico e sociale più serio. Fra i monologhi di Benigni troviamo infatti un passaggio che offre spunti utili per comprendere questa scena:

> Un ministero è una specializzazione. È come per i dottori, non è che l'otorinolaringoiatra si intende di cose cardiache. Gli dici:
> - Oh te, fai il cuore…
> Ogni volta che c'è una crisi cambiano i ministri. Quello del Lavoro all'Economia, quello dell'Economia al Bilancio, quello del Bilancio alle Partecipazioni Statali … Ma come fanno ad intendersi di tutto? Tanto intelligentoni non mi sembrano … E non ho mai sentito un ministro che quando dice:
> - Guardi, a lei gli diamo il Bilancio …
> - NO! Non me lo dia, perché non ci capisco nulla, la ringrazio ma io non ci intendo niente.
> Invece sembra sempre la materia sua! Dice:
> - Guardi lei, Partecipazioni Statali …
> - Cazzo, proprio la materia mia! Io fin da piccolo ho sempre partecipato … statalmente! L'ho detto proprio alla mi' mamma: Mamma, voglio partecipare all'azionario statale io … è proprio la materia mia!
> Ma un ministero è una specializzazione, non è che uno può fare da qui a là, da qui a là, è come quando cambia il direttore di una clinica …
> - Guardi lei, è cambiato il direttore della clinica, cambio dei dottori … lei ginecologo, va a fare il dentista! Lei dentista, ginecologo! (*E l'alluce fu* 18-19)

A parte il comune ricorso alla parola ministero, questo brano e la scena della festa rivelano simiglianze importanti. Come nel governo descritto da Benigni in questo passaggio, anche nella ricostruzione giocosa della società italiana del film, i ruoli sono attribuiti per motivi apparentemente insondabili, e la cui scelta è prerogativa di pochi. Come nell'attribuzione delle cariche del governo, anche qui è arbitrario il motivo per cui le mogli dell'assessore, del vescovo e così via seguono l'esempio della moglie del presidente, che la passa liscia e "non ci fa vedere niente", mentre la moglie del ministro deve fare ammenda e mostrarsi seminuda a tutti. In questa scena, come nel passaggio citato, sessualità e politica sono due sfere i cui confini vengono indebitamente confusi, per diventare sinonimi di quanto, nella società italiana, è riservato ai beati pochi. Il mondo sociale della festa, in cui Dante entra in apparente posizione di controllo, per poi muoversi fra invitati che non conosce e cercando inutilmente di inserirsi nei gruppi già formati, annuncia quindi un tema centrale del film: la separazione che esiste nella società italiana fra gli attori della scena politica, che arbitrariamente stabiliscono le regole del gioco a cui tutti partecipano, e godono dei suoi frutti, e le comparse, ossia tutti quelli che possono solo prendere atto con stupore di quanto vedono svolgersi di fronte ai loro occhi. In questa scena, quindi, le valenze sociali e politiche che Benigni tradizionalmente esprime mediante la marginalità sociale ed erotica del suo personaggio diventano più esplicite, e la sfera del potere personale, sociale, politico ed erotico, si fondono in un tutt'uno di cui la donna è allo stesso tempo l'epifenomeno ed il simbolo.

Questa è peraltro una nozione ulteriormente sottolineata nel finale della scena, in cui tutti gli invitati, con le donne del gruppo, salgono in macchina per continuare altrove la notte di baldoria mentre Dante, fisicamente posto fra di loro, non viene neppure visto, da socialmente marginale diventato come trasparente, e rimane solo come un cane davanti al portone.

Introdotto per la prima volta da questa scena alla festa con Gianna, i temi del sesso e del potere vengono ripresi e sviluppati nel rapporto di Dante con Maria, il personaggio sul quale principalmente poggia lo sviluppo della trama. Oltre a fungere da

propulsore attivo a tutta la vicenda, Maria è anche attivamente coinvolta nel gioco di riflessi speculari che caratterizza la dinamica del doppio fra Dante e Johnny. In particolare, Maria manifesta una serie di contrasti con il boss mafioso: mentre Johnny continua a ripetere che l'altro non gli somiglia per niente, Maria insiste sull'assoluta somiglianza fra Johnny e Dante; mentre Maria è sovranamente disinteressata alla sporcizia, al punto da pulirsi regolarmente le mani sporche sul vestito bianco, Johnny soffre della sua terribile fobia per la polvere; infine, mentre Maria cerca sempre di approfittare dei suoi momenti di distrazione per baciarlo, Johnny non può sopportare di essere baciato: "Eh non mi baciare, lo sai, no, che non mi piace, i baci. I baci li danno le femminucce, e gli uomini sessuali. Io sono l'uomo, Maria. Guarda qua, e poi col rossetto, che schifo [...] ma quando impari a comportarti da uomo!" Questi punti di disaccordo con Johnny vengono tutti controbilanciati nel rapporto di Maria con Dante, che, al contrario, è in un brodo di giuggiole per aver trovato una donna apparentemente interessata a lui, e pur di poterla conquistare, segue passo passo le istruzioni che riceve: va in Sicilia, assume un altro nome, cambia vestito, si desegna un neo sulla guancia, porta in tasca una scorta di stecchini, sempre pronto a mettersene uno in bocca, beve vino essendo astemio, fuma essendo non fumatore, e finisce per esprimersi con le stesse parole di Maria: "Santa Cleopatra!".

Ma tutte queste concessioni si rivelano inutili a conquistare la giovane, che per tutta la permanenza di Dante a Palermo insiste a dormire in letti separati, cosa che una sera, dopo lungo tempo, induce il povero Dante a farle una dichiarazione formale: se lei decidesse di fare all'amore con lui, troverebbe la porta aperta. Prima di andarsene a letto, Dante si avvicina quindi a Maria e le bacia le labbra, nonostante il rossetto, un'azione che porterà Maria, novella addormentata nel bosco, a risvegliarsi dal torpore al quale si era abituata e a ripensare tutto il suo rapporto con Johnny. Questo è un momento decisivo del film, in cui il pubblico si aspetta che i paradossi di questo universo caotico arrivino alla prova della verità: di questi due mondi, quale si salverà? Chi sceglierà Maria come suo partner, il boss mafioso con il cuore di pietra o l'ingenuo autista tutto sentimento? Come

nella scena iniziale, anche questa volta il regista gioca con le aspettative dello spettatore, lo pone di fronte ad un bivio e gli prospetta di scegliere la conclusione più probabile fra la continuazione della trama come si è sviluppata finora, con la morte di Dante, e un finale rosa, in cui tutto torna a posto ed il nostro protagonista si inserisce con successo nel nuovo mondo degli affetti femminili che ha qui scoperto. Tutto rimane volutamente in sospeso fino al momento in cui vedremo che Maria, scortando Johnny fuori città e ferma ad un distributore di benzina, approfitta per dargli l'ultimo bacio. Questo costringe Johnny ad andare al gabinetto per pulirsi il rossetto dalle labbra, e lì, secondo i canoni del genere incontra i picciotti di Cozzamara che gli fanno la festa. In sostanza, Johnny lascia la scena in un modo che ancora una volta irride i canoni del genere, per una "questione di rossetto" anch'essa capovolta, in cui il rossetto, segno classico del tradimento maschile, diventa invece l'emblema della rivolta femminile contro il patriarcato.

Tutto sembra quindi predisposto per il meglio, e lo spettatore si aspetta il classico finale in cui l'eroe lascia la scena avendo conquistato la donna, per integrarsi finalmente nella società, ma le cose non vanno così. Uno dei motivi più evidenti per cui è scorretto interpretare *Johnny Stecchino* come commedia al cento per cento risiede proprio nel fatto che il film non si conclude con un lieto fine. Dopo tutte le sue avventure, dopo aver riconosciuto l'incompletezza della sua vita con Johnny, incluso persino il bacio del cavaliere azzurro che causa il risveglio, il film si conclude invece con la separazione dei due protagonisti. Maria, dato l'ultimo bacio a Dante, si allontana sulla sua macchina lussuosa per andare a godersi la vita fra gli agi e le ricchezze lasciatile da Johnny, e Dante ritorna al proprio piccolo mondo, al suo raccontare a Lillo le sue avventure, in condizioni di marginalità e isolamento peggiori di quelle nelle quali lo avevamo trovato all'inizio della storia, visto che, dopo l'incontro con Randazzo, sarà processato per direttissima per truffa ai danni dello stato. Lungi dal rappresentare il processo di crescita ed integrazione dell'eroe nel tessuto sociale, il film persiste quindi nel sottolineare l'esistenza di una separazione incolmabile fra il mondo dei ricchi e potenti e quello dei piccoli diavoli. Le

convenzioni cinematografiche possono essere utili a rappresentare il vero problema della connivenza fra potere istituzionale e criminalità organizzata sotto forma di gioco, presentando temi concreti e reali sotto mentite spoglie, messi in scena da marionette inoffensive che appartengono al mondo dei fumetti più che a quello della realtà, ma il gioco si ferma lì: queste convenzioni sono abbandonate quando si tratta di rappresentare relazioni di potere e barriere di classe, e su questo schermo come nella vita reale, il proletario o il piccolo borghese non può accedere al mondo di agi e incolumità che è garantito solo alle alte sfere della società.

Nemmeno molto convincente è l'opinione di quanti vogliano vedere il lieto fine del film nel ritorno del protagonista agli affetti quotidiani di sempre, rappresentati da Lillo (Alessandro de Santis). È vero che in questo modo Dante torna all'unica sua relazione affettiva, ed è anche vero, come dice la Borsatti, che così Benigni usa ancora l'immagine paterna dell'insegnante/maestro di vita che lo ha accompagnato sin da *Chiedo asilo* (75-76), ma la presenza dei ragazzi Down in questo film richiama l'attenzione del pubblico a problemi di una tale serietà da sembrare difficilmente coniugabili con l'esclusivo obiettivo del comico di far ridere, come dice Cerami. La scelta di un gruppo di individui portatori di una disfunzione genetica come l'unico tessuto sociale con il quale Dante interagisca, ha semmai l'effetto di sottolineare la gravità della disfunzione presente in una società che protegge i personaggi senza scrupoli e con le mani in pasta nel potere, contro gli interessi dei deboli, dei poveri e dei marginali, un problema a cui evidentemente allude l'immagine finale del film, nella quale Lillo riceve la prestigiosa medicina contro il diabete che Dante ha trovato in Sicilia, e lascia la scena saltando di gioia, con la cocaina.

Invece di ancorare il film al genere della commedia, il rapporto di Dante con Lillo ha semmai l'effetto opposto: funge da ulteriore memento per chi possa essere propenso ad interpretare la parabola di questo film in modo unicamente letterale. L'onnipresente quanto immutata reazione di Lillo a qualsiasi racconto delle avventure di Dante, "hai fatto l'amore?", riportando regolarmente il dialogo al livello zero della

comunicazione, rappresenta semmai un monito diretto allo spettatore, a non seguire tale esempio, e a sforzarsi invece di cogliere il messaggio più profondo, che è presente nel film in tutti quegli elementi che esulano dalle convenzioni di genere.

Per concludere, anche la presenza dei giovani Down, come la scena iniziale in cui il pubblico viene a sua volta preso nella trappola di attribuire a Dante un'identità non sua, il lieto fine quasi annunciato ma non completato, la presenza di Randazzo e mille altri simili dettagli, indica che il regista, invece di aderire alle regole di un qualsivoglia genere, insiste nell'infrangerle e nel sorprendere il pubblico con sviluppi che non rientrano nell'orizzonte di attese a cui il cinema commerciale lo ha abituato, in questo modo costringendolo a prendere atto della denuncia implicitamente espressa dal film. Ancora una volta, il Cioni contestatore e provocatore, che all'inizio della sua carriera voleva "piglia' l'emissione, e interferire l'onda pubblica statale" (Ambrogi e Carpitella 23) fa capolino dietro le quinte del film di questo Benigni più maturo ed, in queste deviazioni dalla norma, in questi scarti, stabilisce un commento che è contemporaneo e parallelo alla narrativa di base, e su essa si impianta. Benigni cambia quindi il costume ed il linguaggio del suo primo protagonista, adeguando Cioni alle esigenze del grande schermo – in questo caso facendolo addirittura vestire all'americana, con una giacca blu ed una camicia a righe bianche e rosse – ma anche nel momento in cui si inserisce nel gran circuito dei film di cassetta, continua a portare avanti la sua opposizione al cinema commerciale, inserendo anche qui un discorso sul modo di fare ed osservare il cinema che si burla delle convenzioni ispirate ad una politica del disimpegno, e sbatte in faccia al suo pubblico problemi veri e pressanti che il momento storico impone di considerare.

Questo mondo al contrario, in cui il problema reale della mafia è presentato in forma caricaturale e pare quasi uscito da un fumetto per bambini, ed in cui il nostro protagonista si muove fra personaggi che non hanno gli strumenti necessari per decodificare una realtà che presenta multipli possibili piani di lettura, prefigura in maniera evidente lo scenario surreale che verremo a trovare ne *Il mostro,* in cui la società è divisa in due

opposti schieramenti, quello delle varie caricature che impersonano i garanti della versione ufficiale della realtà – il commissario, l'amministratore del condominio, lo psicologo – e le orde informi di masse acritiche dei consumatori dei mezzi di comunicazione di massa. Quando uscì *Il mostro*, Silvio Berlusconi aveva appena fatto il suo ingresso nella scena politica italiana, diventando in breve tempo Presidente del Consiglio. In questo contesto, il tema dello strapotere dei mezzi di informazione pubblica era già particolarmente ricorrente nel dibattito pubblico italiano, e questo ovviamente offrì il destro a Benigni e Cerami di rispolverare e mettere in uso tutto l'armamentario di battute che il comico era venuto accumulando contro Berlusconi.[7] Questa era un'opportunità che non si era verificata nel caso di *Johnny Stecchino* che, per il fatto di essere di tre anni anteriore a questi sviluppi politici, si muove in un orizzonte ancora non ben definito.

Se in questo film Benigni e Cerami propongono gli stessi temi dell'identità individuale e della sua manipolazione nella società di massa, dell'isolamento e della crescente marginalità della classe media italiana che saranno al centro de *Il mostro*, a questo punto il nemico ufficiale non si era ancora dichiarato, e quindi tutti i loro attacchi vengono espressi in maniera diffusa, meno mirata. Invece che contro un individuo o contro una corrente politica precisa, in *Johnny Stecchino* la protesta sociale di Benigni e Cerami è inserita e quasi dissimulata nella serie infinita di immagini speculari e simmetriche che, come in un caleidoscopio, dà vita alle diverse prospettive, a volte comiche, a volte serie e a volte tragiche, che questo film offre sulla realtà italiana dei primi anni novanta.

[7] Vedere a questo proposito un mio articolo: "Cinematization and its Discontents: Benigni's *Il mostro*" in Augusto Mastri, ed., *Roberto Benigni, Actor and Film-maker*, di prossima pubblicazione presso la casa editrice Soleil.

Opere citate

Ambrogi, Silvano e Mario Carpitella (Ed.). *Quando Benigni ruppe il video. I primi testi televisivi di Roberto Benigni.* Torino: Edizioni RAI Radiotelevisione Italiana, 1992.

Benigni, Roberto. *E l'alluce fu.* Torino: Einaudi, 1996.

Benigni, Roberto e Vincenzo Cerami. *Johnny Stecchino.* Roma-Napoli: Theoria, 1991.

Borsatti, Cristina. *Roberto Benigni.* Milano: Il Castoro Cinema, 2001.

Celli, Carlo. *The Divine Comic: The Cinema of Roberto Benigni.* Lanham, Maryland, and London: Scarecrow Press, 2001.

Moscati, Massimo. *Benignaccio, con te la vita e bella.* Milano: Superbur Saggi, 1999.

Simonelli, Giorgio e Gaetano Tramontana. *Datemi un Nobel! L'opera comica di Roberto Benigni.* Alessandria: Edizioni Falsopiano, 1998.

"Perché non ho scritto la *Divina Commedia*? Perche non c'ho pensato": Dante's *Commedia* and the Comic Art of Roberto Benigni

Vittorio Montemaggi

> "Perché non ho scritto *La Divina Commedia*?
> Perché non c'ho pensato"[1]

Allow me to begin by being as bold as to try and encapsulate in a single sentence the main idea I would like to get across in the present essay: Dante's *Commedia* and Benigni's work are governed by a similar understanding of human personhood and of human relationships. What follows may be read as a qualification of this statement. And, so as to avoid any misunderstanding, let me make it clear, to pick up on the words quoted above, that I am not trying to say that, had he only thought about it, Benigni could have written a work like the *Commedia*; or that writing a work like the *Commedia* would be a venture fully consonant with Benigni's work as a comedian.

What I am trying to suggest is that Benigni's work may be seen to share similar ethical and theological dynamics to the *Commedia*. Benigni has on many occasions made it clear that Dante is one of his main sources of inspiration. And part of what I would like to suggest is that there are elements in Benigni's comic art which are consonant with crucial aspects of the poetics of the *Commedia*. I would also like to point, however, to how Benigni's work may help one appreciate aspects of the *Commedia* often not taken into account in scholarship on Dante.

[1] Benigni, *E L'alluce fu,* 85. Many of the ideas in the present essay have their origin in a paper I presented to the research seminar of the Italian Department of University College, Dublin in February 2003. I am grateful to John Barnes and the members of the Department for an illuminating discussion. I also wish to thank Pierpaolo Antonello, Catherine Galloway, Robin Kirkpatrick, Matthew Treherne and Denys Turner for their comments on earlier versions of this paper.

In other words, there will be some circularity in my argument – which I hope the reader may forgive.

The way I will proceed is the following: I will first outline, with particular reference to Benigni's appearance at the 2002 San Remo music festival and to his *lectura* of *Paradiso* XXXIII given on RAI later the same year, those which I take to be the main features of the ethical and theological dynamics shared by Dante's *Commedia* and Benigni's comic art.[2] I will then briefly point to how such dynamics may be seen at play in Benigni's latest films, *La vita è bella* and *Pinocchio*.[3] My interest throughout will be on how Benigni's comic art, especially as seen through his comments on his own work, aims to draw one into a particular kind of ethical reflection.

I have argued elsewhere that it is part of Dante's understanding of human personhood as presented in the *Commedia* that the ultimate answers regarding human existence are not available to the human mind and that this may be the basis for one to enter into relationship with others.[4] In Dante's text this is related to reflection on man's embodied nature; and the terms of this relation depend, firstly, on the miracle which every human person may be seen to be and, secondly, on the fact that statements as to human reason's inability to grasp ultimate truth may be at one with statements as to the inexplicability of human suffering. For Dante, moreover, the ultimate

[2] All quotations from the San Remo monologue and the *lectura* (both broadcast by RAI1) have been transcribed from a private recording. All translations of quotations from Benigni's work are my own. Quotations from the *Commedia* are from *Dantis Alagherii Comedia*, ed. F Sanguineti (Florence: Edizioni del Galluzzo, 2001). Translations are from *The Divine Comedy*, ed. and trans. J D Sinclair, 3 vols (Oxford and New York: Oxford University Press, 1961).

[3] For Benigni's dealing with theological questions in works prior to *La vita è bella*, as well as for an analysis of Benigni's relationship to Dante in the light of his experience as a *poeta a braccio*, see Celli, *The Divine Comic*.

[4] V Montemaggi, "La rosa". The reader is referred to this essay also for the Dantean and theological bibliographical references underlying my argument.

inexplicability of human suffering is not so much to be countered by the human mind on the intellectual plain but by the human person on the ethical one; for truth itself consists in nothing other than the love by which one may be ready to have one's actions defined by another person's presence and needs. From a Dantean perspective, therefore, doing theology is not so much a question of providing as objectively accurate a picture of God as humanly possible, as a question of using one's language to invite others to recognize how one's understanding of truth is constantly put into question by one's encounter with other people.

On the above view, theology and ethics are inextricably intertwined, and the aim of Dante's poetry is seen as that of drawing the reader into a reflection on human personhood and relationships based on the idea that these may ultimately not be explained but only wondered at and enjoyed in the 'gioco' which, at its best, human community may be seen to be.[5] Benigni's work, I would like to suggest, has as its aim that of drawing one into a similar kind of reflection. As Benigni might put it, his aim is not so much that of making one laugh as that of making one love. Indeed, at least since *TuttoBenigni 95/96*, Benigni has not tired of reminding his audiences that if there is one thing he would like them to take away after seeing him on stage or on the screen, this would be the Augustinian formulation of the command to love one's neighbour as oneself: "ama e fa ciò che vuoi" [love, and do what you please] (*E l'alluce fu* 149-50).

I do not thus wish to imply that Benigni's comic art is as explicitly theological as Dante's *Commedia* – though, as we shall see, his work is indeed being increasingly characterized by an explicitly theological vein. I wish simply to suggest that in attempting to come to terms with Benigni's work it may be helpful to keep in mind the intertwining of theology and ethics found in the *Commedia*. And that, conversely, our understanding of the latter may be enhanced by its being put alongside the not

[5] For the word 'gioco' ("game" or "play") see *Purgatorio* II, 66; XXVIII, 96; *Paradiso* XX, 117.

so explicitly theological art of Benigni. Perhaps I could put this apologetically: I will have expressed myself misleadingly if what the reader thinks I am trying to do, in saying Benigni's comedy may fruitfully be approached from a theological perspective, is either to elevate Benigni's work or downgrade theology.

That said, in his two latest major appearances on Italian television, Benigni does in fact indulge in the use of theological terms both to describe his work as comedian and to invite his audience to appreciate the beauty of the *Commedia*. Benigni's 2002 appearance on the San Remo stage was preceded by an intense political debate generated by the concern of some that Benigni would use this as an opportunity to express his views against Italian Prime Minister Silvio Berlusconi. Though indeed engaging in some political satire, Benigni surprised his audience by making the recitation of the opening lines of *Paradiso* XXXIII, and not political satire, the climax of his sketch. Most significant for our present purposes, however, are the opening words of the San Remo monologue:

> I am here truly as an act of love (I apologise for using such a big word) [...] because comedians are imbued with love. One cannot ask comedians to be also wise, for when one is in love one is rather foolish. Being in love and wise is only allowed to God. One therefore makes mistakes because of love. We need to protect comedians because they are like saints, they are [...] a gift from heaven – please forgive this advertisement for the profession to which I dream of belonging. They are a most beautiful thing, they break rules, do what they please, are spoilt like children, are rich in love [...] they would let themselves be killed because they love everything [...] they have the power to make one cry and laugh, which is more than Hitler and Stalin had for they could only kill. Comedians on the other hand make one cry and laugh, and this is the greatest power in the world. One has to kiss them, care for them, as it's a matter of love. Now this thing that happened [the political debate mentioned above] is only an affectionate and playful thing: it is truly a matter of love. [...] Even if one thinks one thing and another thinks another, love is felt. I would let myself be killed when one says something different from me, because I love him!

"Solo a Dio è concesso di essere innamorato e saggio" ("being in love and wise is only allowed to God") is as precise a theological statement as one could find in explicitly theological works, take *Paradiso* XXXIII 124-26, for instance. And with it Benigni outlines his understanding of the nature of truth and of man's relationship to truth, as well as of the work of the comedian. Ultimate truth lies with God alone; it is not given to human beings to know the ultimate truths regarding the world and human existence. Yet human beings may and indeed ought to love, Benigni says; and this is where comedians come in because, like saints, their purpose is that of making people love. Comedians may achieve this, Benigni says, because they have "the power to make one cry and laugh" ("il potere di farci piangere e ridere"). As Benigni chillingly puts it, in this a comedian is more powerful than Hitler or Stalin were for they only had the power to kill.

That of the juxtaposition between tears and laughter is a recurring idea in Benigni's statements on the nature of the work of the comedian. As he puts it speaking about Chaplin, "He was the first to make people cry and laugh at the same time. He is the one who turned the comedian's work into something poetic, into the highest and closest thing to God." (Benigni e Cerami, *La vita è bella*, 2nd ed. xvi). Or, as he put it elsewhere, so as to entertain people, "the comedian first needs to suffer, needs to go and see where there is suffering, needs to know how to suffer, so as then to be able to say one has to laugh and find at least a moment of serenity, beatitude, joy" (Benigni and Cerami, La vita e bella, 2nd ed. xiii).

On his own view, then, Benigni's comic art may be seen to arise out of a wish not to neglect the reality of human suffering. Benigni invites one to see his comic art as based on the recognition that laughter and tears are simply the two sides of human existence and that, precisely because this is the case and because it is not given to the human mind to say why this is the case, the comedian ought to direct his artistic energies to making his audience laugh in the hope this may enliven in them a sense of what it may mean not to give suffering the last word. Precisely because there is suffering, Benigni implies, a

comedian should attempt to enliven in his audiences a love of life which, to come back to San Remo, may issue into an ethical attitude antithetical to one that may bring one human being to kill another.

According to Benigni all people should, over and above intellectual and ideological disagreements, be loved for the simple fact that they *are*. "Mi farei ammazzare quando uno dice una cosa diversa dalla mia, perché io lo amo!" (I would let myself be killed when one says something different from me, because I love him!). Or, as he put it later on, "l'amore è l'unica limitazione della libertà che ci rende più liberi" (love is the only restriction to freedom which makes us freer). According to the terms of the San Remo monologue, unless one is able to keep hold of the recognition that human freedom can only properly be based on one's being ready to have one's actions defined by an unconditional sense of love for the other, irrespectively of who that other is, then one is just making the job easier for the Hitlers and Stalins of this world.

We are not very far, I think, from the understanding of human personhood found in the *Commedia*. Like Dante, Benigni seems to take as a starting point the ultimate inexplicability of human existence and suffering. And he does so in the light of the inexplicability of the fact that human beings are capable of love and that, as a comedian, he may have the power to enliven, through laughter, a joy and love of life that may be the basis for an ethical attitude antithetical to the violence that would have people killed. Just as, through his poetry, Dante wishes to draw the reader into a reflection as to what it may mean to act towards others with a sense of the inexplicable miracle every human being may be seen to be and of how one's understanding of truth is constantly redefined by every person one meets on one's way.

Most of this was explicitly brought to the fore by Benigni in his *lectura* of *Paradiso* XXXIII.[6] During the hour of political

[6] Benigni's appearance at San Remo, with its bringing Dante's poetry into primetime television, had met with great approval for the way it allowed Dante's lines to reach and touch a large popular audience without in any way being trivialised. His *lectura Dantis* proper met

satire preceding the reading of Dante, Benigni picked up a favourite theme of his – the sperm's fertilization of the ovum – as a means to have a go at Berlusconi and Italy's leading politicians. While doing so, Benigni also expressed, and called the audience to join in with his wonder at the fact that out of billions of sperm-cells only one should actually make it and that thus, as he put it, "siamo arrivati noi" [we got to get here]. One is reminded of *Purgatorio* XXV's account of human generation. Not, of course, as far as precise scientific detail is concerned, or because Benigni gives evidence of believing every human soul is created directly by God. It may be argued, however, that in saying that every human soul is created directly by God, Dante is doing nothing more than suggesting that inexplicable though the human condition may be, it is nonetheless the case that, in all their embodied particularity, all human beings may partake in the truth that human reason cannot fathom. As we are told in *Purgatorio* XXV, 103-05, they may do so, for Dante, by the way in which they speak, laugh and cry.[7] In the *Commedia* this finds

with an equally enthusiastic response. Benigni's efforts were praised by a number of scholars who saw Benigni's popularisation of the *Commedia* as fundamentally in line with the nature of Dante's text and who, above all else, were impressed by the quality of Benigni's recitation of the canto. It is surprising, however, that amidst the praise little was actually said about Benigni's interpretation of the text, about how this could contribute to one's understanding of Dante's poem, and about how Benigni's reading of Dante may relate to his understanding of his work as a comedian. Many of the reactions to Benigni's *lectura* did not, in these respects, take into account what may have been some of the most important driving impulses of the performance. See Di Stefano, "Nel mezzo del cammin".

[7] On the evidence of *De vulgari eloquentia* I, iii, we know that words are for Dante both rational and physical signs and that they are in this emblematic of what human beings are and the way that, given their embodied nature, they are to communicate. In line with this, *Purgatorio* XXV, 103-05, points to the fact that laughter and tears share in the psychosomatic nature of all human communication. See also Benigni, *E l'alluce fu* 83: "voce e corpo sono inscindibili. [...] 'Ci sono personaggi che sanno tutto e purtroppo questo è tutto quello che sanno'. Non ricordo chi l'ha detto [...] la voce è creazione, la lingua un

full theological expression in Dante's final vision of God (*Par.* XXXIII, 106-45); and Benigni makes clear in his *lectura* that in this at least he agrees with Dante: that because one exists, speaks, laughs, cries, one may partake in truth itself – even if, concerning truth, one may not actually be able to say much more than that.

In fact, Benigni says, this recognition should be the basis for one's coming to terms with Dante's text. Picking up one of the oldest and most important debates regarding the nature of the *Commedia*, Benigni says: "Dobbiamo credere [...] fermamente che Dante sia stato in inferno, in purgatorio e in paradiso. [...] Ma non perché Dio c'è, perché Dio ci sia" – Dante's aim, should not so much be seen as that of describing God, as that of inviting his readers to 'make God be'. For man's understanding of God, according to Benigni, ought to be based on the recognition that one somehow is the truth one cannot understand. As Benigni goes on to say – and in this he is close to Vittorio Sermonti's commentary to the *Commedia* (see, for example, vol. III, pp. viii-ix) – the theological value of the *Commedia* is to be found not in some objective meaning one could abstract from Dante's poetry, but in the relationship the reader may establish with Dante's text and, on the invitation of Dante's text, with others.

> I will now to try to talk you about this thing [*Paradiso* XXXIII]. If nothing happens, nothing happens. But if something happens within you, if something is moved, a spark, a start, then you are Dante, you are the poets, you are God. For one may talk about God only being God.

With one swift stroke, then, Benigni cuts across traditional discussions regarding the relationship in the *Commedia* between poetry and theology, his words putting to one side speculation as to the extent to which it is Dante's concern to make one believe things in the other world are actually as he describes them. For most such discussions are based on the presupposition that the

sistema di citazioni. Bisogna usare la voce come un commento musicale del corpo."

truth Dante wants to talk about in his poem is some objective reality about which, however imperfectly, man may attempt to talk about as objectively as anything else. And on the presupposition that, therefore, the relationship between poetry and theology in the *Commedia* will be seen to depend on how Dante would have seen his language to be descriptive of the objective reality 'God'. Yet, as Benigni's comments suggest, such discussions may be misleading insofar as they neglect the ethical dimension of Dante's theological enterprise. For, according to Dante, God is no objective or objectifiable reality and, as that love which moves the sun and the other stars, is beyond the reach of the human mind. As his final vision of God makes clear, this means that the human mind can properly understand what 'God' may mean by realizing that the face of God is in fact every human face; or, in other words, by realizing that, given the embodied particularity of every human person, one's understanding of truth is caught in a process of constant redefinition determined by one's interaction with others.

Dante may be seen, on the terms of Benigni's *lectura*, to be inviting the reader more than to agree with his theological doctrines, to read his text in the same way its narrative suggests one should meet other people, with an eye, that is, not to the answers it can give but to the questions it may invite one to ask. By foregrounding the sensuous as much as the intellectual features of language, and by foregrounding the *Commedia*'s particularity and provisionality, Dante invites one to see the text and truth claims of the *Commedia* as making their own the recognition that appreciation of truth rests on one's ability to recognize how one's understanding of truth will be questioned by one's meeting other people; how ultimately one can wonder at but not explain human personhood; and how truth itself consists in the communal relationships created by one's being ready to have another's will define one's own actions. On the terms of Benigni's *lectura*, one is not reading Dante's text aright unless one sees its meaning as lying in the ethical reflection it may engage one in.

To summarize thus far: Benigni seems to a great extent to share in Dante's idea of God – for both authors, ultimate truth

lies beyond the reach of the human mind and may be understood only in terms of the love one person may show for another. One could in fact say similar theological and ethical dynamics govern the work of Dante and Benigni. This is not to say that the two would agree on matters of doctrine. But the point is precisely that, on a certain understanding of truth, the aim of theology is seen not so much as that of reaching an agreement in matters of doctrine as that of revealing the extent to which one's understanding of doctrines is at every moment redefined in terms of the relationships one establishes with the people around oneself. So the fact that Benigni's work is not explicitly theological like Dante's may help one recover a sense of what it may mean to read the *Commedia* as a theological poem not with an eye to its encyclopaedic pretensions or doctrinal definitions, but with an eye to how these may be put into question by the fact that it is constitutive of human personhood that, as embodied beings, human beings should both laugh and cry; that they cannot ultimately explain why this is so; and that the best they can do is try to enjoy each other's company as much as possible in the playfulness of an understanding of community based on the recognition that, because one cannot explain the world, one cannot impose one's will on others either, for this would simply exacerbate the scandalous incomprehensibility of the reality of human suffering. I will not attempt to pretend that, as just outlined, there is full logical rigour in the above position regarding human existence. But I would argue that, in their different ways, both Dante and Beningi would say this is the only position that in fact makes any sense at all. As Benigni puts it:

> Evil prevails only when it is clothed in sacredness and is guided by an ideal. When four or five people gather around an idea to change the world, there lies fanaticism. Intolerance and racism introduce themselves promising paradise. But always end up losing themselves in a dark wood, like in fables. By laughing, one brings paradise to earth and the light of intelligence into the wood. (Benigni e Cerami, *La vita è bella*, 2nd ed. xiii)

If it didn't lie beyond the scope of the present essay, it would be interesting to explore the extent to which one may, on the lines sketched above, link Benigni's work to that of Primo Levi,[8] Rabelais,[9] Dostoevsky;[10] or to that of theorists such as Bakhtin,[11] Adorno,[12] Buber,[13] Fackenheim.[14] Let us stay,

[8] See Levi, *La ricerca delle radici*; *Conversazioni e interviste* especially 282-92; *L'altrui mestiere* 15-19, 46-48, 181-85. As the diagram which opens *La ricerca delle radici* shows, laughter, for Levi, is a bridge on which man may stand to find a meaningful existence even between the reality of suffering and the possibility of a godless universe. See also Levi, *Il sistema periodico* 146. Talking about his friend Alberto, Levi says: "Un suo gesto, una sua parola, un suo riso, avevano virtù liberatoria, erano un buco nel tessuto rigido del lager, e tutti quelli che lo avvicinavano se ne accorgevano, anche coloro che non capivano la sua lingua. Credo che nessuno, in quel luogo sia stato amato quanto lui." For ethics in Levi's writing, see Gordon, *Primo Levi's Ordinary Virtues*.

[9] One may take the lead from Levi, *L'altrui mestiere* 18-19: "Gigantesca sovra ogni altra cosa è la capacità di gioia di Rabelais e delle sue creature. Questa smisurata e lussureggiante epica della carne soddisfatta raggiunge inaspettatamente il cielo [...]: poiché l'uomo che sente gioia è come quello che sente amore, è buono, è grato al suo Creatore per averlo creato, e perciò sarà salvato. [...] Rabelais conosce la miseria umana; la tace perché, buon medico anche quando scrive, non l'accetta, la vuole guarire: 'Mieulx est de ris que de larmes escrire/Pour ce que rire est le proper de l'homme'". For the influence of *Gargantua* on Benigni's early work, see Celli, "Cioni Mario".

[10] See, for example, bk 5, chs 4-5 and bk 6 of *The Brothers Karamazov*

[11] For an examination of the relevance of Bakhtin's work for an appreciation of Benigni's comedy, see Celli, *The Divine Comic*. The perspective offered in the present essay should be seen as complementary to the one offered by Celli. For a broader discussion of the implications of Bakhtin's work for reflection on representations of the Shoah, see Des Pres, "Holocaust *Laughter*?".

[12] In Adorno and Horkheimer, *Dialectic of Enlightenment* 140-41, the focus of attention is laughter of the "wrong kind", which may be seen as opposed to the kind of joyful laughter I am arguing is central to Benigni's work. Later in the same work, a link is drawn between the 'wrong', essentially derisive, kind of laughter and anti-Semitism (184-

however, with Benigni and Dante so as to put some flesh on remarks made so far. The best starting point for doing so are the lines which inaugurate Dante's final vision of God:

> Omai sarà più corta mia favella,
> pur a quel ch'io ricordo, che d'un fante
> che bagni ancor la lingua a la mamella. (*Paradiso* XXXIII, 106-14)

[Now my speech will come more short even of what I remember than an infant's who yet bathes his tongue at the breast.]

These lines played a very important role in Benigni's *lectura*, constituting as they did the climax of Benigni's continual returning to the idea that one will learn how to love properly if one is ready to relate to the world around oneself as a child. In commenting on the above lines, Benigni emphasized the notion that, given the human mind's inability to comprehend God, the proper language in which to talk about God is as that of an infant who is yet to learn how to speak, and that the proper way to say 'God' is via the as yet inarticulate sounds voiced by an infant (which Benigni comically imitated). In the light of the perspective outlined above, this points to the idea that in redefining one's grasp of truth every new encounter requires one to learn how to speak anew, and to the idea that one may not therefore be as presumptuous as not to be willing to allow others define the way one speaks, one acts.

85). This is significant as it points to how laughter itself may horribly be integral to the ideological structure sustaining the Shoah. (One is reminded of Levi's notion that concentration camps were "una grande macchina per ridere di noi", *Se questo è un uomo* 21.) In Adorno, *The Culture Industry* 82, laughter of the positive kind is conversely referred to as "the most living thing" about the human person. In this respect, see also Adorno, "Chaplin Times Two".

[13] See, for example, Buber, *I and Thou*.

[14] See Fackenheim, *To Mend the World*.

The importance of the above lines in the *Commedia* may not be overestimated. They bring to completion a reflection sustained at least since *Inferno* XXXII:

> [...] non è impresa da pigliare a gabbo
> descriver fondo a tutto l'universo
> né da lingua che chuami mamma o babbo (7-9)

> [to describe the bottom of all the universe is no enterprise
> to undertake in sport or for a tongue that cries *mamma*
> and *babbo*.]

In glossing these words, commentators have, for the most part, concentrated on how *Inferno* XXXII, 9 may be related to the *De vulgari eloquentia* and be indicative of Dante's stylistic concerns. The above lines, however, inaugurate the episode that will lead to Dante's encounter with Ugolino; and this points to how reflection on them cannot leave aside ethical considerations. For *Inferno* XXXII's "lingua che chiami mamma o babbo" is qualified by the cries of *Inferno* XXXIII, 61-63, 69:

> Come un poco di raggio si fu messo
> nel doloroso carcere, e io scorsi
> per quatro visi il mio aspetto stesso,
> ambo le man' per lo dolor mi morsi;
> ed ei, pensando ch'i' il fesse per voglia
> di manicar di sùbito levorsi
> e disser: "Padre, assai ci fie men doglia
> se tu mangi di noi: tu ne vestisti
> queste misere carne, e tu le spoglia".
> Queta'mi alor per non farli più tristi;
> lo die e l'altro stemmo tutti muti;
> ahi dura terra, perché non t'apristi?
> Poscia che fummo al quarto die venuti,
> Gaddo mi si gittò disteso ai piedi,
> dicendo: "Padre mio, ché non m'aiuti?"
> Quivi morìo; e come tu mi vedi,
> vid'io cascar li tre ad uno ad uno
> tra 'l quinto dìe e 'l sesto; ond'io mi diedi,
> già cieco, a brancolar sopra ciascuno,

e due dì li chiamai, poi che fuòr morti;
poscia, più che 'l dolor, potte 'l digiuno.[15] (*Inf.* XXXIII,
55-75)

[As soon as a little ray made its way into the doleful prison and I
discerned in four faces my own look, I bit both my hands for grief;
and they, thinking I did it from a desire to eat, rose up suddenly
and said: 'Father, it will be far less pain for us if thou eat of us.
Thou didst clothe us with this wretched flesh and thou strip us of
it." I calmed myself then, not to make them more unhappy. That
day and the next we stayed all silent. – Ah, hard earth, why didst
thou not open? – When we had come to the fourth day Gaddo
threw humself outstretched at my feet, saying: 'My father, why
dost thou not help me?" There he died, and, as thou seest me, I
saw the three drop one by one during the fifth day and the sixth;
therefore I gave myself, now blind, to groping over each and for
two days called on them after they were dead. Then fasting had
more power than grief.]

The first of the above *terzine* recalls Dante's final vision of God.
Ugolino's face is the face of his sons – "aspetto stesso". But
Ugolino is not able to realize the extent to which this "aspetto"
may be constitutive of truth and refuses to recognize that one
may speak, act, even when faced with the reality of death; to
recognize, that is, that ethics does not die with suffering. True,
the only thing one may be able to do is cry to one's father for
help one knows cannot be delivered while, at the same time,
recognizing the reality of death may be countered by one's being
ready to suffer death for another. Yet, as the lines just quoted
suggest, this is the only response that may be in line with the
fact that, according to Dante, truth lies in all human faces, in
every person; and that every person, a suffering as much as
joyful one, requires one to learn how to act appropriately before
him or her.

Ugolino says he refused to speak so as not to cause more
suffering in his children, his decision implying that nothing he
could say could ultimately be more than an expression of their

[15] For Benigni's comments on his own recitation of *Inferno* XXXIII
see Celli, *The Divine Comic* 145.

impending death. With his decision, however, Ugolino undermines the possibility of establishing a relationship with his sons that may be an assertion of the fact that death is not the only side to human existence. For Ugolino, as for all the souls of *Inferno*, the self is self-defining and the world and other people do not call into question one's own personhood or define one's understanding of that personhood in terms of the fact that one may offer to suffer death for another. The description of hell is not a task for a mummy-or-daddy-calling-language because from the perspective of hell such a notion is ultimately meaningless. So as Ugolino, faced with his and his children's impending death, cannot bring himself to speak or understand it.

In *Purgatorio* and *Paradiso* Dante makes clear that the *Commedia* ultimately aims to reverse an 'infernal' understanding of language and ethics as just outlined. At present, however, I would like to let discussion on Ugolino lead into discussion on *La vita è bella* and *Pinocchio*. Alongside its critical acclaim, *La vita è bella* has been criticized on the grounds that by bringing laughter into a concentration camp Benigni presents a distorted picture of what life was like inside the camps, disrespectful to the memory of those who in camps suffered and died. That Benigni presents a distorted picture of life in the camps is clear. Benigni, however, is himself the first to insist that no pretensions to the contrary should be advanced on the film's behalf.[16] The crucial idea, for Benigni, is that a film like *La vita è bella* may in its very fable-like character, help one better understand the perverse ethical dynamics that made concentration camps possible – and enliven a kind of laughter antithetical to those dynamics (Benigni and Cerami, *La vita è bella* xi). We find again that for Benigni laughter is one of the ways in which to counter the Hitlers of this world; as a certain

[16] For detailed discussions on *La vita è bella*, see Celli, "Interview with Marcello Pizzetti"; Celli, *The Divine Comic*; Lazoni, "*Life is Beautiful*"; Marcus, "'Me lo dici babbo che gioco è'"; Viano "*Life is Beautiful*". For a reading of the film which calls into play theological dynamics consonant to the ones discussed in this essay, especially in relation to the Jewish tradition, see Ezrahi, "After Such Knowledge".

kind of laughter may enliven a joy of life at one with respect for the life of others.

This may sound rather too nice and simple, naïve perhaps. Part of what Benigni wishes to do, however, is point to how danger may arise when one is no longer able to see the full strength of the ethical implications of such a simple concept. In the preface to the screenplay he reminds us that he chose the title, *Life is Beautiful* because, though it seems a trite phrase, it means precisely what it says: our life is beautiful. Even in moments of great distress that phrase shatters th rib cage, embraces the heart, makes the world appear sweeter (vi). Even Primo Levi painfully writes in *Se questo è un uomo*: 'I thought life outside was beautiful and would continue to be beautiful' (vi). Benigni's daring, fable-like and clearly non-historical move is that of bringing the beauty of life *inside* the camp. And in so doing, he is bringing into play ethical dynamics inversely comparable to those of the Ugolino episode. Benigni almost says as much when he explains that, "precisely because in concentration camps children were systematically murdered, Guido tries, until being killed, comically to protect his son Giosuè" (Benigni and Cerami vi). *La vita è bella* could thus be seen as Benigni's way both of responding to and of making his own the cries of *Inferno* XXXIII, 61-3 and 69. In other words, precisely because human beings were capable of creating camps in which children were systematically killed and in which actions like Guido's would clearly have been unthinkable, one ought, according to Benigni, to recognize that death is not the only side of human existence; that this is so because one human being may be ready to suffer for another; and that comedy which is in line with this should not be seen as disrespectful to the memory of suffering as it aims to foster an ethical attitude antithetical to that which makes concentration camps possible.

That Benigni's comic art is governed by the ethical outlook outlined above, is also suggested, albeit with very different overtones, by *Pinocchio*. Given what has been said so far, it comes as no surprise, for example, to see how Benigni reflects on chapter XV of *Le avventure di Pinocchio*:

Anyone would realize that the Cat and the Fox are the assassins, but not Pinocchio, who is purity personified. They suddenly promise Pinocchio all manner of riches and just as suddenly hang him. They hang him to the oak tree at night and he remains hanging there just like a puppet. Collodi originally ended his story here. Pinocchio had come in the world to make people happy, and people immediately hanged him. His last words are those of Our Lord translated into Tuscan: 'Daddy, daddy, why aren't you here?'. These are things that shatter the heart. (Benigni, *Io un po Pinocchio* 103).

Once again, we find Benigni emphasizing the juxtaposition of joy and suffering; and, again, we have a daddy-calling voice indicative of the darkness of world.[17] Moreover, as Benigni's comments on his film make clear, *Pinocchio* too aims to point to the fact that darkness ought not to be given the last word. As Benigni understands it, Collodi's story too may point to the understanding of human existence outlined above.

Take Benigni's comments on Pinocchio's running:

Pinocchio is always running, he runs, runs, one doesn't know towards what, he runs, runs, through all the valleys of the world, everyone wants to stop him. Every now and then he meets some challenges, surpasses them, forgets them and keeps on running. In his continuous running, Pinocchio is looking for happiness. It is not important to find happiness, it is important to look for it. Looking for happiness is like looking for truth, the one supreme act. Pinocchio is a character who is seeking: he doesn't know exactly what but he is seeking it with a vigour which is also gladness, the sweet gladness of the act of seeking. (Benigni, *Io un po Pinocchio* 38).

[17] In line with what has been said so far and with Benigni's comments in the *lectura* on the relationship between religions, one can see the reference to the 'tuscanization' of Psalm 22.1 and Matthew 27.46 pointing once again to an understanding of human nature in which ethical considerations take precedence over religious and doctrinal definition and difference.

In the light of what has been said so far, nothing I could say could comment on these lines better than *Purgatorio* XVI, 85-93:

> Esce di mano a lui che la vagheggia
> prima che sia, a guisa di fanciulla
> che piangendo e ridendo pargoleggia,
> L'anima semplicetta che sa nulla,
> salvo che, mossa da lieto fattore,
> volontier torna a ciò che la trastulla.
> Di picol bene in pria sente sapore;
> quivi s'inganna, e dietro ad esso corre,
> se guida o fren non torce suo amore.

[Form His hand who regards it fondly before it is, comes forth, like a child that sports, tearful and smiling, the little simple soul that knows nothing, but moved by a joyful Maker, turns eagerly to what delights it. At first it tastes the savour of a trifling good; it is beguiled there and runs after it, if guide or curb do not divert its love.]

'[P]iangendo e ridendo pargoleggia' speaks for itself. Both in the *Commedia* and in *Pinocchio*, moreover, we find that, through the figures of Beatrice in the former and the Fata and Geppetto in the latter, a similar sense of direction is suggested for one's 'pargoleggiar' and for Pinocchio's running.[18]

About the Fata, Benigni says: "She sheds light on death [...] she knows that none of us will be happy, but that we have the duty to look for happiness [...] she wants to educate [Pinocchio] but loves him when he is not educated. She has to save him but loves him when he is lost" (*Io un po' Pinocchio* 113-14). And about Pinocchio's relationship to the Fata: "Pinocchio finds out the most ancient thing in the world: one cannot be happy. But Pinocchio is happy for a moment, and a lot, when he realizes that the Fata loves him very much" (*Io un po' Pinocchio* 241). A sense of direction to Pinocchio's running is increasingly given in

[18] For a study of the relationship between *Le avventure di Pinocchio* and the *Commedia*, see Risset "Pinocchio e Dante".

Pinocchio by the fact that he realizes he is loved as he is; and that both Geppetto and the Fata may be ready to die for his sake.[19] It is perhaps no coincidence that the inscription on the Fata's tomb is altered in Benigni's film with respect to Collodi's original as if to emphasize the fact that Pinocchio is the cause of the Fata's death (*Io un pò Pinocchio* 152-58). One also thinks here of how the cantos of Earthly Paradise reveal that, for Dante, the possibility for one's 'pargoleggiar' properly to be directed rests on one's ability to have one's actions defined by the will of those who could lovingly be one's guide.[20]

Related to all this is the way Benigni sees Pinocchio's search for happiness and truth as inseparable from a particular understanding of poverty:

> Pinocchio is poor, but poverty is the mother of all riches. Pinocchio's poverty is a fable-like poverty which at the same time is real, really real. [...] Geppetto sells his jacket so as to be able to buy a grammar book for Pinocchio, he remains naked for his son. [...] Poverty is a condition of the soul. Pinocchio has nothing yet owns everything. In him there is the magnificence of poverty. (*Io un po Pinocchio* 56-57).

For Benigni poverty not only pertains to the material but also to the ethical and intellectual spheres of human existence.[21]

[19] It is interesting to note that, somewhat against traditional interpretations, Benigni does not read the figure of Lucignolo as essentially 'bad', and sees him at one with Pinocchio: 'È l'altro Pinocchio, ma non l'altra faccia, è la stessa faccia di Pinocchio, senza la Fata turchina!' (*Io un po' Pinocchio* 203) For an opposite reading of Lucignolo, see Pierotti, "Ecce puer" 35.

[20] It is probably no coincidence, therefore, that both in the *Commedia* and in *Pinocchio* the moment the protagonists are reduced to child-like sobbing in recognition of their faults before a person that would lovingly guide them coincides with a moment in which their identities may safely be stated. See *Purgatorio* XXX, 55-66 and the scene in the film based on *Le avventure di Pinocchio*, XXIII. See also Risset, "Pinocchio e Dante" 96.

[21] For Benigni on his childhood poverty, see, for example, Benigni and Cerami, *La vita è bella*, 2nd ed. xxii

Poverty here means the ability to love and enjoy the world and others without attempting to possess or explain them. It is the precondition for "la letizia soave della ricerca" (the sweet gladness of the act of seeking) embodied in Pinocchio's "running". And, to come full circle, I would like to conclude with the idea that in his understanding of poverty too Benigni is close to the *Commedia*. For even in Dante there is an intertwining of poverty as pertaining to the material, the intellectual and the ethical spheres of human existence. The reflection on poverty in the context of *Paradiso* X-XIV, for example, could allow one to argue that for Dante a particular understanding of bodily and material dispossession may be the basis for understanding aright the relationship between one's pursuit of truth and one's enjoying having one's actions constantly defined by those of people who have opinions different from one's own. To the same end, however, one could also pick up that most important of themes in Dante's writings which is exile. This is precisely what Benigni does in words that seem to display the "correre" characteristic of his Pinocchio and with which I would like to end:

> When I was a child my mother always used to tell me: "If you tell lies your nose will grow long like Pinocchio's and then Dante Alighieri will put you in hell!" So when one day I saw a statue of Dante and saw his big nose I thought that *he* was Pinocchio. I then found a passage in the *Convivio* which says: "Truly I have been a piece of wood without guidance carried along by painful poverty". How much more Pinocchio could one get?! (*Io un pó Pinocchio*, See *Convivio*, I iii.5).

Works Cited

Adorno, T. "Chaplin Times Two." *The Yale Journal of Criticism* 9 (1996): 57-61.

---. *The Culture Industry: Selected Essays on Mass Culture*. Ed. J M Bernstein. London: Routledge, 1991.

Adorno, T, and M Horkheimer. *Dialectic of Enlightenment*. Trans. J Cumming. London: Verso, 1986.

Alighieri, D. *La Divina Commedia*. Ed. V Sermonti. 3 vols. Milan: Mondadori, 1996.

Benigni, R. *E l'alluce fu*. Turin: Einaudi, 1996.

Benigni, R and V Cerami. *La vita è bella*. 1st ed. Turin: Einaudi, 1998.

---. *La vita è bella*. 2nd ed. Turin: Einaudi, 1999.

Buber, M. *I and Thou*. Trans. W Kaufmann. Edinburgh: T&T Clark, 1970

Celli, C. "Interview with Marcello Pizzetti." *Critical Inquiry* 27 (2000): 149-57.

---. "Roberto Benigni and the *Cioni Mario di Gaspare fu Giulia* Monologue." *Italica* 77 (2000): 171-86.

---. *The Divine Comic: The Cinema of Roberto Benigni*. Lanham. Maryland and London: The Scarecrow Press, 2001.

Des Pres, T. "Holocaust *Laughter?*" *Writing and the Holocaust*. Ed. B Lang. New York: Holmes and Meier, 1988.

Di Stefano, P. "Nel mezzo del cammin venne Benigni." *Corriere della Sera* 8th January 2003: 33.

Ezrahi, S. "After Such Knowledge, What Laughter?" *The Yale Journal of Criticism* 14 (2001): 287-313.

Fackenheim, E. *To Mend the World: Foundations of Post-Holocaust Thought*, 2nd ed. New York: Schocken, 1989.

Gordon, R. *Primo Levi's Ordinary Virtues: From Testimony to Ethics*. Oxford: Oxford University Press, 2001.

Io un po' Pinocchio: Roberto Benigni racconta il suo film tra le pagine del romanzo di Collodi. Florence: Giunti, 2002.

Lanzoni, R. "*Life is Beautiful*: When Humour Challenges History." *Forum Italicum* 34 (2000): 121-35.

Levi, P. *Conversazioni e interviste 1963-1987*. Ed. M Belpoliti. Turin: Einaudi, 1997.

---. *Il sistema periodico*. Turin: Einaudi, 1994.

---. *L'altrui mestiere*. Turin: Einaudi, 1998.

---. *La ricerca delle radici*. Turin: Einaudi, 1989.

---. *Se questo è un uomo e La tregua*. Turin: Einaudi, 1989.

Marcus, M. "'Me lo dici babbo che gioco è?' The Serious Humour of *La vita è bella*." *Italica* 77 (2000): 153-70.

Montemaggi, V. "'La rosa in che il verbo divino carne si fece': human bodies and truth in the poetic narrative of the *Commedia*." *Dante and the Human Body*. Eds. J C Barnes and M Sonzogni. Dublin: Four Courts Press, for the UCD Foundation for Italian Studies, Forthcoming.

Pierotti, G L. "Ecce puer (il libro senza frontespizio e senza indice)." *C'era una volta un pezzo di legno: la simbologia di Pinocchio. Atti del Convegno organizzato dalla Fondazione nazionale Carlo Collodi di Pescia.* Milan: Emme Edizioni, 1981.

Risset, J. "Pinocchio e Dante." *C'era una volta un pezzo di legno.*

Viano, M. "*Life is Beautiful*: Rception, Allegory and Holocaust Laughter." *Annali d'Italianistica* 17 (1999): 155-72.

Benigni's *Pinocchio,* or The Tale of a Failed National Icon

Rebecca West

Nations have symbols and icons, both official and unofficial, that are readily recognizable in the international context. Most obvious and widespread are flags, but there are also national birds, flowers, songs, myths, and figures. The United States has Uncle Sam, the eagle, the Stars and Stripes, and the Statue of Liberty; France has the "Marseillaise," the "Marianne," and the Eiffel Tower; and Italy has (officially) the national saints Francis and Catherine of Siena (although not many non-Italians would think of them as Italian national icons), and, unofficially, the Leaning Tower of Pisa, "O Sole Mio," Dante, and Pinocchio. If Uncle Sam's appearance has changed little, if at all, over the years, the French Marianne has been embodied in several "most beautiful "French women, according to the tastes of the era, such as Brigitte Bardot, Catherine Deneuve, and Laetitia Casta, just as Pinocchio has been represented in many different ways since the story was first written and illustrated in the early 1880s, although Disney's cartoon Pinocchio may still be the most universally recognized version of the mischievous little puppet. Several actors have played Pinocchio over the years in stage and cinematic versions of the tale, but no one human has become associated with Pinocchio. The animated figure created by Disney's workshop has a universal appeal, just as the classic long-nosed wooden statues, toys and puppets that one finds all over Italy for the delectation of tourists and natives alike is fairly established as the "real thing." Then came Roberto Benigni.

Roberto Benigni has many reasons for associating himself with Pinocchio. He was born in Tuscany, near Arezzo, not far from Pinocchio's "father" Collodi's homonymous place of maternal origin. Because of his comically childlike and often naughty antics on stage and screen, he was already associated with Pinocchio in his native land long before he made his film version of Collodi's classic. It was not until his performance at

the 1998 Academy Awards ceremonies when his film, *La vita è bella (Life is Beautiful)*, won awards for Best Foreign Language film, Best Actor and Best Score, however, that American, indeed, international, audiences could readily see the similarities between the man and the puppet. He leapt, puppetlike, over the seats to reach the stage in the Los Angeles auditorium, from which he delivered an acceptance speech that could not have been more "Pinocchio-esque," ranging as it did from virtually incomprehensible babbling to poetically heartfelt outpourings of gratitude. Having already worked with Giuseppe Bertolucci on a production of Pinocchio's story in the 1970s, Benigni returned to the tale after the success of *La vita è bella*, to the delighted anticipation of Italian critics and general audiences alike. It seemed inevitable that the scamp Roberto would make his own film version of the wooden scamp's adventures, and inevitable too that he would play the puppet. Success appeared to be assured. Appearances deceive, however, as Benigni was to learn upon the release of the film in 2002.

In this essay, I want to explore some possible explanations for the failure of Benigni's film. Why did a film that tells a well-loved and universally known story, that has scenes of real beauty, that stars one of Italy's most hailed comic masters, fail so miserably, especially in the United States? After a pre-release buildup of gigantic proportions and unlike any that an Italian film had ever enjoyed before, Miramax, which poured enormous distribution resources into the film, and which is itself a gigantic production and promotional machine, must have felt the sting of failure as much as the film's creator and star. My contention is two-fold: first, that the film's lack of success may be tied to factors external to the film itself, and, next, that there are some factors that are traceable to Benigni's intentions and to the subsequent choices he made that conditioned elements within the film. Specifically, I am interested in Benigni's obvious desire to pay homage to an Italian national icon, the wooden puppet Pinocchio, but I am also interested in the consequences of what was perhaps his equally strong desire to solidify his own iconic status as a living embodiment of Italy around the world; in short, his desire to become today's Pinocchio once and for all.

In seeking to "embody" Italy in the guise of the puppet, Benigni was reaching for more than onscreen success as an actor and director. His intention and goal had political and socio-cultural implications that far exceed the making of one film. I want to suggest that it may well have been this overreaching that helped to doom the film, in conjunction with other factors that can be teased out of the entire "pasticciaccio brutto" of Benigni's spectacular failure. The fiasco of his Pinocchio is even more striking, following as it did on the heels of the spectacular success of *La vita è bella*, yet it may be that the controversy surrounding the latter ultimately had something to do with the fundamentally negative reception of the former. It is from the tangle of these hypothetical propositions that I seek to find some threads that can be woven into what I hope will be at the very least a possible way of understanding just what went wrong with a project that should have been so right.

Italians themselves often see their collective identity reflected in the puppet Pinocchio, as numerous articles appearing before and after the release of Benigni's film make very clear. I shall have more to say about this shared national appropriation of the figure of the puppet, but first I want to discuss Benigni's personal and very specific attachment to Pinocchio. In an extensive interview (one among many) with Eugenio Scalfari, the editor of *La Repubblica*, Benigni talked at length about his persistent love for the puppet's tale, which began when he was a young boy. When Roberto was a child, his parents did not read the tale to him, nor did he himself read Collodi's story until he was twenty years old, because his mother was illiterate; as he responded to Scalfari when asked when it was that he first read Collodi: "Beato te che avevi i genitori che sapevano leggere! La mia mamma invece non sa leggere ma da piccino mi diceva sempre: 'se dici le bugie ti si allunga il naso come a Pinocchio e poi Dante Alighieri ti mette all'inferno!'" (Lucky you to have had parents who could read! My mama instead is illiterate but when I was very small she would always say to me: if you tell lies your nose will grow long like Pinocchio's and then Dante Alighieri will put you in hell!; in "Vi racconto il mio *Pinocchio*," at www.larepubblica.it.)

Benigni has asserted many times, in many journalistic venues, how much he subsequently wanted to do a film version of *Pinocchio*:"Ogni volta che finivo un film dicevo: 'Oh! Ora faccio *Pinocchio!* '" (Every time I finished a film I would say: Oh! Now I'll do *Pinocchio!*; in Borsatti, 10). The childhood memories and the Tuscan connection are obvious, therefore, as is the appeal of the figure to Benigni's brand of physical humor, depending as it does in great part on his lanky, puppetlike body and his penchant for disarticulated movements, climbs, and leaps. He expressed as well a serious sense of the deeper attractions of the tale, which is also a "myth" about the joys of transgression and the unfindability of complete happiness:

> "Pinocchio è la gioia, la spensieratezza, il dolore, la felicità, l'illusione, la libertà, la fantasia, la cattiveria, la purezza, l'esuberanza, e via e via. . . come tutti i miti porta con sé un conflitto irrisolubile, disintricabile e il più antico del mondo: non si può essere felici" (Pinocchio is joy, the carefree, pain, happiness, illusion, freedom, fantasy, wickedness, purity, exuberance, and so on and so on. . .like all myths it carries within itself a conflict that is the most ancient, irresolvable and impossible to disentangle: one cannot be happy; Borsatti, 10 passim.)

As in the case of his love for Dante's great poem, here too Benigni has gone beyond a merely superficial or sentimental attachment to Collodi's story, and has done serious reading about it, has thought about its complex message, and has much more than a widely shared affection for the puppet scamp. It must be true, also, that being knicknamed "Pinocchio" by friends and associates, including Fellini and Giuseppe Bertolucci, has contributed to his strong identification with this particular figure of Italian literary and popular culture.

Just as *Life is Beautiful* is a work of bricolage, made up of bits and pieces of what Victoria Kirkham has termed Benigni's "storehouse of culture" (see Kirkham's essay in this collection) that draws upon both high and popular cultural sources, so too his attraction to the puppet's tale may also be the result of the

strong association that Benigni makes between Italy's "highest" cultural icon, Dante Alighieri, and Pinocchio, who remains more linked to popular and mass culture, in spite of the seriousness with which the literary institution has taken the tale. Benigni loves hybridity, as is evident in so much of his work; what better hybrid than Dante and the puppet? In the *La Repubblica* interview, he tells the story of how, when seeing for the first time Dante's statue in front of Santa Croce in Florence, "con quel naso che si ritrovava pensai che Pinocchio fosse lui. Poi ho trovato una frase nel *Convivio* che dice: 'Veramente io sono stato legno senza governo portato dalla dolorosa povertade.' Più Pinocchio di così!" (with that nose that you find there again, I thought that he [Dante] was Pinocchio. Then I found a sentence in the *Convivio* that says: "Truly I have been wood [a boat] without a captain, carried along by painful poverty." Can you get more Pinocchio than that! in www.larepubblica.it). Benigni also cites the Bible, Kafka, Shakespeare, Croce, Manganelli, and other luminaries of high culture in discussing the tale, and his desire to film it. He takes his Pinocchio very seriously, tying it in, to be sure, with its fairy tale qualities and its appeal to the child in us, while showing that, for him, the puppet is indeed a national icon on a par with Dante himself.

In this and other pre and post-release interviews and articles on the film, Benigni's aim was, at least in part, to emphasize Pinocchio's status as a national icon; in doing so, he was, of course, elevating himself as today's embodiment of the puppet. I would suggest that, in making his film, Benigni sought to reclaim the tale for Italy on the world scene, wrestling it out of the Disney stranglehold that has so strongly held international audiences in its grasp for decades, and back into a more faithful, more Italian version that would have the power to replace the Americanized cartoon version in the international collective consciousness. Benigni stated in an interview with Curzio Maltese, published in *La Repubblica* on October 19, 2002, after the October 11 release of the film, that he was proud to have brought to the world "una storia che più italiana non si può, con tutti i sentimenti italiani, piena di uno sberluccichio che appartiene soltanto a noi e che spero si sdipani dappertutto" (a

story that could not be more Italian, with all the Italian
sentiments, and full of a kind of humor that belongs to us alone
and that I hope spreads out everywhere; 40). And, in playing
Pinocchio, Benigni's own person became a sort of synecdoche
for the Italian body politic, for the "Italianness" that he wished
would spread throughout the world. If this was in fact his goal, it
was, however, drastically undercut by Miramax's last minute
decision to dub the film with American actor's voices and to
release it as a Christmas season children's movie, a decision no
doubt brought on by the less than spectacularly positive
response elicited in the fall of 2002 upon the film's Italian
opening. Italy had been in a Pinocchio frenzy for months before
the film's debut, and the buildup to it augured a masterpiece
equal to, if not surpassing, *La vita è bella*. An aura of secrecy
surrounded the film-in-progress, about which Benigni had
purportedly required a vow of silence from everyone involved in
the production. An article appeared in *The New York Times* on
October 11, 2002, the date of the film's opening in Italian
theaters, entitled "Pinocchio Infatuates Italians (And That's No
Lie)." Writing from Rome, Frank Bruni reports that "his
[Pinocchio's] likeness is everywhere. . .With the imminent
release here of a new live-action movie of 'Pinocchio' by the
Italian superstar Roberto Benigni, Italians are in a kind of
Pinocchio swoon, attended by a degree of Hollywood-style
hoopla and synergistic merchandising that no homegrown movie
has previously spawned" (A4).

Both before and after the release of the film in Italy,
newspapers and magazines were filled with articles about
Benigni's career and about the original story of Pinocchio, and
the connection between the actor and the puppet was thus
reinforced, reiterated, and fixed in the public's perception.
Benigni himself said that the film was his *Otto e mezzo:* "Mi
perdoni l'esagerazione, voglio dire che è il film più
autobiografico della mia vita" (Excuse the exaggeration, I mean
that it is the most autobiographical film of my life; in Maltese,
41). Yet, in spite of all the positive anticipation and the
collective affection for and pride in their successful native son,
Italian audiences were lukewarm about the film, and critics were

polite but diffident in extending their praise. Some were concerned that Benigni had "gone to bed" with Berlusconi by using the latter's company La Medusa as co-distributor (with Cecchi Gori) of the film, seeing this as just one sign that Benigni the anarchist had been replaced by Benigni the high stakes wheeler and dealer. Some declared that he was just too old (fifty) to play the puppet, and some thought that the film was too ploddingly faithful to Collodi's story while others thought that Benigni tried to update it too much. No critic was unequivocally positive about the long-awaited "masterpiece."

If Italy did not swoon collectively over what had clearly emerged as a disappointment, the United States went much further in its negative response to the film. Benigni's *Pinocchio* opened in American theaters for the Christmas season, 2002, to little fanfare and relatively small and unimpressed audiences. Critical hatchet jobs on the film sealed its fate, and it soon disappeared from theaters. A representative sample of the sarcastic, even vitriolic, critical prose to be found in the American press is Elvis Mitchell's piece in *The New York Times* of December 26, 2002. Even the benevolent spirit of the holiday season had no tempering effect on Mitchell, who wrote that the film was "sneaked into theaters" with "voice-overs, which are so sloppy you might feel as if you're watching a 1978 Hong Kong action picture: the dubbed mouths of the Italian cast are probably still moving an hour after the film is over." Mitchell is just getting going with this opening critique of the dubbing, however. (In an interview done for Tele+bianco that was broadcast on October 11, 2002, the day of the film's release in Italy, but published the day before in *La Repubblica*, Benigni says that he intends to do the English dubbing of Pinocchio's voice himself, but this plan obviously did not work; Grieco; 42.) Dripping with sarcasm, the review next states that "Geppetto doesn't get out much, because his idea of a child is a 40-ish man with a receding hairline, pancake makeup and 5 o'clock shadow: the Pinocchio he fashions is Mr. Benigni." He calls Pinocchio's words (voiced by Breckin Meyer) a "constant bleating," the movie "a chunk of pine," and "so bad that it quickly enters the pantheon of wreckage that includes 'Battleship Earth' and

'Showgirls.' " Pulling no punches, Mitchell wonders what is sadder, "Geppetto's belief that Pinocchio is a child puppet or Mr. Benigni's need to play one. When he affectionately smooches Geppetto's face, it's like Jack playing out one of his outré fantasies on 'Will and Grace'." He ends this devastating review by calling the film "an oddity that will be avoided by millions of people," adding that "Osama Bin Laden could attend a showing in Times Square and be confident of remaining hidden." (All quotations from Mitchell, B5.) This review shows little understanding of the original Collodi tale, and it makes reference almost exclusively to Anglo-American popular and film culture ("Will and Grace," Diana Ross in "The Wiz," Siouxsie of the group the Banshees, and so on), nor does Mitchell say anything about Benigni's past award-winning achievements in filmmaking. It is an extremely harsh and unforgiving review that makes a bad joke of Benigni's beloved project and, implicitly, of the Italian classic at its base. The Italian public's affection for Benigni and the collective pride in his accomplishments on the international scene no doubt kept critics from blasting him in his native land, but no such affection or pride conditioned the response in the United States. Nor is Pinocchio felt to be a beloved part of our cultural inheritance; rather, the puppet is just one of many characters from children's books and cartoons, a long-nosed scamp who is cute enough, at least in Disney's version, but perhaps not anywhere as cute as Mickey Mouse, or as delightfully mischievous as Bugs Bunny. So, in 2002 in America, Benigni's triumph of a few years before with *Life is Beautiful* has been forgotten, Pinocchio's tale has little resonance with viewers, and the film sinks into ignominious oblivion. *Sic transit gloria mundi.*

Counting no doubt on the success he had enjoyed in recent years in the United States and even internationally, Benigni gave himself over to a mega-million dollar film project, for whose extra-Italian distribution rights a record seven million dollars were paid by the gigantic corporation known as Miramax. The actor-director pumped 45 million Euros of his own Melampo fiilmmaking company's resources into the film. Some additional material facts about the making of the film show very clearly

what an enormous undertaking it was. Eight months were spent constructing sets in an ex-chemical plant in Umbria. Shooting went on for twenty-eight months; one hundred fifty artists, two hundred seventy technicians, one thousand pairs of shoes, four hundred seventy seven toys manufactured for the *Paese dei Balocchi* scenes; and on and on. It was the most expensive Italian film ever made, according to Maurizio Torroni, from whose October 13, 2002 article in the magazine *Famiglia cristiana* I gleaned these statistics.

As early as May, 2002, Tullio Kezich wrote a short piece for *Corriere della Sera*, in which he reports on a phone conversation he had with Benigni, who was struggling with the problems of editing down a three-hour print into a more manageable and marketable two hour film, a not surprising fact given the very high number of takes reportedly filmed for each scene. As I have already mentioned, pre-release publicity was intense, even relentless, and the film project was the occasion for numerous ruminations on Collodi's tale, on past film versions of it, on Benigni's rise to fame, and on the ways in which Pinocchio is an emblematically Italian figure who embodies essential qualities of the Italian populace. The October 3, 2002 number of the popular news magazine *Panorama*, for example, has a cover photo of Benigni in his Pinocchio guise, with the title "Pinocchio, un vero italiano" (Pinocchio, a real Italian) and this accompanying cover commentary: "Il prossimo eroe. Un burattino fuori dalle regole, furbo, bugiardo e altamente spericolato. Ma che alla fine se la cava. Il nuovo film di Benigni rilancia il dibattito sul nostro carattere nazionale" (The next hero. A puppet outside of the rules, crafty, lying, and extremely reckless. But who in the end makes it. Benigni's new film reanimates the debate on our national character.) The articles inside are far from sociologically deep studies, however; instead they merely restate rather stereotypical views concerning the puppet's "Italianness," such as his extreme penchant for fantasy, his vanity, his lack of acceptance of rules and conformity, his lying nature, his love of material pleasures and his easy tearfulness ("Pinocchio, un italiano vero" by Manuela Grassi, 293-299 passim.)

Another article in the same issue of *Panorama* by Fabrizio Rondolino is entitled "Ammettiamolo, siamo tutti un po' pinocchi" (Admit it, we are all a little bit Pinocchio-like); in it, however, Rondolino writes that "nell'Italia mediocre, moralista e provinciale di questi anni, pinocchi in giro se ne vedono pochi" (in the mediocre, moralistic and provincial Italy of these years, one sees few pinocchios going about; 302). He nonetheless attempts to find Pinocchio-like qualities in politicians and popular figures, mentioning Francesco Cossiga, Francesco Storace, Achille Occhetto, and Renato Zero, all of whom to one degree or another reveal some aspects of the puppet's character. Benigni is singled out, once more, as the most Pinocchio-like figure in the world of entertainment, in which others are too serious or too vulgar, or both, to be like Pinocchio. In spite of this enormous buildup and attempt to reactivate the iconic and emblematic status of Pinocchio, in the end the hoopla faded fairly quickly once the megafilm was released, in Italy as elsewhere.

And so, what of the film itself? Lietta Tornabuoni's review, published in *L'espresso* on October 17, 2002, is, in my view, a fair description of it; she writes that it is "un film ricco, colorato, splendente, lussuoso. . .è una fedele illustrazione della favola ottocentesca celebre nel mondo: ossia la maggior cosa che Benigni e il suo sceneggiatore Vincenzo Cerami potevano fare. Come illustrazione, è produttivamente impeccabile" (a rich, brightly colored, shining, luxurious film... a faithful illustration of the nineteenth century fable famous throughout the world: in other words the best thing that Benigni and his screenwriter Vincenzo Cerami could do. As an illustration, it is impeccable in terms of its production; 37). Tornabuoni notes that Benigni is fifty years old and that his makeup is imperfect (suggesting that he is just too long in the tooth to have played the puppet, as many others suggested), but she praises the excellent collaboration of set designer Danilo Donati, cinematographer Dante Spinotti, and the cast both major and minor. She concludes that the film reveals little inventivity, scarse creativity, and much fidelity to the original, and perhaps damns

it with faint praise by calling it "un lavoro ben fatto" (a well-done work).

There is indeed something ho-hum about the film, in spite of moments of real visual beauty. It is plodding when it should be fast-paced, and it does little to get at the real darkness of poverty and sacrifice that is at the core of Collodi's tale. My own experience of a first viewing occurred upon its opening in Chicago around Christmas, 2002; I went to see it with friends, among whom an Italian colleague. We were underwhelmed, to say the least, as we sat in the almost empty theater trying to like a film we had looked forward to seeing for such a long time. We saw the dubbed version, of course, which was an atrocious deformation of the original; without Benigni's Tuscan accent and unmistakable speaking style that in and of itself tickles viewers into laughter, we could not even appreciate other aspects of his performance. I ended up focusing on his highly visible five-o'clock shadow and his extreme thinness, which made him look haggard and older than his years. We could not help giggling over the scene when Pinocchio and Lucignolo are in prison and share a lollipop; it unwittingly elicited associations with some sort of gay pickup scene, as two grown men waxed eloquent on the exquisite pleasures of shared licking and, even though Benigni had commented in one of his interviews on the happiness he felt in finding this way of showing the two friends' growing bond, we could see it only as a seriously misfiring moment. The dubbed voices were thoroughly annoying and detracted enormously from the pleasure of watching a film that is, after all, deeply Italian and specifically Tuscan in essence. There were moments that worked, such as the gorgeous opening scene when the Blue Fairy's carriage appears to tinkling music and stardust, or when the log falls off its cart and rumbles through the village, or when, in the final scene, Pinocchio's shadow goes off to continue its adventures while the real boy Pinocchio dutifully goes to school. But, all in all, it was a disappointing viewing experience.

I subsequently purchased the bilingual DVD set in order to be able to see the original Italian version. Hearing the Italian dialogue helps, but it did not fix the strangely wooden, plodding

feel of the film. Piero Cudini wrote in the December 12, 2002 issue of *La rivista dei libri* of his "boredom" upon seeing the film; he further wrote that "la noia non è una gran categoria critica" (boredom is not a great critical category, 11), but that he believes that films should do anything rather than bore audiences. I agree with Cudini, and felt and still feel regret that Benigni's labor of love is not what so many had hoped it would be: a contemporary classic. Cudini makes the important distinction between illustrations of the tale and interpretations of it, the latter of which has stimulated such original works as Giorgio Manganelli's *Pinocchio: un libro parallelo*, (*Pinocchio: A Parallel Book*), Luigi Malerba's *Pinocchio con gli stivali (Pinocchio in Boots)*, and Robert Coover's *Pinocchio in Venice*. The use of Pinocchio's tale in the film *A.I.(Artificial Intelligence)* directed by Steven Spielberg is another example of a successfully creative interpretation and reuse of the story.

Benigni's movie shows many signs of his intention to remain faithfully close to Collodi's book, but in doing so he sacrified inventiveness. Yet he does in fact introduce changes, one of the most striking of which is the great emphasis put on the Blue Fairy, played by his wife Nicoletta Braschi. The fata is, of course, a very important character in the original story, but she does not in any sense dominate the book, while Benigni's film opens with the arrival of the blue-haired,blue-lit Fairy, and she is very present throughout, perhaps too much so, in that one ends up feeling that Benigni is nepotistically weighing the picture in his wife's direction, as if it were mainly a homage to her. Cudini also notes rightly that Benigni ignores two important elements of Collodi's story: "il percorso d'iniziazione a un mondo adulto di fatica (il suo [di Benigni] è un burattino sempre gioioso e scanzonato), il senso acuto, endemico, della miseria" (the voyage of initiation into an adult world of hard work (his is a puppet who is always joyous and happy-go-lucky), [and] the acute, endemic sense of radical poverty; 11). Cudini sees these omissions as perhaps originating in Benigni's view that today's children would not understand nineteenth-century Tuscan poverty, and he implies that this is particularly true of American kids, an important part of the market toward which Benigni was

aiming his film. True or not, Cudini's view that the film clearly wants to be very respectful of the source text, but doesn't really reflect such fidelity and respect in its choices is, I think, a fair criticism. It is the case, however, that some critics saw Benigni's choices in a different light.

In an article in *Il Sole-24 ore* of October 20, 2002, Roberto Escobar praises Benigni's use of a butterfly as a symbol of the ephemeral essence of life (the butterfly first appears in the opening scenes with the Blue Fairy's arrival, and again at the end of the film) and writes: "Basterebbe questo, a suggerirci quanto Roberto Benigni abbia letto e interpretato il capolavoro di Carlo Lorenzini, detto Collodi" (This would be enough to suggest to us to what extent Benigni has read and interpreted Collodi's masterpiece; 29). He likes the look of the film as well, and praises both Benigni's acting and directing, which emphasizes the disconnected, picaresque quality of Pinocchio's adventures: "La regia e la sceneggiatura la difendono, e anzi la esaltano, questa discontinuità narrativa. Benigni sa bene che solo così Pinocchio sfugge alla necessità che grava sugli effimeri, esseri infelici che in un sol giorno tramontano" (The directing and the screenwriting defend and even heighten this narrative discontinuity. . .Benigni knows well that it is only in this way that Pinocchio escapes necessity, which weighs on the ephemeral ones [humans], unhappy beings who die in a single day; 29). I agree that the butterfly is a lovely trouvaille, but I do not think that it saves the film from its overall lack of success in capturing the lightness and darkness both of Pinocchio's world.

Did Benigni simply wait too long to make this film, and take on too much technological novelty? Sometimes years of preparation can be too many, and the right moment passes. In addition, a simpler, less expensive project might have been both more faithful to Collodi's story, and more effective as a contemporary antidote to the massive special effects and spectacular visuals upon which movies rely more and more to captivate audiences and to generate huge revenues. Benigni was both delighted and daunted by the new technologies of filmmaking at his disposal for the making of this film, according to Tullio Kezich, who wrote regarding a telephone conversation

he had with the director several months before the film's release: "[Benigni] si diffonde invece (e qui viene la parte significativa della telefonata) sulla croce e delizia che rappresenta per un cineasta attuale l'adozione delle nuove techniche chiamate effetti speciali."(Benigni instead goes on [and here is the meaningful part of the telephone conversation] on the pains and delights that using the new technologies called special effects causes for today's filmmaker; 36). Kezich observes that Benigni was born into a cinema "di un secolo fa" (of a century ago), when directors, in a much less technologically dependent way, created their scene setups, had the cinematographer film them, and then put the images together as desired. This was the Neorealist mode, and also one that left a lot of room for improvisation. Kezich suggests that Benigni is feeling somewhat overwhelmed by the new technologies at his disposal, having entered "un nuovo e tecnologico *Paese dei Balocchi*, ben contento di starci, ma timoroso di scoprire che all'improvviso gli sono spuntate le orecchie d'asino" (a new technological Toyland, very happy to be there, but fearful to discover that all of sudden he has grown the ears of an ass; 36).

It is also the case that most critics note that Benigni himself was just too old to play a believable Pinocchio, even if the puppet is in some sense ageless. He may have dared to take Pinocchio on only after the enormous world-wide fame that he earned with *Life is Beautiful* (and the financial bankability that such success brings with it), but that very fame placed a great burden on Benigni's narrow shoulders, and he could not carry it in the end. Perhaps it was a brand of hubris that did this project in; Benigni as Pinocchio was to be, I believe, the very embodiment of Italy for contemporary audiences, a living icon to take his place in the pantheon of national icons around the world. It may also be true that success breeds jealousies, resentments, and a desire to see the great and high fall to the depths of ignominy and failure. After all, *Life is Beautiful* did generate a great deal of negative as well as positive reaction, and there were those who, upon the success of that film, already decided that Benigni was not simply an innocuous, entertaining clown, but rather a dangerous and irreverent desecrator of the

legacy of the Holocaust. A "smaller," more modest film, with a younger Benigni, might have worked better.

Pinocchio is a deeply Italian character, and Collodi's book, while having timeless appeal, is nonetheless very much a product of Tuscan post-unification Italy. It must be interpreted and not simply illustrated today if it is to be exported successfully for mass audiences. Its translatability is in strict relation to its understandability outside of the Italian context, and this is especially so when it comes to filmic versions. Disney drastically modified Collodi, giving the world a cuddly little scamp who is dressed in Bavarian garb, and whose hometown looks more like an Alpine village than a Tuscan town. No matter: it worked, and Disney's interpretation has conditioned many generations of moviegoers' perception of the puppet.

Pinocchio is thoroughly Italian to Italians, but he is both Italian and not Italian for people outside of Italy. It may be that he is Italian in the way champagne is "French," even if it is made in California. Some aura of Italianness surrounds the figure of the puppet, but few non-Italians know or care much about the historical and literary cultural meanings of the tale for Italian culture. Benigni cares a lot about those meanings in his native land, meanings that are a part of a cultural legacy that most Italians naturally come by, and it seems that he thought he could export this Italianness in the form of his own person transformed into *the* Italian *par excellence.* Such translations—of deep resonances and felt connections—are difficult, if not impossible, to make; one can learn another language, but acquiring all of the cultural accoutrements that accompany language is another story.

Whatever the specific shortcomings of Benigni's film, I believe that, in the end, it is this sort of obstacle that doomed the film for international audiences. In *Life is Beautiful*, Benigni transcended his Italianness and became a universal symbol of paternal sacrifice and of the saving power of inventive humor; in *Pinocchio,* Benigni attempted to embody Italy in its cultural specificity, and he became the butt of harsh criticism, seen especially by foreign audiences as a middle-aged man acting

silly. The failure of his film is a telling commentary on just how national icons work: when easily understood, without great subtlety, even stereotypical, they are readable and assimilable by the world; when dependent on subtle cultural associations and delicate national emotional resonances, as the "authentic" Pinocchio sought by Benigni is, they may just have to stay at home, appreciated by the cultures in which they were born.

Works Cited

Benigni, Roberto. *Io un pò Pinocchio. Roberto Benigni racconta il suo film tra le pagine del romanzo di Collodi.* Firenze: Giunti Editore. 2002.

Borsatti, Cristina. *Roberto Benigni.* Milano: Il Castoro Cinema. 2001.

Bruni, Frank. "Pinocchio Infatuates Italians (and That's No Lie)." *The New York Times* (Friday, October 11, 2002): A4.

Coover, Robert. *Pinocchio in Venice.* New York: Linden Press/Simon and Schuster. 1991.

Cudini, Piero. "Due/tre postille su Pinocchio/Benigni." *La Rivista dei Libri* (12 dicembre, 2002): 11-12.

Escobar, Roberto. "La marionetta prende il volo." *Il Sole-24 Ore* (20 ottobre, 2002): 29.

Grassi, Manuela. "Pinocchio, un vero italiano." *Panorama (*3 ottobre, 2002): 293-299.

Grieco, Davide. "Pinocchio? E figlio di Fellini." *La Repubblica* (10 ottobre, 2002): 42.

Kezich, Tullio. "Benigni-Pinocchio nel Cinema dei Balocchi." *Corriere della Sera* (4 maggio, 2002): 36.

Kirkham, Victoria. "*Life is Beautiful*: Benigni's Storehouse of Culture." In *Beyond Life is Beautiful: Comedy and Tragedy in the Cinema of Roberto Benigni.* Grace Russo Bullaro, Editor. Leicester, England: Troubador Publishing Ltd., 2005.

Malerba, Luigi. *Pinocchio con gli stivali.* Milano: Mondadori. 1988.

Maltese, Curzio. "Il mio Pinocchio." *La Repubblica* (19 ottobre, 2002): 40-41.

Manganelli, Giorgio. *Pinocchio. Un libro parallelo.* Torino: Einaudi. 1977.

Mitchell, Elvis. "How Many Actors Does It Take to Make a Log Talk?" *The New York Times* (December 26, 2002): B5.

Mollica, Vincenzo (Introduction), and AA.VV. *Roberto Benigni. Biografia eretica di un piccolo diavolo. Supplemento a Ciak*, no. 11. novembre 2002. Milano: Mondadori, 2002.

Rondolino, Fabrizio. "Ammettiamolo, siamo tutti un po' pinocchi." *Panorama (*3 ottobre, 2002): 302-304.

Scalfari, Eugenio. "Benigni: 'Vi racconto il mio Pinocchio." www.larepubblica.it

Tornabuoni, Lietta. "Una favola rimasta intatta." *L'espresso* (17 ottobre, 2002): 37.

Turrioni, Maurizio. "Benigni-Pinocchio. Una favola d'oggi." *Famiglia cristiana* (13 ottobre, 2002): 84-89.

Benigni's Postmodern Storehouse of Culture

Victoria Kirkham

Driven by eclectic verve as an autodidact, Roberto Benigni has ransacked all sorts of intellectual artifacts to mobilize his own highly individual style. In this free-wheeling creative activity, he has crashed and collapsed boundaries of genre systems, discursive registers, narrative taxonomies, and national traditions unlike any other Italian director before--although Alessandro Blasetti in the *Iron Crown* (1942), an epic-fairy tale stuffed with everything but the kitchen sink, and Federico Fellini, in the persona who loved to poke fun at conventional culture by flaunting a "pop" baroque, could have been the ebullient Tuscan's spiritual cousins.[1] This trade-mark iconoclasm peaks artistically in *Life is Beautiful* (1997). Far-ranging source citations pile together in a felicitous postmodern pastiche: folk legend, fable, the bedtime story, autobiography, documentary history, Italian literary classics, dialect literature,

[1] I would like to thank Millicent Marcus for inviting me to present this paper at a conference she organized in October, 1999, at the University of Pennsylvania, "Roberto Benigni's *Life is Beautiful*: In Context, in Depth."

Fellini was another autodidact who had his professional origins in popular culture--as cartoonist, caricaturist, political satirist, and gag writer. On this background and his anti-intellectual attitude toward cinema, see Peter Bondanella, *The Cinema of Federico Fellini* (Princeton: Princeton University Press, 1992), ch. 1. Benigni knew Fellini personally, having worked under his direction when he acted the part of Ivo in *The Voice of the Moon* (1989). See below and n. 23 for Benigni's eulogy on Fellini's death. Blasetti's eclecticism, by contrast, is highly learned. He came of cultured parents, graduated in law from Rome's La Sapienza, and began his career in cinema as a film critic. The *Iron Crown* generated a joke, recalled by the director: Someone lost his umbrella, and they said to him, "Go look in *The Iron Crown*, you might find it there; it has everything in it." See *La Corona di Ferro. Un modo di produzione italiano*, ed. Claver Salizzato and Vito Zagarrio (Rome: DiGiacomo Editore, 1985).

the philosophical treatise, riddles, magical incantations, the enigmatic axiom, Ciceronian oratory, dramatic tragedy, political satire, slapstick humor, farce, silent film comedy, abstract expressionism, and grand opera.

Beginning with the paradox of deeply serious comedy, Benigni's memorial to World War II surprises us with unorthodox juxtapositions, yet in spite of that and the frontal attacks from "Holocaust fundamentalists," it has met with unparalleled popular success.[2] Viewers have not been bothered by Mussolini and Offenbach back-to-back, or Chaplin hobnobbing with Lessing, Snow White with Schopenhauer. They are companions as unlikely as the film's Jewish protagonist and his gentile fairy "princess,"[3] or the words that manage to

[2] Millicent Marcus, "'Me lo dici babbo che gioco è?': The Serious Humor of *La vita è bella*," *Italica* 77.2 (2000): 153-70, has used the term "Holocaust fundamentalism" of the film's detractors, "those who insist that historical accuracy be the principal criterion for judging representations of the Shoah." The film won fifty-three awards, including the Oscars for Best Director, Best Foreign Film, and Best Music. See Internet Movie Database, http://www.imdb.com/title/ tt0118799/awards. Indicative of the negative responses is David Denby, "In the Eye of the Beholder: Another Look at Roberto Benigni's Holocaust Fantasy," review of *La vita è bella, The New Yorker* 15 Mar. 1999: 96-99, illustrated with a cartoon by Art Spiegelman of a haggard, dazed concentration camp prisoner cradling an Oscar statuette the size of a human baby. An overview of critical reactions appears in Maurizio Viano, "*Life is Beautiful*: Reception, Allegory, and Holocaust Laughter," *Annali d'Italianistica* 17 (1999): 155-72.

[3] Apart from the obvious social differences dividing Guido and his "golden" Dora, established in the film to romanticize the relationship, Fascist Italy forbade marriage between Jews and Gentiles. This fact, on the side of all that violates realism in the film, was pointed out by Nicholas Patruno in a paper read at the 1999 University of Pennsylvania conference, "The Discomfort(s) of *Life is Beautiful*." See further, for the decree of 17 November 1938 that declared any such interracial union henceforth null, Attilio Milano, *Storia degli Ebrei in Italia* (Turin: Einaudi, 1963) 397.

keep company in his uncle Eliseo's bizarre pronouncements ("Silence is the loudest scream."), or the many objects crammed helter-skelter in a storeroom near the hotel where Eliseo works. On his guided tour of the clutter, classic statuary beside the Garibaldi bed vies for our viewing attention with a velocipede, a bidet, and a book by Francesco Petrarca. That storeroom, where Guido and his friend Ferruccio find a place to sleep their first night in Arezzo, becomes a cinematic metaphor for Benigni's eclecticism as an artist. Its jumble corresponds to countless odds and ends in the director's repertoire of borrowings that make *Life is Beautiful* an exuberant storehouse of culture.

The film fades in as a fairy tale. As if by magic, it materializes out of the clear blue sky. The solid blue that first fills the frame then quickly dissolves into colorless mists, where a shadowy human form appears, only to be swallowed by clouds. Is he a soul in heaven or a man lost fogbound on earth? Mystery and ambiguity hover in that grey windy space, primordial and pre-narrative. From there, the first sharp images drop, a Tuscan landscape rolling gentle, green, and perfect. In voice-over, to match this bucolic setting, the male narrator announces a "simple story" like a "fable," filled with sadness, wonder, and happiness.[4] True to form, his tale features a beautiful princess. Much like the opening scenes of the film, she seems to fall from heaven, when she tumbles out of a dovecote into the waiting arms of "Prince Guido." Forced toward an arranged marriage, she resists by refusing to rise from her bed, a reincarnation of Sleeping Beauty. Our modern-day Prince Charming will rescue the maiden from her captors by riding into their midst at a Grand Hotel banquet and stealing her away on a fantastic green horse named Robin Hood. Dora herself favors red, the defining color of Little Red Riding Hood. As if

[4] Roberto Benigni and Vincenzo Cerami, *Life is Beautiful (La vita è bella): A Screenplay*, trans. Lisa Taruschio (Turin: Einaudi, 1998) 1: "This is a simple story but not an easy one to tell. Like a fable, there is sorrow, and like a fable, it is full of wonder and happiness."

overnight, in fairy tale time, they become a fairy tale family of three – Mamma, Papa, and Baby, like the Three Bears in Goldilocks.[5] Events too may occur in folk tale rhythms of three's, like the key that thrice falls from above in response to silly "Open Sesame" code words (with a pronounced Tuscan aspiration), "Maria, la chiave!" Impossible things happen in response to Guido's incantations, as if by magic. The third time the huge key drops, "Maria" sends it; when Guido asks this "Maria" on high for a messenger to say when he and Principessa Dora can go for ice cream, a gentleman appears to declare, "Fra sette minuti" (in seven minutes). He is the hotel guest from Germany with whom Guido exchanges riddles, a stock device of the fairy tale, and he has deciphered Guido's puzzle: "Biancaneve in mezzo ai nani" (Snow White among the Seven Dwarfs). To stage his fairy tale, Benigni doesn't exploit technical devices so inviting in cinema as a medium – dissolves, superimposed images, flashbacks and flashforwards. His magic is like that of the magician, really not magic at all, but sleight of hand and deft words that turn an everyday world into Wonderland.

Yet the hero Guido does not survive to live happily ever after with the Princess, his adored Dora. And if the fairy tale ending is denied, so too does La vita è bella declare itself from the beginning something other than a magical fantasy. As soon as the camera comes down to earth, we read a title card: "Arezzo, Italy, 1939." That device for orienting the viewer, descended from the intertitles of silent film into the arsenal of the documentary, violates the first rule of Never-Never Land, where once-upon-a-time is always outside of time, outside of history. In spite of the hilarious scenes that immediately follow, this particular year in history hangs ominously over the film, set in the immediate wake of Mussolini's infamous anti-Semitic

[5] Carlo Celli, *The Divine Comic*, Filmmakers Series, no. 85 (Lanham, Md.: Scarecrow Press, 2001) 111, suggests that the trio Guido, Dora, and Giosuè are also a "holy family."

racial laws of 1938-39.[6] No sooner has Guido alighted from the wild ride in his brakeless car – an escapade straight from silent film comedy – than he begins spinning a fanciful tale for a little milkmaid, Eleonora. His words transport them from the farmyard where they stand to a fabled capital, Addis Abeba; scratching chickens and mundane dairy cows metamorphose into exotic ostriches and camels. They continue the film's programmatic allusions to Fascist Italy, here obliquely invoked with a reminder of its African empire. That colonial domain will later return more assertively, staged in a spectacular procession à la Fellini at Dora's engagement banquet, as four black African bearers enter balancing on a litter an enormous "Ethiopian cake" topped by an ostrich that struts triumphant as a grotesque emblem of the Italian flag.

Realities of the film's historical moment in Fascist Italy insinuate themselves ever more noticeably. In the runaway car episode that launches the story, King Victor Emmanuel II makes an amusing cameo appearance. Caricatured as a midget beside his gigantic ogre of a wife, he is reduced to insignificance in a tableau that pokes fun at the ruler, both for self-consciousness about his diminutive height (he used to wear elevator shoes and pose on boxes beside his wife for official photographs) and in a nastier jab, for the ignoble role he played in the history of those years. Guido usurps the royal couple's flag-waving reception by patriotic roadside crowds, who mistake his warning gesture of "Via, via" (Out of the way! Stand back!) for the official Fascist salute. Once settled in town, Guido's friendly curiosity about the politics of the upholsterer finds a silencing answer as the man

[6] The decrees, which began rolling out in September of 1938 and continued into July of 1939, forced many humiliating privations on the Italian Jewish community. For example, foreign Jews lost their Italian citizenship; Jewish children could no longer attend public schools; school books by Jewish authors were not allowed, neither were Jewish teachers at any level in the educational system; Jewish families could not have Aryan servants; they were limited in the number of employees and land they could have, etc. See Milanesi, 396-97.

calls out to his little boy to stop roughhousing in the shop and calls him and his playmate by name--"Benito! Adolfo!" A bigger Benito will appear in the very next sequence, as Guido applies to open his bookstore at city hall. There a monstrous black and white portrait of Mussolini looms on the rear wall; another image to one side doubles the Dictator's presence with a very substantial bronze bust; and a third picture of him sits aslant the secretary's desktop in a framed photograph. Mussolinis in all sizes may dominate the local seat of government, but slapstick comedy still comes to the rescue as Guido beats a wobbly bicycle retreat after knocking a flower pot on the Fascist bureaucrat's head.

Comedy again controls the situation when Guido steals the show for a more elaborate performance than the madcap run-in with King Victor Emmanuel's subjects. Now the victim is a fat and ridiculous Fascist functionary from Rome for whom Guido's prestidigitation instantly produces just the low-calorie meal he ordered. The players in this scene, one plump with dark plastered down hair and the other a jumpy individual on the scrawny side, hark back to classic Laurel and Hardy. The next morning Guido, pre-empting the silly Fascist emissary, strides into the local Francesco Petrarca school, complete with purloined tricolor sash, to mock hilariously the Regime's racism in a speech that comes to its absurd peroration on the superior Italian ear lobe. Behind him, the room displays a typical Fascist slogan and the letters "DUX." Although conspicuous, they remain innocuous, for Guido makes a nimble exit in the nick of time by hopping out the window, stage rear, like an elf or leprechaun or the bouncy puppet Pinocchio. Even the green horse, the work of invisible *Squadristi* who leave their anti-semitic message, "Achtung! Jewish horse," turns into the whimsical steed ridden by Dora's knight in shining armor, its unnatural color perfectly consonant with the upside-down world of the fairy tale where escape from danger is always possible and wishes always come true.

Fascism, however, moves abruptly from background to the fore, once the film advances into its second half, five years later.

Grim wartime is announced by sandbags around the statue in the town square, and a platoon of German soldiers goosesteps across the *piazza*. To suggest the oppressive atmosphere, Benigni drains his images of color and quotes the murky pre-dawn opening scene in Rossellini's *Open City,* where a squad of troops stomps heavily to a German marching song through Piazza di Spagna. The cultivated Dr. Lessing, a solitary guest from Berlin with whom Guido had pleasantly traded riddles at the Grand Hotel, has now been replaced by many anonymous armed men. From an Italy occupied by Germans it is but a short train ride to the prison occupied by Italians. The film continues, opening into a diptych that operates dynamically in oppositional symmetry.

Events in part two replay darkly the story thus far told; the beginning begins again. As part two unfolds, we realize that a typological relationship of foreshadowing and fulfillment links the two halves. Such typology, which has its archetype in St. Paul's reading of the Old Testament, provides controlling figural patterns in the medieval allegory of Dante's *Divine Comedy*, a poem Benigni knows to the core, as is clear from his bravura canto recitations.[7] Whereas in Dante, *Inferno* comes before, Benigni puts it second (complete with blast furnace flames in the anvil factory), reversing the direction from comedy to tragedy. His film's first sequence after the title "Arezzo, Italy, 1939" follows the open, runaway jalopy Guido and Ferruccio ride into town, high spirited young men happily reeling off poetry. Later Guido, his uncle Eliseo, and little Giosuè are driven away to the deportation train in a military truck, darkly enclosed and under guard, a vehicle much like the one that carries off Pina's fiancé in the famous scene of her death from *Open City.* The beautiful "Barcarolle" from Offenbach's *Tales of Hoffmann*, sung by sopranos in brilliant red costumes as a counterpoint to Guido's powers as a sorcerer exercised on Dora up in the balcony, will replay quite literally as Guido broadcasts that music on a victrola across the black night of the *lager*, willing the same

[7] On Benigni and Dante, see below, n. 19. He knows the Bible, too, of course.

woman to respond from the second-floor of the female dormitory. Each time, in echoic poses, we see Guido in profile, while Dora slowly turns her face frontal. In part one, on a cozy family evening at home the night stand with a vase of flowers "walked" toward Guido; it returns as a rusty metal box-like cabinet in a corner of the prison-camp yard, from which Giosuè peeks out to see his father on the move. With a broad wink at the boy to signal their secret understanding, Guido does an exaggerated goosestep like a wind-up toy soldier (and Chaplin's little Jewish barber in *The Great Dictator*), as he bravely walks off to his execution.[8] Before, his abracadabra turned a Tuscan barnyard into "Ethiopia," conjured a key from the sky, and mesmerized pupils in assembly at the Francesco Petrarca School--talents just right for fun with children and perfect for romantic courtship of a *Principessa.* Now his improvisational skills have become a matter of life and death. Doomed himself, he saves his child with the ultimate trick of illusionism, turning a horrifying machine of destruction into a giant game board.

At the end, *La vita è bella* multiplies its generic systems, reaching beyond fairy tale and national history to resonate as personal history. Benigni, of course, is always autobiographical to the extent that his stage persona typically speaks an exaggerated Tuscan Italian--even when he is a taxi driver who lives in Rome.[9] This time he connects in more specific ways

[8] There are many such programmatic parallels. Celli (107-108) notes the eating scenes, where Guido as waiter is a disruptive presence, first at the lavish engagement banquet for Dora and Rodolfo at the Grand Hotel and then, in the starving camp at the children's party. Some Italian critics attacked the film for this strident dualism, seen as evidence that it was not a unified whole. See, e.g., Stefano Masi, *La vera storia di Roberto Benigni* (Rome: Gremese, 1998) 53. Viano (164), speaking of "recalcitrant opposites," better captures the spirit of Benigni's "weird symmetry."

[9] Benigni's hilarious sketch as a Roman taxi driver in *Night on Earth*, presents a character whose comic monologue, in which he explains to his passenger that he has lived in Rome for fifteen years, pours out all sorts of colloquial Tuscan markers.

with his own past experience. Arezzo, the setting, is not just a place name associated with Francesco Petrarca, born there in 1304 and remembered as the city's most famous son. Benigni, too, claims origins close to the poet's native town. When he was a very young child, before his impoverished peasant family moved from the countryside into town, near Prato, their home was the rural village of Galciana, in the province of Arezzo. Connections with the director's past resurface as the film narrative comes to its end and the voice-over who had introduced it as a "fable" returns, speaking now in the first person: "This is my story. This is the sacrifice my father made. This was his gift to me." An oral frame that brings us full circle, it recalls the Taviani Brothers' *Night of the Shooting Stars*, another memoir of World War II told by an adult reminiscing about scenes from a Tuscan childhood. We can imagine that like the mother who tells her child a bedtime story, Giosuè, now a grown man, is also retelling his past in the nursery.[10] In his own childhood, Benigni heard fireside tales from his father, who fought as an Italian soldier in Albania and was sent to Germany, where he spent two years in a Nazi labor camp.[11]

Benigni's distinctive voice has been traced to his peasant origins, a background held accountable for his barnyard scenes and barnyard language, as well as for his love of the cultural forms that flourish among the illiterate--legends, fairy tales, and rhyming ditties called *filastrocche*. Personal roots in an oral culture help explain his prodigious talent as an improviser, early practiced as a guitar-strumming *cantautore* with songs in *ottava*

[10] Marcus, drawing the parallel in "Me lo dici babbo," proposes that there is an implied child hearing Giosuè's account like the infant who listens to Cecilia tell of her wartime memories, "the new generation of Holocaust witnesses to whom Guido's gift will be given."

[11] A sketch of Benigni's childhood in a family that struggled to keep afloat can be found in Stefano Masi, *Roberto Benigni*, trans. Sandra Eido Tokunaga (Rome: Gremese, 1999) 16-17. See also for his father's experience in the German camp, Celli 98.

rima, the metrical form of the minstrel in Tuscan ever since the Middle Ages.

Earthy forms, however, also have a pedigree in Italian literature as false primitives, products not of the countryside but of the court. The Florentine ruler Lorenzo de' Medici (d. 1492), composed one of the most clever, a rustic romp called *La Nencia da Barberino*. Like a fun-house mirror, it ripples and distorts the old courtly poetry that put woman on a pedestal with its mock portrait of Nencia, a seductive wench from the Tuscan village of Barberina, "so soft and white that she looks like a ball of lard."[12] Benigni's own compositional brand has been compared to the "Bernescanti," poets whose jocose, irreverent, and often obscene verse took its name from Francesco Berni (1497-1535). Berni's *capitoli* include one "On the Urinal"; he composed some Petrarchan lyrics, too, but mostly he parodied that fashionable form. A marvelous sonnet "To his Lady" reshuffles female body parts and clichéd epithets from the *Petrarchisti* to describe a grotesque old hag with silver hair, golden complexion, "curly" (wrinkled) skin, pearl-like (rheumy) crossed eyes, milky white lips, a sagging blue mouth, and rotting black teeth: "Chiome d'argento fino, irte e attorte / Senz'arte intorno ad un bel viso d'oro; / Fronte crespa . . . / Occhi di perle vaghi, luci torte / . . . labra di latte, bocca ampia celeste; / Denti d'ebeno rari e pellegrini."[13] Other prominent writers of the Renaissance followed Berni's example--the painter Agnolo Bronzino, the sculptor Benvenuto Cellini, and Anton Francesco Grazzini, a versatile poet better known for short stories in the tradition of

[12] Lorenzo de' Medici, *La Nencia da Barberino*, ed. Rossella Bessi (Rome: Salerno, 1982): "morbida e bianca che pare un sugnaccio" (142) (V, 5.8). For a discussion in the context of the more courtly forms Lorenzo parodies, see Victoria Kirkham, "Poetic Ideals of Love and Beauty," in *Virtue and Beauty: Leonardo's Ginevra de' Benci and Renaissance Portraits of Women*, ed. David Alan Brown (Washington, D.C. and Princeton: National Gallery and Princeton University Press, 2001) 48-61.

[13] Francesco Berni, *Poesie e prose*, ed. Ezio Chiòrboli (Florence: Olschki, 1934) 79.

Boccaccio. They all pitched *terza rima* in this bawdy register, while composing in other moments linguistically purified lyrics faithful to the dominant Petrarchan mode.[14] In Benigni's repertoire the Bernesque trademarks are sexual and scatological humor, the stuff of his "Inno al corpo sciolto" (Hymn to the Body Loosened) dedicated to the glories of shitting: "Viva la merda e chi ha voglia di cacare" (Long live shit and whoever wants to crap!)[15]

Although Benigni did enroll briefly at the University of Florence in biology, instead of attending class he worked as an actor, beginning a career that in 1972 led him to Rome for stage productions influential on his later activity. One of the earliest of those experimental theater projects was *Le fiabe del Basile* (Basile's Fairy Tales), adapted from a seventeenth-century Neapolitan who was both a follower of Boccaccio and a precursor of the Grimm Brothers. Giambattista Basile's *Lo Cunto de li cunti* (Tale of Tales), also known as *Pentameron*, collects fifty stories with such favorites as "Cinderella" and "Puss 'n Boots." Remarkable for the same kind of border crashing that characterizes Benigni, Basile loved making his earthy native dialect jostle with Tuscan, by then indisputably

[14] For Bronzino's verse, both Bernesque and Petrarchist, see Deborah Parker, *Bronzino. Renaissance Painter as Poet.* Cambridge: Cambridge University Press, 2000; reviewed by Victoria Kirkham with reference to the "high" and "low" parallel registers in Italian literary history, *Renaissance Quarterly* 55 (2002): 698-99. Cellini's activity as a poet receives deserved attention in Margaret Gallucci, *Benvenuto Cellini: Sexuality, Masculinity, and Artistic Identity in Renaissance Italy* (New York: Palgrave Macmillan, 2003). On il Lasca's versatile career, see Robert J. Rodini, *Anton Francesco Grazzini: Poet, Dramatist and Novelliere (1503-1584)* (Madison: University of Wisconsin, 1970), esp. ch. 3, devoted to the burlesque and Petrarchan poetry .

[15] Massimo Moscati, *Benignaccio con te la vita è bella* (Milan: BUR, 1999) 30-32, reproduces the text of the "Hymn of the Corp Sciolt." Celli (8-10) connects him with the Bernescanti, traveling Tuscans of the twentieth century who improvised humorous verse.

established as the official literary language, in a style that mingled popular legend and linguistic vulgarism with sophisticated models from high culture.[16] Benigni plays off Basile, but with a reversal. Heavily aspirated, exaggerated Tuscan becomes his low dialect, the powerless little man's medium, in contrast to the linguistically homogenized Tuscan of standard Italian, property of the political and social establishment. Working in the 1970s with the poet and writer Giuseppe Bertolucci (brother of the film director Bernardo), he was involved in another stage production for children, *Pinocchio*. Collodi's nineteenth-century version of the Pygmalion myth created a character who played into the comic gymnastics of Benigni's persona decades before he returned to perform the truth-challenged puppet in the long-awaited film that came as an anticlimax to *La vita è bella*.[17] Such folkloristic

[16] Giambattista Basile, *Lo cunto de li cunti*, ed. Michele Rak, 4th ed. (Milan: Garzanti, 1995) 1048. Basile's twentieth-century revival is due to the efforts of Croce, who translated the Neapolitan dialect text into Italian in 1925 and presented the author in a still valuable critical introduction. See his classic essay "Giambattista Basile e l'elaborazione artistica delle fiabe popolari," 445-66, in Benedetto Croce, *Storia della età barocca in Italia: Pensiero, poesia e letteratura, vita morale* (Bari: Laterza, 1929). Comparing Basile to Luigi Pulci and Teofilo Folengo, Croce speaks of Basile's "joyous Baroque" that holds readers "in una continua distinzione tra cultura e incultura, tra mente evoluta e mente rozza, tra letterato e volgo" (457). Like his predecessors Bronzino and Cellini, Basile was learned in the most proper Renaissance Petrarchism, which he knew in such model poets as Bembo and Della Casa (463). See further for a useful presentation in the context of Italian dialect literature more generally (Basile is considered the most outstanding prose writer), Herman Haller, *The Other Italy: The Literary Canon in Dialect* (Toronto: University of Toronto Press, 1999) 253-56.

[17] Masi, *La vera storia*, 80-81: "Lui è Pinocchio monello, da piccolo diavolo." On a page that featured Italy's entries in the Cannes Film Festival that year, *La Repubblica* of 15 May 2001: 65, has a small announcement of Benigni's contract-signing with Miramax for the world-wide distribution of *Pinocchio*. Benigni is quoted, "Non c'è

literary material, in a tradition parallel to the classics and oral in its diffusion, would continue to enjoy favored status in his cinematic work.

Even in a context as off-beat as *Down by Law* (1986), his first collaboration as an actor with the American director Jim Jarmusch, Benigni seems to leave his mark in the film's final minutes. He plays "Bob," an idiotically naive character who has landed in a New Orleans jail because he accidentally killed a man with a billiard ball. Saved by the grace that protects saints and fools, he stumbles onto an exit and escapes with his two cell mates, cynical small-time losers, only to get hopelessly lost in the Louisiana Bayou. At last, the exhausted men emerge from the swamp into a clearing with a solitary roadside eatery, Luigi's Tin Top. Bob will walk in on a fairy tale ending, for here dwells no regulation hermit or woodsman or witch, but a beautiful young Italian woman (Nicoletta Braschi) who welcomes him with food, wine, dancing, and an instant proposal of marriage. In his cracked English, he explains to his friends this incredible luck, "just like in a story for children."

Although the comic mask he invented and displayed in his first film (*Berlinguer ti voglio bene*, 1977) is the vulgar Cioni Mario, scurrilous and sexually obsessed, Benigni will climb from those comic bottoms into less offensive fictions populated by more likeable types. As a Tuscan, he must have enjoyed christening the ordinary soul caught up by the Mafia as look-alike for a notorious gangster in *Johnny Stecchino* (1991). Girl runs into boy, quite literally, an inevitable moment in Benigni's male fantasies that will return with a variation when Guido

niente di più bello al mondo, da perdere la testa" The *Corriere della Sera* 16 June 2002: 27, expresses public anticipation of the film's release: "PINOCCHIO: Tutti pazzi per il ritorno sulle scene." See the story as over-optimistically promoted by Miramax Films, "based on the international smash hit movie adapted from the classic fairy tale," Roberto Benigni, *Pinocchio* (Boca Raton, FL and New York: American Media Mini Mags, Inc., 2002). See Rebecca West's contribution to this volume.

knocks down Dora on his bicycle in *Life is Beautiful*. In *Johnny Stecchino* a beautiful Maria in her shiny white Jaguar (Nicoletta Braschi) clips Benigni in the part of a lonesome bachelor pedestrian. Dazed by her beauty more than the incident, he obliges her wish to know who he is, "Come ti chiami? --Dante." This "Dante," however, goes no further than the one-time joke in his name, funny because it attaches to such a timid fellow in the family of Caspar Milquetoast. We can hardly extrapolate from it a "Beatrice" in the glamorous but Mafiosa moll Maria, and his only journey is a plane hop to Sicily, plagued by terrible "traffic" problems. Maria's naïve but good-hearted Dante usually travels as a school bus driver for handicapped children, whom he conducts in performance of zoo sounds, like a ritual from a story-book world.

Haphazard name-dropping from high culture continues and explodes into the wonderful monologue of the Roman taxi driver in Benigni's second Jarmusch collaboration, *Night on Earth* (1992). What input he may have had on the script of *Down by Law* must have been quite *ad hoc*, but it was officially credited for the Italian episode of this international anthology film. Benigni the political leftist gets his jibe at the Vatican by killing off a priest, the passenger in the back seat of the cab, whose last horrified gasps punctuate a crescendo of logorrhea, once again in Cioni Mario mode, as the driver insists on confessing his insatiable priapism, vented on everything from pumpkins to his sodomized sister-in-law. Before picking up his short-lived fare, he passes by the "Hotel Genius." Its neon sign prompts a string of associations as the cabby happily imagines himself signing in: "Good evening, I wanted a room between Leonardo da Vinci and Einstein... O look who's here! Dante Alighieri! How are you? . . . Let's have a cup of coffee with Shakespeare . . . Dear Newton, how are you? . . . Dear Beethoven, do you know Charlie Parker? Charlie Parker, meet Beethoven." If the name "Dante" does not resonate in *Johnny Stecchino* except as a small irony in a character not the least Dantesque, Benigni's catalogue of *uomini famosi* in *Night on Earth* fits more effectively the contours of the sketch. It

measures the huge distance that separates world geniuses from the Nobody character of the taxi driver, ready enough to register at the "Hotel Imbecile." He reels off the names with both respect and envy, perhaps reflecting something of Benigni's own ambivalent perspective as the *contadino* who never went to college. At the same time, the scene captures his verve as self-taught enthusiast for collecting indiscriminately all sorts of knowledge. His entire monologue is as eclectic as the guests at the hotel, where African-American bebop mingles with Germany's most formidable symphonic music. The Rome segment of *Night on Earth* opens on Benigni tooling erratically about the city in his little yellow cab as he loudly sings, with hopelessly misplaced vowel aspirations, the beginning of "The Streets of Laredo": "Hi see by your houtfit that you are a cowboy" Later, when he gets lost in a tight maze of streets, the nocturnal urban cowboy continues entertaining himself at the wheel of his taxi-steed, this time by starting to recite the *Divine Comedy*, "Nel mezzo del cammin di nostra vita." (He is, after all, Italian, not from Laredo.) Suddenly, Dante's sublime verse plummets into an improvised bit of Benigni rap: "Nel mezzo del cammin di nostra vita . . . O cari ascoltatori vi comunico / mi ritrovai in mezzo a un senso unico!" (Midway through the journey of our life . . . O dear listeners, I inform you I found myself in the middle of a one-way street!")

The Benigni who played "Dante" in *Johnny Stecchino*, archived him among the world's greatest minds at the Hotel Genio, and quoted the *Divine Comedy* in snatches at the wheel of a cab, is actually himself an accomplished Dantista.[18] His canto recitations have dazzled the public with learning dismantled from centuries of scholarship. A commentary tradition dating back to Dante's own sons comes out of the comic's paper-shredding machine in nearly unrecognizable strips, yet for all the outrageously coarse language and a level of

[18] Celli, 49, mentions that Benigni's character Bob in *Down by Law* mixes Dante and Walt Whitman in jail house conversations with his cell mates.

vulgarity that barely escapes plain bad taste, he adeptly reproduces a hallowed formula, the "Lectura Dantis." The text of his 1993 commentary on *Inferno* 5 at *Babele* for RAI TV confirms that classic lesson plan, sprinkled with a set of allusions that recall the polyglot guests at the Hotel Genio and anticipate Uncle Eliseo's storeroom-museum: Bunuel, Prezzolini, Goethe, Shakespeare, and Sermonti (a "real" Dantist present on the stage for the reading), not to mention Virgil, Beatrice, Lucia, Paolo, and Francesca.[19]

The world of scholarship makes a butt for satire in *The Monster* (1994), where once again, as in *Johnny Stecchino*, Benigni plays a character mistaken for a violent criminal, this time a serial rapist and murderer. Loris is a mild-mannered man, timid with women, but clever enough to scrounge a livelihood by petty shoplifting, insurance fraud, and rent evasion. For reasons unexplained, he happens to keep a replica of Snow White's dwarf Bashful in his closet, a discovery that leads the bumbling police doctor to diagnose him as a sexual pervert aroused by fairy tales. To trigger one of his attacks, the detective Jessica (Nicoletta Braschi) is ordered to dress up in décolleté and mini-skirt as Little Red Riding Hood. The doctor delivers her costume, more crude than cute, after a night spent reading "the last story in Anderson." Nonsense more like academic gibberish than Hans Christian Anderson, it has the pompous title "Ghosts and Fairy Tales in Contemporary Rape: From the Three Little Pigs to the Monster of Rostov." In a sight-gag near the end of the movie, Loris stands facing away from a store window behind him, through which multiple television screens all broadcast his photograph as the monster except for one, only partially visible, on a different channel. It is running an old Loony-Tunes cartoon, "Red Hot Riding Hood," that opens with

[19] For preliminary thoughts on Benigni and Dante, see Celli (10-11); also Benigni's performance in a two-hour Christmas spectacular on RAI Uno, 23 December 2002, as negatively reviewed by Roberto Fedi:
http://www.drammaturgia.it/giornale/spettacoli/televisione/television e_articoli/benigni_paradiso.htm. I thank Nicoletta Marini-Maio for sharing a copy of her partial transcription of the *Inferno* 5 introduction.

a leering pun on the male sexual appetite, "Once upon a time there was a wolf." Peripheral to the movie frame, the cartoon is also marginal to the plot of *The Monster*. In spite of hilarious moments, when Loris wields an out-of-control buzz-saw before caricatures of vulnerable, older women or amicably waves a meat cleaver while his trousers bulge with the bulky flashlight he absent-mindedly stuck in his crotch, the movie lacks a unifying thread. Its allusions to Little Red Riding Hood, good for a laugh or two because they turn an ingenuous child into a red-hot mamma, function at the level of the film's obsession with sex, but they seem fragments arbitrarily inserted, out of place like the lone dwarf Bashful, severed from his Disney companions and unmotivated in the plot.

Braschi as Red Riding Hood returns less heavily disguised in *Life is Beautiful*, where the fairy tale as genre is conceptually integral. Likewise, the later film's design calls attention to color, but not just as an awkward costume prop connected to a TV screen sight gag. Color is deeply encoded in *Life is Beautiful*, from the major contrast between bright hues at first and the filtered, dulled tones of the second half, to details of décor like the Italian *tricolore* that makes a banner for King Victor Emmanuel's arrival in Arezzo, an ostrich triumphant and confetti at the banquet, and the red-white-green sash that Guido appropriates for his speech at the Francesco Petrarca School.[20] With Little Red Riding Hood in her cinematic genealogy, Braschi still has a cloak of red as Dora, but like the colors of the Italian flag--faceted in a green horse, a white poodle, red frosting on the cake--it verges on the metonymic and resonates symbolically throughout the movie. And, like the refrain "Buon giorno, Principessa," it links episodes across the film. When

[20] The tricolor confetti at the banquet dancing scene recalls the opening sequence of Visconti's *Senso*, where tricolored bits of paper prepared in advance by the clandestine patriots rain down on the audience of Verdi's *Il Trovatore* at Venice's Teatro La Fenice, a sign of defiance against the occupying Austrian troops who occupy the parterre in dress whites.

Guido collides with Dora on his bicycle, she wears a conservative beige suit proper to a school marm, but under the jacket her blouse is bright red. Red dominates the stage in the "Barcarolle" scene, where against a background as deep blue as the Venetian lagoon, the women float on stage to sing their enchanting duet spectacularly swathed in crimson; meanwhile Guido charms Dora with willpower borrowed from Schopenhauer. Afterward, as Guido steps into the role of Gene Kelly dancing in the rain, from a bolt of upholstery cloth he rolls out a red carpet for Dora and chivalrously offers her the shelter of a make-shift umbrella--a red cushion. For the banquet Dora wears a pink gown, attenuated red, and there suddenly appears on her table a cake with red writing, "Buon giorno, Principessa." At the deportation scene, her garb is a bright red suit, all the more striking for its sharp contrast with the gray German uniforms and the gray of the camp, where next morning Guido can pick her out from the other women, thanks to her conspicuous outfit. Time passes, and as the female prisoners one day sort through a heap of clothing stripped from the dead, Guido commandeers the microphone once again to greet Dora, "Buon giorno, Principessa," just as she fingers a scrap of red clothing.

Like recurring rhyme words in a poem or a musical motif in opera, the color red flags Benigni's fairy princess. This time its referent isn't just an implicit Red Riding Hood, complement to the white poodle and green "Robin Hood" (with Expressionist relatives of its own in the red and green animal of Marc Chagall's *Circus Horse Rider* and Franz Marc's *Blue Horse*). Now all these reds carry more learned allusive possibilities. A medieval Christian symbol of love, blood red ("sanguigno") is also the color Dante's Beatrice wears when she makes her first appearance in his *Vita nuova* (ch. 1). *Mutatis mutandis*, Dora resembles Dante's Beatrice, who seemed to be an angelic creature descended from above. She certainly, in any event, has more in common with Dante's beatific lady than the Mafia mistress loved by "Dante" in *Johnny Stecchino*. Dora, who wears red like Beatrice, does also "descend" from above, even if

it means only falling out of a hay loft. Guido emphasizes her "heavenly" origins when he first speaks to little Eleonora in the barnyard, "What kind of a place is this? It's beautiful: Pigeons fly, women fall from the sky!" and again, introducing her to Ferruccio, "This is the princess who fell into my arms from the sky!"[21] She levitates toward high places, the pedestals upon which Benigni-Guido sets her--a balcony at the opera, the second floor in the camp dormitory. Dante, woven into so much of Benigni's production one way or another, colors *La vita è bella*, too.

Turning his sights back on World War II in this Oscar-winning film, Benigni joins major twentieth-century antecedents, a line of Italian movie directors from Rossellini to De Sica to Scola. For the comic approach to Nazism's horrors, which has recently seen a tremendous stage success in Broadway's *The Producers*,[22] his most important model was Charlie Chaplin's *The Great Dictator* of 1940. In that film, a precedent for Benigni's dual roles in *Johnny Stecchino*, Chaplin plays both Hynkel, Dictator of the Nation of the Double Cross, and his look-alike, an anonymous little barber with a shop in the ghetto, eventually sent to a concentration camp. The barber's entrance into the camp is the model for Guido's toy-soldier goose-step exit, both from the German prison and from the film. The guttural sounds of German, barked out in camp rules that Guido can't help but mistranslate, take one suggestion from Hynkel's Hitler-like rantings, broadcast over loudspeakers like those that will amplify Guido's victrola serenade to Dora in the prison. Real words pepper Chaplin's mad, nonsensical, mock-German – *Juden, ghetto, blut, strecken*. In other antecedents

[21] Benigni and Cerami, *Life is Beautiful*, 7, 29.

[22] Performances at the St. James were sold out for months. See the review by John Lahr, "Gold Rush: Mel Brooks is back, mit a bing, mit a bang, mit a boom," *The New Yorker*, 7 May 2001: 84-86. Lahr reports that on the day after it opened, 33, 598 tickets were sold, for a box-office take of $3,029,197, the biggest ever in the history of Broadway.

from Italian film history, German signals an occupying enemy. In Blasetti's *1860*, one of the first Italian films with synchronized sound, German-speaking mercenaries of the Bourbon king invade the Sicilian countryside and silence the locals by removing the clapper from their church bell. Rossellini makes the German Gestapo even more odious by having them repeatedly speak German in *Open City*, down to the final command of the firing squad assembled to murder Don Pietro, the martyred Resistance priest, "Feuer!"

Benigni's eclectic borrowings are like his Uncle Eliseo's quarters, a storeroom stuffed with cultural artifacts. Guido and Ferruccio sleep there on "Garibaldi's bed" amidst large painted canvasses, classical busts, an organ, antique furniture, a bidet, a bicycle – even a copy of Petrarch. The jumble is, in a way, an assembly reminiscent of the guests who might stay at the Hotel Genius, or line up for an appearance in Benigni's doggerel, as they do in his tribute on the death of Federico Fellini--directors and actors lead off a procession that includes Cavalcanti, Dostoyevsky, Mickey Mouse, Pippo Baudo, Fogazzaro, Peppino De Filippo, Christopher Columbus, Fidel Castro, Maciste, Mandrake, Verlaine, Beatrice, James Dean, Euridice, and Rin-tin-tin.[23] In a sense, these accumulations are simply a modern adaptation of an ancient rhetorical device, *accumulatio*. Descended from ancient epic poetry, the catalog had great appeal to the medieval imagination, serving admirably to accommodate throngs of souls in Dante's *Comedy*. Benigni, predictably, shakes it up. In his anti-classical treatment the list loses its well-ordered rationale and turns into a taxonomic nightmare, humorous precisely for its unpredictability as a hit-and-miss hodge-podge.

The world's famous gather again in *Life is Beautiful*, but there is a logic to the assembly that transcends random name-dropping and unmotivated, if funny, interlopers in the plot.

[23] Moscati reproduces the whole poem, "Quando muore Fellini il grido è forte," 68-69.

Ferruccio teaches Guido a lesson from Schopenhauer, whose philosophical theory of the will flows into the incantational powers of magic spells and fairy tale sorcery. [24] Doctor Lessing, played by Horst Buchholz, has an antecedent in Chaplin's film who protects Jews in the ghetto, but at the crucial moment Lessing falls short with respect to the source character. Obsessed by a riddle he cannot solve, we see him reduced to mindless quacking. Zoo sounds heard before in *Johnny Stecchino* on the handicapped children's school bus are no longer just an amusing, disconnected moment with funny noises more for their own sake than plot necessity. Now they express a civilized doctor's degradation under the Nazi swastika; the madness of the camp has driven him into dementia. From dark comedy to insanity the distance is not far. The historical Gotthold Ephraim Lessing, a great eighteenth-century dramatist and esthetic theorist, had traveled to Italy, and his most famous play, *Nathan, the Wise*, adapts a tale from Boccaccio's *Decameron*. Offenbach, composer of the familiar "Barcarolle" (from the Venetian word for "boatman's song") in *Tales of Hoffmann*, was a German by background and son of a Jewish cantor who made his career in Paris with comic opera. The stories by Hoffmann, on which Offenbach's libretto is based, are a collection that significantly combines fantasy with the grotesque and that were inspired by the Italian writer Carlo Gozzi. Gozzi, better remembered for his contributions to German opera libretti than for his Italian plays, rejected his rival Goldoni's theories of linguistic and social realism, choosing instead to defend *Commedia dell'Arte* and write dramatic allegories based on fairy tales.[25] The Germans

[24] For introductions, see Didier Raymond, *Schopenhauer* (Paris: Seuil, 1995); Bryan Magee, *The Philosophy of Schopenhauer* (Oxford: Clarendon Press, 1983).

[25] Carlo Gozzi, prominent in the Venetian Accademia dei Granelleschi (The "Big Balls" or Testicular Club), called his plays "fiabe." His *Love of Three Oranges* has many similarities with Mozart's *Magic Flute*; Wagner based his first opera, *Die Feen* (1834) on Gozzi's *La donna serpente* (1762). In Italy Puccini's *Turandot* is the most famous operatic adaptation from Gozzi. See John Louis DiGaetani, *Carlo Gozzi: A Life in the 18th Century Venetian Theater, An Afterlife in*

Schopenhauer, Lessing, Offenbach, and Hoffmann, are all ironic reminders of the cultural links between Italy and Germany at a time when one country was trying to destroy the other.

The stand-up comic has grown up. From the coarse figures with adolescent hormones like Cioni Mario or the sex-starved Dante and Loris, Benigni has evolved beyond the mask and become a character--a married man, a bookseller and stationer, whose best friend Ferruccio is a poet. He has cast himself in a dignified and cultured role. He even can sing in French, repeating for Dora the refrain of the "Barcarolle" as he dances in the rain with an umbrella-cushion on a pole, "Belle nuit, o nuit d'amour, / Souris à nos ivresses! / Nuit plus douce que le jour, / o belle nuit d'amour!" From the simple sketch or routine, he has expanded his reach and transcended *commedia di equivoco* with a complex and unified film that is not just funny, but a vehicle for exploring the very possibilities of humor. *La vita è bella* inaugurates a new era of Italian cinema, in the tradition of Fellini, but unmistakably Benigni, a contemporary baroque imprinted with the signature of his cinematic pidgin, the autodidact's collected *mirabilia* displayed in a postmodern storehouse of culture.

Opera (Jefferson, N.C. and London: McFarland and Co., 2000) 2-4, 116. Jakob or Jacques Offenbach (1819-1880) rose to fame under the Empire of Louis Napoléon, becoming the Musical Director of the Comédie Française and eventually founding his own comic opera theater, Les Bouffes-Parisiens. For a recent recording, consult Jacques Offenbach, *Les Contes d'Hoffmann*, compact disk, Emi Classics, 1989. For background on Lessing, Marino Freschi, ed., *Lessing e il suo tempo* (Cremona: Libreria del Convegno, 1972); and T. W. Rolleston, *Life of Gotthold Ephraim Lessing* (1889; Port Washington, NY: Kennikat Press, 1972), provide useful overviews.

Works Cited

Basile, Giambattista. *Lo cunto de li cunti*. Ed. Michele Rak, 4th ed. Milan: Garzanti, 1995.

Benigni, Roberto. *Pinocchio*. Boca Raton, FL and New York: American Media Mini Mags, Inc., 2002.

Benigni, Roberto, and Vincenzo Cerami. *Life is Beautiful (La vita è bella): A Screenplay*, trans. Lisa Taruschio. Turin: Einaudi, 1998.

Berni, Francesco. *Poesie e prose*. Ed. Ezio Chiòrboli. Florence: Olschki, 1934.

Bondanella, Peter. *The Cinema of Federico Fellini*. Princeton: Princeton University Press, 1992.

Celli, Carlo. *The Divine Comic*. Filmmakers Series, no. 85 . Lanham, Md.: Scarecrow Press, 2001.

Croce, Benedetto. "Giambattista Basile e l'elaborazione artistica delle fiabe popolari." Croce, *Storia della età barocca in Italia: Pensiero, poesia e letteratura, vita morale*. Bari: Laterza, 1929. 445-66,

Denby, David. "In the Eye of the Beholder: Another look at Roberto Benigni's Holocaust fantasy." Rev. of *Life is Beautiful*. *The New Yorker* 15 Mar. 1999: 96-99.

Di Gaetani, John Louis. *Carlo Gozzi: A Life in the 18th Century Venetian Theater, An Afterlife in Opera*. Jefferson, N.C. and London: McFarland and Co., 2000.

Down by Law. Dir. James Jarmusch. Criterion Collection, 1986.

Fedi, Roberto. Rev. of Benigni's performance on a Christmas spectacular, RAI Uno, 23 December 2002. http://www.drammaturgia.it/giornale/spettacoli/televisione/televisi one_articoli/benigni_paradiso.htm.

Freschi, Marino, ed. *Lessing e il suo tempo*. Cremona: Libreria del Convegno, 1972.

Gallucci, Margaret. *Benvenuto Cellini: Sexuality, Masculinity, and Artistic Identity in Renaissance Italy*. New York: Palgrave Macmillan, 2003.

The Great Dictator. Dir. Charles Chaplin. Charles Chaplin Productions, 1940.

Haller, Herman. *The Other Italy: The Literary Canon in Dialect*. Toronto: University of Toronto Press, 1999.

Kezich, Tullio. "PINOCCHIO: Tutti pazzi per il ritorno sulle scene." *Corriere della Sera* 16 June 2002: 27.

Kirkham, Victoria. "Poetic Ideals of Love and Beauty." *Virtue and Beauty: Leonardo's Ginevra de' Benci and Renaissance Portraits of Women*. Ed. David Alan Brown. Washington, D.C. and Princeton: National Gallery and Princeton University Press, 2001. 48-61.

-----. Rev. of *Bronzino: Renaissance Painter as Poet*, by Deborah Parker. *Renaissance Quarterly* 55 (2002): 698-99.

Lahr, John. "Gold Rush: Mel Brooks is back, mit a bing, mit a bang, mit a boom." Rev. of *The Producers*. *The New Yorker*, 7 May 2001: 84-86.

Magee, Bryan. *The Philosophy of Schopenhauer*. Oxford: Clarendon Press, 1983.

Marcus, Millicent. "'Me lo dici babbo che gioco è?': The Serious Humor of *La vita è bella*." *Italica* 77.2 (2000): 153-70.

Masi, Stefano. *La vera storia di Roberto Benigni*. Rome: Gremese, 1998.

Masi, Stefano. *Roberto Benigni*. Trans. Sandra Eido Tokunaga. Rome: Gremese, 1999.

Medici, Lorenzo de'. *La Nencia da Barberino*. Ed. Rossella Bessi. Rome: Salerno, 1982.

Milano, Attilio. *Storia degli Ebrei in Italia*. Turin: Einaudi, 1963.

Moscati, Massimo. *Benignaccio con te la vita è bella*. Milan: BUR, 1999.

Il mostro. Dir. Roberto Benigni. Columbia Tristar Video, 1995.

Night on Earth. Dir. Jim Jarmusch. Fine Line Features, 1991.

Offenbach, Jacques. *Les Contes d'Hoffmann*. Cond. André Cluytens. Orchestre de la Société des Concerts du Conservatoire. Compact disk, Emi Classics, 1989.

Parker, Deborah. *Bronzino. Renaissance Painter as Poet*. Cambridge: Cambridge University Press, 2000.

Patruno, Nicholas. "The Discomfort(s) of *Life is Beautiful*." "Roberto Benigni's *Life is Beautiful*: In Context, in Depth." Conference at the University of Pennsylvania, 29 Oct. 1999.

"Per Pinocchio: Benigni, accordo con la Miramax." *La Repubblica* 15 May 2001: 65.

Pinocchio. Dir. Roberto Benigni. Miramax, 2002.

Raymond, Didier. *Schopenhauer*. Paris: Seuil, 1995.

Rodini, Robert J. *Anton Francesco Grazzini: Poet, Dramatist and Novelliere (1503-1584)*. Madison: University of Wisconsin, 1970 .

Rolleston, T. W. *Life of Gotthold Ephraim Lessing*. 1889. Port Washington, NY: Kennikat Press, 1972.

Salizzato, Claver, and Vito Zagarrio, eds. *La Corona di Ferro. Un modo di produzione italiano*, Rome: DiGiacomo Editore, 1985.

La vita è bella. Dir. Roberto Benigni. Miramax Films, 1997.

-----. Awards won. The Internet Movie Database. http://www.imdb.com/title/tt0118799/awards.

Viano, Maurizio. "*Life is Beautiful*: Reception, Allegory, and Holocaust Laughter." *Annali d'Italianistica* 17 (1999): 155-72.

Section Two

A Prismatic Look at *Life is Beautiful*

Benigni's life-affirming lie: *Life is Beautiful* as an aesthetic and moral response to the Holocaust

Gefen Bar-on

Small children entering Nazi death camps had no realistic chances of survival. Together with other victims deemed unfit for work, they were generally gassed shortly after their tragic arrival. The cinematic narrative of *La Vita è bella* conflicts with this historical reality. The facts of life–more precisely, the facts of death—in concentration camps would make it unfeasible for a Jewish father to hide a child successfully, let alone provide him with spirit-lifting distractions: once broadcasting with him a cheerful message to his mother over the camp's radio system, and on another occasion helping him to emerge undetected from an accidental mingling with children of Nazi officers. This alteration of the reality of the Holocaust has fed the often angry reception of *La Vita è bella* among critics who consider historical accuracy to be a primary concern of Holocaust art. A number of critics have charged Benigni's film with distorting the reality of the Holocaust and injuring its historical memory for the purpose of popular success and material gain. One example is Stuart Liebman's reaction in *Cineaste*:

> For the last three months, I have a recurring nightmare. Somehow, I am sitting in the audience in the Academy Awards ceremony. Two glamorous figures, their identities indistinct, stand at the podium. They are about to announce the award for the "Best Foreign Language Film." The hall falls silent. "And the winner is…" They pause; the suspense slowly builds. "*La Vita è bella*, Roberto Benigni, director." The crowd goes wild. I wake up screaming…(20).

Liebman's rhetorical scream places the critic in a position of moral superiority over Benigni, the distorting director, as well as over the "wild crowd" that falls into the easy trap of enjoying his inventiveness and forgetting history. The nightmare that he experiences figures Liebman as a victim of the film. The success of Benigni's Hollywood rendition of the Holocaust abuses those members of the audience who stand apart from the multitude, who are morally sensitive and respect historical truth.

On the surface, realism is a reasonable requirement for art that deals with history, especially with an event as extreme as the Holocaust. The imperative never to forget, made more urgent by the growing problems of Holocaust denial and Holocaust minimization, requires that alterations of facts in Holocaust art be carefully scrutinized to ensure that they do not propagate injurious ideas. This is especially true for works with as wide a popular distribution as Hollywood films. And yet, critics who venerate accuracy in Holocaust art seem to ignore the problems of realism and oversimplify questions about the relationship between art and history. Hilene Flanzbaum recognizes that the demand for realism in Holocaust art is at odds with the diminished status of that artistic mode in general: "The assumption that realism as an aesthetic category is the most effective means by which artists can portray the truth has been debunked for at least a century" she says. "In the case of Holocaust art, however, that assumption still prevails" among critics who "feel a moral compulsion to preserve the memory of genocide in its most authentic form" and "position themselves as 'caretakers'" who demand "authenticity above all else (Flanzbaum 273-4). As visual medium, film heightens the demand to "mirror" historical reality. It raises the expectation that an accurate "document" of the event can be produced, transforming the Holocaust from something distant and incomprehensible into a thing that can be "viewed" and understood. That expectation, of course, is naïve. Steven Spielberg's *Schindler's List* has been widely

acclaimed as a successful representation of the Holocaust. And yet, the problems with the director's attempts at realism have not gone unnoticed. Miriam Baratu Hansen warns that by "posing as the 'real thing'" films can "usurp the place of the actual event." The attempts to give a direct representation to "an event that defies depiction, whose horrors render an attempt at direct representation obscene" risk "trivializing and sensationalizing" the Holocaust (Baratu Hansen 83). The survivor Elie Wiesel objects to the use of "special effects and gimmicks to describe the indescribable" and argues that "the last moments of the forgotten victims belong to themselves" (quoted in Doneson 179).

As the demand for realism continues to be articulated with persistence, the search for a different, more appropriate aesthetic code with which to represent the Holocaust is also a pressing concern. In an article about the aesthetic obstacles of Holocaust writing in his collection of essays, *The Wall and the Mountain: The Extra-Literary Reality of the Writer in Israel*, the Israeli novelist Abraham B. Yehoshua, one of Israel's most well-known writers internationally, brings much-needed precision to the Holocaust art debate by identifying five obstacles that cause major problems in Holocaust writing.[1] Israeli consciousness—and by extension Israeli literature—has been deeply impacted by the Holocaust. As a major national writer, Yehoshua is well positioned to understand that impact, and the obstacles that it imposes on writers who approach the Holocaust. *La Vita è bella* is neither Israeli nor literature—it is film. The obstacles that Yehoshua discusses, however, are not specific to a national literature or an artistic medium. The fundamental problems of representing the Holocaust do not derive from particular characteristics and limitations of country or genre; they are inherent in the Holocaust itself, in its unique place in history as an event that defies representation because it represents the worst in human

[1] The article is in Hebrew, and the references to it throughout this essay are my own translated paraphrases of Yehoshua's words.

nature. Therefore Yehoshua's discussion proves to be a useful lens through which to view Benigni's film because it highlights the need for non-conventional ways of representing the Holocaust.

To condemn *La Vita è bella* on the basis of its alteration of the facts is to assume that art's role in relation to history is to document, to give a human face to events in order to inform the public about them. Clearly, Benigni does not set out to instruct the audience about the facts of the Holocaust. Rather, he assumes their knowledge of the basic realities of the event—transportations, gas chambers, starvation. In turn, he uses that knowledge to generate tragic irony, which functions as the film's moral voice. When judged in light of the obstacles of Holocaust art, *La Vita è bella* emerges as an aesthetic and moral triumph in its ability to utilize viewers' knowledge of the Holocaust in order reawaken in them a critique of the absurdity of the Nazi mentality. With its energetic portrayal of irrepressible goodness and humanity, the film also asserts an alternative set of values founded on solidarity and family love that is essential to the moral survival of humanity in a post-Holocaust age. As such, *La Vita è bella*, I argue, is possibly the most *morally* accurate film about the Holocaust ever made. In its rejection of mimetic realism, it offers poignant meta-cinematic commentary about the limitations of art in imitating the un(reality) of the Holocaust and about the need to find new artistic ways to engage with the event.

The failure of realism to provide an aesthetic response to the Holocaust is rooted, according to Yehoshua, in the problem of identification. For him, this is the first obstacle of Holocaust art. The power of art relies on the ability of the readers or viewers to perform a realization of the works in their minds, to make connections between what they see or read on the one hand and what they know about the world through their own experiences on the other hand. The singular, horrifying characteristics of the Holocaust severely impair the process of identification, making it impossible to

imagine parallels between our life and the experience of the Holocaust, at least not in conventional ways (Yehoshua 136-37). *La Vita è bella* provides viewers with more possibilities for identification than a "mimetic" Holocaust film by allowing for unrealistic continuity between life before the camp and in the camp. To protect Joshua from the truth, Guido convinces him that the Holocaust is an elaborate competitive game, thus encouraging him to think about the horror and the struggle to survive in "familiar," "exciting" terms. Some of the key experiences depicted in the first part of the film return in "mutated" forms to "soften" the experience of the camp. Joshua's vehement resistance to taking showers, established in the family home in Italy, is what saves him from the gas chambers. Guido's and Dora's love for Offenbach bonds them from a distance when he places a record player on the window of the Nazi headquarters building and broadcasts the Barcarolle, their favorite tune. The magical belief in Schopenhauer's theory of will power that Guido gleans from his poet friend Ferruccio in Italy helps him to save Joshua from the Nazi-trained dog.

The "survival" of the hero's charisma, the persistence of his way of being, even in the concentration camp, runs the risk of minimizing the degree to which life in the Nazi camps deviated from anything that could be termed normal, the degree to which the camp experience shattered and depressed the light of human personality. The sharp discontinuity between life before the camp and in it is one of the most persistent themes of survivor accounts. In *Survival in Auschwitz*, Primo Levi defines the reality of the camp as hell: "This is hell. Today, in our times, hell must be like this." (22). He emphasizes that the reality of the Lagers, the camp barracks, could not be described in familiar terms:

> Just as our hunger is not the feeling of missing a meal, so our way of being cold has need of a new word. We say 'hunger', we say 'tiredness', 'fear', 'pain', we say 'winter' and they are different things. They are free words, created and used by free

men who lived in comfort and suffering in their homes. If the Lagers had lasted longer a new, harsh language would have been born; and only this language could express what it means to toil the whole day in the wind, with the temperature below freezing, wearing only a shirt, underpants, cloth jacket and trousers, and in one's body nothing but weakness, hunger and knowledge of the end drawing near (123).

The reality that survivors such as Levi attempt to explain is not imitated in Benigni's film. Guido, Joshua, Dora and the uncle all experience shock upon their arrival at the camp, but that shock is significantly softened by Guido's ability to maintain, perform and generate happiness. The deprivation of freedom that the characters experience is manifest in the significant reduction in the physical humor that Guido is able to perform after the family enters the camp, but even in those extreme conditions, his charming personality flourishes relatively unaltered.

Did Benigni soften the Holocaust too radically? Did he "overcome" the obstacle of identification too easily and superficially, at the risk disrespecting and misrepresenting historical experience? Is it wrong to enjoy the film's uplifting ending as Joshua exclaims "We won...we won!" (Benigni and Cerami 162) when his survival is predicated on a distortion of historical reality—a reality responsible for the death of millions of real children, a reality in which the few that survived generally emerged from the camps as abject skeletons, for the most part incapable of such energetic reactions? Not only is the child's survival unrealistic; the psychological premise that facilitates the film's ending risks entering into a dangerous dialogue with the phenomena of Holocaust minimization and distortion. Joshua accurately reports the reality in the camp when he tells his father that "a man was crying and he said they make buttons and soap out of us...They cook us in the ovens!" (Benigni and Cerami 131). His shock and sadness are consistent with historical accounts of survivors who describe learning the truth about the camp. Guido, however, does not permit Joshua's shock

to mature into a full recognition of horror. He responds with laughing denial which would be impossible to sustain in a real concentration camp:

> Joshua! You fell for it again! And here I thought you were a sharp kid! *He smiles.* Buttons and soap. Right. And tomorrow morning I'm washing my hands with Bartholomew and buttoning my jacket with Francesco and my vest with Claudio...*He is laughing as he pulls a button off his jacket and lets it fall on the floor.* Uh-oh, Giorgio fell off! . . . They cook us in ovens? I've heard of a wood burning oven, but I never heard of a people burning oven. Oh, I'm out of wood, pass me that lawyer over there! No, that lawyer's no good, he's not dry! Come on, Joshua, get with it! Let's get serious now (131-32).

The charge of Holocaust distortion that has been directed at Benigni seems to embody the assumption that the audience's historical understanding of the Holocaust would be modified through their identification with the child's point of view. This is a simplistic position that underestimates the sophistication of both the film and its audience. Guido's difficulty in explaining the reality of the camp to a son whom he is determined to protect is not Holocaust distortion. Rather, it reminds the audience of the difficulty of articulating the reality of the Holocaust in a language predicated on love and civility, in a language designed to save and celebrate, rather than to destroy, life. The challenge that Guido faces also mirrors the difficulty that is at the core of Holocaust art—the difficulty of people who are humane and good natured to represent a reality controlled by people who lack these qualities.

For a culture that has lived with knowledge of the Holocaust for over half a century, the danger of denial is accompanied by the equal danger of desensitization. As "realistic" images of the Holocaust flood popular culture, there is a danger that the event will increasingly become identified with a series of commonly known historical facts

and pictures, and hence lose its power to horrify. The distance that Benigni's film maintains from realistic depictions of the Holocaust enables the director to use history to remind the audience of the moral lessons that it contains. Guido's protective conversations with his son awaken in the viewers the horror and disbelief that the Holocaust *must* continue to generate in a culture that has become so familiar with its basic facts and images. The audience knows that "people burning ovens" *did* exist in concentration camps, and that the victim's body parts were indeed used to produce buttons and soap. At the same time, they recognize Guido's denial as an attempt to shelter his son from an absurd reality. His protective denial serves as a reminder that our "pornographic" familiarity with the Holocaust should never numb our reaction against the mentality that produced that tragedy. In a place that turned human beings into objects, Guido transforms objects back into humans, using humor to highlight the absurdity of Nazi perversion: "And tomorrow morning I'm washing my hands with Bartholomew and buttoning my jacket with Francesco and my vest with Claudio," he tells his son in mocking disbelief. His call to Joshua, "let's be serious now" does not undermine the seriousness of the Holocaust. To an audience familiar with its perversions, it evokes tragic irony which resonates with moral outrage.

Tragic irony, a device dating back to Greek tragedy, is generated when the audience or the reader has knowledge of a tragic outcome which the character lacks. Writers of Greek tragedy could use that irony effectively because they wrote for an audience who was already familiar with the tragic fate of the hero (Abrams 99). Benigni finds himself in a similar position in relation to the Holocaust and uses the audience's familiarity with the event to enact art's moral responsibility in relation to history—not only to document, but also to comment. It is unfair to uphold accuracy as a central criterion for evaluating the film when accurate knowledge of the Holocaust is precisely what Benigni requires the viewers

to bring with them to the film in order to experience its emotional and moral effect. Viewers who understand the Holocaust empathize with the father who is determined to shelter his son from its horrors. To them, Guido's denial of the reality of the camp only emphasizes the degree to which the Holocaust deviated from any "normal" circumstances that could be explained to a child.

The process that leads Guido to that denial sheds light on the incomprehensibility of the Holocaust, on the difficulty of the civilized mind, and of the artistic mind, to describe the event in familiar terms. Before the camp, Guido's attempts to reassure his son take the form of "rationalization" rather than flat-out denial. Guido "explains away" Italy's racist policies using human phenomena that would be comprehensible to a child. He explains that a sign forbidding dogs and Jews from entering a store by appealing to the legitimacy of individual preferences: "People do as they please!" The next day, Guido tells Joshua, they too will prohibit spiders and Visigoths from entering their own store—after all, Joshua does not like spiders (Benigni and Cerami 82-83). The reality of the gas chambers, unlike "milder" forms of persecution, cannot be "explained away," and hence the turn to denial. What some critics view as distortion can, in fact, be understood as a warning against Holocaust minimization, as the transition from "rationalization" to "denial" highlights the distinctions between the Nazi extermination machine and less extreme forms of oppression. To facilitate Joshua's survival in the camp, Guido literally assumes the role of a translator, who also becomes a transformer of reality. He translates the decrees of those who have no respect for human life in terms that would encourage his child. When the Nazi Corporal shouts "You are privileged to work for our great Germany, building our great empire!," Guido translates: "We play the mean guys, the ones who yell! Whoever's scared loses points!" (Benigni and Cerami 110). That his translation is necessarily a distortion is a reflection of the distorted moral

reality that the speech communicates, not of a moral flaw of Benigni's art. In his memoir, Levi describes the torture of a man who was forced to act as an interpreter in the camp: "One sees the words that are not his, the bad words, twist his mouth as they come out, as if he was spitting a foul taste" (24). Guido's translation, on the other hand, "speaks back" to the reality of the madness and humiliation into which he is forced and enacts humane values that seek to transform it.

La Vita è bella is not unusual in being a Holocaust narrative with family and romantic love at its centre. Many Holocaust narratives depict love and friendship in the midst of horror. However, it is often questionable whether their characters are worthy of interest in their own right, beyond their entanglement in the historical situation. Yehoshua identifies this uneven relationship between character and history as the second obstacle of Holocaust art (138). Are the characters merely vehicles of history, victims of the situation not only historically, but also artistically? This charge is hard to make for *La Vita è bella*, in which the charismatic Guido captivates the audience from the beginning of the film, even before the historical subject matter comes to the forefront. Hints of the ominous period loom over the film from the beginning: Guido's gesture to the crowd to move away from the speeding car in the opening scene is mistaken for the fascist salute; his car's headlights entering the city illuminate posters of the fascist leader; his uncle is attacked by a gang as Guido and Ferruccio enter his house. These, however, are initially no more than subtle shadows placed in a film which appears to be about a subject matter quite independent from historical events: Guido's adventures in the city and his courtship of Dora. The audience discovers that Guido is Jewish only well into the film when his uncle's horse is vandalized. Guido, however, uses humor to deflate the warning message: "What can they do to me? The worst they can do is strip me, paint me yellow, and write, 'Attention, Jewish waiter! Come, let's go, Uncle...I didn't know that this horse was Jewish. I'll clean him up for you

tomorrow morning, okay? (65). Guido's optimism recalls the hopefulness of many Jews who underestimated the dangers of Nazi oppression. His assumption about what the worst possible scenario might be generates tragic irony that highlights the Holocaust's violation of previously imaginable boundaries. His claims of ignorance about the horse's "Judaism" mirror the audiences ignorance of Guido's own background. The claim that the horse is Jewish speaks to the absurdity of race as a category. It is a classification that does not seem to mean much to Guido. Benigni presents Guido as an assimilated Jew who does not perceive himself as belonging to a separate category from the rest of the local population and does not seem to regard himself as much more Jewish than the horse. He does not hesitate, on one comic occasion, to implore the Christian Madonna to help him obtain the key to Dora's heart. The aura of universalism enveloping the hero flies in the face of identity politics, which have been a force in the Holocaust discourse. This is possibly one additional reason for the irritation of some viewers with the film.

The relative distance from history in which Benigni positions his hero does not imply indifference to historical problems. While Guido is not an ideological person, the film nevertheless communicates a strong anti-fascist and anti-Nazi message. From the beginning, when Guido's visit to the school to see Dora provides him an unexpected platform for a farcical satire of race theory, the couple's love is juxtaposed with the intolerant atmosphere of the regime. Dora's house is called Liberty, an ironic contrasting reminder of the sinister Auschwitz slogan that work liberates. When the headmaster asks how much the state would save if unfit individuals were eliminated, Dora is horrified, but her disgusted exclamation "I can't believe it" is wrongly appropriated by the fascist headmaster as an appreciation of the German "race:" "That exactly was my reaction, Dora! Good Lord, it can't be! That a child of seven can solve a problem like this? It's a difficult equation: the

proportions, the percentages. Throw in a little algebra. For us it's high school material...It's truly another race" (Benigni and Cerami 68-69). This miscommunication draws attention to the absurdity of the reality around them and necessitates Guido and Dora's escape into a self-created sphere. When Guido takes his "princess" away on the maliciously painted "Jewish" white horse, she enters with him into a private universe where human values can be enacted against a dehumanizing historical reality. In that sense, the couple's marriage and the birth of their son are also political statements. Guido's attempts to protect his son provide a platform for the film's anti-fascist message. When Guido is taken away from his store to the Police Headquarters, he delivers his condemnation of that unfair act through an apparently routine reminder to his son: "careful how you treat your customers" (Benigni and Cerami 85). When he is pushed by German soldiers into the freight car, he responds with a single "magic" word that is designed to reassure his son of the normalcy of the situation, and also functions to assert human decency in the face of brutality—"Thanks" (Benigni and Cerami 98).

La Vita è bella represents goodness amply and generously. But how effective is this touching story of romantic and parental love in representing evil? A third limitation of Holocaust aesthetics derives, for Yehoshua, from the pathetic nature of the event that juxtaposes innocence and evil, helpless victims and cruel murderers. Literature, Yehoshua argues, tends to thrive when it deals with morally ambiguous situations in which the distinctions between good and evil are not easy to make. The Holocaust, however, does involve extremes of evil and innocence that tend to invite automatic identification with the victims and hence are not typically conducive to artistic achievement. Works of Holocaust art, he observes, tend to be more successful when they focus not on the basic conflict between murderers and victims, but on relationships within each group (Yehoshua 138). *La Vita è bella* does present the

victims as good characters fully worthy of empathy. It does not probe the thorny ethical questions and moral differences that often affected relationships among Jews in the death camps. The film does, however, fruitfully explore the question of Nazi evil through the character of Dr. Lessing, a German guest who patronizes the restaurant where Guido works in Italy and later reappears as a concentration camp doctor. The question of how "civilized" people can commit acts of extreme evil runs through many works of Holocaust literature and film. Lessing is more complex, and possibly more accurate, than some other cinematic renditions of the "civilized Nazi" because he is not simply a person who is civilized on the one hand, but commits atrocities on the other hand. Benigni calls into question the nature of the doctor's "civility" not simply by depicting his involvement in atrocities, but by showing that his "cultured" pursuits—specifically his love of intelligent riddles—are empty of moral content, and that they contribute to his blind indifference to the reality of suffering that he has helped to create.

When the audience first encounters him at the hotel restaurant, Lessing appears as a civilized gentleman, pleasant and intelligent, if somewhat obsessive. Before his departure for Berlin, Lessing bids farewell to "the cleverest waiter [he has] ever known," a genius in the fine art of riddles, while Guido on his part tells the Berlin-bound doctor that he is "the most cultured guest [he has] ever served" (Benigni and Cerami 67). The doctor's preoccupation with solving riddles, a task in which Guido assists him, appears to corroborate his image of refined intelligence. In the camp, however, this "cultured" hobby becomes a positive source of horror. Guido is very hopeful when Lessing recognizes him and invites him to wait at the SS party. The encounter with a beloved waiter seems to awaken the doctor's humanity, and Guido trusts that Lessing has devised a plan to help him escape the camp. He is confident of that intention when he informs Lessing that Dora is also imprisoned. "Okay, Guido,

listen carefully," the doctor whispers after intentionally spilling a glass to summon the anxious prisoner:

> Fat and ugly as can be, and all yellow—that's me. Ask me what I am, I answer cheep, cheep, cheep! It is the Ugly Duckling—but it's not! I haven't slept in four months. A veterinarian friend sent it to me from Vienna, and I can't send him mine until I solve this one...I thought maybe a platypus, but it doesn't say cheep, cheep! The platypus goes frrr...frrr...I translated it into Italian for you last night. What do you think? Everything points to the Ugly Duckling. Help. Guido! (Benigni and Cerami 145)

This is the picture that Benigni paints: not a sadistic monster, but a mind obsessed with a task, oblivious to the tremendous suffering of others, to the obvious fact that it is them, not he, who desperately need help. It is his inability to solve a riddle, not the horrors around him, that deprives Lessing of his sleep. He recruits Guido from the concentration camp barrack to wait tables at the party for no other reason than the hope that he would save him from intellectual "torture." In the process, he provides the viewers with a possible answer to the "riddle" of how the "civilized" Nazis committed atrocities: with the same inflexibility and selfishness, barely distinguishable from mental insanity, with which they approached their "civilized" hobbies and pursuits. It is Dr. Lessing, not Benigni, who disrespects history in his grotesque lack of proportion, in his apparent inability to recognize the horror which his actions have helped to create.

Though tragically absurd, Dr. Lessing is not a wholly unrealistic character when viewed in the light of historical accounts of concentration camp doctors. In *The Nazi Doctors: Medical Killing and the Psychology of Genocide*, Robert J. Lifton documents the indispensable role of doctors in the Nazi extermination machine, a system which was repulsively "rationalized" as "racial healing." According to one of the survivors that Lifton interviews, "the killing

program was led by doctors—from the beginning to the end." The doctors' involvement in the killing machine was comprehensive and included many tasks:

> First, the chief doctor assignments to his subordinates concerning duty schedules and immediate selection policies; second, the individual doctor's service on the ramp, performing selections "in a very noble [seemingly kind] manner"; third, the doctor riding in the ambulance or Red Cross car to the crematoria; fourth, the doctor ordering "how many [pellets] of gas should be thrown in...these holes from the ceilings, according to the number of people, and who should do it . . . "; fifth, "he observed through the hole how the people are dying"; sixth, "When the people were dead, . . . he gave the order to ventilate, . . . to open the gas chamber, and he came . . . with a gas mask into the chamber"; seventh, "He signed a [form] that the people were dead . . . and how long it took"; and eighth, "he observed . . . the teeth . . . extraction [from] the corpses." (Lifton 166).

Otto Wolken, an Austrian-Jewish prisoner physician, reports that SS doctors Mengele and Thilo "made their selections while whistling a melody" (Lifton 165). According to another Auschwitz prisoner doctor, the SS doctors

> did their work just as someone who goes to an office goes about his work. They were gentlemen who came and went, who supervised and were relaxed, sometimes smiling, sometimes joking, but never unhappy. They were witty if they felt like it. Personally I did not get the impression that they were much affected by what was going on—nor shocked. It went on for years. It was not just one day (Lifton 193).

The incomprehensibility of the Holocaust derives, in part, from the gap between the extreme suffering, and massive death, of the victims on the one hand, and the cool, "civilized" manner of the murderers on the other hand, their ability to commit atrocities over the period of years as if they

were simply doing "work," while also pursuing their "cultured" hobbies at the same time. The Nazi mentality is profoundly unsettling because it disassociates qualities like "organization," "planning" and "intelligence" from their normally positive connotations. The "very noble, [seemingly kind] manner" of many Nazis calls into question one of the assumptions upon which our trust in others is founded: that there is a correlation between "civilized" behavior and moral character. Benigni is fearless in his confrontation with that assumption, in his depiction of the darkness within German civilization.

Before the arrival in the camp, Guido and his family try to mentally locate evil outside the boundaries of civilization. When Guido's uncle is assaulted by a fascist gang in the beginning of the film, the old man dismisses his attackers as "barbarians." His insistence that "silence is the loudest cry" (Benigni and Cerami 10) mirrors the passive, "patient" initial response of many Jews to Nazi persecution. Political conflict is initially presented as a children's violent game when the upholsterer scolds his strategically named pillow-fighting sons: "Benito! Adolf! Behave" (Benigni and Cerami 15). With the entry into the camp, however, it becomes clear that evil can no longer be located outside the sphere of "civilized" behavior. To imbue him with enthusiasm about the game, Guido tries to impress Joshua with the skill of the "organizers:" "Look at that organization!" (Benigni and Cerami 103). The depiction of the Holocaust as a well-organized perverted "game" is tragically, absurdly, accurate. Levi describes a belief that he developed in the camp that "all this is a game to mock and sneer at us" (24). Lessing, it seems, approaches riddles with the same seriousness and inflexibility with which he approaches his role as camp doctor. While La Vita è bella pays respect to German culture (respect that many European Jews shared) through Guido's appreciation of Offenbach and Schopenhauer, the film ultimately probes the problems with that culture—in

particular its dangerous tendency for amoral inflexibility—more deeply than other Hollywood films.

The reality created by "cultured" people such as Lessing exceeded the most twisted nightmare imaginable. As such, the Holocaust paradoxically places restrictions on the creative imagination of artists, limiting their use of some of art's most effective tools such as humor and irony. Yehoshua's fourth obstacle of Holocaust art is concerned with these aesthetic restrictions (Yehoshua 139). Much has been said about humor in *La Vita è bella*, about its power to affirm humanity in the face of evil, but also about its questionable legitimacy. I have already argued that Benigni's humor produces tragic irony that, far from disrespectful to the Holocaust, functions to highlight the absurdity of the event. But does Benigni's "creative license" distort the experience of concentration camp victims who were totally deprived of their freedom and were often beyond the possibility of hope and encouragement? In convincing Joshua that what he sees around him is a game, Guido essentially uses the same technique as a fitness instructor. Standing in front of a class of exhausted people, the cheerful instructor exclaims something along the lines of "this is fun!", and the exercisers are encouraged by being told that the painful experience is in fact a pleasurable activity. But is it wrong to suggest that the same technique, essentially, would be effective in a death camp? Clearly, as explained before, what Guido does would not be possible in the Holocaust. And yet, Guido's strategies cannot be dismissed as disrespectful to the experience of the Holocaust without examining the role that the imagination played in real stories of survival. The role of "the life of the mind," to use Tzvetan Todorov's term in *Facing the Extreme: Moral Life in the Concentration Camps*, is acknowledged in many survival accounts. Holocaust memoirs abound in stories of victims who did everything in their powers to comfort beloved family members, in particular children. Imagination, acting and "pretence" often assumed a central function in the

attempts of victims to encourage themselves and one another. One example is documented in Lifton's book:

> Dr. Henri Q. stressed the importance of humor, telling of a middle-aged French-Jewish dentist who kept "making jokes, laughing, and telling us stories": "I told myself he was completely crazy." He would say such things to Dr. Q as "Dear Marquis, at five o'clock we are to have tea together," making Q. wonder whether the dentist "did not realize what was going on here." But, in retrospect, he helped the prisoner doctors "by telling his stories"—that is, by creating a consistent debunking alternative, however unreal, to the terrible actuality (Lifton 222).

There are important differences, of course, between Henry Q. and the French dentist on the one hand and Guido and Joshua on the other hand. Dr. Q is aware of the unrealistic nature of the "tea talk." Joshua, however, while expressing some doubts about his father's story, generally seems to believe him (or perhaps decides to believe him). Joshua's survival, facilitated by the powers of his father's imagination, is, as explained before, unrealistic. The basic premise upon which *La Vita è bella* is based, however, that love and the imagination assist in the struggle to survive by providing a "consistent debunking alternative" to reality, is not as alien to the world of concentration camps as it may at first appear.

Yehoshua's final difficulty of Holocaust art derives from the ultimate inexplicability of the event. According to Yehoshua, no matter how hard one tries to grasp the reality of the Holocaust, some aspects of it will forever remain incomprehensible. To portray the Holocaust accurately, the artist must not trivialize or rationalize these aspects, but rather represent their confounding effect on the human mind (Yehoshua 139-40). To charge Benigni with disrespect for the Holocaust is to suggest that he attempted to overcome this obstacle too easily through Guido's invention of the "game." Benigni, however, makes it clear in key moments in

the film that while Guido does everything in his power to protect his son, the Holocaust is nevertheless incomprehensible and horrifying to his own self. In the truck that carries them to the camp-bound train, Guido reassures Joshua that the trip is part of a family tradition: "It makes me laugh. My daddy organized the same thing for me when I was a little boy" (Benigni and Cerami 97). When Joshua falls asleep, however, Benigni takes advantage of the opportunity to inform the audience that the father's reassuring air does not reflect his own mental state. With a "worried and disbelieving expression," Guido stares into his uncle's eyes and asks: "where are they taking us? Where are we going?" (Benigni and Cerami 96). Towards the end of the film, Joshua's sleep once again provides the conditions for a confrontation with horror when Guido encounters a pile of corpses, a familiar image of the Holocaust. Liebman seems to trivialize the scene: "Yet there are occasional disconcerting moments. When Guido wanders off in the fog one evening, he finds himself in front of a huge (and obviously painted) pile of corpses whose presence seems to surprise him but which otherwise has no lasting effect" (Liebman 21). Both the *opinion* that the scene has no lasting effect and the qualifier "obviously painted" are designed to call Benigni's commitment to the authenticity of the Holocaust into question. The picture of the corpses is not, in fact, simply painted, but is based on archival images that the audience should easily recognize. Rather than undermine the importance of history, that scene reminds the audience of the complicated question of art's use of historical materials to deal with horror. That the presence of death does have a "lasting effect" becomes clear towards the end of the film when Guido is murdered.

Hanna Yaoz explains the "tendency towards the fantastic" in second-generation Holocaust writing in terms of the "fantastic" qualities of the event itself: "what the Nazis did deviated from any former reality and pushed the imagination to the absurd, so when we speak of the

Holocaust the fantastic *is* real" (Yaoz 164). Her observation is helpful for understanding Benigni's turn away from realism. The director never turns away, however, from history itself. By integrating an archival picture into his film, Benigni signals to the audience that his work is a commentary about a historical reality, not an attempt to escape it. His cinematic aesthetic rejects mimetic realism, but it never denies history. If on one end of the aesthetic spectrum lies mimetic realism, on the other end lies aestheticism. In "The Decay of Lying," Oscar Wilde pleads for "Lying in art," for the "telling of beautiful untrue things" (292-3, 320). Realism, for him, is a failure, and there "is such a thing as robbing a story of its reality by trying to make it too true" (295). In some ways, Benigni's alterations of facts are "lies" in the Wildean sense, asserting beauty against the ugliness of reality. But the aesthetic ideal of "art for art's sake" cannot hold for Holocaust art. Theodor Adorno's well-known statement about the impossibility of poetry after Auschwitz challenges the independence of art from history and morality. It would be absurd to argue that Holocaust art, if it can exist, does not have a moral obligation to maintain the memory of the event. Barbie Zelizer, writing on *Schindler's List*, notes that "ground zero of historical representation is, and must be, the event itself" (Zelizer 21). Benigni's cinematic aesthetics sees art as a tool of response, not of replication. It serves the memory of the event by drawing attention to the moral lessons that can be learned from it. The story of *La Vita è bella*, Joshua informs the viewers in the beginning of the film, is not an easy one to tell. But Benigni is not paralyzed by the difficulties of Holocaust art; his non-conventional approach to portraying the camp experience successfully confronts the obstacles of Holocaust art discussed by Yehoshua. In its power to speak back to the experience, *La Vita è bella* is not another artistic "victim" of the Holocaust, but a potent meta-artistic statement on the power of art to confront evil.

*I would like to thank Alexandra Peat for her helpful comments. All remaining errors are my own.

Works Cited

Abrams, M.H. *A Glossary of Literary Terms*. Sixth Edition. Orlando: Harcourt Brace College Publishers, 1993.

Benigni, Roberto and Vincenzo Cerami. *La Vita è bella: A Screenplay*. Trans. Lisa Tarushio. New York: Hyperion Miramax Books, 1998.

Doneson, Judith E. *The Holocaust in American Film*. Philadelphia, New York, Jerusalem: The Jewish Publication Society, 1987.

Flanzbaum, Hilene. "But Wasn't it Terrific?": A Defence of Liking *La Vita è bella*." *The Yale Journal of Criticism* 14.1 (spring 2001): 273-286.

Hansen, Miriam Bratu. "*Schindler's List* is Not *Shoah*: Second Commandment, Popular Modernism, and Public Memory." *Spielberg's Holocaust: Critical Perspective on Schindler's List*. Ed. Yosefa Loshitzky. Bloomington and Indianapolis: Indiana University Press, 1997. 77-103.

Levi, Primo. *Survival in Auschwitz: The Nazi Assault on Humanity* (1958). Trans. Stuart Woolf. New York: Simon and Schuster, 1996.

Liebman, Stuart. "If Only Life Were So Beautiful." *Cineaste* 24.2-3 (1999): 20-22.

Lifton, Robert Jay. *The Nazi Doctors: Medical Killing and the Psychology of Genocide*. New York: Basic Books Inc. Publishers, 1986.

Todorov, Tzvetan. *Facing the Extreme: Moral Life in the Concentration Camp*. New York: Henry Holt and Company, 1996.

Wilde, Oscar. "The Decay of Lying: An Observation." *The Artist as Critic: Critical Writings of Oscar Wilde*. Ed. Richard Ellman. Chicago: The University of Chicago Press, 1968. 290-320.

Yaoz, Hanna. "Inherited Fear: Second-Generation Poets and Novelists in Israel." *Breaking Crystal: Writing and Memory after Auschwitz*. Ed. Efraim Sicher. Urbana and Chicago: University of Illinois Press, 1998.

Yehoshua, Abraham B. "The Aesthetic Obstacles of Holocaust Literature" (citations are based on my own translation of the Hebrew original). *The Wall and the Mountain: The Extra-Literary Reality of the Writer in Israel*. Tel Aviv: Zmora Bitan Publishers, 1989.

Zelizer, Barbie. "Every Once in a While: *Schindler's List* and the Shaping of History." *Spielberg's Holocaust: Critical Perspective on Schindler's List*. Ed. Yosefa Loshitzky. Bloomington and Indianapolis: Indiana University Press, 1997. 18-40

La torta etiope e il cavallo ebreo: Metaphor, mythopoeia and symbolisms in *Life is Beautiful*

Laura Leonardo

Tra l'orrore e il ridicolo il passo è un nulla
Eugenio Montale

Benigni defined *La vita è bella* as: "un film fantastico, quasi di fantascienza, una favola in cui non c'è niente di reale, di neorealista, di realismo" (a fantastical film, almost science fiction, a fairytale with no reality, no neo-realism, no realism in it)[1] yet since its first screening the very lightness of the tone of the film, exhibited perfectly in Benigni's playful words, has seemed to many to be intuitively offensive. Detractors and enthusiasts alike have debated its worth focusing their discussion on the legitimacy of its apparently whimsical, a-historical approach to a topic as tragically real as the Shoah. Such treatment is not apt for such matter. The main controversy surrounds the historical accuracy (or lack thereof) within the context of the film, through which Benigni tells his story. However, such historical inaccuracy and lack of factual truth, as I hope to demonstrate in the following pages, are necessarily indispensable to the real techniques of Benigni's film. The fulcrum of my discussion will be the fairy tale element present in the film and the myths, symbols and metaphorical images that the director uses to create an indirect representation of a history assumed to be unrepresentable.

Many critics saw *La vita è bella* as an inexcusable attempt to ridicule and diminish the enormity of the Nazi persecutions and labelled it an egotistical, horrific attempt to ignore the real dimension of the holocaust of six million

[1] R. Benigni, "Il mio film", in *Corriere della Sera*, 19th December 1997 (all translations are my own unless otherwise stated).

Jews. This perspective naturally leads to the accusation of revisionism: Benigni's film portrays a distorted and inaccurate version of historically documented facts and he even attempts to re-write the horror of the Nazi's extermination camps, intentionally leaving out any distressing details. Hoberman, in a highly opinionated piece, argues that the film: "for its first half is a cheerfully antifascistic slapstick romp" before turning, midway, into a "stunningly inappropriate" representation of the horrors of the concentration camps (Hoberman 4). The director's arguably light-hearted approach to the Shoah has been seen as an attempt to conceal reality and parallels have been drawn between the way in which Guido in the fiction shelters his son Giosuè from the horrors of the camp and its nightmarish reality, and a supposed attempt on Benigni's part to shelter his public from the vision of evil and the perception of the appalling truths connected with the historical facts.

Moreover, some of the fiercest critics have read Benigni's film in a negationist perspective, accusing it of denying the true extent or even the very existence of the Holocaust by producing a reassuring, consoling, domesticated film where blandly portrayed evil is counterbalanced by a lame *buonismo* and a sublimation of good sentiments in a mixture of clownesque and Chaplinesque delivery. The negationist point has been one of debate amongst Jewish scholars, camp survivors and the Jewish press and although the film met large success in Israel and within the Italian Jewish community, it nevertheless attracted serious criticisms from several Jewish sources. "The enormous success of 'Life Is Beautiful' suggests that the audience is exhausted by the Holocaust, that it is sick to death of the subject's unending ability to disturb" (Denby 99), wrote the *New Yorker* ten days before the Oscars ceremony. Drawing on Adorno's famous assertion, referred to as the "11th Commandment", that there could be no more poetry after Auschwitz, critics questioned

the right of anybody, let alone a non Jewish, comic actor/director, to approach something as tragic as the Shoah. They appropriated Adorno's belief declaring that "after Auschwitz, our feelings resist any claim of the positivity of existence as sanctimonious, as wronging the victims; they balk at squeezing any kind of sense, however bleached, out of the victims' fate" (Hoberman 4).

So how did Benigni dare to give form and meaning to what is seen as a completely irrational event, even going as far as to insert comical elements? Furthermore how dare he go against the axiom formulated by Elie Wiesel that only survivors have the right to talk about the Shoah? I believe that those who accuse Benigni's film of revisionism or *negazionismo* commit a fundamental interpretative error as they begin from the assumption that Benigni was involved in a "realist" endeavour. Instead I believe *La vita è bella* to be a metaphorical transposition of fascist myths and propaganda to fairy tale canons, a deep focus tale that concentrates on the individuality of a family's experience in order to render meaningful the universality of the events that supply its context.

Having spent months working with the *Centro Documentazione Ebraica Contemporanea*, having read all he could on the Holocaust, Benigni made the conscious choice to abandon the historical perspective, adopting "an approach that recognizes the event as so vast and incredible that it defies description" and "defend[ing] himself against charges relating to the film's suspension of disbelief by citing Proust and Poe, who felt that a story should never provide all the details but should allow room for the reader's or spectator's imagination" (Celli 113). He chose to tell a fairy tale that does not trivialise the historical element but, like all fairy tales, simply does not depend on it and can resort to fantasy and imagination to tell a human story of love and devotion. "Sto girando un film sdrammatico, che ha la commozione nel cuore mentre una risata vola sulle realtà più tragiche" (I am making an undrammatical film, that has

emotion at its heart, while laughter flies over the most tragic reality) (Grassi 1), he told the *Corriere della Sera* and in a later discussion for an online French cinema review, he warned his critics to approach his film aware of the fact that "il ne faut rien y chercher de réaliste" (One should not look for any realism in it) (Entretien 1). It is in comments such as these that there exists, perhaps, the key to a different and valid interpretative approach to the film; one which may yield a defence of the film as a whole.

Benigni has always insisted that the apparent historical mistakes in *La vita è bella* are not due to ignorance or lack of accuracy; rather these inaccuracies were carefully created and deliberately employed. Admitting that there are various anachronistic details in his film, Benigni disclosed his aim of remaining free to treat his subject without being held responsible for misrepresentation. After all, the film "is not a documentary, and it is not a theory about the Holocaust" and in Benigni's opinion: "to show proper respect the best thing to do is stay away from the reality" (Wooton). Does this approach diminish its value as a respectful, if unusual, attempt to make us once again remember? I believe it does not as the film is, first and foremost, a fairy tale, that depicts "une idée – au sens quasi platonicien – […] l'idée d'une antre du Mal, d'une antre du monstre. Comme dans un conte pour enfants" (An idea – almost in the Platonic sense – the idea of Evil's lair, of the monster's lair. As in a fairy tale) (Entretien).

I will argue that *La vita è bella* has been thought, written and shot following the classic canons of the fairy tale and, analysing it from a structuralist perspective, I would like to devote further attention to at least two distinctive paradigms woven into the plot. Both are represented by Guido's and Dora's love story: the imprisoned princess and the prince toad. First, a prince is in love with a princess who is imprisoned in an inaccessible tower (her commitment to fiancé Rodolfo that embodies fascism). The prince will successfully manage to liberate his love's desire and they

will live happily ever after (or at least until the end of their fairy tale that coincides with the end of the first part of the film). Second, the prince has been transformed into a toad by an evil witch (fascism and its impositions on him) and he is ultimately rescued by Princess Dora who kisses him under the table at the engagement party so that he, reinstated as prince, is able to find the courage and strength to penetrate the witch's cave (the Grand Hotel) and (metaphorically) destroy it with the help of his white charger.

The interest in analysing the film's subplots in a formalist frame lies in the parallel that can be established between two very differently aimed mythopoetic systems: Guido's and the fascist regime's propaganda. The manipulation of historical truth that Benigni uses in the fiction represents a parody of that employed by Mussolini and his regime during the fascist *ventennio* and conveys a conscious critique of Italian fascism.

Guido uses the techniques of fascism to combat fascism; his actions, his words, ironically deconstruct the very system which seeks to destroy him. The obvious fairy tale aspect of the first part of the film arms the viewer with the means to assimilate and comprehend the second part. There are more myths and fairy tales in the film that could be analysed. First the film itself: in the very important opening voiceover a grown up Giosuè, who is the narrating voice of the whole film, sets the scene when he says: "Questa è una storia semplice eppure non è facile raccontarla. Come in una favola c'è dolore e come in una favola c'è meraviglia e felicità". A simple fairy tale, then, where the focus is not the inenarrable horror of millions of people killed in the frenzy of an inexcusable folly, but a simple story of happiness and desperation that carries a message of love and hope and survival to all its recipients. When he comments at the end of the film, our attention is drawn to the fact that the story does not represent a triumph of all things Good against Evil, rather: "Questa è la *mia* [my italics] storia. Questo è il sacrificio che mio padre ha fatto per me, questo è stato il suo

regalo per me". Another fairy tale paradigm can be found in the camp where Guido creates an enchanted, safe, parallel reality by inventing a game with an intricate system of rules. The purpose of this second construct is that of guaranteeing the child's survival and of preserving his innocence, while feeding him the necessary information that will later allow him to fully comprehend the extent of the ordeal and of his father's "gift". Here the technique of fascism is used to protect the innocent (Giosuè), not to justify the slaughter of the innocents.

The role of myth for Mussolini was paramount. Like most (aspiring) totalitarian dictators, he could count on a very powerful propaganda machine that managed to create and maintain rose-tinted, alternative realities that kept the Italian people believing in the fascist cause even in the face of defeat and adversity. Examples include the Ethiopian campaign, where arid bare desert was depicted as the new land of milk and honey; the vacuous promise of creating an air force that would "obscure the sun"; all the myths about autarchy or indeed the legends created around Mussolini and his own personal habits.

Concentrating more specifically on the interpretative clues of the first part of the film, Guido's myth making endeavours start very early on when, venturing into the yard of a country house, he meets a young girl. For her amusement he instigates the first of his fairy tales:

GUIDO Oh bambina... c'è la mamma, dov'è? L'ha messe la tua mamma tutte queste cose qui? [...] Si può comprare qui? Che è un mercato? Dov'è la mamma? Quanti anni hai? Ti ho fatto troppe domande? Te ne faccio una sola: come ti chiami?
ELEONORA Eleonora
Guido le fa un inchino grazioso
GUIDO Molto piacere, principe Guido!
ELEONORA Principe?
GUIDO Sí, sono principe! Qui tutto è mio, qui principia il principato del principe. Questo posto lo chiameremo Addis Abeba. Via le mucche, tutti cammelli. Via i polli, tutti struzzi! Ti piace Eleonora? (Benigni and Cerami 8-9).

This funny scene presents many of the motifs that constitute the foundations of the film's language. First of all Guido reveals his gift for words and storytelling by bedazzling the little girl and, later on in the same scene, Dora. His way of saying things, his quick wit and galloping imagination will make it possible for him, for example, to take the place of the inspector in the famous scene at Dora's school, and also to improvise the heart wrenching translation of the gruesome camp rules for Giosuè's benefit.

The second interesting focus is the subtle irony that Benigni achieves by letting Guido create his own little empire in the farmyard. He announces with ease and pomp his intent to rename the place; he discloses his absurd intention of equipping the farm with camels and ostriches. Then, with disarming simplicity and childishness, he asks: "Ti piace Eleonora?" The whole exchange is easily interpreted as a playful, yet revealing, parallel with the attitude the fascist government had towards the conquest of the Italian empire, or, to put it Millicent Marcus's words, it seems to reveal "the elements of exoticism and romance on which Italy's dream of an empire was built" (Marcus 157). Mussolini was an exceptionally good, charismatic orator, who commanded the undivided attention of his public and, just like in a fairy tale, did not necessarily consider truth a virtue to be pursued. He kept the Italian people dazzled under his spell, just as Guido charms Eleonora, by an intricate fabric of fantasies, myths and expectations.

The third important aspect is the way in which this scene establishes a parallel reality, that of the fairy tale, that Guido achieves by choosing for himself the role of the prince. He will also establish Dora as the princess by apostrophizing her with the famous "Buongiorno Principessa!" used throughout the movie. This important moment of self determination and establishment of the object of his desire will underlie the whole of the metaphorical imprint of the first half of the film where Guido, the prince, will woo his princess and save her from her metaphorical tower. Once the main characters in

Guido's fairy tale are named and established, the film continues to tell the alternative story of their love that culminates and surfaces more apparently at the engagement party at the Grand Hotel. The whole episode is richly layered and supports several metaphorical representations of the myth system of the fascist regime: these fabrications clash severely with those constructed by Guido, the Jew, the clown, the *raconteur*. In the engagement scene, albeit temporarily, Guido's perspective will prevail as he deconstructs the whole of the fascist superstructure by, practically as well as metaphorically, penetrating it and stealing away Dora.

The three metaphorical elements that need to be investigated further in the Grand Hotel scene are the scenography, the Ethiopian cake and the Jewish horse. By creating a symbolically dense imagery, Benigni operates "a kind of enchantment, [an] attempt […] to magically undo the fascist order – a trademark theme in farce about fascism" (Rothestein 28) opening a breach into the regime's representation system by subverting the established order. Guido will deliver a forceful attack on fascism and its social and class constructs while creating a dialectical tension between himself and those characters identifiable with the regime itself. In this comprehensive part of the film, Benigni is faithful to a long tradition and employs the Grand Hotel as an extended multifaceted metaphor. In the denouement of the scene Guido will also symbolise the whole of the Jewish people as he stands up to the regime (and to its perfect embodiment, the pompous, arrogant Rodolfo) and manages to defeat it (albeit temporarily) and break out of the claustrophobic closeness of its whitewashed walls. I believe it would not be farfetched if we were to apply an observation by James Hay, writing about Fellini's *Amarcord,* to this aspect of *La vita è bella:*

> In a personal or psychological sense, [it] is an adult director's conscious attempt to give cinematic presence to a *coscienza* or ideology through various childhood or subconscious images.

His audience is invited to confront these images through the centralized perspective of young Titta. In structuralist terms, *Amarcord* demonstrates the manner in which social, political, and economic realities are explored, questioned, and shaped through a cultural mythology in the midst of crisis. The audience reconstructs the political realities of Italian fascism through their temporary bond with Titta's mythical worlds. So, rather than demystify Fascism by exposing it merely as repressive ideology, Fellini demythologizes and deconstructs Titta's limited domain (xii).

As in the case of *Amarcord,* it is through our link with Guido's necessarily antifascist view of the world that we, the audience, can reconstruct the image of the regime as a grotesque circus. It is through our empathy with his fairy tale quest that we find ourselves aware of the evil power he is confronting. Following these ideas, it becomes clear that one of the central truths of the film may be that the myths we create for ourselves also determine our representation of reality. This is not only true of Guido, but also of the adverse force with which he struggles. Mythopoeia is his way of controlling the reality around him and thus protecting, preserving and amusing those dearest to him.

Undoubtedly fascism had different aims in its construction of the myth, but there are many similarities to those that Guido puts in place throughout *La vita è bella.* The highly organised system of practices and beliefs that the regime created and enforced during the *ventennio* contributed to giving a sense of security and strength to the people. Italians, lulled by these artificial beliefs, lived under the illusion of belonging to a virile, autarchic and honourable nation, with a prosperous economy, a great reputation among foreign allies and a capability for mighty enterprises. Great shows of orderly gymnasts, beautiful and grandiose military parades, perfectly choreographed, uniformed *sabati italiani,* forceful speeches delivered from the unattainable height of Palazzo Venezia's balcony, all

contributed to lull the nation into a dream, a construction that hid serious power abuse and real economic downfall.

Order, cleanliness, sanitation and (empty) grandeur characterised fascism both as a doctrine and within its social structure and one of the fields where this imprint was particularly evident is architecture. During the years of Mussolini's domination many imposing architectural projects were designed and efficiently implemented throughout the country. The architects of the regime, themselves, in a way, theorists of the fascist doctrine, supervised the construction of train stations, post offices, libraries, *case del littorio*, sporting arenas (including the monumental Foro Mussolini in Rome) and of new popular housing quarters. Even whole new cities were built in the reclaimed and drained Agro Pontino. All these projects responded to precise criteria of space and linear rigour, all the new buildings were designed to depict an image of efficiency and opted for an aseptic yet functional employment of space and materials. Supreme examples of this effort are the EUR quarter, built in 1939 for the 1942 Universal exhibition but never finished because of the war, and the *Città Universitaria La Sapienza*. These complexes are mainly built out of white marble with tall imposing colonnades and arches of a clean cut design. The main inspiration comes from neoclassical canons, thus foregrounding the importance of the connection between fascism and the imperial Roman civilization, seen as the root and validation of Italy's glory. It is quite revealing to observe the kind of language used by the contemporary newscast written and promulgated by the regime. The words which are most commonly employed to depict such architectural endeavours are: *grande, grandioso, enorme, massimo, amplio, monumentale, moderno, razionale, vigoroso, sano, ridentissimo, igienico* with a strong emphasis on the fact that everything was built with *mattone italico e bianchissimo travertino d'Italia. (big, grandiose, enormous, maximum, ample, monumental, modern, rational, vigorous, healthy,*

very bright, hygienic [...] *Italian brick, extra white Italian travertine).* The founding concepts that informed these buildings, and with them the whole of the fascist architecture, are exemplarily summarised in this comment about the building of EUR:

> Agli architetti fu assegnato il compito più impegnativo: costruire una messa in scena che abbia del magico", per dare al pubblico "un grandioso spettacolo dimostrativo, realizzato col far muovere il pubblico entro un'attrezzatura scenica fissa" di architetture, sculture e decorazioni murali di grande efficacia visiva, atti a colpire e impressionare l'immaginazione di chi guarda", raggiungendo "la memoria dei visitatori attraverso la fantasia", per mostrare "al popolo la magica continuità, universalità e attualità della civiltà italiana, nostro privilegio e segno distintivo" (Gentile 257-7).[2]

These elements closely correspond to the choices Benigni made for the setting of the engagement scene. Denby wrote:

> He [Benigni] has assembled the master craftsmen who worked for Fellini at different times – the production and costume designer Danilo Donati and the cinematographer Tonino Delli Colli – and they have provided him with enormous sets that are dressed white on white, in a de-luxe, wedding-cake style that suggests a satire of Fascist kitsch. [...] his idea was clear enough: Italian Fascism, with its fantasies of Roman imperial glory, was built on illusion; it was itself a form of buffoonery, and satire of it effectively diminishes it (Denby 98).

[2] "Architects were given the more demanding task: to build a "magical mise-en-scene", that would give the public "a grandiose demonstration spectacle, achieved by having the public move within a fixed scenic apparatus" of architectures, sculptures and wall decorations of "great visual impact, designed to capture and impress the onlooker's imagination" thus reaching "the visitors' memory through imagination" in order to show "to the people the magical continuity, universality and contemporaneity of the Italian civilisation, that is our privilege and distinctive sign".

Analyses of the set of the Grand Hotel ballroom, the guests attending the engagement party and the Ethiopian cake will establish these images as metaphorical representations of the mythological system fascism had created for the consumption of its people. The scene represents a very clear satire of fascism and of its cultural and social infrastructure and it appears that Benigni is using the engagement party to overtly ridicule and criticise the regime and its beliefs in a manner that is indirect, yet effective. Furthermore Benigni uses the Grand Hotel as a "narrative and rhetorical strategy and as a highly ritualized, interpretative model" (Hay 41) and "The film's scenography, which juxtaposes careful period detail with over-the-top artifice, also emphasizes the film's deconstruction of the boundaries between reality and fantasy" (Ben-Ghiat 32).

The great ballroom of the Grand Hotel was designed as a circular, continuous space that would allow the film narrative to take place undisturbed by room and scene changes and it responds quite dramatically to the criteria and characteristics of fascist architecture detailed above. The room is ample and sumptuous in its white rigour. Tall, imposing walls, ornate with fluted columns, are painted stark white, and although normally all these architectural features should bestow an impression of airiness and grandeur, there is something suffocating and stifling in this particular Grand Hotel. There are many windows, but they are all blind and encased among heavily draped velvet curtains, painted in the background. The whole ensemble creates a sensation of subtle suffocation, of closure and asepticity, almost: "a sense of a medieval enclosure, a lack of information, a lack of contact with the unheard of, the new" (Hay xi). In this grotesque depiction even the grand staircase is transformed, by a biased camera perspective, into a descent into an infernal pit. There are a few revolving doors leading into the hall: their glass panes are heavily frosted and do not allow even a glimpse of the outside world that is therefore deliberately forgotten, ignored. The elegant guests are kept

perfectly oblivious of the threatening atmosphere outside where thugs are allowed to humiliate Uncle Eliseo through vandalising his horse and his home, where Jewish property and people are left at the mercy of every ill intentioned vandal. These oppressed people, in opposition to the guests of the Grand Hotel, cannot count on the help or protection of the state, on its comforting cocoon of lies. Yet the people inside do not seem to realise or indeed care and when Guido rides the acid green horse into the Grand Hotel, the guests' reaction will be one of astonishment.

The surprise is not, however, caused by the pitiful state the horse is in or by the significance of what has been done to it. The guests are so brainwashed and unaware that they will believe it to be part of the exotic choreography of the party and will applaud quite enthusiastically when Guido and Dora canter away. The Grand Hotel, symbolic representation of the fascist state and its propaganda, has served its purpose: keeping the population in an artificially whitewashed womb-like environment where everything is beautiful and efficient. The ballroom, like Mussolini's press, denied access to the outside world or its opinions allowing the Italian people to float in a comfortable state of ignorance and artificially induced contentment.

In an on-line interview Benigni stated: "Le fascisme était une chose épouvantable. Mais il est facile de le dire après coup: moi, je voulais aussi le présenter comme une clownerie, un cirque stupide" (Fascism was a horrific thing. But it is easy to say so with hindsight: I also wanted to present it as a clown show, a stupid circus) (Entretien). The circus that Benigni associates with fascism is clearly represented by the ferociously characterised guests and their allegorical duality: the images in the frescoes. In the ballroom the walls are adorned with large fresco paintings depicting elegant, although somehow lifeless and static, images of high society ladies and gentlemen enjoying a party and drinking champagne. These images tower above the guests who, in their own right represent grotesque

caricatures of the Aretinian high society, but also embody the worst face of the local petite bourgeoisie. Portrayed at the apex of their social stature and at the best of their public image, they represent a sad menagerie of characters. The ladies' attire suggests a kind of pomp and *goût* that betrays the angst of conforming to the ideal of elegance and status set by an equally pompous society. In a clumsy attempt to recreate Hollywood splendour they sport overly sequined dresses full of frills and layers, their sleeves are puffed, their hats extravagant while the colours clash and scream in a dance that is as *macchiettistica* as the happy fox-trot that enchants them under a snow of tricolour confetti. Dora herself is wrapped in an impossible horror of pink taffeta and sequins that only contributes to highlight the contrast between what she wants and what she is being forced to do. Her mother, on the other hand, appears perfectly integrated, as she beams in an all white cloud of feathers and fur. In the microcosm of the ballroom the guests live their own wish-fulfilling moment cocooned by the safety of the superstructure; they see themselves reflected in the elegant figures of those frescoes and rejoice in their own fictional image. Although the hall is full of mirrors, these are made of tiny mosaic pieces, and are therefore unable to reflect the real images. In their place, the broken surfaces beam back a distorted, safely overlooked double that renders the false mirror of the beautiful pictures viable and attainable.

Benigni not only uses symbolism and metaphorical imagery to deconstruct the malignant superstructure of fascism in the set of the Grand Hotel, but extends it to the guests and also to the central scene of the engagement party sequence, represented by the entrance of the Ethiopian cake. In Uncle Eliseo's words: "[...] è l'ultimo grido della pasticceria, la torta etiope, tutta fatta di [zabaglione di] uovo di struzzo. *(Con tono ironico)* Questo è l'Impero!" (the latest in patisserie fashion, the Ethiopian cake, all made with ostrich egg [zabaglione]. (*With an ironic tone*) This is the Empire!) (Benigni and Cerami 76). The poignancy of this

exclamation lies in the fact that the cake could – and I believe should – be seen as a powerful embodiment of the myth that fascism built around the conquest of the Italian Empire. Through propaganda Mussolini was able to encourage the Italian people to sustain and provide for the Imperial war effort. Ethiopia was depicted, through the relentless work of the skilled fascist myth-makers, as a real heaven waiting only to be reclaimed by *Italic* wit and strength. According to the fascist party line, Africa was this fabulously rich continent where one could find gold and fertile land, where men were savage and prone to laziness and women were beautiful and available.

This wonderful, albeit imaginary, promised land quite dramatically comes to life in the Ethiopian cake and in the whole setting in which it is presented to the guests. While an orchestra plays intoxicatingly exotic music, four black *Ascari,* in full colonial uniform with their fez adorned by tricolour ostrich feathers, bring in the huge, richly decorated cake. Each of the three tiers is perfectly white, festooned and decorated by little mirrors framed by big square gems representing the three colours of the Italian flag. The opulent picture is completed by an intricate decorative lattice made of sparkling golden sugared almonds that convey an impression of richness and wealth.

Benigni's critique of fascism and its structures, of its ways and enterprises continues with the glorious entrance of the Ethiopian cake: all the gems and the gold amplify the chasm between the promised riches and the actual sacrifices that the African campaign entailed. The ill-fated ambition to submit into slavery a free, civilised country, full member of the Society of Nations, is represented by the four black carriers who bear the weight of the Empire (the cake) on their shoulders and have had to add the Italian colours to their military honour (the fez). The profusion of gold resounds with the emptiness of the fascists' promise as all the colonisers found in the newly acquired Empire were inhospitable lands, proud people willing to defend their

motherland, and illness they were not equipped to cope with. It also conjures up the images of the unabashed call that the Duce sent out to his people in preparation for his war. In a highly symbolic, ritualised gesture, perfectly staged in great public displays, all Italian women were asked to donate their wedding rings to the fatherland in order to finance the expeditions in Abyssinia. Cauldrons and stages were set up in Italian squares and (almost) every Italian wife, including the Queen, queued to homage the Duce with this all important offering. Their reward was the many unfulfilled promises and an iron ring with the engraving "Oro per la patria" (Gold for the fatherland) to substitute the original one.

The symbolism, however, does not stop with the gold. The cake, metaphorical image of the Empire, depicted as the land of milk and honey and of gems and gold, is crowned by a small stuffed ostrich, itself white and decorated with a profusion of golden jewels and little mirrors, and sporting a beautifully sumptuous tail of white, green and red feathers. Exotic and opulent, the ostrich also carries a very strong allegorical meaning and one that mocks the mythological apparatus built by Mussolini. In African mythology ostriches represent justice, equity and truth to the point that in Egypt this bird was associated with the goddess Maat. She would oversee the judgement of the souls using an ostrich feather to determine the worthiness of the deceased as the feather symbolised universal order founded on justice. The whole imperial paraphernalia represents in a way the false dream of richness and power created by crafty propagandists while it deconstructs the true basis of their own beliefs. The imperial war effort, the myth of *italiani brava gente*, actually hid the atrocities that were inflicted on the indigenous population: the rapes, the cruelty, the mustard gas. The ostrich, symbol of equity and justice, sits on top of the symbolical empire as a sad mockery of all those false promises. In his quite ruthless depiction of fascist imperial dreams, Benigni does not spare those who followed the myth, not even those who

did so without realising what they were doing. One of the most translucent travesties in the film is represented by the three frames dedicated to the fascist sycophant. As the cake is being reverentially carried by the four Ethiopian soldiers, the camera pauses, rather at length, on a fat man with a vacant expression. In full fascist uniform he welcomes the cake with a rigid roman salute and the sharp click of his heels. His alacrity is stridently ridiculous especially as the focus pauses on his blank, unintelligent expression that seems to reveal a blind commitment to the cause without any real understanding of its reason or tenets nor any introspection on his own beliefs. He is brainwashed and mechanical, almost a puppet, and sadly embodies many Italians who were completely taken in by the fascist vortex and followed it to the bitter end. As the cake progresses, the man remains frozen in his salute and a while later, when Guido is entering the Grand Hotel ballroom on horseback to take Dora away, the camera bestows a last, caustic glimpse upon this fascist soldier: he is still there, rigid, still holding his roman salute, staring into space, totally unaware of what is going on around him.

If the whole set, the cake and the party guests in the scene are all part of an extended metaphor for fascist hierarchy and ideals, it is through some of the characters, and not only Rodolfo, that Benigni establishes a dynamic opposition between bad and good, fascist and non-fascist. He achieves this by portraying their inner selves in the most unfavourable perspective, showing us their true colours that reveal themselves even in the gleaming, distorting lights of the Grand Hotel ballroom. In stark contrast to these characters Benigni places himself as Guido, the gentle Jewish waiter who has the clear mission of "undermin[ing] natural law (the very heart of fascist rhetoric)" (Rothestein 28). His opposition to everything fascist is not only ideological or circumstantial (the *gerarca* wants to marry the woman he loves), but also formal and physical. Of his character Benigni says: "je suis antifasciste, non seulement

au fond de mon coeur, mais aussi physiquement: dans ma façon d'apparaître, on comprend que je ne peux pas être fasciste, parce que mes sourcils, mes incisives, mon ventre sont antifascistes! Je représente la liberté totale, la générosité. Et également l'enfance" (Entretien). Thus, Guido, antifascist with every part of his body, and representing total freedom, much as a child does, is the diametric opposite to Rodolfo, who is not only a fascist but a *gerarca*. He is also severe and grown up and cannot even laugh at one of the basest comic sketches, that of a vase falling from a window or of a hat full of eggs. In fact:

> Fascist humor may be an oxymoron. Fascism, after all, is a serious matter. It submerges the whims and freedoms of the individual to the uniform demands of the state. It treats the authority as natural law and any opposition as mortal sin. Humor is just the opposite. It thrives on offence, plays on vulnerability and absurdities, inverts authority and mocks nature; it is surreptitious, sly, iconoclastic. Humor may be, in its essence, anti-fascistic. It takes what is most self important, most unyielding and most unforgiving and dissolves it into absurdity. Fascism met its match in farce (Rothestein 28).

In this opposition, then, the one man represents everything that the other hates (in the case of Rodolfo) or does not understand (in the case of Guido). Guido is a Jew, Rodolfo a fascist; Guido is capable of joy and passion (see, for example the crazy night after the opera in which he finally wins Dora's heart) while Rodolfo is measured in his feelings and always puts duty before love (see his refusal to turn down the Prefect's invitation even after Dora's insistence). Guido is playful, childish and happy simply to be alive, he is a clown and a jester (a real one who brings love and joy to all of those he touches). Rodolfo is serious, determined and unemotional (see the episode of the mathematical question that the school director proposes during the dinner and the answer he offers), he is ridiculous (but not a clown), and his audience-captivating jokes during the engagement speech

only manage to raise circumstantial laughter. In this binary opposition lies the fundamental message of this scene. There are two powers at work: the glowing, positive enthusiasm that radiates from Guido which will win over the dark force symbolised by Rodolfo and everything he stands for. The good and bad opposition and the denouement that sees the forces of good prevailing over those of evil is a classical *topos* of traditional fairy tales and is employed by Benigni to great effect as it contributes to creating the dreamy atmosphere of love and happiness that will make the suffering in the second part even harder to bear.

Within the storybook structure of *La vita è bella* it is expected that a prince rescuing his princess can only do so with the help of a beautiful white charger. Once again Benigni keeps to fairy tale conventions and in a heavily symbolic scene introduces Robin Hood, uncle Eliseo's horse with whom he rides around town in a quaint, if anachronistic, little cart. Robin Hood does not simply embody the means of escape of the two lovers: his metaphorical and symbolical value is much more complex than that.

An outlaw and a thief, Robin Hood is certainly more famous for his courtesy, for his robbing the rich to give back to the poor and for his hatred of any injustice. A green-clad hero that stands for righteousness and stability and will help Guido penetrate and destroy the evil tower. He too opposes the fascist construct with his honesty and integrity symbolised not only by his name, but also by the complex allegorical meaning that he, as a horse, embodies. This particular Robin Hood is not simply a horse, but a green painted "Jewish horse" and this undoubtedly permeates the whole scene with a high symbolic charge. When Robin Hood, gently but steadily, is lead by Guido inside the inner sanctum of fascist representation and then shortly after canters away from the Grand Hotel, he also operates a deconstruction of the whole structure. The Jewish waiter on the Jewish horse manages to reach and, in a sense, violate

the very heart of the fascist construct. The metaphor could be easily expanded to a penetrative one: the closed, womb-like ballroom is violated when the horse, representing phallic strength, enters it. The horse does not only symbolise instinct and might; it is also the representation of sexual desire, of creative force and youthful might. Through the story these characteristics have also been established as pertaining to Guido and it is therefore moral and consequential that man and horse would accomplish their fairy tale mission of allowing the two lovers to go freely towards their destiny and the sexual act that will create Giosuè. The child, fruit of love and passion, himself object of supreme love, will provide his father with the necessary strength to once again fight and defy the system in order to guarantee his child's survival, even at the cost of his own life.

The horse is used by Benigni as a symbol that condemns and deconstructs, by opposition, the whole of the fascist infrastructure and is established early on in the scene. At the beginning of the engagement party, when Guido is still happy and carefree as he is still oblivious to the identity of the bride-to-be, a fellow waiter summons him with pressing urgency to his uncle. Outside the Grand Hotel, in the night, Guido is confronted by a grotesque spectacle. Robin Hood, the beautiful white horse has been coloured acid green and symbols of skulls and lightning have been drawn in black all over its mantle. "Achtung Cavallo Ebreo" has been written on his flank and bows and ribbons have been tied to its mane and tail. Guido reacts to the horrid view with a bemused shrug as he tries to joke about the whole thing, but his uncle is far less amused because he is able to see the real evil behind the comic façade.

This scene does not only represent a premonition, a rip in the narrative fabric of the first half through which Benigni is somehow warning his public about horrible things to come, but it is also an important moment in which clear symbols are used to assert the absurdity of the fascist claims

and the vainglory of their actions. Other similar narrative rips are, for example, the initial sequence that accompanies the voice over; when Guido carrying Giosuè stumbles upon the heap of corpses; and the arrival of Guido and Ferruccio at Uncle Eliseo's house. By the start of the second half these premonitions have turned into solid reality. During the family's bicycle ride, Arezzo has a different face: there are sacks of sand everywhere, threatening posters dirty the walls and soldiers are marching through the streets. It is here that Giosuè sees the notice "Vietato l'ingresso ai cani e agli ebrei" (No dogs or Jews allowed).

Returning to Robin Hood, this horse seems to incarnate, symbolically, all the qualities that we attribute to uncle Eliseo who, in his own right, epitomises the whole of the Jewish people. The gesture of the fascist thugs is, therefore, invested with a very important meaning and we understand why it is not wise for Guido to take it lightly. The horse represents the intellect and the intellectual strength of Eliseo and, with him, of the Jewish people, and the horse's vulgar profanation by the fascists is a terrible attempt to render ridiculous something that would otherwise be strong and rational. In this almost ritual painting of the horse we could summarise the whole of the fascist drive to annihilate Jewish culture and intellectual strength. This violation is paralleled by the symbolic corruption of purity, conveyed by the whorish make up and by the acid green that covers the white mantle. The desecration of the horse is a big blow to Eliseo and, metaphorically, to his people, but Guido will succeed in transforming this almost blasphemous action in a force that conquers and wins, giving back to Robin Hood his noble role notwithstanding his appearance and the efforts of those who attempted to rob him of his dignity.

To many commentators, *La vita è bella* appears to be a film of two halves or even two separate films or two distinct episodes within a story. As we have seen, the first part follows the paradigmatic schemes of the fairy tale: it all starts, according to the best tradition, "once upon a time"

when a beautiful princess fell from the sky into the arms of a handsome prince. Their love blooms immediately but is strongly opposed by a wicked, powerful character who tries to keep the princess hostage under his evil spell until the prince, on a white stallion, comes to the rescue, challenges the monster, risks his life and manages to rescue the princess. Following his success, they gallop away in the sunset to live happily ever after. In the first forty five minutes of so of the film the fairy tale canon suspends all the rules of realism. When all around him things are starting to turn ugly and threatening signs are gathering on the horizon, Guido manages to stay in control of what is happening by taking refuge in a parallel and fabulous reality influenced by his will and created for the benefit and the fruition of himself and those close to him. The interpretative norms forged in this mythopoetic creation furnish the viewer with the tools to confront the second, harrowing half of the film.

If the first half is a fairy tale, then the second part retains all the characteristics of a nightmare. Guido is still creating the myth, creating the fable, but this time he will not be able to benefit from these efforts: the only recipient will be Giosuè who gets transported to an alternative reality woven by his father in the desperate attempt to protect him from evil, and thus guaranteeing his survival. Here it is inconceivable that the audience cannot feel the oppressive weight of the real crushing the very childish narration of a desperate father. Myth making only amplifies the real.

Just how can Guido safely defy his enemy and win? There are, in my opinion, two reasons why he succeeds in his deed. The first is, once again, deeply embedded in the fairy tale. At the engagement party Guido is shocked and hurt beyond measure when he realises that Dora is the one to be married to "lo scemo delle uova" and seems to lose his composure. He trips, falls, looks bedazzled and creates one mess after the other. Having thrown the whole content of a serving tray on the floor while looking at Dora, Guido hurriedly disappears under the top table to try and gather the

spilt bonbons and avoid a serious reprimand from his uncle. Dora sees the whole scene and follows him under the table where she kisses him and implores: "Portami via" (Take me away). This kiss is thaumaturgic, of the kind capable of turning toads into princes. It is thanks to this kiss and all the promises it carries that Guido will make the ultimate decision to take Dora away, no matter what it entails. The second, albeit less romantic, justification can be found in an interesting book by James Hay. In his chapter on "The Myth of the Grand Hotel" he states: "In one sense the *hôtel de luxe* conjures traditional theatrical settings, the decorum and snobbery of the *bel mondo*. In the other sense, however, the hotel – as public and carnivalesque space – actually enables characters [...] to parody what is institutional and traditionally proper" (Hay 61).

This is exactly what Benigni does throughout the long engagement scene. Symbolism, scenography and character study all concur to create a long metaphorical attack on fascism and its constructs. The strong dichotomy between Guido and his integrity and all the falsity and pomp of the fascist construct becomes more and more evident as Benigni shows us two different kinds of parallel realities. The audience knows that the film is not realism, that it cannot be realism. We know that the horror of which the film will speak is like the light of the sun: too powerful to perceive directly or represent realistically. The fairy tale created by Guido that will grant his love wish and will allow him to temporarily defeat the system is based on his good sentiments, on his positive determination, on his righteousness. The macabre parallel reality crafted by the fascist propaganda glitters with gold and sequins but hides the gravest of truths, the violence, the extermination, the folly of a regime driven by impossible aspirations. Benigni neither denies nor negates this, but he knew he could never represent it.

Works Cited

"*L'architettura. 40 filmati di opere di architettura e ingegneria progettate e realizzate negli anni '30*" [videorecording], Archivio Istituto Luce (cl. 00213).

Adorno T., *Negative Dialectics* (first pub. 1966) trans. E. Ashton, London: Routledge, 1973.

Ben-Ghiat Ruth. "The Secret Histories of Roberto Benigni's *Life is Beautiful*", *The Yale Journal of Criticism*, vol.14.1, 2001.

Benigni, Roberto. "Il mio film", *Corriere della Sera*, 19th December 1997.

Benigni, Roberto and Vincenzo Cerami. *La vita è bella*, Torino: Einaudi, 1998.

Celli, Carlo. "The Representation of Evil in Roberto Benigni's *Life is Beautiful*", *Journal of Popular Film and Television*, Summer 2000 v28 i2.

Chevalier, J and A. Gheerbrant. *Dizionario dei simboli*, Milano: BUR Rizzoli, 1986.

Cro, S., "*La vita è bella (Life is Beautiful)*, *American Journal of Italian Studies*, n.59, vol. 22, 1999

Denby, David. "In the Eye of the Beholder", *The New Yorker* 10th March 1999.

Gentile E. *Il culto del Littorio. La sacralizzazione della politica nell'Italia fascista*. Roma e Bari: Laterza, 1993.

Grassi G. "Ciack nel lager, ecco Benigni tragico", in *Corriere della Sera*, 31st July 1997.

Hay J. *Popular Film Culture in Fascist Italy – The Passing of the Rex*. Bloomington & Indianapolis: Indiana University Press, 1987.

Hoberman, J. "Nazi Business", *The Village Voice*, 21th October 1998.

Mack Smith, Dennis. *Mussolini,* London: Weidenfeld & Nicolson, 1981.

Marcus Millicent. "Me lo dici babbo che gioco è? The serious humor of La vita è bella", *Italica* n.2, vol.77, 2000.

Marino V.E. "Mal d'Africa" [videorecording] *Video Club Luce*, (cl. 00168).

Rothestein E. "Using Farce to Break the Dark Spell of Fascism", *The New York Times Review*, 18th October, 1998.

Wootton A. "Benigni interviewed by A. Wootton", *The Guardian*, 7th November 1998.

Life is Beautiful and the protection of innocence: Fable, fairy tale or just excuses[*]

Grace Russo Bullaro

Anyone wading through the morass of reviews and critical articles about Roberto Benigni's *Life is Beautiful* is liable to walk away reeling from the wildly divergent opinions expressed by the critics. At times it is difficult to believe that they are all writing about the same film. Now that the hype has died down, and with the greater clarity of vision that the passage of time brings, it is worth reexamining the film to get a better perspective on its effectiveness in the light of the controversies that it has generated.

As many people already know, *Life is Beautiful* is a story that takes place in Italy in the years preceding and during World War II. Guido, the character Benigni plays, is a happy-go-lucky Jewish man who woos and weds Dora, a Gentile young woman who is about to marry a Fascist officer. These are the events of the first half of the film. In the second half the "racial laws" of 1938 have been promulgated. Guido, by now the father of a five-year old boy, is deported to a Nazi death camp along with his son and his uncle. His wife begs to be allowed to go along. While in the camp, Guido hides the young boy in the men's barracks in order to save his life, we presume. Furthermore, to protect the child's innocence Guido attempts to hide the knowledge of the true nature of the camp by pretending that they are playing an elaborate game in which the Nazi officers allot points for following "the rules." The prize for the winner is a ride in a military tank. In this manner Guido keeps the boy silent and compliant. In the closing scenes of the film the Allies liberate the camp. The "game" has ended.

[*] This article appeared in a slightly different version in *Post Script*, Vol. 23 No. 1 (Fall 2003) pp. 13–26.

Looking at the reviews and responses that appeared in its wake, and even to this day, we can easily see that there are very few critics who have succeeded in eschewing the passionate in favor of the objective. Among these few we find Kate Matthews, who, in her essay, "Serious Laughter," attempts to place *Life is Beautiful* in a broader and more diachronic context, showing how canonical works of literature and film such as Shakespeare's *Romeo and Juliet* and Spielberg's *Schindler's List* have all been shaped by the technique of mixing comedy and tragedy (105-106). Matthews underlines that the mix "can be subversive, critical, and emotionally powerful: it can be used as a counterpoint and enhance the serious matters it brushes up against" (106).

However, Matthews is in a very small minority. Most of the other reviews are either passionately for or against. Among the positive reviews, one mentioned that Benigni "brilliantly explores the relationship between individual, seemingly insignificant acts of rudeness and the Holocaust" (Blake 31). Indeed, the same critic goes so far as to say that Benigni "has dared to reduce atrocity to absurdity" (31). Still, the prize for the most improbable and incomprehensible favorable comment on this film should go to Steve Wulf, who claims that Benigni "strives for historical accuracy" (108).

Still on the positive side, we should also remember that especially around the time of the Oscars in 1999 Benigni was being lionized by Hollywood, after having already won many awards and prizes in Europe and Israel. In Hollywood, where he won two Oscars (Best Actor and Best Foreign Language Film) it was almost a consensus that now he would be able to write his own ticket to success. In "Robert De Hero," an article in *Entertainment Weekly,* we learn that, "He's now a major international star," and that, "When you win a Best Actor Oscar, you're right up there" (8). In short, the world was Mr. Benigni's cinematic oyster. It was only a question of "*l'embarras du choix.*"

However, this rosy picture does not, by any means, tell the whole story of the critical reception of *Life is Beautiful*. Once you start to collect as many reviews and articles as possible, you quickly learn that the positive articles and reviews are buried under an avalanche of negative criticism, most of it remarkably passionate and consistent. One of the frequently recurring complaints is that the film consists of "two barely reconciled halves," as Rooney has stated (61). John Simon, another prominent critic, elaborates on this by calling the first part "silly farce," the second "totally unbelievable and downright stupid," and the whole thing "imbecile lies" (54). In addition, and even more harshly, he says, "Hard to tell who is the bigger idiot: the smart, precocious kid who falls for this running lie, or the audience that falls for this movie" (55). Stanley Kauffmann is no more flattering. He sees the plot situation devised by Benigni as being "blatantly impossible," "theatrically phony" and "an actor's shallow conceit" (26-27). Kurt Jacobsen of *New Politics*, underlining the outrageous historical inaccuracies, talks of Benigni's "opportunistic violations of reality", a "plethora of implausibilities," and enumerates only a few of them: "the absence of kapos", "the unnoticed presence of a child in the men's barracks" and "every inmate speaking Italian" (2). Other critics have also pointed out that Guido, the father, manages to include the boy into a group of officers' children for a free meal even though he is wearing the uniform of an inmate and speaks Italian; the patently impossible likelihood that Guido would be able to take over the public address system in order to play a reassuring song for his wife Dora, housed in the women's barracks; and the sheer ridiculousness of believing that Nazi officers would allow him to have the run of the camp. Moreover, Jacobsen believes that Benigni provides absolutely no insight into the Nazi "systemic murder machines" and that "in order for the film to work…the camp must become an outrageous lie" (4).

David Rooney, writing for *Variety*, focuses on the film's cinematic aspects. And apparently even from this

perspective it comes up short, although surprisingly, after having criticized the film from every angle, Rooney then awards it a grade of "A." Rooney declares it to be "sluggish, uneven and lacking in rhythm" and points out its sloppy writing and limp editing and the two "barely reconciled halves" mentioned above. I could add the names of many other critics who have expressed similar concerns, indeed a majority of the most authoritative critics seem to concur, but I believe the point is amply made. [1]

The most acrimonious of the criticism concerns Benigni's choice of genre. Making a comedy about the Holocaust was bad enough. But even more seriously, what many of the critics could not swallow was the manner in which he chose to portray what is probably the most emotionally charged historical event of the twentieth century, if not of all time. Not only did he make a comedy out of a tragic event, but he also sanitized and prettified the concentration camp and the Nazis, instead of dwelling on the documented horrors that many, if not most, people are familiar with.

This controversy is not unprecedented. In 1975 Lina Wertmuller's *Seven Beauties* also generated a heated debate for similar reasons, despite the fact that Wertmuller's film was much darker than Benigni's. Objections to Wertmuller's film centered more on the film's perceived message than on her vision of the setting. *Seven Beauties* was not so much implausible as unsavory. Many viewers and critics thought that Wertmuller, through her protagonist Pasqualino, was suggesting that in life only survival is of paramount importance: survival at *any* price. Everything else, including moral integrity and concern for the collective welfare, is secondary. Of course, it can be argued, and it was by many others, that this was not Wertmuller's message at all. What

[1] Among this coterie we find Stuart Liebman of *Cineaste,* Owen Glieberman of *Entertainment Weekly,* John Calhoun of *Interiors,* Richard Alleva of *Commonweal,* Daniel Davies of *The Lancet* and Charles Tesson of *Les cahiers du cinéma.*

she is attempting to show is that even though Pasqualino misunderstands the meaning of his experiences, he still comes back from the concentration camp a changed man, a man who is devastated by what he has seen and lived through. [2] Although *Seven Beauties* was a comedy, it was a dark comedy, and Wertmuller was not really castigated, as Benigni has been for *Life is Beautiful*, for having made fun of the Holocaust. The tone of her film though flip, was not light. And ultimately the viewer walks away from it with the bitter taste of defeat that Pasqualino's haunted gaze into the camera has made inevitable. The conclusion of *Life is Beautiful*, especially in the North American version, which includes the voice-over, is schmaltzy and perhaps difficult to understand as the "happy ending" that Giosuè and the mother seem to think it is. It's true that as the situation was framed by his father Guido, the happy ending would mean getting the promised ride in the tank, but one has to wonder, how could the grown-up Giosuè (who is now narrating the events) forget, as apparently he has done, that his father died, if not as a result, then at least as part of the same event? *Seven Beauties* ends in resignation and bitter acceptance of inevitability, *Life is Beautiful* ends in celebration.

As Glieberman has put it, Benigni has made "the first feel-good Holocaust weepie." He adds that "the death camp looks like something out of a 50s musical. You'll laugh! You'll cry! You'll smile through the evils of genocide!" (54). Although Glieberman can joke about this, many other critics can't. Nevertheless we will look closely at the debate, the accusations and Benigni's defense, in the course of this paper. As part of his defense Benigni has declared that *Life is Beautiful* is not a film about the Holocaust, it is a "fable" about a father's love and his attempt to protect his child's innocence (and one presumes, his life). However, it is

[2] For a detailed discussion of this topic see Bullaro's "Lina Wertmuller's 'Man in Disorder' and the Idea of Human Perfectibility in *Seven Beauties*".

possible to question whether first, the child actually has any "innocence" to protect, given the context of the setting, and second, whether the film conforms to the conventions of a fable. Then we will look at the implications of our answer. We will allow Benigni his "given". If he claims to have made a fable, then let's examine the film from this perspective in order to evaluate its effectiveness. What are the purposes of a "fable" and are they consistent with this film?

Before we move to the exploration of these issues there is another perspective from which this film must be looked at, its reception in Italy. While in the United States, as we have seen, it has been strongly criticized for its lack of realism and its prettification of what has been called the "existential tremendum" of the century, in Italy the situation is different (Liebman 22).

In "La vita è bella?" Francesco Caviglia attributes many merits to this film. One of the most surprising for a North American reader is that of having opened the eyes of the Italian general public about the realities of the Shoah and of having given a human face to the victims and the executioners (1).[3] We learn that in Italy it is only recently that responsibility for the deportation of Italian Jews has become a national debate. As Caviglia relates, until the present the Italian attitude has always been to blame the Italian *Shoah* on Germany and its occupying forces. However, in recent years the issue of Italy's complicity has been openly discussed as a result of (or in combination with?) exhibits such as "La menzogna della razza" ("the racial lie") and the publication of memoirs by surviving Jews who have lived through the horrifying experiences. To convey the extent of this collective denial of responsibility, Caviglia underlines that "even today the great majority of

[3](All translations from the Italian, unless otherwise stated, are by Grace Russo Bullaro.) "...si può dire che il film abbia avuto—tra gli altri meriti—quello di aprire gli occhi al grande pubblico dando un volto a vittime e carnefici della Shoa degli ebrei italiani" (1).

history textbooks underplay the importance of this black hole in our history."[4]

Caviglia's praise of the film, for having opened the eyes of the Italian public, should therefore be read as a measure of the previous lack of information on the subject. If we compare Caviglia's favorable opinion of *La vita è bella's* historical framework to the outrage expressed by so many North American critics who have blamed Benigni for trivializing and sanitizing his depiction of the death camp experience and its horrors, we are once again reminded that viewer response to any film is a function of the total cultural context in which it is released. Americans have long been familiar with the inhuman horror of the Holocaust, and they recognize inaccuracies in its representation. The Italians' level of education on the subject is as yet very poor and they are therefore more easily misled by what Benigni has presented to them.

Caviglia's glimpse into an alternative evaluation of the film adds another dimension to the overall response it has evoked. Whereas many Americans, both critics and members of the general public, have been offended by what has been perceived as a trivialization of documented genocide, many Italians (if we are to believe Caviglia) have appreciated *Life is Beautiful* as an eye-opening and didactic accusatory statement of complicity. Further reinforcing this Other cultural perspective, we learn that while Caviglia freely admits that part one of the film utilizes many elements of fairy tale, he sees the second part as being, "pure and simple reality" (4).[5]

Of course the true insidiousness of such an evaluation of the film is that people can be lulled into believing that the Holocaust wasn't so bad after all or that all it took was a little ingenuity to come out of it alive. Jacobsen states that "ingenuity über alles" seems to be Benigni's keynote (3).

[4] "Ancora oggi la maggior parte dei libri scolastici di storia non da un grande rilievo a questo buco nero della nostra storia."

[5] "la realtà pura e semplice"

Furthermore, as Jacobsen adds, what is even more disturbing is that it masquerades as a true story (4). People like Primo Levi and Bruno Bettelheim, who lived and survived the death camp experience, have expressed a radically different opinion of what it took to survive. In *Survival in Auschwitz* Levi makes it clear that no amount of ingenuity, pluck or charm could benefit you. Most often the survivors of death camps were those who were physically the fittest and morally the most ruthless. Indeed, as is made clear by Levi's life-long pessimism and cynicism regarding humanity, in some ways the disillusion that ensued proved to be the worst part of the experience. For some, as for Levi, the bitterness proved to be fatal after the fact. Levi committed suicide as a result of it.

Richard Alleva concurs: "By collapsing the greatest tragedy of our time into domestic pathos, it gives the audience permission to laugh and sob and applaud and, quite possibly, breathe a sigh of relief. The Holocaust? Not so special after all" (19). This danger, at a time when more and more eye witnesses to the genocide are dying (and thus taking their credibility with them) and the "denialist"[6] contingent of the population is growing, is very real. Benigni is very much aware of these criticisms and has a ready defense. As many people already know by now, Benigni even anticipated possible hostility to the basic premise of making a comedy based on the Holocaust. He therefore invited Marcello Pezzetti of the Center for Contemporary Hebrew Documentation (Centro Documentazione Ebraica Contemporanea) of Milan to serve as historical consultant for the film (Celli 2000:75). As it later turned out, Pezzetti became Benigni's chief apologist and defender in the face of the pervasive and acrimonious criticism, stating that some of the most effective films on the subject of the Shoah have been deliberately conceived to avoid explicit representations of the violence and horrors. He cites *Ambulans* by Janusz

[6] Those who claim that the Holocaust never happened or that it is a historical hoax.

Morgenstern (1961) and *The Passenger* by Andrzej Munk (1960) as examples (Celli 2000:76).

Vincenzo Cerami, Benigni's co-writer of the script, has justified the decision to conceive the film as a comedy referring to a different theory. According to him the present cinema is plagued by a technologically created "hyper-reality." Everything that is imaginable can now be reproduced through computerization. The result of this, Cerami continues, is a diminishment of film's "poetic qualities" (Celli 2000:76). I propose that to this we should also add the viewers' radical desensitization and the ensuing difficulty of shocking them. By now viewers are used to strong medicine indeed. It is thus commensurately difficult to impress the extent of the horror on their violence-saturated consciousness.

Benigni has advanced a number of reasons for his decision to downplay the horror. He alludes to the theories of Marcel Proust and Edgar Allan Poe, who believed that an effective story implies as much as it renders explicit and that some details should always be omitted in order to allow the reader's/viewer's imagination some free play (Celli 2000:76). Moreover in an unpublished interview conducted by Vanina Pezzetti and appearing as an appendix in Carlo Celli's book, *The Divine Comic*, Benigni provides a further argument. He declares that "Absence makes sharper presence" (140) and that "Terror is always present [in *Life is Beautiful]* but never shown directly. It is evoked. There is nothing more powerful and terrible than an evoked terror" (Celli 151). Thus, all three, Pezzetti, Cerami and Benigni lay claim to the power of the reader's/viewer's imagination. To further defend himself against the critics, Benigni has also reiterated that his primary goal was not to make a movie about the Holocaust; he wanted to make what he has at times called "a beautiful movie" (Liebman 21) and at others "a fable" (Cerami et al.).

All these arguments appear to be specious and glib because advanced after the controversy. They sound self-

serving and self-exculpatory. Nor are they based on any profound literary insight. They are in fact little more than clichés. Judging from the existing critical reaction to them, they were not at all effective or convincing.

However, his claim that he wanted to make a "fable" [7] may be more cogent and will be closely scrutinized later in this paper. In his interview with Vanina Pezzetti, Benigni has revealed that his father was interned in a German labor camp in World War II . Benigni's childhood recollection is that when his father told the stories about that experience, "he did not make me relive it as a trauma. He always told me about it gently…" (Celli 150). Consequently Benigni conceived of the idea of telling a tragic story in an attenuated manner that he calls a fable. The much-criticized idealized camp of *Life is Beautiful* was envisioned as part of this decision. "I reconstructed an archetype of a camp with brick buildings, without the wooden barracks…With Donati [the production and costume designer] it was decided to build a set which would give the idea of a fable and at the same time of the horror of the concentration camp," Benigni has stated (Celli 152-153). Again this reason has proved to be unconvincing to the critics. Liebman, to name only one of many, is adamant: he sees the claim as a "prophylactic move to insulate his film from strong charges of falsifying history" (27) and asks, "Should fundamental, crushing facts about the Holocaust…be disregarded so cavalierly?" (27).

Yet Benigni's perception of how he used history in his film differs sharply. He tells Pezzetti that in order to avoid "large mistakes, I had to learn, read and research. To do otherwise would have been a terrible mistake as well as a lack of respect…we were dealing with a wound that has remained opened" (Celli 153). Thus, on the one hand he did see the need for research and accuracy, and on the other he then decided to take liberties to conform to his vision.

The question of this film's effectiveness as a fable or

[7] I will shortly question his use of the word, as it is more likely that he should have called it a fairy tale.

fairy tale is central in its evaluation and appreciation. Embedded in this question is the issue of innocence on more than one level.[8] The director has stated many times that he "got the idea of having to protect the innocence of a little boy in the midst of a tragedy so big" (Fuller 78). With this basic premise went along the comic approach, because, naturally, at least to Benigni the comedian, "if you are able to laugh, you are the owner of the world. And what is more simple or more beautiful than to protect innocence...?" (Fuller 78).

Having committed himself to protecting innocence, Benigni realized right from the start that he would have to do this on more than one level: in the film itself it is his character, Guido, who creates the "game" that insulates Giosuè, his five year old son, from the brutal realities of the Nazi death camp in which they have been interned. This game, by implication, is meant to save both his life and his innocence. The connection between these two imperatives, or their respective priority, is never made clear, either in the diegesis or the many interviews that Benigni has given on the subject of his film.

On another level Benigni found that he had to protect the young actor who played Giosuè, Giorgio Cantarini, from the events he would be witnessing and participating in as an actor. "It was so unbearable to think about making this kind of movie with such a little kid" the director tells us (Fuller 78). He and his real life wife, Nicoletta Braschi, (who plays Giosuè's mother, Dora) tried to tell Giorgio "the story of the movie as a fable, with good guys and bad guys..." (Fuller 78). In the Pezzeti interview Benigni provides a fuller description of his directorial/paternal strategy with the young boy who was actually acting for the first time ever. Thus we learn that Benigni, as director, was treading a very fine line

[8] The definition of innocence is not univocal. It can refer both to a) "freedom from sin, evil or guilt, or b) "freedom *from knowledge of evil*" *(Webster* 945). I believe that "b" is the more relevant for our discussion.

with the boy. While he had to immerse the child in the fictional yet disturbing world of the camp enough to get him to portray strong emotions successfully, he also did not want the boy to be scared by the "screams, tortures, and guns..." that were a part of the plot. In the end his directorial approach mimicked the principles of fairy tales, he simplified and schematized good and evil by having the boy identify the Jews with good and the Nazis with evil, thus personifying those abstractions.

These two layers of protection were deliberate and conscious on Benigni's part. However, when the film was released it quickly became apparent that, as a result of his strategy to attenuate the depiction of violence of the historical events, he had inadvertently created still a third layer of insulation. Alleva expresses it this way: "Just as Guido transforms the horror of the camp into fun-and-games for the sake of the child's mental health, so does Benigni tame the horror for the sake of the viewer's mental comfort " (19). While the critic deems the father's deed heroic, he finds the director's to be "craven." The fact that Benigni has treated the viewing audience patronizingly, like children, as Glieberman has suggested, has been commented on by many critics (54). Jacobsen also declares that he feels himself cheated that Benigni and "Guido bluffed the kid and us, the audience" (4). In the final analysis we have at least a triple "deceit" going on: Guido deceives Giosuè, Benigni deceives Cantarini and Benigni deceives the audience.

However, I would propose that despite Benigni's many pronouncements on the need to protect a child's innocence, it is legitimate to question whether his view on the subject is either coherent or consistent. Much has been said and written on the gullibility of the child and this has sparked a debate among critics. The question frequently asked in different ways is, "Would an intelligent young boy really believe his father's ridiculous explanations in such a sinister environment?" (Davies 102). Benigni himself has either explicitly or implicitly expressed confusion on this score.

When asked by Vanina Pezzetti whether the child is aware of what is going on he responds that, "Objectively the child should not be aware, but he actually does know what is happening (Celli 140). As proof of this he offers the scene in the bookstore between Giosuè and his grandmother. As Benigni explains it, he included this scene in the film and fought not to have it cut, precisely for the purpose of illustrating the boy's awareness of reality. In the film the child says he does not know his grandmother since she has broken relations with her daughter, Dora, when the latter married Guido. The grandmother thus enters the store on the pretext of purchasing a book. When she leaves Giosuè says, "You forgot your change, Grandmother." Benigni tells us that he was attempting to show that "the child knows more than we might think, like all children, who are so amazing" (Celli 140). Yet Benigni has also implied that the child's mind is mysterious, and virtually unfathomable, "who can tell how they actually see the rain or the barking of a dog?" (Celli 140).

It seems to me that his thoughts on the innocence of children are problematic. On the one hand he implies that if a child has ever had any innocence, at best it was limited and qualified: "the child knows more than we might think." On the other hand he has structured his film on the premise that he must insulate the child from the knowledge of the true nature of his environment and the people who inhabit it. Yet it is logical to question the consistency of the pattern that the director is employing. If "the child is playing with his grandmother," by pretending not to know her, as Benigni claims, why should we believe that he is so easily fooled in the camp? The pattern set by the director in the bookstore scene must also apply in the camp if it is to remain coherent. Why then does Giosuè play along with Guido if he sees through his father's strategy? This situation could suggest that the boy also is trying to, in a sense, "protect" his father by pretending ignorance of the true nature of the situation. Thus, by maintaining the fiction that his innocence is being

protected, it is the child who successfully gives a purpose to his father's life and actions in the camp. If this is the case we would need to add still a fourth layer of the well-meaning "deceit" I have discussed above. At least three of these are expressions of love or benevolent concern: Guido for Giosuè, Benigni for Cantarini, and Giosuè for Guido, thereby thrusting the viewer into a phantasmagorical house of mirrors.

J.R.R. Tolkien, in his *The Monsters and the Critics,* has advanced a theory that would lend still more weight to the idea that children are not so easily fooled. He states that the appearance that it is easy to work the "spell of belief" on children is often an "adult illusion produced by children's humility, their lack of critical experience and vocabulary..." (133).

Charles Tesson, writing in *Les cahiers du cinéma,* proposes still another possibility to help us gauge Giosuè's level of awareness. He suggests that the reality that Guido attempts to create for Giosuè corresponds to their interior emotional landscape, "...in such a manner that reality becomes an idealized echo of his interior landscape, animated by magic and marvels, where all is goodness and cheer" (46).[9] Tesson argues that Guido's denial of reality starts with his lies about the racist sign ("no Jews or dogs allowed"), continues with the hilarious but highly inaccurate translation of the camp rules, and ultimately ends with the substitution of the harsh reality of the death camp by the frivolous goal of winning a ride in a tank. The author clearly suggests that Guido has abdicated his parental role and shirked his responsibility of initiating his son into the unpleasant and sometimes cruel facts of life. Moreover, Tesson states, as a result of Guido's irresponsible behavior, someone else, possibly his mother, will later have to perform

[9] "...de telle sorte qu'elle [la realité] soit l'echo idéal de sa vie intérieure peuplée d'images magiques et merveilleuses où tout est douceur et bonté." (Translation from the French by Grace Russo Bullaro.)

that necessary initiatory task. The extent of Guido's denial is such that despite his participation in the events depicted, Giosuè will later be able to say that he has seen nothing and experienced nothing. Indeed, it will not be necessary for the boy to erase the memory of the events since they have never registered on his consciousness (Tesson 46).

Clearly Tesson does not share Benigni's view that the boy instinctively knows. On the contrary, his consciousness must be raised, he must be taught the meaning of his experience, he must be made to evaluate it on a moral scale that conforms with society's values. The boy is a *tabula rasa* on which society, through his parents, must encode its rules. Tesson, like J.R.R. Tolkien, David Luke and Bruno Bettelheim, asks the question that is the theoretical pivot of child psychology, children's literature, and most particularly, fairy tale and fable: Should we spare children confrontation with the worst? And with knowledge of evil? More relevant to our discussion, in claiming to have conceived *Life is Beautiful* as a fable in order to allow his character, Guido, to protect the innocence of his son, has Benigni chosen a strategy that makes sense? In order to answer this question we must look more closely at fairy tales and fables and the purpose they serve in a child's development.

Despite the fact that most people (critics and Benigni included) appear to use these two terms, fairy tale and fable interchangeably, we learn that they are not so. Benigni has reiterated many times that his film is a fable, yet if we look at the definition and description of these two genres, we realize that he should have called it a fairy tale. According to Bruno Bettelheim, widely acknowledged authority on the subject of children's literature, a fable is prescriptive, telling what one ought to do; and it "demand[s] and threaten[s]" (26). A fairy tale, on the other hand, "far from making demands...reassures, gives hope for the future, and holds out the promise of a happy ending" (26). Nor are fairies a mandatory requirement. Indeed, Bettelheim maintains that the genre has been misnamed, for "in most, no fairies

appear" (26). If we think of the reassurance and the promise of the ride in the tank that Guido holds out to his son in order to get him to accept the game, we quickly see that this definition is much more apposite to the plot of this film. Tolkien also, like Bettelheim, rejects the definition of fairy tales as "stories about fairies," finding it too narrow and states that "it becomes plain that many, even the learned in such matters, have used the term fairy tale very carelessly" (113).

Furthermore, a fable can be seen as a cautionary tale which, "by arousing anxiety, prevents us from acting in ways which are described as damaging to us " (Bettelheim 38). Far from arousing anxiety, Benigni has attempted to assuage and even totally eliminate it if possible, for the boy and possibly for the audience. Moreover, if we look at some of the features of the fairy tale, it becomes even more obvious that this is the word Benigni should have used to describe his film; for in a fairy tale we find that situations are simplified, details are eliminated, characters are generalized rather than unique, and good and evil are polarized (Bettelheim 26).

Francesco Caviglia has also commented on the stock elements of *fiaba* (fairy tale) that he finds in *Life is Beautiful*. [10] He names the following: Guido is a capable magician; *narrative providence* acts as a fairy godmother, making possible the impossible; a princess (Dora) falls into the hero's (Guido) arms; flowerpots and hats unexplainably end up on the *right* heads; Guido evokes magical powers when he calls on "Maria" to throw down the key; Guido and Dora ride off on a white horse (4).

But it still remains to be seen whether what Guido aims to do for his son, to insulate him from the brutal reality of the environment in which they find themselves, is actually beneficial to the boy. The manner in which Guido aims to accomplish his goal is congruent with the approach of a fairy tale. A child's world is more intellectually simple than an

[10] In Italian the word for fable would be *favola*.

adult's and thus it is easier to schematize people and events as being dichotomous: good/evil, friends/enemies. Flattened, simplified events, reduced to polar opposites and devoid of complicating details, become more easily comprehensible to children. The death camp, reduced to a game where one thousand points will win you a ride in a real-life military tank (i.e. the promised happy ending) is easily contained within the parameters of a child's understanding.

The problem with this approach is that it does not conform in one very important respect to the world of fairy tale; for unlike the sanitized (and fictitious) world created by Guido for his son's benefit, the world of fairy tale is a violent one. Tolkien, Luke and Bettelheim would significantly add, necessarily so. Indeed, classic collections of folk, myth and fairy tales such as Basile's *Pentamerone,* Perrault's *Contes de ma mère L'Oye* and Grimm's *Fairy Tales,* [11]before Disney bowdlerized them to make them more palatable to today's children, were much more violent than what we are used to today. Leading theorists concur that there are some very good reasons for the violence. David Luke suggests that since violent impulses and guilt about them exist in children, repeated encounters with violent or cruel fictional events, "far from being frightening or disturbing, may be satisfying, guilt-relieving, reassuring and therapeutic" (37). Thus we see that the omission by the storyteller, of a particularly gruesome or disturbing feature, will meet with the child's protests. The child, while recognizing that the story represents a world of make-believe, nevertheless simultaneously recognizes the events to be "true" in a "displaced, symbolic way" (Luke 37). The purpose of such a story is not simply to scare children into prudent behavior but to be "a symbolic fantasy which confronts, expresses and...relieves a primitive anxiety" (Luke 35).

[11] For a detailed account of the evolution of this process see Bettelheim, Luke's Introduction to *Grimm's Fairy Tales,* and Windling's article.

Bettelheim similarly sees the need to expose the child to the ugly truths of life if he or she is to grow into a well-adjusted adult. "The dominant culture wishes to pretend, particularly where children are concerned, that the dark side of man does not exist", he states (8). But this is a mistake, since it fails to convey to the child what Bettelheim believes to be the source of mental health and adjustment, the child must learn that " a struggle against severe difficulties in life is unavoidable…but that if one does not shy away…one masters all obstacles and at the end emerges victorious" (8). This is not all, we should also make it clear to children that much of what goes wrong in life is due to the baser instincts and behaviors of human beings who are not always good or noble. Children should be made aware that we are often aggressive, asocial, selfish or angry. The result of misrepresenting ourselves as unfailingly good is that the child will become confused and see himself or herself as "a monster in his own eyes" since they will be aware of their own failings and that they are not always good (Bettelheim 7).

Terri Windling, in "On Tolkien and Fairy Stories," illustrates how the unbowdlerized fairy tales helped her cope with and overcome a dark childhood where unemployment, alcoholism and domestic violence featured prominently. She stresses that her beloved collection, *The Golden Book of Fairy Tales* was shortened but not simplified—the gruesome and dark bits had been left intact. In her recollection, "These were tales of children abandoned in woods; of daughters poisoned by their mother's hands; of sons forced to betray their siblings…"(5). When shortly after this period of her childhood, her own life reached a crisis and she left home, still carrying her *Golden Book* under her arm, she found that the lessons learned from it served her well. She, like her heroes, knew that you must arm yourself with "quick wits, clear sight, persistence, courage, and compassion" if you are to defeat the wolf and the wicked witch (5).

To know that the witch is evil and the wolf can eat you

qualifies perhaps as a loss of innocence. But what does Guido attempt to do if not to hide facts analogous to these from Giosuè? We have seen that Tesson has already commented on the damage that such protection can cause the child in the long run. We now see that Guido's strategy (and of course for Guido we can read Benigni) also runs counter to Tolkien's, Luke's and Bettelheim's assertions that the purpose of a fairy tale is to "confront the child squarely with the basic human predicaments" (Bettelheim 8). These include death, aging, the limits to our existence, and the wish for eternal life, among others. And I am confident that to these we could add the brutality of a death camp, encompassing as it does, all the others.

Also worthy of note in our analysis, is that while both good and evil are powerful forces in fairy tales, Benigni, through his authorial and directorial strategy, has attempted to deny evil its measure of power in *Life is Beautiful* by representing the camp not as the locus of evil that it is, but as a place of fun-and-games where the *summum bonum* is winning the ride in a tank and the utmost penalty is to lose your accumulated points.

Bettelheim argues that the quest for a meaning of life is a life-long process that starts in childhood, culminating eventually into what we call psychological maturity. "At each age," he maintains, "we seek and must be able to find, some modicum of meaning congruent with how our minds and understanding have already developed" (3). In falsifying Giosuè's entire experience by distorting its meaning, no matter how well-intentioned, Guido (and Benigni by extension) interferes with his son's emotional and psychological adjustment and maturity. Guido misrepresents the meaning of the camp experience. Instead of "men are evil and irrational and you must learn that in order to survive," he substitutes, "life is a game without serious consequences." In the first instance failure means death; in the second, missing out on a ride in a tank. Indeed, as it is conceptually and stylistically framed, *Life is Beautiful* does

have a happy ending. The boy does get his wish fulfilled.

Since the true nature of the event has been misrepresented by the father, and probably misconstrued by the son, serious repercussions will ensue subsequently. (If, as the other possibility, the boy has seen through the whole game, should he, at the end, be so willing to trade his father's death for the granting of his wish? How do we explain his joy at getting the ride in the tank despite his father's death?) Further, because of the distortion of the meaning of this crucial experience, the "master plan" of human nature and behavior will continue to be misunderstood in the future. If we are to believe the experts, the child may fail to develop adequate adjustment strategies when facing severe difficulties. The only strategy that he has learned in this case is to hide from danger. Needless to say, in life this does not always prove to be successful, nor even desirable. The well-intentioned father has cheated his son out of a precious, though harrowing, opportunity to make a giant leap towards psychological maturity.

On a secondary level Benigni has done the same to the viewer. By essentially vitiating the camp and its meaning, he deceives the viewer as he has deceived the boy. As he minimizes the horror for the boy, he minimizes it for us. As he denies the full impact of events for his son, so he rejects the full impact of the historical events we know occurred. As the director spares the audience the descent into the depressing depths that historical accuracy would have made necessary, he robs us of the Aristotelian catharsis that the evocation of pity *and terror* would have made possible.

Thus Giosuè is the mirror image of the viewer. Indeed, much has been said about Giosuè's role as spectator when hiding in the box at the end, peering out through a slot as he watches his father led away by the Nazi soldiers. The box, we are told, functions as a "camera obscura" which, by placing the boy into the position of control as viewer, allows him to accept the reality created by the father, and thus he

laughs as Guido is marched off to death.[12] That "Benigni never entertains the notion that distorting a child's experience of the Holocaust, and excluding him from a terrible collective memory may not be a wholly good thing," (Calhoun 86) is obvious. That he consequently puts us all in Giosuè's position, "licensed to close our eyes to the truth" (Calhoun 86), is sad. That he then expects kudos saying that, "if we can talk about it [the Holocaust] and also even smile about it, not sneeringly, but to naturally make fun of it, to smile at the Holocaust, we will be able to get over it" (Liebman 6) is either naïve or cynical and self-serving. However, it is ironic that by sparking this controversy about his trivialization of the Holocaust Benigni has indirectly and unwittingly done more to recreate its horrors than if he had accurately presented them in his film. The many critics who have lambasted him for his decisions have recreated the horrors for him by naming them and fully describing what the director either omitted or misrepresented. In short, they re-evoked the historic scenes of the Holocaust that we are already familiar with by signaling their absence.

Thus, from the artistic point of view, as previously discussed in this paper, the film is highly problematical. [13]Conceptually, he has sacrificed historical accuracy in order to focus on a father's attempt to protect his child's innocence in the extreme circumstances represented by the Holocaust. In order to defend himself against negative criticism that this decision has generated, he has then reiterated that his intention was to make a fable (although it is really a fairy tale). Yet having examined the film in the context of his own given, we cannot help but see that the strategy of representing the lived experience of evil as a fictionalized fairy tale, far from being beneficial to the child, will, in the

[12] Tesson and Celli (2001), among others discuss this mechanism at length in their respective texts.

[13] For a fuller discussion of the cinematic aspects of *Life is Beautiful,* which would exceed the scope of this essay, the reader can see Alleva and Calhoun.

long run, most likely prove to be detrimental to his psychological development. Indeed, the apparently insensitive interpretation of Guido's sacrificial death on the part of the grown-up Giosuè seems to confirm this. We are thus justified in questioning the wisdom and efficacy of the strategy chosen for Guido by the director and must therefore also discount Benigni's glib self-defense as mere excuses to hide that failure.

Works Cited

Alleva, Richard. "Nothing to Laugh About." *Commonweal.* (March 26, 1999) V136i6: 18-19.

Anonymous. "Robert De Hero: Roberto Benigni has conquered Hollywood, not to mention America. What will he do in the afterlife?" *Entertainment Weekly.*(April 9, 1999) i480:8.

Bettelheim, Bruno. *The Uses of Enchantment.* New York: Alfred A. Knopf, 1991.

Blake, Richard A. "Genocide Now." *America* (March 13, 1999) v180i8:31.

Bullaro, Grace Russo. "Lina Wertmuller's *Man in Disorder* and the Idea of Perfectibility In Seven Beauties. *Italian Culture* XV (1997): 371-389.

Calhoun, John. "Life is Beautiful. *Interiors* (April 1999) v158i4:85-86.

Caviglia, Francesco. "Tra Chaplin e Fellini: *La vita e bella* come summa di fine secolo." http://www.hum.au.dk/romansk/ romfrc/ papers/benigni.htm:6pp. Accessed on May 29, 2002.

Celli, Carlo. *The Divine Comic.* Lanham, Maryland and London: The Scarecrow Press, Inc., 2001.

———."The Representation of Evil in Roberto Benigni's *Life is Beautiful. Journal of Popular Film and Television* (Summer 2000) v28i2:74-85.

Davies, Daniel. "Striking the Wrong Note." *The Lancet* (March 20, 1999) V353i9157:102.

Fuller, Graham. "The Brave Little Film that Could." *Interview* (November 1998) V28 1178: 54.

Gleiberman, Owen. "Happy Camper." *Entertainment Weekly* (November 6, 1998): 54.

Grimm, Jacob and Wilhelm. *Selected Tales.* Translation and

Introduction by David Luke. London: Penguin Books, 1982.

Jacobsen, Kurt. "Camping Out: Roberto Benigni's *Life is Beautiful"* *New Politics* (Summer 1999) v7 n.3 (new series) whole no. 27. www.wpunj.edu/newpol/issue27/Jacsen27.htm Accessed on April 30, 2002.

Kauffmann, Stanley. "Changing the Past." *The New Republic* (November 23, 1998):26.

Levi, Primo. *Survival in Auschwitz: The Nazi Assault on Humanity*. Translated by S. Woolf. New York: Macmillan, 1958.

Liebman, Stuart. "If Only Life Were So Beautiful" *Cineaste* (Spring-Summer 1999) V24 i2-3:20-29.

Matthews, Kate. "Serious laughter: critics of *Life is Beautiful* and the question of comedy." *Australian Screen Education* (Autumn 2003) i31: 105-110.

Rooney, David. *"Life is Beautiful"* *Variety* (December 22, 1997) v369 n7:61.

Schickel, Richard. "Fascist Fable" *Time* (November 9, 1998): 116.

Sharma, Ruchi. "Brilliant, sensitive, serious cinema." Rediff.com http://www.rediff.com/movies.2000/nov/04beaut.htm Accessed on October 15, 2003.

Simon, John. "Film: Lies are Unbeautiful" *National Review* (February 22, 1999):54.

Tesson, Charles. "L'enfance de la mémoire à propos de La vie est belle" *Cahiers du Cinéma 529* (November 1998): 46-48.

Tolkien, J.R.R. *The Monsters and the Critics and Other Essays*. Boston: Houghton Mifflin Company, 1984.

Windling, Terri. "On Tolkien and Fairy Tales" http://www.endicott-studio.com/fortolkn.html Accessed on June 6, 2002.

Wulf, Steve. "Roberto Benigni: Finding Humor in the Face of the Holocause, He Reminds The World Why Life is Beautiful" *Entertainment Weekly* (March 1, 1999) i474: 108.

Ma la vita è davvero *bella*? Lo spettacolo dell'Olocausto, ovvero del nuovo *kitsch*

Erminia Passannanti

La questione che intendo affrontare è se sia lecito sul piano etico rendere l'Olocausto il soggetto di una commedia. Se si, qual è il senso della proposta in chiave tragicomica del genocidio di sei milioni di israeliti provenienti da ogni parte d'Europa, di cui ci viene nuovamente raccontata la tragedia ne *La vita è bella*, di Roberto Benigni. Prima di addentrarmi nelle ragioni delle mie perplessità in merito alla forma che l'autore ha eletto per la sua trattazione, vorrei ricordare che la denuncia degli esiti atroci del patto nazifascista è stata a lungo al cuore della cinematografia neorealista di Roberto Rossellini, Vittorio De Sica, Luchino Visconti e post-realista di Pier Paolo Pasolini, e continua a rimanere attiva in opere più recenti quali *The Schindler's List* (1993) di Steven Spielberg e *The pianist* (2002) di Roman Polanski a testimoniare l'impatto che il secondo conflitto mondiale ebbe sulla loro arte.[1] A partire dal progetto neorealista di ripensamento critico della storia, fino alla cinematografia contemporanea, la persecuzione degli ebrei nell'Italia fascista, insieme al dramma del conflitto sull'economia e sulla cultura della nazione, sono stati temi centrali di innumerevoli opere letterarie e filmiche.

Nel decennio successivo alla Liberazione, protagonisti della scena culturale italiana come Cesare Pavese, Alberto Moravia, Beppe Fenoglio, Pier Paolo Pasolini e Elio Vittorini, trovavano nei presupposti antifascisti di Antonio Gramsci nei *Quaderni dal carcere* (1929-1935) e negli

[1] Luchino Visconti, "Cinema antropomorfo", in *Neorealismo Poetiche e Polemiche*, a cura di Claudio Milanini, Torino: Il saggiatore, p. 34. Visconti così commentò quegli anni: "L'esperienza fatta mi ha soprattutto insegnato il peso dell'essere umano".

scritti dei pensatori marxisti della scuola di Francoforte i motivi ispiratori di opere letterarie e filmiche da affiancarsi all'azione politica, riconoscendo in un socialismo umanitario e antidogmatico la comune base ideologica per la critica delle istituzioni al potere.[2] Alla fine degli anni Cinquanta, a partire dalla crisi provocata nel 1956 dalla pubblicazione del *Metello* di Vasco Pratolini e dall'invasione da parte dell'URSS stalinista della Polonia e dell'Ungheria, la prospettiva storico-sociologica della produzione neorealista si scontrò con le nuove proposte della neoavanguardia, che risollevava il problema dell'autonomia dell'arte e l'esigenza di un'innovazione formale dei linguaggi artistici. L'irrisolta tensione tra le premesse del neorealismo etico e le istanze dei nuovi linguaggi emergenti determinò un serrato scontro di prospettive che, come ha notato Claudio Milanini, rivelava "valutazioni spesso divergenti, talora contraddittorie" della storia recente.[3] Sullo sfondo della guerra fredda e nel clima delle alleanze di partito, il mandato degli intellettuali di rinnovare la coscienza e l'identità culturale della nazione perdeva forza e coesione. Un primo attacco ai presupposti teorici del neorealismo militante venne da Pasolini, che mise in luce il problema dell'evoluzione artistica delle forme e dei linguaggi rispetto all'adesione fedele dello scrittore alle istanze imposte dal Partito. Calvino, a sua volta, indicava l'urgenza di un

[2] *La luna e i falò*, di Cesare Pavese, *L'Agnese va a morire, (1949)*, di Renata Vigano, *Una storia italiana,* (trilogia comprendente il *Metello*), di Vasco Pratolini, *Cristo si è fermato a Eboli*, di Carlo Levi (1945), *Se questo è un uomo*, di Primo Levi , *La storia* , di Elsa Morante, *La Ciociara,* di Alberto Moravia, *I 23 giorni della città di Alba*, di Beppe Fenoglio (1952), e *Si fa presto a dir fame*, di Piero Califfi (1955), affrontavano, infatti, la tragedia bellica sulla base di esperienze soggettive, che assumevano un carattere universale quale incubo collettivo. Lo stesso avveniva in cinematografia, con i film neorealisti di Pier Paolo Pasolini, Vittorio De Sica, Visconti, e Roberto Rossellini.

[3] Cfr. Claudio Milanini, *Neorealismo e polemiche,* Milano: Il Saggiatore, 1980, p. 9.

impegno individuale dell'artista verso il rinnovamento stilistico del medium espressivo.

Il problema è stato risollevato nel 1995 da Jurgen Habermas, in *Die Normalitat einer Berliner Republik*, dove si sostiene l'origine culturale degli orrori del nazismo. Habermas denuncia la responsabilità individuale e collettiva dell'aberrante fenomeno, e raccomanda una rottura radicale con i valori della tradizione e dell'identità nazionale che avevano reso possibile l'errore storico. Rifacendosi al Lukács di *La distruzione della ragione* (1954) e ripercorrendo la filosofia irrazionalista che da Schelling giunge fino a Hitler, Habermas mostra come, a una valutazione retrospettiva, la storia tedesca sia essenzialmente una storia di complicità collettiva con l'ideologia di Hitler.[4] Habermas ribadisce la centralità della cultura come strumento per la rinascita di una civiltà capace di trascendere i confini nazionali per analizzare la propria storia criticamente. Da questa prospettiva, dobbiamo costantemente chiederci quale lezione abbiamo appreso dall'Olocausto e in che misura la nostra presente civiltà sia in grado di farsi garante di una memoria affidabile degli errori storici al fine di evitarne la tragica reiterazione. Fatta eccezione de *Il pianista* (2002) e *The Schindler's List*, la cinematografia contemporanea sull'Olocausto ha abbandonato ogni stretto legame con i presupposti del

[4] Si veda la "teoria consensuale della verità", in *Storia e critica dell'opinione pubblica* di Jurgen Habermas (7 ed., Bari: Laterza, 2000). La presa di coscienza da parte di un popolo che lo rende capace di opporre resistenza a tali dinamiche seguirebbe, secondo Habermas, lo stesso percorso d'apprendimento collettivo, attraverso i momenti d'autocritica forniti non solo dalle festività nazionali quali l'8 maggio, che, in Germania, celebra la fine della guerra e la Liberazione da un regime in cui il popolo si era, tuttavia, così bene identificato, ma dal cambiamento di mentalità ricavabile dalla critica ai valori degenerati all'interno della civiltà europea, che con la persecuzione nazista negava ogni principio razionale.

socialismo realista.[5] Un riesame del passato nazista affidato a principi attendibili è, relativamente presente in *The Schindler's List*, nel senso che il film alterna alla *fiction* stralci di film-documentari che mostrano come l'eccidio originasse dalla promulgazione di ordinamenti giudiziari che legalizzavano in Germania i già presenti pregiudizi antisemiti.

L'abbandono delle proposte del neorealismo critico è stato segnato dal passaggio di un modo di pensiero – quello marxista – ad un altro suo antagonista – quello del postmodernismo, quale facciata estetico-culturale della pulviscolarizzazione e dissoluzione dell'unità politica, ideologica, economica, e sociale, dell'occidente, annunciata da teorici come Jean-Françoise Lyotard e Gianni Vattimo. Vanamente contrastato dalla vecchia guardia del Marxismo ortodosso, che ha negativamente designato il fenomeno come indicatore di un pensiero che avvalla la mancanza di prospettiva storica, l'inumazione dello scontro ideologico, l'appropriazione parodistica che il postmodernismo fa dei materiali della tradizione mediante l'uso indiscriminato della citazione e del *pastiche*, mette in tavola l'eclettismo di un orizzonte filosofico che si propone di abbattere l'egemonia dei grandi sistemi di pensiero, ed eliminare le differenze tra cultura "alta" e cultura popolare.[6] Questa definizione, che

[5] Cfr. Remo Ceserani, *Raccontare il postmoderno*, Torino: Bollati & Boringhieri, 1997, p. 146. Ceserani osserva: "l'Italia è stata velocissima nell'adattarsi alla nuova temperie e ha contribuito con tanta prontezza a darle forma", "invece, gli intellettuali ed i critici letterari italiani sono rimasti così inflessibili nel respingere le nuove tendenze e si sono rifiutati di dar loro il minimo credito."

[6] Cfr. Terry Eagleton, *The illusions of Postmodernity*, London, Blackwell, 1996, p. viii. Eagleton precisa: "Postmodernism is a style of culture which reflects something of this epochal change, in a depthless, decentered, pluralist art which blurs the boundaries between 'high' and 'popular' culture, as well as between art and every-day experience [...] I accuse postmodernism from time to time of 'straw-targeting or caricaturing its opponents' positions"

Terry Eagleton desume dall'analisi di Lyotard in *Condition Postmoderne* (1979), designa, pertanto, un'arte e una cultura che non assume a vessillo della sua causa l'eticità a tutti i costi, come urgenza teorico-programmatica, ma la dissimula e la frammenta in "micro-narrative", che rompono ogni diretta dipendenza dall'idealismo otto-novecentesco di estrazione borghese. Gli attacchi all'estetica del postmoderno di critici del marxismo militante, quali Franco Fortini, in "Due Avanguardie" (*Verifica dei Poeteri*, 1974), insieme al dibattito condotto, ad esempio, da Romano Lupini nei suoi interventi sul potmodernismo, da Renato Barilli in *Il ciclo del Postmoderno* (1987), da Alfonso Beradinelli, in *La fine del postmoderno*, e da Francesco Muzzioli, in *L'alternativa letteraria*, non rendono giustizia ai meriti di questa cultura debitrice alle nozioni di dialogia, eteroglossia, e riso dissacratorio della teoria di Mikhail Bakhtin, che potrebbe avere ispirato Benigni nell'ideare i modi specifici della trattazione del soggetto de *La vita è bella*.[7] La cultura che da vent'anni tende al "pensiero debole" ha i suoi indiscutibili meriti, prima tra questi mostrare la perniciosità di ogni struttura sovrapersonale sulla prospettiva del singolo individuo.

Da questa ottica, spero non appaia priva di senso la proposta di sottoporre ad un più attento vaglio il ricorso alla comicità in rapporto al tema dell'Olocausto. Bisogna innanzitutto chiedersi se gli aspetti ludici e citazionisti de *La vita è bella* vadano o meno inquadrati all'interno di un discorso di tipo postmodernista. È chiaro che un artista di questo genere, che stimasse, ad esempio, la teoria del "pensiero debole" di Vattimo, o la "sintesi dialettica delle

[7] Cfr. Mikhail Bakhtin, *Rabelais and His World*, trad. Helene Iswolsky. Cambridge: The M.I.T. Press, 1968, p. 96. In quest'opera, l'autore nota come le celebrazioni carnascialesche siano la ridicolizzazione collettiva delle forze al potere, operata con l'inversione sistematica delle gerarchie ufficiali, la violazione del senso comune del decoro, e il rovesciamento dei valori istituzionalizzati.

contraddizioni" di Friedric Jameson, metterebbe in rilievo la
necessità di un relativismo prospettico ad indicare
l'inattendibilità d'ogni sapere bipolare. Benigni, al contrario,
ricade nella rete dell'idealismo classico (ovvero del
"pensiero forte"), essendo la sua esposizione non
pluralistica, metastorica, estetizzante, ma interamente calata
nel sistema di pensiero che crea un mondo in bianco e nero e
lo divide in buoni e cattivi, persecutori e vittime. Nei
contenuti tematici de *La vita è bella* non si avverte una vera
resistenza alle potenze sovrapersonali, di cui parla Vattimo,
in *Le avventure della differenza* (1980), ma solo una
elaborazione della realtà da parte del soggetto in nome di
esigenze e valori personalistici che ritiene gli altri
condividano. La coscienza del protagonista Guido è una
sorta di ramificazione della coscienza egemonica
occidentale, nel senso che non rinuncia a pronunciare la
superiorità dei valori e della testimonianza dell'intellettuale.
In tal senso, più che una coscienza, Benigni esprime un forte
sentimento della storia come tormento dell'artista che si
schiera dalla parte del popolo e denuncia lo squilibrio dei
rapporti di soggezione e dominio, rivelandosi più
"cantastorie" dell'Olocausto, che storico. L'elemento
comico e favolistico, utile alla sopravvivenza, insomma, non
basta a fare di questo film un'opera aperta al pensiero della
crisi, come crisi radicale dell'artista borghese nel proprio
mondo storico-sociale. Poetico e carico di nostalgico *pathos*,
questo film fa piangere e ridere, ed è questa l'intenzione
ammessa da Benigni. Nulla di impoetico o di prosastico ne
affligge l'andamento, e se parlo di *kitsch*, ne parlo proprio in
ragione di tale eccesso di pateticità e del ripetersi
preordinato di dati *topoi* poetici.

Ma poniamo attenzione adesso all'espressionismo post-
realista con cui Pasolini trattava il tema dell'eccidio. Alla
fine degli anni Settanta, con il film *Salò, o le 120 giornate di
Sodoma*, il soggetto proponeva una rilettura in chiave
allegorica dell'Olocausto, con cui Pasolini ammoniva di
interpretare l'esperienza nazifascista non solo sul piano

politico-ideologico, ma a livello della struttura psichica di tutti gli individui coinvolti.[8] Non c'è alcuna istanza di comicità in *Salò*, bensì una greve, intollerabile satira, che fa un uso spietato del grottesco, del deforme e dell'abietto. Non c'è alcuna lezione consolatoria, o facile ottimismo da comunicare e apprendere. Non vi si trova traccia di rappresentazioni bellettristiche della natura umana, come invece avviene in *La vita è bella*, con la sua retorica dell'incanto latente anche nel più fondo terrore. Nell'ottobre 1976, la "scandalosa" analisi dello sterminio di 770 civili a Marzabotto (BO), ad opera delle SS, condotta da Pasolini nel *Salò*, fu sottoposto ad immediata censura; in realtà, nella sua ricostruzione orgiastica dei crimini nazifascisti, Pasolini rappresentava la fine di ogni netta divisione tra il bene e il male, ponendo l'accento sulla sinistra presenza nella Repubblica di Salò di un numero altissimo di giovani che svolgevano il ruolo di collaborazionisti, mettendo al contempo in evidenza la tragica incapacità di rivolta del popolo oppresso. Nel 1986, ne *I sommersi e i salvati*, Primo Levi riproponeva la natura complessa dei rapporti tra oppressi ed oppressori, nell'ambito dell'Olocausto, e l'esistenza di zone grigie di tradimenti e sopraffazione anche tra le fasce dei perseguitati. Per Levi, solo una retorica superficiale può credere che tra i prigionieri raccolti nei campi di concentramento nazisti ci fosse uguaglianza di stato, solidarietà e coesione, come invece sembrerebbe emergere da *La vita è bella*, con la sua dicotomia vittime-carnefici, che affida il genocidio alla sfera della mera narratività.

Il problema che si poneva a Benigni era probabilmente di riuscire a presentare i contenuti altamente problematici del film a un'*audience* ormai lontana da quelle circostanze storiche che ne avevano innescato l'orrore: infatti, una larga fascia delle persone che si reca al cinema è costituita da

[8] Mi permetto di rimandare alla mia monografia, *Il Corpo & il Potere: Salò, o le 120 giornate di Sodoma di Pier Paolo Pasolini*, Troubador: Leicester, 2004.

spettatori appartenenti ad una generazione che ha appreso del genocidio degli ebrei unicamente attraverso documentari e film. Alla luce di queste barriere culturali, generazionali e nel rispetto delle esigenze dell'industria cinematografica di investire in un prodotto di ampio successo, Benigni non ha rinunciato alla possibilità di spettacolarizzare e alleggerire il soggetto dell'Olocausto. Ed è proprio la rappresentazione caricaturale di certi tropi della persecuzione degli ebrei (non il graffito sulla saracinesca, ma il cavallo verde bardato a festa con la fascia antisemita), e della vita nei campi di sterminio (non il Guido servitore, ma il suo incanto al suono della canzone diffusa dagli altoparlanti), che mi ha indotto a riflettere se la progressiva distanza che veniamo ad assumere dal fatto storico autorizzi l'ingresso di questa tragedia nel genere della commedia. Oltre a ciò, è l'aggravio che l'esuberante espressività dell'immaginario di Benigni pone sul mio personale senso della storia ad indurmi a verificare a quale tipo di variazione, nella vasta gamma di forme esistenti dell'esegesi dell'Olocausto, appartenga questo film.

A proposito dell'atteggiamento dell'intellettuale e dell'artista postmodernista nei confronti della storia, Eagleton ha notato: "La cultura postmoderna ha prodotto nella sua breve esistenza, in tutto il panorama delle arti, una ricca, audace e stimolante massa di opere che non può essere in alcun modo attribuita a una sconfitta politica. Ha altresì generato una dose massiccia ed esecrabile di *kitsch*."[9] A questo fine, ha demolito una serie di certezze, messo in evidenza "totalità paranoiche", e "contaminato purezze". Ha in altre parole prodotto, con il suo relativismo culturale, un sano scetticismo verso l'arte stessa: ha demistificato la sua serietà, il suo ruolo. Tuttavia, secondo Eagleton, per smantellare l'austerità dell'arte modernista, e rifare il verso alla forma merce, il postmodernismo "è riuscito a rafforzare le assai più paralizzanti austerità generate dal mercato." Allo stesso momento, il postmodernismo trasgredisce e

[9] Cfr. Terry Eagleton, *Le illusioni del postmoderno*, Roma: Editori Riuniti, 1998, p. 39.

scimmiotta la "verità" storica, fondando una società della finzione, apolitica e astorica.[10] La distanza temporale di per sé non è necessariamente un dato svantaggioso. Nel saggio "L'opera d'arte nell'era della riproduzione meccanica", Benjamin spiegava come nella cultura di massa, la dissoluzione dell'aura, quale effetto dell'applicazione della tecnologia al prodotto artistico, possa assumere una valenza positiva, offrendolo allo spettatore il distacco necessario a una revisione critica del messaggio. Nell'ottica di Benjamin, la perdita della dimensione auratica dell'opera d'arte privilegia il momento comunicativo tra il prodotto artistico e il pubblico fruitore. Un'eccezione sarebbe costituita dal cinema d'arte e dal cinema d'avanguardia che, anche quando affrontino argomenti storici, lo fanno da una prospettiva che pone in primo piano la ricerca formale in ragione di un preciso progetto estetico, mantenendo su un secondo piano l'istanza comunicativa. In questo genere di produzione cinematografica, la storia, afferma Benjamin, è in sé mero pretesto, subordinato al mantenimento dell'aura di autonomia artistica che la tecnologia vorrebbe dissolta.

Rispetto alla nozione di attendibilità dell'opera d'arte, Jameson ha espresso scetticismo verso il cinema d'autore. Secondo Jameson, nella ricerca dei nuovi linguaggi, questo genere di cinema perseguirebbe un'intensità autoreferenziale, che va a tutto svantaggio della rilevanza e attendibilità storica. Il consolidarsi sul mercato cinematografico di questo genere di opere autografe, in cui prevale l'elemento stilistico quale espressione di un discorso privato privilegiato, contribuirebbe a ridurre ulteriormente il

[10] Ibidem, pp. 40-41. Eagleton aggiunge: "Come ogni tipo di anti-realismo epistemologico, nega regolarmente la possibilità di descrivere com'è fatto il mondo, e altrettanto regolarmente si trova appunto a descriverlo. Insieme libertario e determinista, sogna un soggetto umano liberato dalla costrizione, che scivola con ebbrezza da una posizione a un'altra, e simultaneamente sostiene che il soggetto è solo l'effetto di forze che lo costituiscono da cima a fondo."

contatto del prodotto artistico con le strutture sociali; ciò accadrebbe in virtù del prestigio acquisto da un dato autore, che accresce l'alienazione del pubblico dal fondo di realtà dei fatti narrati. Il pubblico è indotto a partecipare da una distanza che, mentre sembra agevolare una libertà critica ed interpretativa, in realtà subordina lo spettatore alla prospettiva imposta dal regista. La stessa cosa accade, a mio avviso, nella cinematografia postmoderna, fondata essenzialmente su un appiattimento ingigantito delle ideologie a favore della molteplicità delle forme e degli stili, che, pur sottraendo importanza all'autore, ed enfatizzando il momento della ricezione, pone ugualmente in secondo piano la realtà storica, limitando la facoltà dei fruitori di venire a contatto con la vicenda narrata ed esercitare un'autonomia interpretativa rispetto alle idee che in essa convogliano.

La cifra caratteristica della prima parte de *La vita è bella*, come ho già detto, sembrerebbe essere una nostalgia *retrò*, che ripropone non tanto il contesto storico, quanto il sapore della cultura in voga negli anni del regime. Ne consegue che il ripensamento della storia che vi si trova tradisca un punto di vista che procede per luoghi comuni. Come ha notato Primo Levi nel romanzo-memoria sui lager nazisti, *I sommersi e i salvati*, se tale "desiderio di semplificazione" potrebbe anche apparire giustificato, la "semplificazione" in sé non sempre lo è. La riduzione a commedia degli orrori nazisti, operato da Benigni, è un esempio di questo desiderio di semplificazione, che in qualche misura rischia di intralciare la cognizione esatta delle angosciose ambiguità dei Lager di cui parlava Levi.[11]

[11] Parlando della propria esperienza del lager, in *I sommersi e i salvati* (Torino: Einaudi, 1986), Levi notava: "Hai vergogna perché sei vivo al posto di un altro? Ed in specie di un uomo più generoso, più sensibile, più savio, più utile, più degno di vivere di te? Non lo puoi escludere: ti esamini, passi in rassegna i tuoi ricordi, sperando di ritrovarli tutti, e che nessuno di loro sia mascherato o travestito; no, non trovi trasgressioni palesi, non hai soppiantato nessuno, non hai picchiato (ma ne avresti avuto la

Basti esaminare la giustificazione al titolo dell'opera offerta da Benigni, a metà strada tra il luogo comune e la più ambigua forma d'innocenza:

> Ho scelto il titolo *La vita è bella* perché sembra una frase consumata e invece vuol dire proprio quel che dice: la nostra vita è bella. Anche nei grandi momenti di sconforto quella frasettina spezza il costato, avviluppa il cuore, fa sentir più dolce tutto il mondo. È anche un bel verso, ora perché l'abbiamo già sentito mille volte, ma il primo uomo che ha detto a una donna: «I tuoi occhi sono come le stelle» è il più grande poeta del mondo. Così come chi ha detto la prima volta "la vita è bella" [...] "Il film è *sdrammatico.* Non è una parodia e non è neppure un film neorealista, è una fiaba. Non è malinconico, è commovente e la cosa è ben diversa. Quando la risata sgorga dalla lacrima si spalanca il cielo. Finisce il primo tempo che gli spettatori hanno le lacrime agli occhi dalle risate ...[12]

Dall'intenzione comica di Benigni emerge chiaramente la speranza di indurre lo spettatore agli estremi del "riso" e del "pianto". Tuttavia, malgrado la descrizione teorica che Benigni offre di queste opposte manifestazioni emotive dinanzi a rappresentazioni di tipo "carnascialesco" e "tragicomico", non mi pare che questi due "estremi" caratterizzino la vera risposta dello spettatore medio alla trama del suo film.

forza?), non hai accettato cariche (ma non ti sono state offerte), non hai rubato il pane di nessuno; tuttavia non lo puoi escludere. [...] I salvati del Lager non erano i migliori, i predestinati al bene, i latori di un messaggio [...] Sopravvivevano di preferenza i peggiori, gli egoisti, i violenti, gli insensibili, i collaboratori della zona grigia, le spie. [...] Mi sentivo sì innocente, ma intruppato tra i salvati, e perciò alla ricerca permanente di una giustificazione, davanti agli occhi miei e degli altri. Sopravvivevano i peggiori, cioè i più adatti. I migliori sono morti tutti."

[12] Cfr. Roberto Benigni e Vincenzo Cerami, *La vita è bella*, Torino: Einaudi Tascabili, 1999, p. 6.

Personalmente non vedo in quali particolari scene di *La vita è bella* si possa ridere fino alle lacrime, o piangere di commozione tanto dal riderne. Credo piuttosto ci si senta storicamente "imbarazzati". La prima parte del film, ambientata intorno al 1939-40 in una cittadina dell'Italia fascista, per lo più rievoca, come dicevo, la cultura fascista – l'architettura, la moda, la musica in voga in quegli anni. La trattazione del soggetto fascista è arricchita da intenzioni polemiche; Benigni, infatti, attacca l'ideologia del regime, trasmessa dalle istituzioni scolastiche, le quali vengono ridicolizzate nella scena della visita del protagonista Guido, in veste di falso ispettore del Ministero, alla scuola elementare dove insegna Dora, la maestrina che corteggia e che di lì a poco diventerà sua moglie. Questo elemento fiabesco illustra come la cultura fascista alimentasse, e fosse alimentata, dall'immaginario collettivo popolare, da una parte, e dai miti della modernità di marca americana, dall'altra. La repentina messa in scena delle persecuzione degli ebrei nell'Italia filonazista segna l'inizio della seconda parte del film. Il piccolo Giosuè, nato da Dora e Guido, ha cinque anni quando legge sulla saracinesca della cartolibreria di suo padre un graffito antisemita. L'Italia è in guerra. La vicenda di Guido e del suo piccolo nucleo familiare, da questo momento in poi, diventa la stessa vicenda di nera angoscia della popolazione civile dinanzi ad una guerra di cui non comprende le ragioni e a cui non è preparata né psicologicamente né materialmente. Nel giro di pochi metri di pellicola, si iniziano a verificare sfollamenti e deportazioni. A Guido, suo zio e suo figlio viene imposto di salire con altri uomini su un vagone stipato come un carro bestiame. Il lungo treno deporterà centinaia di inermi civili in un campo di concentramento in Germania. Dora sarà fatta salire insieme ad altre donne su un altro vagone dello stesso convoglio. Il piccolo Giosuè ha sentore del pericolo, ma Guido, nel tentativo di celare l'autentico fine di quel viaggio, e certo sperando che il figlioletto possa vivere quella esperienza senza traumi, dà inizio a una messinscena che

durerà fino alla fine del film: egli fa finta che si tratti di un gioco, di una grande gara, alla fine della quale, i vincitori riceveranno in premio "un carro armato vero". A proposito di gioco e messinscena, va notato che anche le SS ricorrevano spesso al pretesto ludico e alla simulazione (si ricordino le docce comuni che mascheravano le camere a gas) per nascondere ai prigionieri il loro vero destino. In *La vita è bella*, invece, la capacità di dissimulare la realtà, presentandola come gioco, è esibita come un'attività indispensabile alla sopravvivenza (dell'innocenza). L'elemento bizzarro di questa dissimulazione non sfugge allo spettatore che è indotto a ridere alla battuta: "Ci bruciano nel forno? Il forno a legna l'avevo sentito ma il forno a uomo, mai, eh! Oh, è passata la legna, passami l'avvocato! [...] Va a finire che un giorno ti dicono che con noi ci fanno i paralumi, i fermacarte... e te ci credi veramente!" Ma quale valore ha per noi, in effetti, questo riso? Vi cediamo spontaneamente, o ne siamo forzati, come serrando i denti, un riso amato, di riflesso, intimamente colpevole d'aderire al cattivo gusto della battuta? La realtà dell'Olocausto appare momentaneamente oltre la cortina dell'artificio come mero emblema, allorquando, il Benigni-regista fa intravedere in lontananza, oltre la cortina spessa della nebbia in cui si è smarrito il Benigni-attore, un cumulo di cadaveri accatastato in attesa di essere bruciato nei forni crematori. Nella rappresentazione dei rapporti sociali tra personaggi, Benigni usa di frequente nel film l'esagerazione comica che non sfocia mai nel grottesco dissacratorio. Nel rispetto delle convenzioni della commedia, è il ridicolo ad evidenziare gli eccessi dei gerarchi che partecipano al regime, come ad esempio nel caso del medico tedesco, ossessionato da enigmi e rebus, rientrato in patria allo scoppio della guerra e divenuto ufficiale medico del lager.

Nella sua analisi della comicità nell'opera di Rabelais, Mikail Bakhtin ha messo in evidenza come la combinazione farsesca di elementi normalmente incompatibili, nelle opere a carattere comico, abbia lo scopo di smorzare i toni del

dramma, indurre al riso, e dunque destabilizzare il terrore prodotto dagli abusi del potere. Ciò avviene anche in quelle tragedie classiche come *Amleto*, dove la comicità di alcune scene, e ne è esempio il dialogo tra i due becchini sul teschio di Yorik, ha l'intento di ridurre lo spazio abissale tra alto e basso nella scala dei valori a cui il testo fa appello. Secondo Bakhtin, le interpretazioni popolari dei sistemi del potere costituito avrebbero sempre carattere dissacratorio e sovversivo. Tuttavia, il riso, se da una parte restituisce al popolo le vicende di cui è vittima in forma liberatoria e distanziante, dall'altra tende a privare i fatti di verosimiglianza, diventando cronaca "di parte". Nel pamphlet *Mass Civilisation and Minority Culture*, pubblicato negli anni Trenta, F.R. Leavis, notava come la valutazione di una data epoca sia abitualmente affidata a una ridotta minoranza, che, attraverso l'ermeneutica storica, letteraria o artistica si pone come coscienza di un popolo.[13] Ma cosa accade quando il compito di elaborare un'interpretazione della vita collettiva, estetica o ideologica che sia, è avvallata dalla logica dell'industria culturale, per garantire all'*audience* l'illusione di una realtà spiata a distanza nell'oscurità confortevole della sala cinematografica? Una chiara indicazione di questo patto di reciproco *comfort*, ne *La vita è bella*, è data dalla convinzione di Guido della priorità della fantasia sul senso della realtà, fantasia che si traduce in ovattata bugia nell'educazione di Giosuè. Nessuno contesterebbe il valore della bugia di Guido, che modifica i termini della vicenda patita per proteggere Giosuè dal trauma di scoprirsi non solo discriminato socialmente per essere figlio di un ebreo, ma di essere vittima di una persecuzione di tipo razziale. Il pubblico non può che commuoversi dinanzi a questo tipo di menzogna, ideata a fin di bene, espressione dell'amore

[13] Il saggio di Leavis è incluso in Patrick Deane, *History in our Hands*, London: Leicester University Press, 1998, pp. 16-25.

paterno. Ma se trasformata in pedagogia di massa, questa strategia dovrebbe trovarci meno consenzienti.[14]

Ci si deve chiedere se sia davvero utile censurare film come *Salò* che, diversamente da *La vita è bella*, sbattono in faccia allo spettatore la bruttezza e l'orrore. L'inganno comico di Guido, motivato dalla preoccupazione di preservare in Giosuè la speranza nel futuro, occultandogli l'orrore del presente, restituisce un'immagine indiscutibilmente edificante ed ideale del ruolo del genitore. E tuttavia, a mio avviso, questa preoccupazione non basta a legittimare l'umorismo nero che grava sulla seconda parte del film. Ad esempio, l'irrealtà trasognante della serenata di Guido a Dora attraverso gli altoparlanti del campo, come rievocazione comica degli idilli romantici dei *musicals* hollywoodiani, collocata all'interno di un luogo di sterminio, induce ad assumere un distacco dalla tragedia in atto. Questo frammento umoristico e sentimentale, inserito all'interno della narrazione dei crimini nazisti, rimuovendo i termini di valutazione del tragico, opera una riattivazione nostalgica del dato storico, che pone in secondo piano la realtà. Parafrasando le riflessioni di Hans Georg Gadamer in *La conoscenza storica* (1969), concordiamo sul fatto che la storia non possa essere intesa o esposta secondo modelli di arida conoscenza oggettivistica. La comprensione storica dovrebbe avvenire come atto dell'esistenza, "progetto gettato". Da questa prospettiva, afferma Gadamer, ogni rigida pretesa oggettivistica appare una mera illusione, poiché ogni ermeneutica storica fa parte di una catena incessante attraverso la quale il passato si rivolge al presente della nostra vita. La coscienza etica dell'interprete dovrebbe poter essere, al tempo stesso, sostanza etica dell'"educazione", della "cultura", della conoscenza

[14] Il tema dell'immaginazione e dell'affabulazione come risorsa salvifica, indispensabile all'educatore, serve a consolidare lo stereotipo del buon padre di famiglia italiano, votato alla protezione della propria prole, ma, al contempo inguaribile sognatore, eterno bambino, e spesso riluttante eroe.

concreta degli obblighi morali e dei fini dell'esegesi storica. Seguendo Aristotele, Gadamer ricorda che la conoscenza storica è, al contempo, un sapere storico e, soprattutto, un "essere storico globale" profondo, calato nella realtà dei fatti. Il fine dell'ermeneutica storica è, dunque, quello di analizzare la struttura della nostra comprensione del vero, sulla base di una relazione circolare tra il tutto e le parti, e nel rispetto di un inalienabile senso della realtà.

Dalla prospettiva di chi pone in primo piano le realtà della finzione, gli elementi fortemente metafilmici de *La vita è bella* hanno senza dubbio un loro indiscutibile valore. Infatti, se si vuole, il titolo del film suggerisce implicitamente non tanto che sia la *vita* ad essere bella, quanto il *cinema*. Inoltre, il messaggio di Benigni sembra rivolgersi più che al cittadino, allo spettatore. Se è vero com'è vero che ogni autore, nel momento in cui concepisce una data narrazione, ha in mente un interlocutore ideale, fondamentalmente, Guido riscrive l'Olocausto per il suo unico spettatore, Giosuè: consapevole di essere costantemente osservato dal bambino, opera, infatti, un riadattamento della storia personale e collettiva a suo uso e consumo, e recita fino in fondo il proprio ruolo di autore-regista-attore per amore della fiducia assoluta e acritica che Giosuè ripone in quella narrazione. Il gioco-bugia di Guido, come mezzo che altera la realtà, non è un semplice strumento per calmare le ansie del bambino, ma un'invenzione che genera un'elaborazione di significati aventi un'autonomia e un dinamismo suoi propri. La relazione tra la realtà e il Guido regista-interprete del gioco è, dunque, trasgressiva, e avviene lungo un percorso metafilmico ottimistico, ai limiti della credibilità. Negli ultimi dieci minuti del film, Guido, travestito da donna nel tentativo di camuffarsi e sfuggire alla cattura, viene scoperto e trascinato in un angolo buio dal soldato nazista che, di lì a poco, lo abbatterà viso a viso. Intanto che la scena ha luogo, Guido sa di essere sotto lo sguardo del figlio, che ha appena fatto in tempo a mettere in salvo in un casotto di ferro;

sapendosi osservato, continua a fingere, *in extremis*, che si tratti di un gioco, e recita per l'ultima volta un ruolo comico, camminando come un burattino nello spazio scenico dato dal campo visivo di Giosuè, che, attraverso lo spiraglio rettangolare del suo nascondiglio, vede suo padre condotto via a forza nell'oscurità di una strada laterale, senza immaginare cosa davvero lo aspetti. Questo dettaglio costitutivo suggerisce l'idea che Giosuè stia guardando sbalordito un film in formato *cinemascope*:

> Gli occhietti di Giosuè si accendono nel buio del casotto, al di là dello spioncino. Vedono...Guido, vestito buffamente da donna, che ora, d'improvviso, gli fa l'occhiolino e gli sorride. Poi l'uomo prende un'aria divertita e cammina con il passo dell'oca, i movimenti militareschi che Giosuè conosce bene. Il ragazzino, nascosto là dentro, reprime una leggera risata. Il soldato s'innervosisce, non capisce quella buffonata.[15]

Sul piano della resa tecnica della tragedia che si sta compiendo sotto gli occhi dello spettatore Giosuè, la dimensione spazio-temporale è ridotta ulteriormente a pochi secondi. In questa sequenza finale nel lager, ripresa dall'interno dell'angusto casotto a mostrare l'area perimetrale del cortile, la componente storica (la fine della guerra e l'arrivo degli Alleati) è, per un attimo, subordinata a quella metafilmica. Il soggetto statico, Giosuè, osserva i due soggetti in movimento, il padre e il soldato delle SS, che passano dinanzi al suo campo visivo trasversalmente. Gli indicatori deittici spazio-temporali qui intessono una rete simbolica tra l'azione del padre (il mostrare, l'essere modello) e quella del figlio (l'essere ricettore, assimilatore del messaggio), permettendo di riconoscere i termini del rapporto parentale/filiale, rispetto al succedersi delle generazioni all'interno del divenire storico. L'articolazione duplice dei piani prospettici si basa, pertanto, su una netta distinzione tra chi agisce e chi osserva, che come tecnica di

[15] Benigni e Cerami, *La vita è bella*, cit., p. 186.

ripresa chiarisce la prospettiva dalla quale il vero spettatore, nella sala cinematografica, segue il film.

Il potenziale narrativo, o metanarrativo, di questo brano di vita si condensa nel gesto indicatore delle mani di Guido, che, marciando sotto il tiro del fucile, si muovono rigidamente avanti e indietro, a mò di marionetta, e il lieve, impercettibile sorriso del bambino, che credulo sorride a quella "buffonata" paterna. L'autoreferenzialità del messaggio pone, dunque, in risalto gli occhi di Giosuè non già come sguardo di un testimone oculare della realtà, ma come sguardo incantato di uno spettatore dinanzi a quella che per noi è una palese finzione scenica. La carrellata, che segue Guido verso la sua esecuzione sommaria, contrasta con la staticità del bambino, costretto come uno spettatore nel suo posto a sedere tra le quattro pareti di ferro del suo rifugio. La scena di Guido che cammina facendo il passo dell'oca, non vuole far sorridere solo Giosuè, che vive nell'incoscienza dei fatti: vuole sollecitare ilarità anche nel pubblico. L'immediato "svoltare l'angolo" della coppia, composta dal persecutore e dalla sua vittima, cela a Giosuè, ma non a noi, l'esito dell'azione scenica tutt'altro che comica, di cui è protagonista suo padre. Tuttavia, come Giosuè, è preferibile che noi non indulgiamo nella contemplazione del brutale assassinio. Presto arriverà la fine dell'incubo anche per noi spetattori, e il sorriso, benchè bagnato da qualche lacrima di commozione, ritornerà anche sulle nostre labbra. Da queste contrapposte simmetrie, acquisiamo consapevolezza che il film voglia innanzitutto svolgere una funzione protettiva rispetto alla realtà dell'Olocausto, che viene mostrato e non mostrato. Il punto di vista dello spettatore coincide esattamente con quello di Giosuè, chiamato a confondere la realtà con la *fiction*.

Nella fase conclusiva del film, Giosuè si trasforma dall'osservatore inconsapevole della storia dell'Olocausto al futuro narratore della storia alterata a cui ha assistito, essendo l'affabulazione a cui suo padre l'ha esposto l'unica versione della realtà che ha potuto apprendere. Malgrado

questi aspetti metafilmici siano degni di nota, la comicità kitsch con cui Benigni tratta l'Olocausto grava sul narrato: kitsch è, in chiusura, l'entrata in scena del grande carro armato americano, che Giosuè, sempre al riparo nel suo nascondiglio e immerso nel suo stato di cauta meraviglia, ammira, sgranando gli occhi. La sua fiducia assoluta è stata, infatti, premiata, come dimostra il fatto che gli si pari dinanzi l'enorme giocattolo destinato al vincitore, promessogli da suo padre se fosse riuscito a scampare alle regole di quello strano gioco. Il finale realizzato da Benigni nello stile di "Arrivano i nostri!", da un punto di vista politico, è francamente improponibile, nel suo avvallare il mito dell'eroismo americano e il ruolo risolutore degli Stati Uniti nelle vicende dell'inetta Europa. La sequenza finale ripropone un'immagine edificante dell'America, confezionata per le nuove generazioni. Ma da una prospettiva etica, a chi è utile, in fin dei conti, l'ignoranza dei fatti in cui Guido ha mantenuto suo figlio? Alla solidità della famiglia? Al futuro della nazione? All'integrità dell'individuo? Alla supremazia della finzione sulla realtà in ambito cinematografico?

Cioran ha notato come l'eclettismo e la comicità nascano là dove l'energia creativa si sia esaurita, ovvero in quelle circostanze nelle quali le possibilità speculative si siano prosciugate e l'artista non abbia altra strada che il ricorso all'uso parodistico di tutto il materiale accumulato e selezionato in base a giudizi di valore e eticità del tutto sommari.[16] Fermo restante il ruolo dell'arte dissacratoria e dissidente, Cioran non esclude che la comicità possa contribuire ad operare delle modificazioni nei rapporti di potere, né mostra una vera avversione all'uso della comicità in quanto tale, ma sembrerebbe contrario all'appiattimento dell'orizzonte critico-espressivo di certe forme dell'arte postmodernista e del *pastiche*. Kandiski, sulla stessa linea polemica nei confronti della "comicità a tutti i costi", una

[16] Cfr. Emile Michel Cioran, "Il senso della cultura contemporanea", in *Sophia*, n. II, 1999, pp. 30-35.

volta ebbe a dire: "Lascio questa città se solo sento uno scherzo sull'Olocausto." In effetti, queste traduzioni comico-ludiche della tragedia umana, se non condotte attraverso distorsioni espressionistiche, pensate come fondamenti per la lotta delle generazioni future contro il Male, piuttosto che destare la coscienza delle masse, l'assopisce ulteriormente, diventando schematizzazioni positivistiche e consolatorie che spargono i loro "aromi spirituali" sul tanfo della miseria storica. Da questa prospettiva, sebbene *La vita è bella* avrebbe voluto rappresentare un ripensamento originale dell'esperienza nazifascista, non ci sembra presenti una alternativa artistico-ideologica abbastanza forte da garantire un reale superamento della passata barbarie. Il gioco dell'Olocausto, sembra profetizzare Benigni, sarà giocato in altre epoche a venire; l'inerzia e l'inettitudine dei giocatori deboli e inconsapevoli continuerà a darla vinta ai bari, la provvidenza continuerà a nutrire gli sconfitti con il "carro armato Perugina" dei buoni sentimenti; noi del pubblico continueremo a pagare la nostra quota di pena per sentircelo ricordare. Aveva ragione Pasolini a fare pagare a caro prezzo questo biglietto ai suoi spettatori, stimolandoli alla repulsa contro tale complicità *voyeuristica*, e inducendoli alla ribellione contro lo stesso *medium* cinematografico Il *Salò* non si faceva guardare: non voleva commuovere né coinvolgere i nostri migliori sentimenti, ma spingerci col dovuto disgusto fuori dalle sale.

Che l'esperienza nazifascista sia stata una concatenazione incontrollabile di crimini contro l'umanità non è casuale, dato che l'aberrante fenomeno si andò espandendo come monolitico pensiero-cultura, di cui la violenza era la faccia complementare. Nel film la logica di questa cultura è riprodotta con gli stilemi della *fiction*; quando la Storia entra nell'ambito della finzione, e la morale non è proponibile che per via allegorica, il senso della realtà si ricostruisce per prospettive. La cultura fascista aveva imposto una prospettiva univoca che non lasciava spazio ad interpretazioni autonome, ed è questo il lato positivo che

ottiene il relativismo di Benigni dalla sua particolare angolazione: la realtà è una, lì fuori, ma io, pur nella mia miseria, l'interpreto e la narro a mio piacere. Gli orchi, del resto, non originano dalla fantasia del favolista, ma dalla cruda realtà reinterpretata dalla fantasia popolare. Tuttavia, sappiamo quanto i bambini, tramite la favola, finiscano col provare piacere al brivido dato dalla prossimità a quei mostri che noi adulti vorremmo temessero. L'orrido diventa spettacolo da palcoscenico, un gioco di ruoli. Non dico che la sola via sia strappare la maschera dal volto degli attori, esporne l'artificio alla maniera di Pirandello e Brecht, rovinando il piacere del *thriller*. Mi rendo conto che lo spettatore pagante vuole essere assecondato nella sua esigenza di inganno, che rende la vita tollerabile. Cosa preferire, dunque, il reale o l'ideale? La maggior parte di noi sceglie senza saperlo di partecipare ad una quotidiana misura di collettiva illusione e sconsideratezza. Penso ad Erasmo e alle sue riflessioni sull'"inopportuna saggezza" dei dotti. Laddove la natura rappresenta il bene, per Erasmo, la civiltà nella sua organizzazione è il Male. La favola consente una salvezza solo illusoria dai suoi meandri sotterranei: è l'estremismo della follia a consentire la vera fuga. L'uomo è buono, la civiltà lo ha reso cattivo: ci si crede o non ci si crede, è una questione di fede. Vediamo quest'idea sintetizzata nei personaggi di Guido e del dottore nazista, nel loro confrontarsi non tanto sul piano dell'intelligenza, ma su quello dei sentimenti e della morale. Oscillando tra tragedia e commedia, cultura popolare e cultura alta, realtà e favola, l'eclettismo di Benigni appare a tratti una sintesi debole della realtà storica, non riuscendo a restituire il tragico dell'Olocausto con un'azione sovversiva pari al *Salò* di Pasolini. Ricorrendo ad una certa misura di *sentimentalismo dell'ingiustizia* dickensiano, Benigni riporta in campo il mondo delle classi più povere o perseguitate, impiegando uno stile a metà tra il neorealismo e quello delle *comedies* americane, evitando così di affrontare la crudezza propria della cinematografia rosselliniana o desichiana

dell'immediato dopoguerra. Se Pasolini accentua espressionisticamente le folli scelleratezze del nazismo usando ed esasperando gli stessi suoi mezzi, Benigni idealisticamente cerca di porvi rimedio con la favola e l'utopismo dei buoni sentimenti, le osserva, come avrebbe fatto Andersen, e infine le inserisce in un orizzonte di senso, essendo queste scelleratezze un elemento fondante del gioco medesimo tra il Bene e il Male, realtà e finzione. Per Benigni la favola è la sua forma di Resistenza. Pasolini, al contrario, pessimisticamente non attribuisce nessuna funzione edificante alla sua narrazione dell'Olocausto; come Erasmo, si finge dalla stessa parte della Follia, sviscera la realtà brutale, l'espelle e la torce.

Le differenze dei vari tipi di approccio al tema dell'Olocausto qui esaminati – quello ludico e quello espressionistico – in qualche misura riassumono le controverse tendenze che hanno caratterizzato la ricezione dell'estetica del postmoderno, il suo rapportarsi al reale da una prospettiva fondata sul relativismo prospettico. Il dibattito sul postmoderno e sui suoi codici ha, infatti, continuato a mantenere al suo nucleo il problema di capire quale funzione svolga l'arte nel sociale, e quale specificità possa vantare, come voce *sui generis*.

Per concludere, il mio sospetto è che *La vita è bella* appartenga alla fascia delle rappresentazioni meno compromesse che siano mai state realizzate intorno al tema dell'Olocausto. Non vorrei suonare paradossale, ma, dalla mia prospettiva, la censura e l'interdizione patite dal *Salò* rappresentano un ben più importante riconoscimento del premio conferito a Benigni. Il primo procedimento mette in evidenza la problematicità e il coraggio osato da Pasolini nella sua denuncia al nazifascismo, il secondo, invece, indica fin troppo chiaramente il processo di assimilazione di un discorso all'interno dei parametri leciti sanciti dall'industria culturale. Non si tratta qui di volere rivalutare a tutti i costi le metodologie espressive della cinematografia d'avanguardia degli anni Settanta, o fare di Pasolini il

maestro incontrastato del cinema della "denuncia", che sa presentare violentemente al pubblico i torti che subisce, usando le modalità con cui il potere glieli fa subire, ma piuttosto mostrare l'aspetto belletristico di questo nuovo, osannato cinema dei "buoni sentimenti", che, nel Terzo Millennio, fa vibrare le sfinite corde del nostro acume critico. A proposito del contrasto tra "coscienza" e "sentimento", Pasolini scriveva:

> San Francesco abbracciava i lebbrosi; ebbene non trovo che la cosa sia così insuperabile. Se fosse necessario, un lebbroso lo abbraccerei anche io. Ma la volgarità è peggio della lebbra. I fascisti sono prima di tutto degli uomini volgari. Mi dispiace, mio intelligente amico cattolico, ma non riesco a vincere la ripugnanza di tale volgarità [...] Ma l'imperativo evangelico di cercare i fascisti per cercar di trascinarli a una discussione democratica che gli è innaturale, è un imperativo della coscienza. Il sentimento è un'altra cosa. Il rimprovero che lei mi muove di non aver avuto un sentimento, o di un avere avuto un sentimento abbastanza forte e infatti il primo errore che ne deriva è un errore estetico nel linguaggio: rimprovero, le ripeto, che io ho meritato, ma che tuttavia pervicacemente considero da parte mia inevitabile.[17]

Il tipo di schieramento richiesto agli intellettuali, in quel decennio, difficilmente si ripresenterà con le stesse caratteristiche, rimanendo legato a quelle peculiari circostanze storiche che ne fecero un fenomeno epocale. Se è pur vero che per superare una crisi epocale, "un uomo vivo trovi sufficienti ragioni di gioia negli altri uomini vivi", l'Olocausto, come ha notato Gaime Pintor in una lettera al fratello del 1943, è un'esperienza collettiva che sgombra il terreno da molti comodi ripari, mettendo l'intellettuale "brutalmente a contatto con il mondo inconciliabile".[18]

[17]Pier Paolo Pasolini, *I dialoghi*, Roma: Editori Riuniti, 1992, p. 790.

[18] Cfr. Gaime Pintor, "Lettera al fratello Luigi", Napoli 28 novembre 1943, in *Neorealismo, poetiche e polemiche*, a cura di

Opere citate

Bakhtin, M., *Rabelais and His World,* trad. Helene Iswolsky. Cambridge: The M.I.T. Press, 1968.

Benigni, R. e Cerami, V., *La vita è bella*, Torino: Einaudi, 1999.

Cioran, E.M., "Il senso della cultura contemporanea", in *Sophia*, n. II, 1999, pp. 30-35.

Habermas, H., *Die Normalitat einer Berliner Republik* (1995), English trans., *The Berlin Republic*, University of Nebraska Press, 1997.

Landy, M., *Italian Film*, Cambridge: Cambridge University Press, 2000.

Leavis, F.R., *Mass Civilisation and Minority Culture, in History in Our Hands*, a cura di Patrick Deane, Leicester: Leicester University Press, 1998.

Levi, P., *I sommersi e i salvati*, Torino: Einaudi, 1986.

Marrus, M.R., *The Holocaust in History*, Penguin, 1987.

Milanini, C., *Neorealismo, poetiche e polemiche*, a cura di Claudio Milanini, Milano: Il saggiatore, 1980.

Vattimo, Gianni, *Le avventure della differenza*, Milano: Garzanti, 1980.

"No True Darkness"? The Critical Reception of *Life Is Beautiful* in Italy and Australia

Mirna Cicioni

> Il film è una favola, non dissimile da quelle fiabe dove c'è un Orco cattivo [. . .] niente a che vedere, dunque, con la filologia dell'Italia degli anni 40, né con quella dei campi di concentramento [. .][1]

Public debates about *Life Is Beautiful* began with the first reviews in Italy during the 1997-98 Christmas season, continued in all the countries where the film was released, resumed after it won three Academy Awards in 1999, and have since progressed in academic and non-academic forums. The continuum of comments ranges from "unforgivably obscene" (Peary 9) to "a powerful, destabilizing mixture of laughter and tears" (Marcus 284). All assessments within this continuum are characterized by what Italians would call *trasversalità*: they cut across existing divides within countries and within political, cultural and religious allegiances. As the journalist Giuliano Ferrara put it, "[l]a linea di demarcazione [. . .] è una linea sottile, che riguarda la coscienza culturale, l'informazione e la disponibilità psicologica a fare i conti, in un modo o in un altro, con la piú grande tragedia di questo secolo." (Ferrara 32)[2]

[1] "The film is a fairy tale, not unlike those stories where there's a big bad Ogre [...] it has nothing to do with being a historically correct reconstruction of Italy in the 1940s, or of the concentration camps [...] (Taccone 1997, vii).

[2] " The dividing line [...] is very fine; it depends on how culturally aware, informed, and psychologically ready people are to confront, one way or another, the greatest tragedy of this

Mapping out the points of convergence and divergence between what public intellectuals, defined here as writers, historians and film critics, Jews and non-Jews, conservatives and radicals, say about the film may be useful in identifying the main historical, political, cultural and ethical issues which underlie the discussions. I do this by looking at debates about *Life Is Beautiful* in two countries: Italy, its country of origin, and Australia, a multicultural nation where critical responses were mainly from non-Italians. [3] My focus is on three questions. The first is the extent to which the film is criticized as a revisionist representation of history. The second is the extent to which it is seen as an undue appropriation of Jewish discourses by a non-Jewish writer/director. Thirdly I look at interpretations of the functions of laughter in the film: some view it as cathartic, others as something comforting which ends up making the Holocaust acceptable, while yet others claim that the film's humor and ironies effectively foreground the tragedy of persecution and extermination. The framework for my analysis consists of three major essays published in the United States and informed by contemporary scholarship: Maurizio Viano's discussion of the American reception of the film (155-171), Millicent Marcus's study of its humor in a Pirandellian perspective, (268-284) and Sander Gilman's discussion of the film in the context of Holocaust humor (279-308).

A comparative analysis of debates in Italy and Australia shows that there are few national differences in emphasis or approach, and that there is no strong polarization between Jewish and non-Jewish perspectives in either country. The political context, however, does play a role in the discussions in Italy. At the end of 1997, when the film was released, political power was in the hands of the centre-left *Ulivo* coalition, which in 1996 had narrowly defeated a

century."
[3] An earlier essay on this topic has already appeared in print in Australia: Piero Giorgi, *Life is Beautiful* in Italy and Australia"

right-wing coalition led by Silvio Berlusconi. Since Benigni was (and still is) an outspoken *Ulivo* supporter, the objections to *Life Is Beautiful* made by Ferrara and other conservative public intellectuals such as the historian Franco Cardini and the philosopher Marcello Veneziani can be construed as attacks on Benigni as well as historical or aesthetic criticisms.

Benigni's rejection of what he calls *filologia*, historical correctness – repeated in several interviews and in the foreword to the screenplay published by Einaudi soon after the film's release (Incontro xi) – is interesting, as it is a deliberate rejection of any claim to historical plausibility. The equally frequent statement that the film was conceived and developed as *una favola*, a fairy tale, is an overt admission that historical facts have not only been disregarded, but actually rewritten in order to convey a hopeful message that love prevails even in the worst conditions imaginable. Seeing the story as a "fairy tale" means also that its symbolic representations of "good" and "evil" are universalized, and transcend contingent historical labels such as "fascist", "antifascist", "Jewish" and "non-Jewish". It is not surprising, therefore, that some of the strongest negative criticisms of the film come from historians. According to Enzo Traverso, the author of numerous essays on contemporary European Jewish history and anti-Semitism, "if the message that the film wants to convey is universal, the tale it tells does not take place in an imaginary setting…" for Auschwitz then becomes the object of an account devoid of any critical reflection on the concentration camps. The result, Traverso adds, is trivialization, despite any good intentions on the director's part (16-17 my translation of original text).

Some historians claim that the film glosses over the collaboration of fascist officials in the deportations of Italian Jews, and criticize its image of Italian fascism which consists mostly of ridiculous and ineffectual people (the pranksters who daub slogans on a horse, the bureaucrats

fooled by an ugly Jew who comically masquerades as an example of Aryan physical harmony), as opposed to powerful, threatening Germans. This is particularly relevant in view of current debates on revisionist history within the Italian historical-political context, especially the heated arguments of the late 1990s as to whether equal status as "war dead" should be granted to the soldiers of Mussolini's Italian Social Republic, who actively aided the German army in hunting down and deporting Italian Jews. These arguments echoed earlier debates on revisionist history in general and the works of Renzo De Felice in particular. Richard Bosworth, an Australian historian well known for his studies of changing interpretations of fascism, holds that revisionist accounts of fascism, starting with those of De Felice, are all based on the same notions: that fascism only "became 'bad' " in 1938 with the anti-Semitic laws; that even while the war was in progress the Italians on the whole behaved as *brava gente*, decent people, as opposed to the cruel and heartless Germans; and that Italian fascists were not directly involved in the deportation of Jews (Bosworth transcript). In an interview for the Australian Broadcasting Corporation program *The Europeans*, Bosworth connects *Life Is Beautiful* to revisionist history:

> [. . .] Fascism of course was different from German Nazism and also from the Gulag in the Soviet Union, but it also was a tyrannical regime, it was a dictatorship, it did manage to eliminate more than 100,000 people in North Africa. It did tolerate the use of poison gas in military actions; it did dissolve all political parties and break up trade unions and it was appallingly anti-women, and so on and so forth, and I think none of that comes through in the first half of Benigni, it is simply a cosy story (Bosworth transcript).

In a letter to *The Australian*'s *Review of Books*, Bosworth also says that "such a grotesque distortion of the past may not be much help as we try to chart our path from past to future." A similar view is presented by the European Studies

scholar Peter Morgan, who states that, " the good myths of decency in their sentimental but lovable Italian form" manifest, "a failure to come to terms with the Italian past" (Bosworth transcript). Bosworth and Morgan's letters are responses to a short reflection on the film by another important Australian historian, Inga Clendinnen, the author of *Reading the Holocaust*, a sensitive analysis of the ways works of testimony show how humanity was preserved or lost in the death camps (5). Bosworth and Morgan express disappointment at the way Clendinnen's views on *Life Is Beautiful* change from an initial annoyance at the lack of historical accuracy ("I had watched the film as a historian and.. . . I loathed it because it was not reportage"), to an appreciation of the film's surrealist, rather than realistic, approach: ("Benigni casts realism to the winds by daring to assume a comic mode . . . Benigni's comic lyricism can be experienced as an indrawn breath of horror") (5).

The issue of revisionist representation of history is also raised by Alberto Cavaglion, an Italian Jew who has written both historical studies and literary criticism. He argues against the film from a Jewish perspective, referring to it in a book entitled *Ebrei senza saperlo*, a collection of reflections on the historical and political responsibilities of Jews in Italy at the beginning of the twenty-first century. He situates the film in the context of controversial historical analyses of fascism, such as De Felice's: "La tesi su cui si fonda il film non è nuova: all'Italia s'addice la fiaba, alla Germania la tragedia. Una tesi, come sappiamo, edulcorata e falsa, contestata al povero De Felice" (Cavaglion 58) [4]

Historical credibility is mentioned by many commentators in relation not only to the representation of fascism, but also to that of the death camp where the second part of *Life Is Beautiful* is set. This camp is deliberately left

[4] "The thesis on which the film is based is not new: fairy tales are appropriate for Italy, tragedy for Germany. As we know, this is a watered-down and false thesis, for which poor De Felice was taken to task [...]

nameless, which allows it to become a symbol of camps and Evil in general, but the construction of what goes on there has hardly anything in common with factual reality. Several critical responses to the film condemn the implausibility of the setting: "a cardboard holiday camp with Spartan pretenses" (Clendinnen) or as Edith Bruck, a Hungarian survivor of a death camp stated, "an imaginary camp... where prisoners were not watched or locked in, or ever assembled for roll call and counted at sunrise and sunset" (my translation 1). This is the basis for the negative assessments by the majority of intellectuals who have had personal contact with the reality of the death camps, either directly (as in the case of Bruck) or indirectly. Survivors' children, such as the Italian publisher Daniel Vogelmann and the Australian political scientist Robert Manne, make particularly critical connections between the lack of darkness of the setting and the danger that, over fifty years later, discourses on the Holocaust might be trivialized. Vogelmann recalls a much-quoted aphorism by Theodor Adorno: "Valenti critici cinematografici diranno che il film è una favola a fin di bene e che quindi la verosimiglianza non è importante [. . .] Ma allora io mi domando, parafrasando una famosa frase: 'Si possono scrivere favole su Auschwitz?'" (Vogelman 5). [5] Manne in 1996, discussing revisionist history and revisionist fiction in his book *The Culture of Forgetting,* had expressed his fears that the Holocaust would end up being banalized and distorted. In his comments on *Life Is Beautiful* he echoes these fears:

> Benigni is, I suppose, aware that if at the end of this terrible century he is to convince us that life is, indeed, beautiful, he cannot avoid taking us to the heart of humankind's darkest experience. Yet once he has led us there, because it is a sunny

[5] "Excellent film critics will say that the film is a well-meaning fairy tale and that therefore historical accuracy is not important [...] But then, I wonder, paraphrasing a famous saying: 'Is it possible to write fairy tales about Auschwitz? "

fairy tale he has to tell, he finds no alternative but to avert his eyes from its reality and to dissemble. In any age the kind of child-like optimism that shapes Benigni's vision would be unconvincing and thin. In an age such as ours – after Auschwitz and the Gulag and Hiroshima – it seems to me evasive, and almost absurd (13).

An equally problematizing but more sophisticated view of the question of "authenticity" is put forward by the Australian academic Peter Christoff. He sees *Life Is Beautiful* in terms of "magical realism" and considers the very implausibility of the film's concentration camp a device to remind the audiences of the impossibility of representing what the death camps really were: "We know that none of the characters would have survived reality. So this magical realism belies a serious intent. The film's importance rests in the unbearable tension generated by its deliberate narrative dissonance, its refusal to represent reality" (Christoff 13). The implausibility of Benigni's camp is viewed positively also by the Italian historian Anna Maria Bruzzone, whose area of specialization is the history of deportation. Bruzzone wonders, why should people object to a film that conveys the horror of the death camps without actually showing them? (4).

The problems associated with "authenticity" become even more complex when linked to a well-publicized fact: that Benigni – in spite of his claimed rejection of historical *filologia* – actually went to great lengths to build a camp which was as accurate as possible in its visual details. His consultants were Marcello Pezzetti, a historian from the Centro di Documentazione Ebraica Contemporanea in Milan – the main Jewish research centre in Italy – and two Italian survivors of the camps, Nedo Fiano and Schlomo Venezia, who provided first-hand expertise on details such as the bunk beds and the deportees' uniforms (Gandus 82-84). The painstaking attention to visual detail in a narrative which progresses in a way totally remote from historical facts could be seen as an appropriation of specific historical elements to

create a suitably dark dramatic backdrop for the generic tale of Love triumphing over Ultimate Evil. Cavaglion views this as shrewd emotional exploitation:

> Benigni e Cerami (astutamente), nella seconda metà della loro opera, si sforzano di essere precisi tanto quanto erano stati elusivi nella prima. Di qua la fiaba [...] di là i colori cupi, i volti scavati, i corpi scheletrici in uniformi larghissime, uno sfondo che più realistico non si potrebbe immaginare, compreso il cumulo di cadaveri esibito sfrontatamente con citazioni palesi dai documentari, una voluta confusione fra realtà e finzione (Cavaglion 57).[6]

Connected with the issue of "authenticity" is the question of Benigni's entitlement to write about a Jew's experience of marginalization, deportation and death. It is often pointed out, less outspokenly in Italy than in English-speaking countries, such as Australia, that the experiences of Benigni's father, allegedly the initial inspiration for the film, were not representative of the Holocaust. Luigi Benigni was deported as a member of an enemy army and spent time in a POW camp rather than a death camp. *Life Is Beautiful* could therefore be seen as an undue appropriation of devastating experiences by a member of the majority speaking on behalf of the minority. Gilman cogently and uncompromisingly sums up this view: "Benigni is neither Jewish himself nor has he self-consciously played Jewish characters in the past." Furthermore, we learn that, "The idea of doing a comic film about the Holocaust was first dismissed by Benigni, who imagined it as "Donald Duck in an

[6] "Benigni and Cerami shrewdly, in the second half of their work take pains to be as accurate as they had been elusive in the first. There you have the fairy tale [...]here somber colours, hollowed out faces, and emaciated bodies in oversized uniforms, a background that couldn't possibly be any more realistic, including the mound of corpses shamelessly displayed as a blatant reference to documentaries, creating a deliberate confusion between fact and fiction."

extermination camp" (292-293). And yet when working on
the film with Cerami he began to refigure his own identity as
the child of a survivor. Apparently this was meant to give
him the moral authority to make this film, at least
retrospectively (292-293).

Other critics question not so much Benigni's origins, as
the fact that his construction of a Jew shows no culture-
specific elements and not the slightest awareness of Jewish
history or traditions. One of the people to make this point
was the late Alberto Lecco, a novelist and essayist, in a
comment published in the magazine of the Turin Jewish
community, *Ha Keillah*. Lecco suggested that Franz Werfel,
although not Armenian, successfully recounted the history of
the Armenian genocide by the Turks in his novel *I quaranta
giorni del Mussa Dag*, precisely because he had thoroughly
familiarized himself with Armenian culture and therefore
acquired the authority necessary to such an enterprise (16).

The protagonist of *Life Is Beautiful* does lack any
element that could possibly characterize him as a Jew (such
as borrowings from Hebrew adapted to his dialect, or hints
of different cultural practices). This is interpreted by some
critics, such as Viano and the Italian-born Australian
academic Tiziana Ferrero Regis, as a foregrounding of the
near-assimilation of Italian Jews until 1938 (Viano 107-
108). Another view could be, however, that Benigni's
perspective as a writer-director-actor remains that of an
outsider, and therefore is inadequate when it comes to
representing either the shock of Jews at being declared Other
in 1938, or their troubled retrieval of their history and
traditions after that date.

Historical-political and artistic critiques of *Life Is
Beautiful*'s lack of "authenticity" tend to make unflattering
comparisons between the film and works of testimony, most
notably those by another Italian, Primo Levi. This is not
surprising, given Levi's authoritative status as one of the
most powerful Holocaust witnesses and as a voice of
twentieth-century Italian secular Jewry – particularly in

Australia, where his works are practically all that is known about the Italian experience of the Holocaust. Manne, who has acknowledged his intellectual and ethical debt to Levi in a number of articles and books, bases his comparison on criteria of historical "truth": "The interpreters of the Holocaust I came most to admire – Primo Levi and Hannah Arendt – could peer into the heart of darkness without flinching. Benigni does not belong with them. In his representation of the Holocaust there is no true darkness, no true terror" (Manne 13). Similarly, the Melbourne journalist Luke Slattery starts his review of *Life Is Beautiful* by mentioning Levi as an implicit yardstick of both historical truth and artistic achievement: Levi's description of the shame he and other survivors had felt at the moment of liberation is contrasted with Benigni's moment of liberation, which "comes with a splash of sunshine and an envoy from a brighter world" (Slattery 20-21).

A different view is presented by Marcus, who quotes Levi's rhetorical question "ma non sono anch'esse storie di una nuova Bibbia?" ("But are they not stories of a new Bible?") in order to argue that Holocaust writing, like the Bible, encourages multiple interpretations. Ferrero-Regis goes further, maintaining that *Life Is Beautiful* complements Levi's works, by showing that the true testimony is the silence of those who, like the film's protagonist, did not return. My own view is that comparisons with Levi are understandable but problematic. In works of testimony, including Levi's, the Holocaust is the central theme, and consequently the writers' reflections on their survival are overwhelmingly affected by guilt, by various kinds of shame, and by the constant awareness that all those who were deported experienced some loss of their previous moral parameters. Therefore the final pages of all these works are usually pervaded by uncertainty and unease. In Benigni's film, the Holocaust is an almost metaphorical background, and the prevailing mood is hope; the last scene, tinged by

sadness, but full of gratitude for the father's selfless sacrifice, is totally consistent with the tone of the rest of the film.

The hopefulness of the ending is probably one of the reasons why critical responses to it are the most polarized along lines of cultural identification. Most non-Jewish, and especially Catholic, readings stress the importance of optimism and the value of sacrifice, implicitly (and problematically) opposing individual heroism to genocide. The National Film Committee of the Conferenza Episcopale Italiana (Italian Bishops' Conference, a Catholic body which frequently takes a stand on Italian social and cultural issues) recommends it, as a sort of metaphorical commentary about the best that human beings are capable of and their ability to overcome the tragic circumstances that History sometimes presents them with. The Italian Cardinal Ersilio Tonini, in an interview, emphasizes that, if we remember only the horrors of the Holocaust we negate the hope that it can inspire (De Martino 33). The well-known, non-Jewish writer Rosetta Loy, the author of a sensitive short novel about the 1938 laws, *La parola ebreo* (1997), found the film unsettlingly beautiful. Her review sees the "fairy tale ending" as an ambiguous blend of individual salvation and collective tragedy (43).

The majority of Jewish critics, on the other hand, condemn the ending as feel-good (in Italian, *consolatoria*). They often connect it to the ending of another popular, and controversial, film about the Holocaust, Steven Spielberg's *Schindler's List*, objecting that a focus on the few who had escaped extermination "fails to look evil squarely in the eye," as the Australian historian Mark Baker put it. According to Baker, "[f]or Jews… there is no redemptive aspect to the Holocaust; only a black hole of genocide into which centuries of Jewish learning, language and culture vanished forever" (Baker 17). This view is echoed by Manne's assessment of Benigni's film: "With Spielberg, Oskar Schindler's Jews are saved. With Benigni, when Joshua tells Dora "we won," he seems to be speaking for us

all. Over the evil of Nazism, the human spirit, as represented by Schindler and Guido, has triumphed" (Manne 13). A minority of Australian Jewish viewers, however, tend to agree with the view that the ending is cathartic. The Australian writer Goldie Alexander describes going to the film with a non-Jewish German friend (born after the end of World War II) and links the experience to Aristotle's theory that all great art purifies its audience by inspiring pity and fear, and thus brings greater understanding:

> We talked about what it felt like to be victims [. . .] of one of history's greatest tragedies. We poured out our fears about having to confront our various guilts: for me to be alive, for her to be German and guilty by implication. We talked about Bosnia and Serbia, and how easy it is to fall into easy rationalization that what happens there could never happen to us. We talked about how we must guard against history repeating itself. . . . If Aristotle had been listening in, I think he would have been pleased (13).

Preoccupations about the present and the future are shared by Jews and non-Jews; one aspect, however – the effect of the film on the younger generations – is expressed most poignantly by Jews whose families have had first-hand experience of the Holocaust. Some of them worry that the film may mislead the young, who are more likely to want to learn about history from mainstream films than from documentaries or books. Giuliana Tedeschi, who survived Birkenau and wrote a well-known book of testimony, *Questo povero corpo*, is concerned about the downplayed information that the "fairy tale" narrative may convey to the young who have had no prior education based on history or testimony (20). Cavaglion concludes his book with an essay entitled "Piccoli consigli al ventenne che in Italia studia la Shoah" (Brief Advice to a Twenty-Year-Old Studying the Shoah in Italy), which includes a chilling warning that those who are trying to comfort the young by misrepresenting the

concentration camps are misleading them. Stories about Auschwitz are not meant to comfort, but to trouble. He suggests that if the young need comforting they should choose to read a different kind of book or to view a different kind of film (179-180).

Non-Jewish commentators, instead – especially in Italy – tend to see the film as potentially educational. The National Film Committee of the Conferenza Episcopale Italiana suggests that it should be shown in teaching situations. That is, to deal with themes not only related to World War II and concentration camps, but also to learn about the power of the imagination. Bruzzone argues that the film, like all fairy tales, teaches compassion, solidarity and caring, which are the opposite of Nazi values: "Così il nazismo, e il male *tout court*, viene ripudiato e minato alle origini: chi di quei valori ha imparato a nutrirsi sarà aguerrito contro il male nella sua veste estrema e anche contro le varie forme della sofferenza inflitta ad altri, a partire dalle piccole crudeltà quotidiane."[7] The historian Giovanni De Luna, the author of studies of anti-fascism and the Resistance, sees the film mainly as an effective means of passing on the memory of the Holocaust:

> Troppa luce rende ciechi, diceva Pascal. Così è per la memoria dell'Olocausto; la sua dimensione eccessiva favorisce l'oblio, non il ricordo. . . . Forse, per lo storico, il film è soprattutto questo: un efficace strumento per raccontare un passato altrimenti muto, all'interno di un difficilissimo passaggio della memoria tra le generazioni (De Luna 27).[8]

[7] "Thus Nazism, and evil in general, is repudiated and undermined. Those who have learned to draw sustenance from those values will be armed against the various forms of pain inflicted upon others, starting with little, everyday acts of cruelty."

[8] "Too much light makes people blind, as Pascal put it. This is the case with the memory of the Holocaust: its magnitude encourages forgetting rather than remembering [...] Possibly this is what the

An essential part of the effectiveness of *Life Is Beautiful*, according to its admirers, is its humor. A number of critics have argued that the film's laughter has a cognitive function: through either understatement or hyperbole, (Morandini 4). Benigni provides an alternative discourse to those of the fascist and Nazi oppressors, and foregrounds their contradictions, encouraging reflection on them. Viano draws on the well-known essay "Holocaust Laughter" by Terrence Des Pres, whose thesis is that laughter is valuable even in Holocaust-related contexts. According to Des Pres, "[t]he paradox of the comic approach is that by setting things at a distance it permits us a rougher, more *active* response" (286). He continues, by adding that, "As comic works of art, or works of art that include a comic element, they give us laughter's benefit without betraying our deeper convictions. They foster resilience and are life-reclaiming" (286).

Viano defines *Life Is Beautiful* as a tragicomedy: the first part is comedy, and the second tragedy – the laughter stops after Guido's "translation" of the camp rules. Viano sees this symmetry as an allegory of the duality between laughter and tears, and humor as a strategy to foreground its philosophical dimensions. The Italian film critic Giorgio Cremonini emphasizes the acceptance of contradictory dimensions by defining the film as "luogo privilegiato dell'ossimoro, ovvero di una contraddizione comico/tragico che non chiede superamenti, ma solo coesistenza." ("a privileged site of oxymoron, namely of a contradiction between comedy and tragedy which merely requires their coexistence rather than a solution") (11).

The actor, performer and writer Moni Ovadia, who has introduced Italians to the humor of Eastern European Jewry, places the laughter of *Life is Beautiful* in that tradition:

film is to historians: an effective means of telling about a past which otherwise would remain unspoken, in the context of the very difficult handing down of memory between generations."

> Questo umorismo è un bagliore filosofico che illumina le insolubili contraddizioni dell'esistenza attraverso un vertiginoso meccanismo autodelatorio, è la critica della ragione paradossale che spiazza la violenza e sfibra il pregiudizio. Benigni sa tutto questo, lo sa per istinto, lo sa con la ragione del cuore, della mente e del corpo.[9]

Gilman's view is different, and less favorable: he concedes that in *Life Is Beautiful*, as in a number of other films, laughter can be a weapon against the oppressors, but he points out that the survival of Guido's wife and son as a result of Guido's sacrifice makes laughter part of an implausible "rereading of the Shoah as the place of heroic action" (308). Marcus's completely positive analysis defends the humor of Benigni's film on the basis of Luigi Pirandello's 1908 essay "L'umorismo": she convincingly argues that viewers, being aware of what lies behind Guido's gags, will interpret them as what Pirandello called *il sentimento del contrario* (the awareness of the reasons why people act in incongruous ways). Marcus then applies this notion to the film's ending, which she sees as profoundly ironic: the *sentimento del contrario* makes viewers aware of the "devastating cost" of Giosuè's shout of "victory"(166).

Negative responses to the humor of *Life Is Beautiful* tend to have political overtones. In Italy, Ferrara's articulate and politically motivated attack mocks the film's potential audience, which he intimates "claims its right to laugh and to be given carefree, refreshing good faith which cleanses and restores you, and allows you to go on living," (my translation, 33). In Australia, Slattery's critique makes

[9] "This humor is a philosophical flash of light which shows up the insoluble contradictions of human existence through ceaseless self-deprecation; it is critique of paradoxical reason, which destabilizes violence and wears down prejudice. Benigni knows all this, he knows by instinct, he knows with the reason of his heart, of his mind and of his body."

unfavorable connections between the film's laughter and the memory of the Holocaust: "By retreating from gravity into levity, and from an epic to a domestic scale, Benigni offers laughter as a momentary release from the burden of remembering" (4). In these negative perspectives, the film's powerful foregrounding of incongruities (such as the scene where Guido dismisses as laughably absurd Giosuè's discovery that human beings are being used to make soap and buttons) tends to be seen as over-the-top irony rather than as a strategy to elicit a *sentimento del contrario.*

In a frequently-quoted scene, little Giosuè reads, but fails to understand, a sign in a shop window that says, "No Jews and dogs allowed in." His father explains the sign in terms of individual preferences rather than in terms of power and prejudice:

> *Guido*: "Well, they don't want Jews and dogs in their shop. Everybody does what they like! There's a shop over there, an ironmonger's . . . they won't let Spaniards and horses in. And whatshisname . . . the chemist, yesterday I was with a friend . . . a Chinaman who has a kangaroo: 'No Chinese and kangaroos allowed in here!' . . . Tomorrow, we'll put up a sign too. What don't you like?"
> *Giosuè*: "Spiders! And you?"
> *Guido*: "Me? Visigoths! So tomorrow we'll write: No spiders and Visigoths allowed here" (Benigni and Cerami 103).

This dialogue seems to me an appropriate metonym for *Life Is Beautiful* as a whole. While its humor does lead to a *sentimento del contrario*, the scene – like the rest of the film – endorses the strategy of concealing the darkness of political oppression by pretending that everyone is equally powerful. This makes the film problematic, especially as a future point of reference for young people. Clendinnen's concern as a historian seems well-grounded: "[T]he Holocaust passes inexorably from the custodianship of those who experienced it into the hands of historians, museum-

keepers and artists. [. . .] [A]rtists will embed the Holocaust in popular consciousness, with the emphasis falling on the popular" (5). History may be losing its relevance after the end of direct contact with witness survivors; this may mean that the younger generations' knowledge will be largely based on popular constructs such as *Schindler's List* or *Life Is Beautiful*, which focus on exceptions rather than the rule, and heroic narratives rather than the daily destruction of moral and cultural frameworks as well as lives.

Yet *Life Is Beautiful* is a complex text that raises difficult political questions which often do not have straightforward answers, as is evident from what intellectuals of diverse backgrounds and beliefs have said about its representation of politics and history. Exploring the sources and developments of the debates about it may lead to further reflections which are at the same time intellectual, ethical and political: on the uses of fictional and surreal (as opposed to documentary) historical constructs; on the role humor and irony might play in re-framing the past with the hindsight of the present; and on whether humor is a better tool than confrontation to encourage young people to approach the Holocaust.

Works Cited

Adorno, Theodor W. *Prisms*. London: Neville Spearman, 1967.

Alexander, Goldie. "A Jew and a German Went to the Movies ..." *The Age* 15 Feb. 1999: 13.

Baker, Mark. "Raiders of Schindler's Lost Ark." *The Age* 12 Feb. 1994: 17.

Benigni, Roberto. "Incontro con Roberto Benigni." Interview with Maria Stella Taccone. *revision* 1997 <http://www.revision.com/ci_vita.htm>

---. "Un poeta nel lager." Interview. *L'Unità* 12 Dec. 1997: 7.

---. "Presentazione." Introduction. Benigni and Cerami v-xi.

Benigni, Roberto, and Vincenzo Cerami. *La vita è bella*. Turin: Einaudi, 1998.

Borsatti, Cristina. *Roberto Benigni*. Milan: Il Castoro Cinema, 2002.

Bosworth, Richard J. B. "Explaining 'Auschwitz' after the End of History: the Case of Italy." *History and Theory* 38.1 (1999): 84-99.

---. "Grotesque Distortion." Letter. *The Australian*'s *Review of Books* 12 May 1999: 28.

---. "*Life Is Beautiful*." Interview. *The Europeans*. ABC Radio National. 25 July 1999.

Bruck, Edith. "L'inverosimile favola del lager di Benigni." Rev. of *Life Is Beautiful*. *L'Unità* 18 Jan. 1998: 1+.

Bruzzone, Anna Maria. "Una favola di alti contenuti." *Triangolo rosso* 2 (Apr. 1988): 3-4.

Cavaglion, Alberto. *Ebrei senza saperlo*. Naples: L'ancora, 2002.

Christoff, Peter. "*Life* Isn't Always as it Appears." *The Age* 17 Feb. 1999: 13.

Clendinnen, Inga. *Reading the Holocaust*. Melbourne: Text Publishing, 1998.

---. "Remember This." Rev. of *Life Is Beautiful*. *The Australian*'s *Review of Books* 14 Apr. 1999: 5.

Cremonini, Giorgio. "Uno, due, tre: oggi si ride (storto)." Rev. of *Life Is Beautiful*. *Cineforum* 37.10 (Dec. 1997): 9-11.

De Luna, Giovanni. "Mediare Auschwitz." In "La vita è bella? Roberto Benigni e Auschwitz," *Passato e presente* 17.48 (Sept.-Dec. 1990): 22-27.

De Martino, Marco. "Il clown, l'Olocausto, gli intellettuali. Un intreccio da Oscar." *Panorama* 25 Mar. 1999: 30-39.

Des Pres, Terrence. "Holocaust Laughter." 1987. Rpt. in *Writing into the World – Essays: 1973-1987*. New York: Viking, 1991. 277-86.

Farina, Renato. "A volte *La vita è bella* perfino se c'è Benigni." Rev. of *Life Is Beautiful*. *Il Giornale* 21 Dec. 1997: 3.

Ferrara, Giuliano. "Olocausto Show." *Panorama* 22 Jan. 1998: 30-33.

Ferrero-Regis, Tiziana. "Rethinking *Life Is Beautiful*." *Australian Screen Education* 33 (2002): 105-110.

Gandus, Valeria. "Auschwitz e Benigni, i retroscena mai raccontati." *Panorama* 18 Dec. 1997: 82-84.

Gilman, Sander. "Is Life Beautiful? Can the Shoah Be Funny? Some Thoughts on Recent and Older Films." *Critical Inquiry* 26 (Winter 2000): 279-308.

Giorgi, Piero. "*Life Is Beautiful* in Italy and in Australia." *ConVivio* 5.1 (Apr. 1999): 63-75.

Lecco, Alberto. "*Train de vie* di Radu Miheaileanu. Commento autoliberatorio al film da parte di un narratore ebreo italiano." *Ha Keillah* Apr. 1999: 16-17.

Loy, Rosetta. "Un giullare nel sacrario del secolo. La favola audace di Benigni." *L'indice dei libri del mese* 3 (Mar. 1998): 43.

Manne, Robert. *The Culture of Forgetting*. Melbourne: Text Publishing, 2002.

---. "Life Is not So Beautiful." Rev. of *Life Is Beautiful*. *The Age* 12 Feb. 1999: 13.

Marcus, Millicent. "The Seriousness of Humor in Roberto Benigni's *Life Is Beautiful*." *After Fellini – National Cinema in the Postmodern Age*. Baltimore and London: Johns Hopkins UP, 2002. 268-84.

Morandini, Morando. "La leggerezza vincente del bambino Guido-Giosuè." Rev. of *Life Is Beautiful*. *Cineforum* 37.10 (Dec.1997): 4-5.

Morgan, Peter. "Misplaced Sentiment." Letter. *The Australian's Review of Books* 12 May 1999: 28.

Ovadia, Moni. "Divertiti Roberto, da oggi sei ebreo honoris causa." *Corriere della sera* 19 Dec. 1997.

Peary, Gerald. "No Laughing Matter." Rev. of Life Is Beautiful. *Boston Phoenix* 30 Oct. 1998 (Arts Section): 9.

Slattery, Luke. "Is a Holocaust Comedy a Bad Joke?" *The Weekend Australian Review* 20-21 March 1992: 2-4.

Tedeschi, Giuliana. *Questo povero corpo*. Milan: EdIt, 1946. Rpt. as *C'è un punto della terra ...: una donna del Lager di Birkenau*. Turin: Loescher, 1989.

---. "Immagini senza colore." *Ha Keillah* 3 June 1999: 20.

Traverso, Enzo. "Lo schermo edificante." In "La vita è bella? Roberto Benigni e Auschwitz," *Passato e presente* 17.48 (Sept.-Dec. 1990): 13-22.

Viano, Maurizio. "*Life Is Beautiful*: Reception, Allegory, and Holocaust Laughter." *Annali d'Italianistica* 17 (1999): 155-71.

Vogelmann, Daniel. Rev. of *Life Is Beautiful*. *Il Tirreno* 18 Dec. 1997: 1.

Online Sources

Benigni, Roberto. "Incontro con Roberto Benigni." Interview with Maria Stella Taccone. *reVision* 1997. <http://www.revision.com/ci_vita.htm>

"*Life Is Beautiful.*" *The Europeans*. ABC Radio National. 25 July 1999. An unrevised transcription is in
http://www.abc.net.au/rn/talks/europe/stories/s46774.htm

Review of *Life Is Beautiful*
http://www2.chiesacattolica.it/acec/seed/cn2_acec.c_vedi_fil
m?c.doc=103>

Breaking the Commandments of Holocaust Representation?
Conflicting Genre Expectations in Audience Responses to *Schindler's List* and *Life is Beautiful*

Janice Wendi Fernheimer

The debates surrounding recent Holocaust films, Roberto Benigni's *Life is Beautiful* and Steven Spielberg's *Schindler's List,* illustrate the overdetermined relationship between popular reception and representational authority. The films' overwhelming success with popular audiences reignited long-standing controversies concerning the ethics of Holocaust representation. These controversies highlight the aesthetic challenges *Life is Beautiful* and *Schindler's List* face when evaluated by the differing genre conventions of Holocaust representation and non-documentary film. Holocaust aesthetics demand a dialectic of unspeakability, unrepresentability, distanced realism, and allusive presence that seems mutually exclusive with the desire for escapism and suspension of disbelief that films invite.

Unable to uphold expectations for both genres simultaneously, both *Life is Beautiful* and *Schindler's List* break conventions of Holocaust representation to fulfill expectations for popular film, and consequently are accused of "trivializing the Holocaust." The films' mechanisms of departure enable audiences to connect with multiple "truths," and the ends these connections can achieve may be more praiseworthy than critics would like to admit. Unfortunately, these broken conventions just as easily can enable a disconnection from, and *mis*-understanding of the very "truths" they claim to represent. In most cases, the difference hinges upon the degree to which audience members come equipped with outside knowledge.

Numerous scholarly articles have been dedicated to the various generic and literary conventions of *Life is Beautiful* and *Schindler's List*, but surprisingly no article has examined the two together. Moreover, critical discussions ignore not only the popular audiences these films satisfy, but also the texts popular audiences generate in response to them.[1]

Embarking on territory largely ignored by film and literary scholarship—public responses to film— this essay will show how audience responses to *Schindler's List* and *Life is Beautiful*, posted publicly on the Internet Movie Database (IMDb), attempt to reconcile conflicting genre expectations for film, Holocaust representation, historical realism, and fable. These IMDb responses illuminate the complicated interplay between audience desire and expectation. Offering a more nuanced understanding of the films' great popularity than published newspaper and journal reviews provide, audience responses illustrate firstly how *Life is Beautiful* and *Schindler's List* deliberately break conventions of Holocaust aesthetics to adhere to the conventions for popular film, and secondly, how the ability for these broken conventions to enhance viewers' Holocaust understanding depends upon the degree to which viewers come equipped with prior historical knowledge.

The Internet Movie Database, which has the largest number of responses for these films, provides a forum where anyone with Internet access may post her thoughts.[2] As of

[1] Film criticism by Janet Staiger and Tom Stempel acknowledges the failure of academic discourse to both recognize and address the importance of audience concerns and responses. Their recent works argue against and attempt to rectify the long-standing disciplinary and institutional convention that assumes popular audiences are passive, incapable, or ill-equipped to make critical judgments of films. Neither Staiger nor Stempel fully engage audience responses as texts worth evaluating.

[2] While respondents may provide identifying information, there is no guarantee that the information is accurate and not fabricated. Gauging from the range of responses I read (nearly 900 in total), participants include parents, high school students, adults late in

October 2, 2001, when I collected them, there were 534 responses to *Life Is Beautiful* and 338 responses to *Schindler's List*.[3] The responses to *Schindler's List* and *Life Is Beautiful* alone represent 45 countries and 39 states.[4] I am less concerned with the numbers, however, and more interested in the responses' content, specifically the rhetorical topoi and argumentative strategies employed by participants.

The responses address topics too varied and numerous to be considered in their entirety, so I focus on selected topoi:[5] the discussion of external texts in the responses to *Schindler's List*; the discussion of the idea that "critics miss the point" in responses to *Life Is Beautiful*; and the comparison of *Life Is Beautiful* to *Schindler's List* in responses to *Life Is Beautiful*.[6] My analysis will illustrate how viewers' expectations for genre and prior historical knowledge determine their responses to the films. Audience responses struggle to reconcile their concept of the

life, college students, and others. I recognize that this community is limited by the availability of Internet access and user's own comfort levels with technology.

[3] As of August 27, 2004 there were 675 responses for *Life is Beautiful* and 604 comments for *Schindler's List* (http://www.imdb.com/title/tt0118799/usercomments and http://www.imdb.com/title/tt0108052/usercomments, respectively).

[4] I recognize that my sample consists of a self-selecting group of individuals. Like Stempel, I make no claims that the sample is statistically representative in the sense that social scientists would define the term.

[5] I follow Fahnestock and Secor's model in "The Rhetoric of Literary Criticism."

[6] Before selecting topoi, I read through all the responses and kept a list of recurring topics. I then returned to the responses to mark and count the recurring ones. Most responses to both films were overwhelmingly positive. They varied in content from the simple "this film was great, you should see it" to the more complicated and reasoned explanations for *why* the film was great.

"Holocaust" with the representations that *Schindler's List* and *Life Is Beautiful* provide.

The horrifying nature of the events to which the term Holocaust metonymically refers is both barely within, yet at some level always fundamentally outside of our understanding. To this end, any act of representation necessarily rips the events out of the utter incomprehensibility that defines them. But such representation is needed to foster greater understanding. Theorists Saul Friedlander and Hayden White provide heuristics that help to set standards for accomplishing such ethical representations.

In the introduction to *Probing the Limits of Representation*, Friendlander explains that Holocaust aesthetics are girded by a principle in which "[r]eality is there, in its starkness, but perceived through a filter: that of memory (distance in time), that of spatial displacement, that of some sort of narrative margin which leaves the unsayable unsaid" (17). What constitutes the unsayable and how much should be left unsaid are precisely the issues that *Life Is Beautiful* and *Schindler's List* raise. Though Friedlander acknowledges, "there are limits to representation which should not, but can easily be transgressed," he does not clearly define "what the characteristics of such a transgression are" (3). Instead he merely suggests that they are "far more intractable than our definitions have so far been able to encompass" (Friedlander 3).

Hayden White's reflections on the appropriateness of genre provide insight into what the nature of such transgressions might be. In his article, "Historical Emplotment and the Problem of Truth" Hayden White writes:

> We can confidently presume that the facts of the matter set limits on the *kinds* of stories that can be *properly* (in the sense of both veraciously and appropriately) told about them only if we believe that the events themselves possess a "story" kind of form and a "plot" kind of meaning. We may dismiss a

"comic" or "pastoral" story, with an upbeat "tone" and a humorous "point of view," from the ranks of competing narratives as manifestly false to the facts or at least to the facts that matter—of the Nazi era. (39, emphasis in original)

White's criteria suggest that there are representational limits set by the nature of the events and that some plots or representations are "manifestly false to the facts that matter" (39). To this end it might seem that all representations of the Nazi era would have to be tragedies because they are based on tragic events. White argues, however, that a representation should be dismissed only if it meets the following conditions:

(1) it were presented as a *literal* (rather than *figurative*) representation of the events
(2) the plot type used to transform the facts into a specific kind of story were presented as inherent in (rather than imposed upon) the facts. For unless a historical story is presented as a literal representation of real events, we cannot criticize it as being either true or untrue to the facts of the matter. If it were presented as a figurative representation of real events, then the question of its truthfulness would fall under the principles governing our assessment of the truth of fictions. And if it did not suggest that the plot type chosen to render the facts into a story of a specific kind had been found to inhere in the facts themselves, then we would have no basis for comparing this particular account to other kinds of narrative accounts, informed by other kinds of plot types, and for assessing their relative adequacy to the representation, not so much of the facts as of what the facts *mean* (39-40, emphasis in original).

As White points out, representations that do not purport to present literal history tend to be evaluated on their ability to adequately represent what the "facts *mean*." Debate over whether or not *Schindler's List* or *Life Is Beautiful* effectively communicates the meaning of such "Holocaust facts" is inextricably tied to the competing genre constraints informing the films, their creation, and reception.

Each audience member comes to the "Holocaust" with a set of pre-inscribed images. Some sort of signifier that is "the Holocaust" exists outside of the frames of these films and is there in all its presence, but it is also "absent" in the sense that this signifier can trigger any number of things for each audience member. Each audience member's "image" depends upon the prior knowledge she brings with her to the films. Consequently, when non-documentary films take the Holocaust as their subject matter—even if it is only relegated to the background—the expectations for history, realism, and Holocaust representation are brought to bear on what otherwise would be considered purely fictive representations.

When Holocaust films are considered within the genre constraints of romantic fable and historical realism, the issues become even more complex. On the one hand, expectations for the genres of fable and film set these representations in the realm of the fictive. Given this fictional status, it would seem that Holocaust aesthetics for presence might or should be tabled. On the other hand, the fact that audience members expect the films to be "about the Holocaust" suggests that Friedlander's and White's criteria apply. These disparate expectations are brought to the fore when we consider public responses to *Schindler's List* and *Life is Beautiful*. Both films break various criteria for Holocaust representation by bringing what Friedlander terms the Holocaust's "stark reality" too close, though they employ different means of accomplishing this task.

Schindler's List presents itself as a "historic film," and under this pretense, breaks conventions of Holocaust representation by presenting graphic, violent events and suggesting that they can be grasped and represented in all their true horror, and by setting itself up as a "true" and representative story about the Holocaust. *Schindler's List* presents itself as "an immediate and unmediated access to the past" and as a "transparent medium through which one may witness the workings of history" (Hansen 83, Horowitz

121, respectively). These strategies coupled with the film's use of black and white and shots that resemble documentary, newsreel, and CNN footage, position the film to claim some of the authenticity we usually associate with official documentaries or history books (Loshitzky 109). The film's attempt to claim a position *within* rather than *alongside* authentic historical representations prompts many of the responses' concerns. Audience responses convey a fear that the film will be understood as reality, or an all too close approximation of it. In particular, comments that refer other viewers to external texts express concerns about the film's "fiction of presence."

Of the 338 responses to *Schindler's List*, 27 encouraged viewers to read or screen external texts to acquire the requisite knowledge to appropriately recognize *Schindler's List* as a fictional, filmic Holocaust representation.[7] Particularly concerned with "the facts that matter," respondents who saw *Schindler's List* recognized that knowledge from external texts—other films, scholarly texts, museums, survivor accounts—is necessary both to understand the film itself and to evaluate it properly. For them, *Schindler's List's* graphic reality can only be

[7] Of the 338 responses to *Schindler's List*, 30 countries and 33 United States are represented; 234 positively reviewed the film; 56 criticized the film; and 12 gave ambivalent reviews with both positive and negative comments; 110 responses mentioned historical accuracy, truth, realism or documentary; 43 mentioned school, school children, or history lesson; 27 addressed the ending of the film; 5 made specific mention of *Life Is Beautiful*; 34 mentioned the "colorized girl;" 139 made some mention of emotions or the affective qualities of the film; 2 specifically mentioned *Seinfeld* and the episode relating to the movie; and 27 mentioned external texts mainly to encourage other readers to read these other texts. Despite the fact that more people in general responded to Benigni's film, an equivalent group of responses where viewers point other viewers to outside texts is smaller, though not completely absent in the responses to *Life Is Beautiful*.

celebrated when recognized explicitly as historical fiction and only one of many constructed Holocaust representations.

Illustrating the impossibility of a single movie capturing the "truth" of an historical event that spanned nearly a decade, one viewer, Caleb Weaver, calls attention to *Schindler's List* and his expectations for film in general:

>I would argue that no single movie can ever truly capture the experience of an entire continent during a six year period or [sic] war, much less a 13 year period of Nazi rule in Germany. Regardless of how incredible *Schindler's List* is, it should only be the first of many Holocaust movies to be made. . . .(Weaver 1/28/99)

His consciousness of the text's inability to capture the events' essence reflects an awareness that *Schindler's List's* seamless narrative is a construction. Moving from the analytical to the prescriptive, his comment suggests that many Holocaust movies "should. . .be made," to mitigate the dangers of the film's totalizing impulse.

Weaver articulates the multi-valenced nature of audience expectation when he shifts the focus of his response to discuss expectations for film in general. He continues: "Thus, I agree with people who argue that there was more to the Holocaust than this film, but to not recognize the greatness of this film for that reason is simply ridiculous. . . Do we really expect film to be reality?. . . " Although he concedes that, "there was more to the Holocaust than this film," he suggests that even when dealing with historical events, films are not expected to be "reality." His response reflects the way a film like *Schindler's List* causes viewers to blur the distinctions between conflicting expectations for Holocaust representations that require self-consciousness and historical accuracy, and for non-documentary films that by definition are fictional and seamless. Although Weaver does not specifically refer other viewers to external texts, his recognition that such texts should be made demonstrates the

concern he shares with other respondents whose recommendations are more specific.

One anonymous reviewer fills in the gaps that Weaver leaves by recommending that viewers be exposed to more "authentic" texts if they want the "true facts" (4/13/2001). Apprehensive about the "fiction of presence" that *Schindler's List* elicits, this reviewer, like Weaver, points out that the film does not represent the events' reality. Employing a similar rhetorical strategy, she first critiques the film's conceits and then upholds the value of watching the film. She begins with a plea for greater, more "authentic" knowledge:

> I think that if you really want to learn more about the Holocaust, it should not be through films such as this, but through actual real-life documentaries . . .[that] truly tell the real pain, the real hurt and loss of the Jewish people who were treated so badly just because they believed differently from others. . . . (Anonymous 4/13/2001).

Recognizing that *Schindler's List* is a fictional representation of the "facts," this response suggests that *real* knowledge of the Holocaust comes from first-hand accounts. Her repetition of words such as "actual, real-life, real, truth, truly" underscores the importance she places on grounding facts in experienced, authentic presence that she suggests documentaries but not Hollywood imitations can provide.

Despite her criticism of the film's conceits, like Weaver, this respondent also deems it worthy of viewing. She continues, ". . .I do think this film is worth watching, no doubt, but please don't automatically assume you know everything about the Holocaust because you watched this film; this film portrayed life less harshly than life for the imprisoned actually was" (Anonymous 4/12/2001). Even in conceding some value to the film, this respondent cannot help but issue a caveat to its totalizing impulse. The respondent urges other viewers not to assume that "you know everything about the Holocaust because you watched

this film." She emphasizes that the film, precisely because it is a film and therefore fiction, necessarily portrayed even its most graphic contents "less harshly" than they were experienced in actual reality. Urging other viewers to "[p]lease watch documentaries on the Holocaust, research more through books and legitimate media, if you want the true facts," she illustrates her distrust of film and the privilege of authenticity she grants to print culture and more "legitimate media."

Other reviewers echo these concerns and question the educational role that *Schindler's List* both took upon itself and is used by others to accomplish. Another reviewer notes that, "[d]espite its considerable problems, 'Schinler's [sic] list' is still widely used to introduce the new, unsophisticated audience to the mid-twentieth century horrors: whether or not is [sic]should be, remains open to debate" (Vlad B. 4/20/99). Leaving the question "open for debate," this reviewer implicitly recognizes that using a popular film to "introduce" this period of "mid-twentieth century horror" to an unfamiliar audience brings both advantages and disadvantages. While using *Schindler's List* to open discussion and begin the process might be better than having them remain completely ignorant, it might stage the very mis-understandings its critics fear most.

It seems that expectations for history and entertainment, implicit in the genres of Holocaust representation and non-documentary film respectively, collide most presciently on the grounds of education, because knowledge enables viewers to properly contextualize and evaluate *Schindler's List*. These responses suggest that prior knowledge of the Holocaust may be the only way to protect oneself from *Schindler's List's* seductive illusion of presence. Since audiences need to come prepared with this knowledge beforehand, these responses suggest that *Schindler's List* may be most dangerous to the audiences it seems to target and best satisfy: those uneducated or uninformed about the horrors of the Holocaust.

Of course these comments seem to operate under a naïve presumption of realism and its assumed potential for "accessing" events-as-they-occurred. Though documents, documentary, and even survivor testimony (in video or written form) carry with them the cultural capital of more "authentic" truth, these too are constructed representations organized by a narrative principle, even if this framing device may not be as self-announcing as that of fiction. Here, on the shared grounds of narrative and textuality, is where the more nuanced shades of truth play out.[8] For uncontained, unnarrated, but merely "reported" as history, the "facts that matter" may indeed lack the coherence and comprehensibility that enables an audience to construct meaning and thereby *allow* the facts to matter. Yet, given the events of the Holocaust itself and the aesthetics for representing them, it is precisely this vehicle that fosters comprehension and coherence —the iconic presence that *Schindler's List* provides—that defies the very nature of the events in their fundamental incomprehensibility and refusal to be contained.

Prior knowledge is helpful not only when screening the graphic and detailed if fictive presence of *Schindler's List*, but also the fabulated displacement and substitution of *Life Is Beautiful*. If prior knowledge can help ensure that *Schindler's List* is not mistaken for a true documentary's presence, then it also can help viewers fill in the gaps of *Life Is Beautiful's* fable. While *Schindler's List's* iconic approach incites debate over the dangerous implications of realistic, albeit fictionalized, history, *Life is Beautiful's* fabulated

[8] The recent controversies over the questionable authenticity of Wilkomirski's so-called narrative *Fragments*—an award-winning Holocaust "memoir" told from a child's point of view whose author was later determined not to be the survivor he believed he was—demonstrate the problems inherent in the "automatic" privileging of experienced presence. See Amy Hungerford's "Memorizing Memory" and *The Wilkomirski Affair: A Study in Biographical Truth* by Stefan Machler, John E. Woods (trans.).

approach ignites a series of related but different debates that focus on the question of whether or not fable can appropriately give voice to the historical presence that Holocaust representations require. A close analysis of *Life is Beautiful* responses from two categories: those that claim "critics miss the point" and those that explicitly compare *Life is Beautiful* to *Schindler's List*, demonstrates how competing audience expectations for fable, film, and Holocaust representation manifest themselves as an irreconcilable tension between audiences' desire for displacement and avoidance of the "facts that matter" and a simultaneous desire to vindicate *Life Is Beautiful* as a film that does not trivialize or dismiss the Holocaust.

Of the 534 responses to *Life is Beautiful*, 48 explicitly addressed the films' critics (be they academic, media, or other viewers who have posted to the forum) and accused them of "missing the point."[9] The responses demonstrate the

[9] Of the 534 responses to *Life Is Beautiful* posted as of October 2, 2001, 348 were positive; 172 mentioned the emotional effects the movie provoked (a common topos was that of "laugh/cry" in that reviewers tended to group these emotions together and discuss the fact that the film "made them laugh, made them cry"); 89 were negative; 62 mentioned the fact that it was a "foreign film" or the use of subtitles; 45 explicitly compared the film to *Schindler's List* (as opposed to the 4 responses to *Schindler's List* that mentioned *Life Is Beautiful* –which may in part be due to the fact that *Life Is Beautiful* was released in the U.S. 4 years after *Schindler's List*); 22 talked about the need for greater audience understanding; 18 specifically recommended that viewers see other films (among the films recommended were *The Bicycle Thief, Escape from Sorbibor, Shoah*, and others. Often viewers located Benigni within a comedic tradition—in these cases Chaplin's *The Great Dictator*, the television sit-com *Hogan's Heroes,* and Mel Gibson's *The Producers* were often mentioned); and 4 mentioned other external books including but not limited to *The Diary of Anne Frank*. This essay's scope prevents me from addressing all 48 responses in this category, so I have "randomly" selected 5 responses addressing this topos by counting every 9th response. I will analyze these five

difficulty of reconciling the conflicting genre conventions that *Life is Beautiful* instantiates. Audience responses perform a dislocation and substitution that parallels the film's own narrative moves. They either praise the film because it is "not about the Holocaust" but rather a fable of other designs; or they praise the film's ability to domesticate what is otherwise unrepresentable, and thus bring the Holocaust into a realm of greater understanding.

Given the nature of both the Holocaust and the fabulist genre, one might suspect that White and other viewers would automatically dismiss *Life is Beautiful* under the premise that it is "manifestly false. . .to the facts that matter" (39). Rather than dismissing it outright, however, audience responses employ White's explanations, if not his exact terminology, to redeem and laud *Life Is Beautiful* against its critics who "miss the point" and judge it by the standards of what White terms "literal representation." As White points out, representations that do not purport to present literal history tend to be evaluated on their ability to represent what the "facts *mean*." Perhaps because Holocaust representation's demand for "presence," complexity, and the refusal of containment might necessarily be mutually exclusive with the fable's fictional conventions to simplify and reduce, defenses of the film are forced to privilege one genre over the other. Accepting the film's substitution of emotional content for the Holocaust's stark reality, the film's defenders fail to consider the implications of the substitution the film performs. In suggesting that the Holocaust, which by definition is anything but upbeat, is well-represented in an optimistic, "love conquers all" message, they fail to acknowledge that this substitution may be false to what the "facts mean."

Unlike the responses to *Schindler's List* where very few respondents directly address other respondents, here respondents feel obliged to both recognize and address the

and generalize from them as representative of the group included in my sample.

"other viewers" who dispute their value judgments about the film. Illustrating the dangers inherent in the kind substitution that *Life Is Beautiful* performs, one respondent encourages other viewers to see the film precisely because it is not the "downer" one expects:

> *Life Is Beautiful* is the rarest of films, literally making you laugh one minute and cry the next. Having said that, this is not a "downer" of a movie, but inspiring like no movie ever made. Don't be afraid to see it because it. . .involves the Holocaust; you'll be missing an experience that will stay with you forever. (Randjuke 1/15/00)[10]

The draw here is not that the film fulfills expectations that Holocaust films are inherently depressing, but rather that it defies them. Displacing the expected "downer" content with something more inspirational and upbeat, the film's fabulation moves into the realm of approachability. According to this respondent, this substitution and domestication—the upbeat message—makes *Life Is Beautiful* worth viewing. However, the danger of such substitution is that the genre of fable allows the film to provide "meaning" that runs counter to the "facts that matter," and Randjuke extols this very transgression.

The fable's conventions prompt respondent Randjuke to move from the topos of praise to that of "critics miss the point:"

[10] This response is representative not only of the "critics miss the point" topos but also the typical praise most viewers showered on the film. Most positive reviews emphasized the film's genius as a Holocaust film due to its "unique" use of comedy and as a film in general. The phrase "making you laugh one minute and cry the next" places the agency for these emotions outside the viewer, as if the viewer has no choice but to engage in these emotional responses. This topos of "laugh/cry" was often accompanied by reviewers' claims for the emotional, experiential power of the film.

. . .The folks who trash this movie because it dares to place humor and the Holocaust in the same picture have allowed their bitterness and grief to block their understanding of the message of *Life Is Beautiful*, and I pity them for what they have lost and have missed. . . .I would agree with other posters that. . .the constant is the attitude and love for his family of Roberto Benigni's character. (Randjuke 1/15/00)

Although less explicit than other respondents who address the same issue, this response suggests that "folks who trash this movie" because of its humorous approach, somehow miss the movie's "real point" which this viewer suggests is the "constant" or "the attitude and love for his family of Roberto Benigni's character" (Randjuke 1/15/00). This "love conquers all" theme enables the film to have the inspiring effect that Randjuke praises earlier in the response. What Randjuke fails to address, however, is what exactly the theme of "love conquers all" has to do with the Holocaust? Randjuke recognizes that "bitterness" and "grief," inherent in the "facts that matter" about the Holocaust, are what prevent other viewers from accepting the terms of *Life Is Beautiful's* positive outlook. In this respect, Randjuke's comments stage the difficulties of White's terms for emplotment. Suggesting that viewers who deem the Holocaust to inspire bitterness and grief by its very definition and nature will not be able to accept a message that runs entirely counter to this notion, Randjuke's comment illustrates the impossibility of reconciling *Life Is Beautiful's* content with the demands for Holocaust representation.

Yet Randjuke is not alone in criticizing critics for their "closed-mindedness." Identifying himself as Pillowboy, one viewer ends his response remarking that only those who,

. . . are open minded enough to see past the fanatical political correctness of most mainstream films, . . .will find in "*Life is Beautiful*" a truly beautiful, simple yet stunning, unpretentious film, where the auteur tries to let the viewer into a world where the events of the Holocaust are given their rightful

place, but where the first and foremost subject is love. Bravo.
(Pillowboy 11/13/99)

Pillowboy's critique of those who are not "open minded enough" to move beyond the "fanatical political correctness of most mainstream films" illustrates his recognition of the demand for realism and presence that Holocaust aesthetics require. Unable to demonstrate how *Life is Beautiful* meets these demands, however, Pillowboy privileges fable over Holocaust aesthetics, when discussing the issue of genre. Suggesting that those who understand Holocaust aesthetics to necessitate a certain degree of realism will not be able to acknowledge the "truly beautiful" and "stunning" qualities of the film, Pillowboy faults these standards rather than the film itself for not fulfilling them. Pillowboy reads the film's dislocation of Holocaust "realities" and substitution for them with the subject of "love," as a new, innovative approach to the subject. In setting "love" as its "first and foremost" subject, however, "the events of the Holocaust" are relegated to the background. That Pillowboy deems this background "their rightful place" suggests that *Life is Beautiful* fulfills audience desire to dislocate and displace the terror the Holocaust's stark reality exposes.

Throughout his response Pillowboy returns to the "real subject" of *Life Is Beautiful*, and uses its displacement and substitution as grounds to defend the film against critics who claim it is not historically accurate. Pillowboy begins his response by acknowledging the commenting controversy on the database itself and calling attention to the film's alleged "lack of respect of history:" "[b]efore I start this comment, I must admit I was a bit dismayed at the negative feedback this movie has received. Many criticize it's [sic] lack of respect of history, others it's inane plot and others, the lack of action (=boring)." But his defense almost immediately shifts its focus to the film's "true" subject, and attempts to argue that the film's dislocation—the fact that it is "not really about the Holocaust"—does not impede its ability to communicate the "seriousness of the Holocaust's events":

> . . . *Life Is Beautiful* is really about the love of a man for his
> wife and his son. . . . I felt that the movie in no way alleviates
> the seriousness of those events. Those who saw it as a simple
> parody of the Nazi occupation seem to have totally missed the
> point of the movie. Benigni is not laughing at the
> concentration camps but is trying to show how a loving father
> struggles to protect the simple mental health of his son by
> making him believe that he was playing a game. . . .
> (Pillowboy 11/13/99)

Pillowboy calls attention to the film's love stories to
justify the lack of gruesome details, and simultaneously
suggests that this lack of detail does not trivialize or
"alleviate the seriousness" of the Holocaust.

The occlusion that the love theme and the child's point
of view combine to provide becomes the central focus of
another viewer's response. Unlike Pillowboy who attempts
to justify the film's absence and substitution with a
complicated chain of displacements all his own, this
respondent concedes that the critics' questions are
legitimate:

> And yet, there are legitimate questions raised by it's [sic]
> detractors, who often feel as if the merit of the story is lost by
> presenting what could be viewed as a too sanitized version of
> the Holocaust. As is said in the beginning of the film, the story
> is a fable,in leaving the true horrors of the concentrations
> camps to our imaginations *Life is Beautiful* allows us to
> become involved more strongly with the moral tale and subtle
> feelings invoked by individual characters and events without
> bludgeoning us with sheer horror and revulsion. . . . (Sai-Ken
> 6/8/99)

This comment consciously recognizes that the "story" is
divorced from the background against which it takes place.
The story of love is separate from what one would expect to
be a story about the Holocaust, and the generic conventions
of fable facilitate and permit this divorce. Yet almost as soon

as this recognition is made, the comment's focus switches from story to genre, from content to form, and the viewer uses the fact that the film is "just a fable" to excuse the film's lack of graphic details.

Despite this dislocation and attempted justification, this viewer maintains that *Life Is Beautiful's* "vagueness" and lack of historic presence may be as problematic as its critics suggest. When acknowledging that the "true horrors of the concentration camps" are left to viewer's "imaginations," Sai-Ken implicitly suggests that viewers must have some prior knowledge of those horrors in order to properly imagine them into the gaps the film leaves. Since most respondents did have some concept of what the signifier "Holocaust" means, the latter half of Sai-Ken's response demonstrates the strengths of the fable as genre—the ability to present an individual story with which an audience can identify. He writes that the fable's lack of gruesome details allows the audience to "become involved more strongly with the moral tale and subtle feelings." Enabling the audience to connect with "individual characters and events" without getting "bludgeoned" with "sheer horror and revulsion," Sai-Ken's response shows that both the fable's and *Life Is Beautiful's* shortcomings are trumped by their ability to facilitate emotional connection (Sai-Ken 6/8/99).

Sai-Ken's response reflects the complex layers of truth *Life Is Beautiful* might be said to represent. On the one hand, he wrestles with the potential dangers of its "too sanitized" version of the Holocaust. On the other hand, he recognizes that it is precisely through the mechanism of sanitation that the fable enables *Life Is Beautiful* to communicate the "smaller, unstated" horrors in a way that perhaps leaves the unsayable unsaid but not entirely absent.

Like Sai-Ken, Kinnard insists that even within or perhaps in spite of the fable's unrealistic context the film still adequately presents the horrible inhumanity. Rather than the love theme, however, Kinnard's analysis of the fog provides the answer to the "unrealistic" attack:

. . . .Some say [the] film didn't deal with the profound evilness of the concentration camps. A number of people that I talked to didn't even remember the scene where Benigni and his sleeping son happened upon the hill of bodies through what was thought to be fog, which turned out to be smoke from the furnaces. Maybe without that scene, one could've made some argument that the film didn't deal with the inhumanity of it all. With that scene it made it all clear what it was all about. I could barely speak when the film was over. . . .(Kinnard, 4/7/99)

Kinnard contends that the fog scene calls attention to the "real" horrors of the Holocaust. He reads the fog as "smoke from the furnaces" and maintains that the scene highlights and presents the inhumanity of mass, industrialized murder. Situating his defense within these constraints, Kinnard's response also demonstrates the need for prior knowledge that Sai-Ken emphasizes. Without the knowledge that the Holocaust entailed the mass extermination of Jews by means of gassing and incineration, Kinnard might not have read the scene as he did. He might have mistaken it for the "simple, literal" fog that it appeared to be. But since his prior knowledge conditions his expectation for Holocaust representations to present evidence of death, he is able to read the "hill of bodies" as such. Kinnard's response illustrates that without such prior knowledge, the snippet of "what it [the Holocaust] was all about" would be missed. Concluding his response with a declaration that the film left him speechless, Kinnard points to the film's emotional impact, rather than the need for audience's prior knowledge.

Pointing to the fact that respondents do not expect films to provide them with reality, Ade72 appeals to the genre of film, rather than fable, to justify the liberties *Life Is Beautiful* takes. According to her, the fact that *Life is Beautiful* is a film excuses it automatically from any responsibility to educate about the Holocaust and justifies the lack of Holocaust presence in its content. Ade72 writes:

. . .You're right to say that children and other folks should read in books about the actual horrors of the Holocaust. This movie is not supposed to be an'educational film'. Your kids go to school for that. You go into it knowing that it's a "tragicomedy". [sic] If you send your kids to a movie nowadays in order to really teach them something, you've got problems. (3/6/99)

Assuming that the audience will come to the film with prior knowledge of the "actual horrors of the Holocaust," Ade72 argues that films are for entertainment as opposed to education. Her defense echoes the criteria that White stipulates. For Ade72 commercial film (as opposed to educational or documentary film) is a kind of emplotment that is necessarily and already figurative. As non-literal figuration, therefore, film is not required to present the kind of reality one would hope that an "educational" film or book about the "actual horrors" of the Holocaust would provide.[11]

Since the expectations for Holocaust representation and film are mutually exclusive in Ade72's schema, one necessarily gets recognized at the expense of the other. Thus Ade72 misses the opportunity to laud the film in a way that its critics might be willing to acknowledge, if not endorse. She does not recognize how the fictionalized story a commercial film presents might be used to humanize some of the Holocaust's "unstatable horrors."

Of the 543 responses to *Life Is Beautiful*, 45 of them specifically mention *Schindler's List*. [12] Many of the responses that discuss the fact that "critics miss the point" specifically mention *Schindler's List* as a comparative

[11] Like the responses to *Schindler's List* that similarly mention external texts, here Ade72's response operates on assumption that print and "educational" materials are more legitimate or authentic means of representing Holocaust horrors.

[12] In this section, I will discuss responses that explicitly pair the two films. I counted every 9th response to select 5 responses, a random but representative sampling from the topos.

touchstone, illustrating how the issues of genre and genre expectations push these two films up against one another. Both the film's supporters and critics demonstrate the dangerous implications of the dislocation and substitution *Life is Beautiful* provides, because their defenses of and attacks on the film, respectively, focus on the same issues: not presenting enough of the facts, exploiting the child's perspective to shield the audience, and shifting the focus of the movie to the "love theme" which has little to do with the "facts that matter." Deeming the fable ineffective as a Holocaust representation, critical respondents tend to hold *Schindler's List's* presence up as a model which should be emulated and preferred when compared to the revisionist substitution that *Life is Beautiful* performs. Illustrating the danger of the false presence of emotional domestication that *Life is Beautiful* provides, those who laud the film tend to like *Life Is Beautiful* precisely because it avoids and substitutes for the graphic reality that *Schindler's List* makes present. Preferring *Life Is Beautiful's* displacement to *Schindler's List's* all-too-gory fictionalized presence, these supporters welcome the escape the film provides from the otherwise "too heavy" content of the Holocaust.

Life is Beautiful's supporters maintain that despite or perhaps because of, its displaced presence the film effectively communicates the "life truths" of the camps, even if it does not present the illusion of "authentic presence" that *Schindler's List* provides. Tiffany Mills praises *Life is Beautiful* for its ability to personalize and enable audience identification and connection, a quality that the film's displacement and substitution facilitates. She writes:

> . . . Just because Roberto Benigni didn't show people getting shot in mass quantities every 15-20 minutes, for 3 hours, doesn't make it any less effective in relation to the experience of the camps. I was very disturbed by the murders and violence in *Schindlers List* but I was actually moved by it only a few times. Eventually, the people became nameless

casualties that just piled up. You didn't know their stories and you could only guess their feelings. (Mills 3/13/99)

Mills locates the film's ability to "move" audiences in a way that *Schindler's List* does not in the individualization and domestication that it provides. She faults *Schindler's List's* effected authentic presence for depersonalizing and dehumanizing the victims in ways similar to that of textbooks and other "authentic" histories. In this respect, her response succeeds in reconciling the conflicting expectations for Holocaust representations and fables or film. She highlights the strength of fable in particular and literature in general to humanize what might otherwise remain "dry facts on the page," and then privileges its conventions over those demanded by Holocaust aesthetics. Arguing that *Life is Beautiful* is not less effective than a more "serious" treatment of Holocaust subject matter, Mills suggests it stays faithful to what Friedlander terms the "stark reality" of the camps.

In order to catch the suggestions of deeper, more "realistic" truths that *Life is Beautiful* only hints at, however, viewers must come armed with prior knowledge of what the Holocaust was and what living through it entailed. Mills continues her response by praising the film not only for the human connection the displaced presence enables, but also for the active participation it requires on the part of the viewer:

To me, the main element that made *Life Is Beautiful* so excellent is that it takes the focus off of the violence and gives us the emotions of the characters. I got to know Guido, Dora, and Joshua. I truly felt the emotions pouring out of their performances. Many if [sic] us have gotten so used to everything being shown to us and spelled out in films that we've started to leave our brains behind. The horror and violence is only implied, but you should be able to use your head and read between the lines....(Mills 3/13/99)

Mills reiterates that the substitution of characters' emotions for graphic violence is a source of the film's effectiveness. Since the violence is only "implied," viewers are forced to use their "head and read between the lines" (Mills 3/13/99). Of course, she assumes that audience members already know enough about the Holocaust and the kind of violence that took place in the concentration camps that they actually can fill in these gaps. Mills argues that *Life Is Beautiful's* gaps function as a tool—they leave the "unsayable unsaid" and enable greater audience participation and engagement. [13]

But the danger of the film's lack of details is illustrated in another viewer's response. For those who are unable to actively fill in the gaps with the appropriate history are liable to mistake the film's substitution—the message of "love conquers all"— for the graphic details of Holocaust horror. Unfortunately, like the blanks the film leaves in regards to the details of atrocity, this response fails to recognize the disconnect between the film's upbeat content and the "facts that matter" about the Holocaust. Rather than the tactics employed by other viewers, which suggest that even in its deeply blurred and dislocated presence *Life is Beautiful* still conveys the horrors, this response seems to celebrate the fact that the film completely absents them. Spies writes:

> . . .The story could indeed be compared to *Schindler's List* in that one gets to see the picture from the victim's side, without the war being the centre of the plot. I felt that the lesson to be learned here was that one can rise above one's life situation and problems. . . .Guido gave the ultimate sacrifice of love, namely his life to his family. This scene must be one of the most intence [sic] I have ever experienced. . . .He shows us that life is beautiful indeed, if one strives to make it beautiful and be willing to share that beauty with people around us. (Spies 9/13/99)

[13] See also CherQueen9's comment.

Although Spies may not realize it, what he praises the film for—its ability to cause him to experience deep emotion, to tell a story about the power of the human will to accomplish what it strives for, despite its circumstances, no matter what those circumstances are, really has nothing to do with the Holocaust. If anything, these ideas run directly counter to what most survivor accounts suggest about their experiences. In this case, the film's substitution of "love" for "horror" enables both its domestication and the dangerous misconception that Holocaust inmates could indeed survive based on sheer will alone.

Not surprisingly the critics' responses focus more on the impossibility of reconciling the film's substitution and displacement with knowledge of the Holocaust's more disconcerting truths, and consequently these responses argue the film necessitates a need for greater audience knowledge. Calling attention to the genuine presence and first-hand experiences of those who lived through this historical period, one reviewer suggests that the film might be offensive to a Holocaust survivor. He writes: "Sure, I would not like to be a Holocaust survivor and to be forced to watch this movie, because I would be probably deeply offended" (Pandd 2/22/99). Here the unstated but implicit assumption suggests that a survivor with lived experience of the actual reality will be upset by the substitution for and evasion of this very reality that *Life is Beautiful* presents.

Indeed, Pandd complains of being "personally" offended by the "unrealistic nonsense" the representation provides:

Personally I was hurt by the extreme superficiality and by the several nonsenses which create really unbelievable situations. In the movie the tragedy is deliberately turned into a tale, from a father to a son, for the psychic survival of the child. But the fiction of the "game" must be confined to the child's eyes, and not extended to the whole scenario of the camp. In this way, the show is irritating. > [sic] From a mere artistic point of view, the movies is not very well directed and acted. Ideas are "old", gags on Nazis. . .are boring and annoying. Once again,

Nazis are shown mostly as stupid and their behaviour arouses
mirth. Tragically, they were not! . . .(Pandd 2/22/99)

Pandd criticizes the child's perspective for being even
too unbelievable for a fable. Attributing these weaknesses to
faulty directing, he recognizes that the shift from tragedy to
"tale" or fable displaces the focus of the film from the
Holocaust to the plot regarding the father and son
relationship. Moreover, he suggests that this dislocation is
yet another weakness. Pandd concludes his response by
bringing the issue of audience knowledge to the forefront:
"The great success of the movie in U.S. is amazing [sic]. I
only hope that young people, facing for the first time this
page of our History, will prefer to read books and watch
documentaries or, if they like modern movies, Spielberg's
'Schindler's List'. . .." (Pandd 2/22/99). He would rather
have an audience who lacks any prior knowledge of the
Holocaust be exposed to the "realities" of the event through
"books" or "documentaries." While Pandd does mention
Schindler's List as part of the series of texts which he deems
to have educational use value, he relegates it to the last
position. His comment suggests that since *Life Is Beautiful*
does not make the horrors of the Holocaust central, it should
not be the first or only vehicle used to expose an otherwise
ignorant audience to the Holocaust. Rather, if an audience
must first be exposed to the horrors through popular film,
they should see a more "realistic" representation such as
Schindler's List.

Underscoring the fact that *Life is Beautiful's* lack of
authentic presence gives cause for its dismissal, yet another
viewer has difficulty understanding how survivors could or
would accept the film. Respondent Tinlizzy writes:

. . . .I cannot possibly imagine how rabbis and survivors of the
Holocaust can recommend this movie to anyone. . .
.Auschwitz is portrayed as a particularly grubby holiday camp
where no one is beaten, the guards never shoot Benigni as he
runs around looking for his little boy; people go to the

> infirmary and come back; and no one starves. I'd say this film plays into the hand of the revisionists who claim that the Holocaust never happened. . . .(Tinlizzy 1/2/99)

Tinlizzy faults the film for absenting the harshness of daily life in the camps and replacing it with a representation that might suggest to both the uneducated and revisionists that "the Holocaust never happened." Tinlizzy's response reflects an anxiety over the kinds of gaps such a dislocated presence leaves. She expresses fear that such gaps, rather than being filled with audiences' knowledge of the "true horrors," will be left empty and interpreted as confirmation that such horror never took place. She continues:

> Run Chaplin's THE GREAT DICTATOR to see a truly brilliant film about life in a Fascist state, and then run SCHINDLER'S LIST to find the best fictional portrayal of the Holocaust. . . .This [*Life is Beautiful*] is a real disservice to the memory of the people who died in the camps. . . .(1/2/99, emphasis in original)

Her privileging of Holocaust representation conventions over those of fable, illustrates the near impossibility of reconciling the two when evaluating *Life Is Beautiful*. Given her desire for presence, it is no surprise that she recommends *Schindler's List* as the "best fictional portrayal of the Holocaust."

Public responses demonstrate the complexity of the numerous generic conventions *Schindler's List* and *Life Is Beautiful* are expected to uphold. As both commercial, non-documentary films and Holocaust representations these texts are beholden to cross-purposes. Since each film performs its own compromises, it becomes all the more important to recognize these compromises, the potential dangers they set in motion, and the specific ends they serve. Recognizing the films' deliberate breach of certain Holocaust aesthetics can help audiences better know how to interpret the truths each

film communicates. *Schindler's List* dons the cloakings of "historical realism" to present the illusion of unmediated access to the horror, and in so doing, invites a discussion of its own fictionality and textuality. Yet, as some viewers recognize, it is this attempt to function as a "history lesson" which leads the film to fail in the same way a history book would—by dehumanizing the very victims it presents. The iconic images and graphic details *Schindler's List* provide are, simultaneously, the vehicles for both greater audience connection and disengagement. Similarly, *Life is Beautiful's* fabular conceit presents an individualized story with which audiences can identify and engage the Holocaut's injustices. However, it too, through the very mechanisms which it enables greater understanding, the fabular reduction and humanized story, also provides the vehicle through which the audience can miss out on other Holocaust truths—the fact that at its essence it is wholly dehumanizing and senseless and that regardless of how strongly it was felt, ultimately, love and will had no place in determining who did or did not survive.

While both films break conventions of presence and get accused of "trivializing the Holocaust," perhaps the means through which the films accomplish these broken conventions suggests something about the ends they can accomplish for an uneducated audience. If *Schindler's List's* effected presence of genuine authenticity threatens to be mistaken for "real," legitimate, and representative history, at the very least it provides an illusion of the horrors that the Holocaust entailed. On the other hand, the double breach that *Life Is Beautiful* performs is doubly threatening, for it not only absents the details that *Schindler's List* makes all too present, but it then substitutes for them with a plot that directly counters the fundamentally uncontainable, undomesticated terror of the Holocaust. Although it may allow audiences to connect with an individualized story, the "love conquers all theme" has little to do with the "facts that matter" about the Holocaust (White 39). In this sense the

story plays into audience desires to evade or repress the Holocaust under the auspices of attempting to better understand it. While these are the dangers that both films present, it is clear from the audience responses that any black and white dichotomy is a false one. The responses themselves struggle with and attempt to determine grayer shades of truth than the films present. Respondents may not be able to reconcile the conflicting genre expectations of film, Holocaust representation, historical realism, and fable, without privileging one genre over another. The very act of engaging in the critical debates, however, forces them to articulate what they perceive as the films' strengths and weakness, and thereby proves to be a productive exercise in-and-of-itself.

Works Cited

Ade72. "Some of Us Are Missing the Point. . . ." Online Posting. *Life is Beautiful* Comments. 2 October 2001. <http://us.imdb.com/CommentsShow?118799/360>

Anonymous. "Powerfully Disturbing Film with Lack of Credibility/Unnecessary Storyline of Oskar Schindler." Online Posting. 13 April 2001. *Schindler's List* Comments. 2 October 2001. <http://us.imdb.com/CommentsShow?108052/40>

Cherqueen9. "A 'Beautiful' Masterpiece." Online Posting. 3 February 2000. *Life Is Beautiful* Comments. 2 October 2001. <http://us.imdb.com/CommentsShow?118799/120>

Fahnestock, Jeanne and Marie Secor. "The Rhetoric of Literary Criticism." *Textual Dynamics Of the Professions: Historical and Contemporary Studies of Writing in Professional Communities*. Ed. Charles Bazerman and James Paradis. Madison: University of Wisconsin: 1991. 76-96.

Friedlander, Saul. "Introduction." *Probing the Limits of Representation*. Ed. Saul Friedlander. Cambridge: Harvard University Press, 1992.

Hansen, Miriam Bratu. "*Schindler's List* Is Not *Shoah*: Second Commandment, Popular Modernism, and Public Memory."

Spielberg's Holocaust: Critical Perspectives on Schindler's List. Ed. Yosefa Loshitzky. Bloomington: Indiana University Press, 1997.

Horowitz, Sara R. "But Is It Good for the Jews? Spielberg's Schindler and the Aesthetics of Atrocity."*Spielberg's Holocaust: Critical Perspectives on Schindler's List.* Ed. Yosefa Loshitzky. Bloomington: Indiana University Press, 1997.

Hungerford, Amy. "Memorizing Memory" *The Yale Journal of Criticism* 14.1 (2001): 67-92.

Kinnard, Rupert. "It Was a Fable And It Was As Unrealistic As It Needed to Be." Online Posting. 7 April 1999. *Life Is Beautiful* Comments. 2 October 2001
<http://us.imdb.com/CommentsShow?118799/300>

Life Is Beautiful. Dir. Benigni, Roberto. Miramax, 1997.

Loshitzky, Yosefa. "Holocaust Others: Spielberg's *Schindler's List* versus Lanzmann's *Shoah.*" *Spielberg's Holocaust: Critical Perspectives on Schindler's List.* Ed. Yosefa Loshitzky. Bloomington: Indiana University Press, 1997.

Maechler, Stefan. *The Wilkomirski Affair: A Study in Biographical Truth.* Trans. John E.Woods New York: Schocken Books, 2001.

Mills, Tiffany. "One of the Best Movies I've Ever Seen." Online Posting. 13 March 1999. *Life Is Beautiful* Comments. 2 October 2001.
<http://us.imdb.com/CommmentsShow?118799/360>

Pandd. "The Tragedy Is in Superficiality and Nonsense." 22 February 1999. *Life Is Beautiful* Comments. 2 October 2001
<http://us.imdb.com/CommentsShow?118799/400>

Randjuke. "Outstanding." Online Posting. 15 January 2000. *Life Is Beautiful* Comments. 2 October 2001.
<http://us.imdb.com/CommentsShow?118799/140>

Sai-Ken. "A Truly Beautiful Fable, No More, No Less." Online Posting. 8 June 1999. *Life Is Beautiful* Comments. 2 October 2001. <http://us.imdb.com/CommentsShow?118799/240>

Schindler's List. Dir. Stephen Spielberg. Screenplay by Stephen Zaillian, Universal, 1993.

Spies, Thys. "A Brilliant Piece of Motion Picture Art." Online Posting. *Life Is Beautiful.*Comments. 2 October 2001. <http://us.imdb.com/CommentsShow?118799/200>

Staiger, Janet. *Perverse Spectators: The Practices of Film Reception.* New York: New York University Press, 2000.

Stempel, Tom. *American Audiences on Movies and Moviegoing.* Lexington: The University Press of Kentucky, 2001.

"Vita _ bella, La (1997)." The Internet Movie Database. 2 October 2001. Internet Movie Database Ltd.
<http://imdb.com/title/tt0118799/>.

"Schindler's List (1993)." The Internet Movie Database. 2 October 2001. Internet Movie Database Ltd.
<http://imdb.com/title/tt0108052/.>

Weaver, Caleb. "A Work of Art." Online Posting. 28 January 1999. *Schindler's List* Comments. 2 October 2001.
<http://us.imdb.com/CommentsShow?108052/280>

White, Hayden. "Historical Emplotment and the Problem of Truth." *Probing the Limits of Representation.* Ed. Saul Friedlander. Cambridge: Harvard University Press, 1992.

Brief Filmography and Note

Because some of the essays in this book are in English and some in Italian, the following is a brief filmography that provides the names of Roberto Benigni's films in both languages.

As Actor:

Berlinguer ti voglio bene/Berlinguer I Love You
Italy, 1977, 90 min. Director: Giuseppe Bertolucci

Il Comizio
Italy, 1978, 22 min. Directors: Paolo Brunatto, Mario Maglietti, Elio Rumma

Chiaro di donna/ Clair de femme
Italy/France, 1979, 110 min. Director: Constantin Costa Gavras

I giorni cantati
Italy, 1979, 110 min. Director: Paolo Pietrangeli

Letti selvaggi/ Tigers in Lipstick
Italy, 1979, 80 min. Director: Luigi Zampa

La luna/The Moon
Italy/USA, 1979, 140 min. Director: Bernardo Bertolucci

Chiedo asilo/ Seeking Asylum
Italy/France, 1979, 112 min. Director: Marco Ferreri

Il Pap'occhio/Pope in Your Eye
Italy, 1980, 101 min. Director: Renzo Arbore

Il minestrone
Italy, 1981, 165 min. television, 105 min. theatrical version
Director: Sergio Citti

F.F.S.S. ovvero che mi hai portato a fare sopra Posillipo se non mi vuoi bene?

Italy, 1983, 98 min. Director: Renzo Arbore

Tuttobenigni
Italy, 1986, 87 min. Director: Giuseppe Bertolucci

Down By Law
USA, 1986, 110 min. Director: Jim Jarmusch

Coffee and Cigarettes
USA, 1986, 6 min. Director: Jim Jarmusch

La voce della luna/The Voice of the Moon
Italy, 1989, 100 min. Director: Federico Fellini

Night on Earth
(Episode: *Rome)* USA, 1992, 22 min.
Director: Jim Jarmusch

Il figlio della pantera rosa/ Son of the Pink Panther
USA/Italy, 1993, 93 min. Director: Blake Edwards

Asterix/ Asterix and Obelix Take On Caesar
France, 1999, 109 min. Director: Claude Zidi

As Director

Tu mi turbi/ You Upset Me
Italy, 1983, 87 min.

Non ci resta che piangere/Nothing Left To Do But Cry
Italy 1984, 111 min. (With co-director Massimo Troisi)

Il piccolo diavolo/Little Devil
Italy, 1988, 110 min.

Johnny Stecchino
Italy, 1991, 121 min.

Il mostro/The Monster
Italy/France,1994, 118 min.

La vita è bella/Life is Beautiful
Italy, 1997, 130 min.

Pinocchio
Italy, 2002, 108 min.

TRANSFERENCE
CINEMA

In the same series

Passannanti, Erminia, *Il Corpo & il Potere: Salò o le 120 giornate di Sodoma*, di Pier Paolo Pasolini, 2004

Printed in the United Kingdom
by Lightning Source UK Ltd.
105081UKS00001B/3

9 781904 744832